Complete Guide to
Life Drawing

GOTTFRIED BAMMES

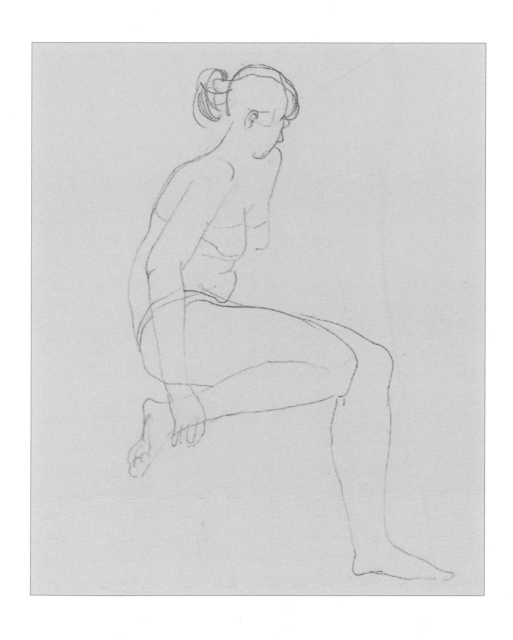

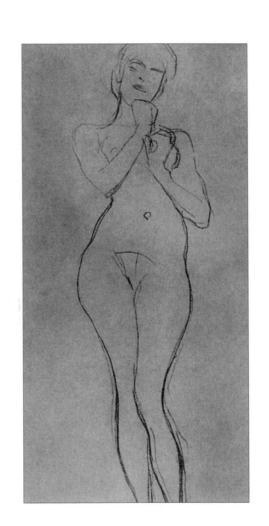

Complete Guide to
Life Drawing

GOTTFRIED BAMMES

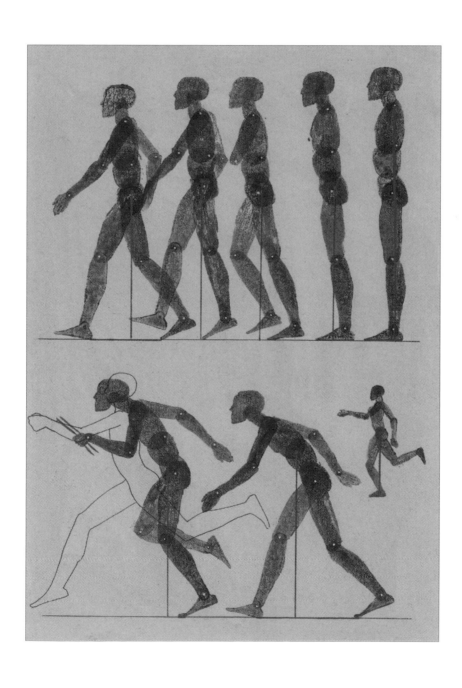

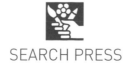

SEARCH PRESS

First published in Great Britain 2011

Search Press Limited,
Wellwood, North Farm Road,
Tunbridge Wells, Kent TN2 3DR

Reprinted 2012, 2013, 2014, 2015

Original edition ©: 2010
World rights reserved by Christophorus Verlag GmbH,
Freiburg, Germany

Original German title: *Menschen zeichnen Grundlagen zum Aktzeichnen*
English translation by Cicero Translations

ISBN 978-1-84448-690-8

All images and drawings illustrating working methods
are original works created by the author during the
years 1984 to 1987, except when another credit
is given.

The Publishers and author can accept no
responsibility for any consequences arising from the
information, advice or instructions given in
this publication.

Printed in Malaysia

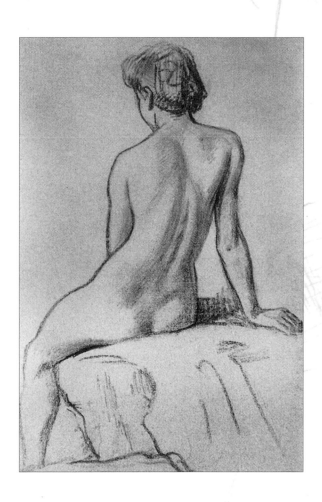

Contents

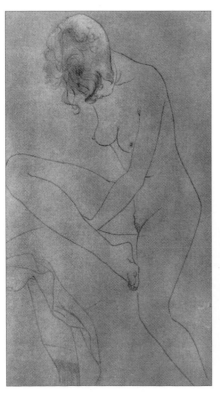

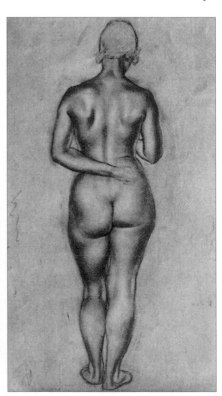

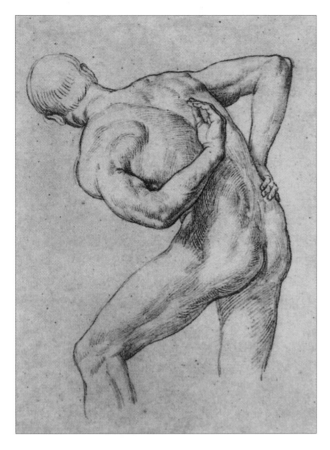

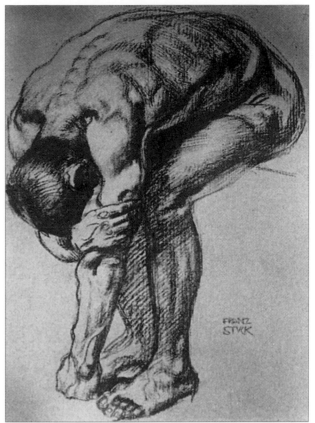

Preface

This book attempts to provide a concise and elementary foundation for drawing the human figure. The subject is made accessible to a wide range of people through its methodical approach and simple presentation, which distils work derived from decades of study of the human form. The reader will understand that I had to keep any discussions to a minimum.

In my earlier books, particularly in *Figürliches Gestalten* (The Form of the Figure) and *Sehen und Verstehen* (Seeing and Understanding), I simplified a vast and demanding topic in a way that could be justified from a practical and artistic point of view. I have taken this approach again, and have even taken it further by making it the main teaching approach for the torso and limbs of the body and for the body as a whole. It is, after all, becoming more and more necessary to strive for clarity when teaching. Understanding while seeing, and seeing while understanding, are not just an absolute necessity for a practising artist; these ideas are an indispensable teaching aid, regardless of the topic being taught and the way in which they are modified to fit the teaching method.

With this in mind, I did my best to make the illustrations even more memorable and informative, without allowing myself to be diverted into scholastically and artistically unjustified abstractions or formulas. All the simplifications of the human form used here, whether in words or in pictures, were newly created for this book. Where I have resorted to long-established teaching methods, these are recast and adjusted to make them not only easier to understand, but also much more effective and striking. To achieve my initial intention to increase the understanding of the precise nature of the human physical form, I have gone to the furthest limits in simplification.

There are always two aspects to such an intention: on the one hand I have simplified in order to make the understanding of physical form accessible to a wide group of users, and on the other hand I wanted the reader to develop a basic routine when drawing from life, namely to identify the essential form and to increase his or her powers of observation.

It has been possible to keep the text quite concise, thanks to a rich, informative and convincing set of illustrations. Instead of a continuous text from page one to the end, the relevant explanatory text faces each page of illustrations. In this way, every illustrated page can be used in conjunction with its text page as a self-contained source of information. Nonetheless, the content has been designed as a single, carefully coordinated and interlocking sequence.

It is not only natural but also inevitable that I bring my teaching experience as an anatomical artist to the issues raised in drawing each of the topics presented. Artistic anatomy is by far the most suitable means of acquiring the basic artistic skills and knowledge required to achieve insightful and well-structured drawings.

I believe it essential to make a serious study of the principles of natural subject matter, to retain this and fully absorb it in concise and sensitive drawings incorporating those artistic principles. The concise information on each topic is always followed by recommendations for exercises and proposed solutions. These have often been prepared for and made feasible by arranging the illustrations according to the stages in the artistic work. The recommended exercises also apply to working with a sketchbook.

By combining factual information with exercises, we consciously engage with the essential and consistent preliminary work that is required to become artistically creative.

In order to keep the context always in view, the book contains drawings from world art for you to refer to as you work along with us. These will create necessary bridges and explain the human body as based on natural principles.

The artistic examples, which are largely little known or unknown, will be silent but eloquent and informative friends, telling us how concepts and content, experience and empathy and the will for form and expression can be mastered.

We will study proportion, learn the principles of dealing with the body in repose and in movement, and explore the structure and functional characteristics of its limbs and its various shapes, its structure in constructional drawings and the psychologically determined expressive forms of so many modelling poses. These are the subjects of our artistic enquiry.

The unclothed body provides us with the most striking answers to our questions, particularly as it has become a common sight these days. When it is wrapped up in clothing, many of the body's actions, as well as the physical reality of what is only hinted at through the clothing, are hidden from the untaught. Our visual experience is undermined and our perception replaced by superficial (quite literally) assumptions. The disclosure of the body and information about how it operates, its limb structure as a whole, its parts and how they are put together must therefore stand at the centre of this book. Here we find visual knowledge and experience, contemplation of detail and of the whole, experience and empathy necessarily combined.

Professor Dr. paed. habil. Gottfried Bammes

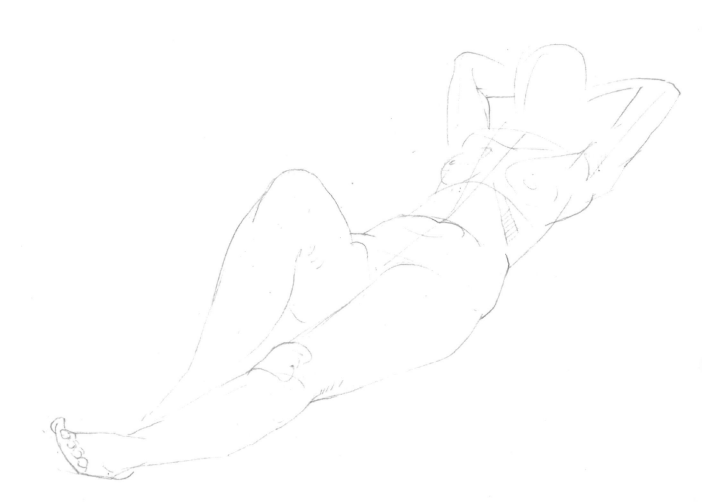

Basic Approaches

When we draw people, we are growing towards others and ourselves and we reveal things that were lost before to our fleeting glances and inaccessible to our experience. With life drawing, we experience both ourselves and otherness. To enter this state awakens us to visual, emotional, physical, mental and social involvement. Our perceptions of others and of ourselves, long hidden away, are illuminated and enter into our sympathetic, insightful seeing. The following points can be made about drawing:

• Drawing is work that requires planning.

• Drawing emphasises strong impressions and leaves out weak ones. It makes movement conscious and filters, purifies and rescues by creating order in the face of many overwhelming impressions.

• When we are drawing the naked human form we observe its physical qualities but we also engage on a deeper level as the subject's true self shines through. This aspect strives to make itself known even in the simplest gestures. The fact that the inner has an outer and the outer has an inner is the final concept which concludes this book.

• We ourselves will change as we draw the human figure. The more often we do so, the more lasting the change. As our visual experience grows, so does our sensitivity, even when we are drawing an initial, exploratory exercise. This is different from purely biological science, because we are building up the body's physiognomy – expressing character through a physical description – working on figural qualities and their relationship with the whole person by lending expressiveness and the convincing depiction of form to the actions of the limbs.

PERSONAL RESPONSE

A great deal will escape a purely visual observation if it is not combined with our own receptiveness and sensitivity. A purely mechanical observation of proportion does not tell us anything about the body's physiognomy if the artist does not bring into play his own intuition and expression when capturing both the overall form and its details. Without subjective responses to the qualities of character, shape and structure, we could simply restrict ourselves to scientific measurements to produce the sort of thing you might see in a textbook for anthropology or medicine. But, of course, this would not lead to artistic creativity.

FORM AND FUNCTION

To make it possible to experience and understand the proportions of the physical body and the structures of men and women, boys and girls, or the form of a small child, it is necessary to bring about an experience, not a diagram, which will create relationships between different areas of the body that are based on similarity or equivalence while also discovering the various different qualities and organic features. Lastly, in the final phase of an exploration of proportion, it is necessary to acquire the skill and ability to appraise forms.

But figure drawing isn't only about form, structure and the relationship of individual parts – far from it. Your ability can only fulfil its own, never-diminishing purpose when it is united with a broader objective: the achievement of purposeful impressions. These include the static resting positions of the body, the processes of bodily movement and gesture, and the dynamically defined changes of place and position. Execution and a sure vision of interrelationships melt into these impressions. Both these areas – the body at rest and in movement – can become familiar through a coordinated learning approach.

We cannot explore proportion without first considering function. The leg and foot, torso and shoulder girdle, arm and hand, and, in fact, the whole figure have fundamentally developed from their origins into their current forms. So I will provide structurally simplified frameworks at the beginning of each subject, to make statements about the origins of movement and sculptural form. Explaining the joint structures and their associated muscle groups has proved to be a tried-and-tested method in this respect. From these relationships we can draw conclusions about predictable movement processes and the legitimate sizes of muscle groups and find out why, for example, an arm or a leg must take on a certain structure and no other in a particular movement or when seen from a specific viewpoint.

In the case of untrained artists, forms with numerous articulations often result in many layers piling up. This problem can be prevented by making efforts to simplify overly complex forms into easily understood general shapes that can be easily articulated. These will be invaluable in creating accessible and memorable representations. Hopefully by the end of this book you will see that drawing is not merely a preliminary process and you will find that it helps you understand the phenomenon of the human form. As art historian Wilhelm Pinders (1878–1947) said, 'Drawing the human figure is not an end in itself, but serves the study of man'.

STRIPPING BACK TO THE ESSENTIALS

As in my other books, *Figürliches Gestalten* (The Form of the Figure), *Sehen und Verstehen* (Seeing and Understanding) and *Der nackte Mensch* (The Naked Human), the preparatory work proposed here is closely linked to the need to think visually at many levels and is intended to allow the reader to penetrate observable phenomena, expressing that which is recognised as essential – the essence of the subject.

Of course, what we consider to be the essence is not a constant value. It is only what remains behind in the 'filter' of seeing during the perception process, reflecting the artist's reaction to the object being drawn, in the process of which the artist makes a selection from the many possible impressions that are significant to him. The essential thus has fluctuating margins, but, from the teaching perspective, it is possible to encourage the student to distil the perceptions in different ways and to avoid detours or fruitless paths. This requires concentration and even restricting oneself to just a few topics. Well-taught concentration provides more support in making sure that the student does not copy objective reality and its appearance in a flat and superficial way.

There are two important factors involved here: an understanding of anatomy, and the development of visual perception. This is also the reason why the serious student cannot deal with figure drawing 'in passing', but must effectively treat it as a duty. You must do this as an endlessly repeated exercise and you will find that in keeping it constantly before the eyes, this perpetual visual experience leaves its traces behind and becomes entrenched as an inner, mental model. It is only in this way that the artist gradually builds up a feeling for organic forms. Finally, the main characteristics gained from perception and knowledge are shaped and organised together with other important features into a representation of the sensory experience of reality.

ALL IN THE DETAILS

Attention to details – a hand, a knee, a foot, an ear – is often rejected these days as 'fuddy-duddy'; rejected out of fear of losing artistic unity. Is this about taking away the stimulus of physical structures and replacing them with artistic ones? This would in itself be unjustifiable, because there are also artistic practices that strive to achieve a certain expression through the exaggeration of details.

The job of artistic anatomy is to clarify the nature of details, which has nothing to do with mindless copying, and this is part of the programme and method used in this book, even when we present an individual object in its most simplified form and assign it its value within the body as a whole.

GOING BY THE RULES

Since the start of the twentieth century, modern art theorists have accused the ancient world, the Renaissance and the academies of putting rules and art theory before the practice of art. With regard to artistic interpretation one might agree, but one certainly has to object if the rules and principles of nature and its processes are to be axed by such a judgment. We do not teach artistic rules in this book, but rather the rules and laws of nature. Rules can therefore be viewed as typical cases. Events and processes that happen according to fixed, incontrovertible principles take on the character of basic laws. If we violate these laws, we are contravening basic facts. One of the most important tasks of this book, therefore, is to teach naturally defined rules and laws in an easily readable way.

Knowing the rules and laws of formal structures and formal proportions is a guarantee that one will not fall into the bottomless abyss of ignorance and inability in the artistic and intellectual creation of the figure.

We also have to mention another limitation, which this book cannot avoid. Rules and laws tend to result in a physicality that is striking in its finality, as opposed to the infinite, open-ended nature of creative approaches. As regards the artistic study of the body, this means that linear and finite interpretation – which achieved its greatest perfection with Michelangelo – has to be balanced by more nebulous qualities – the sfumato of Leonardo da Vinci's or Rembrandt's painterly portraits and nudes, with their openness and permeability in indefinite space. Since the aim of this book is to teach the fundamentals of figure drawing, we must limit ourselves to the comprehensible simplicity of the physical founded on rules and laws.

There are nevertheless latent hints at traits of 'openness' in this book: in drawings left deliberately unfinished and open, in the proportion and movement studies, in the series of the first artistic conceptions of the physical and its functions, and in the unfinished results, which most of all allow the endless changeability of the figure's character to resonate in the general overview.

The limitation discussed here, which I have imposed myself, has resulted in the elimination of any indication of settings in the drawn life studies. The treatment of physical structures, the definition of functions, the direction and formal articulations of the limbs, the clarification of the spatial and surface planes and their extensions are what need to be placed in the foreground of your mind. All this implies that working with elementary, simplified forms is not subject to a random schematic construction and abstraction. In the end this work is the result of penetrating examination, which goes beyond the purely instructional.

Drawing people as a form of self-awareness does not demand that you create art. Our objective here is skill in the artistic rendering of the body, which does not assume any ideal artistic form.

Study of Proportion

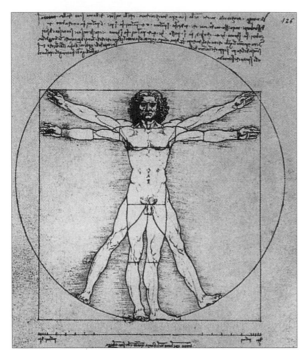

Leonardo da Vinci (1452–1519), Vitruvian man, c. 1485–1490.

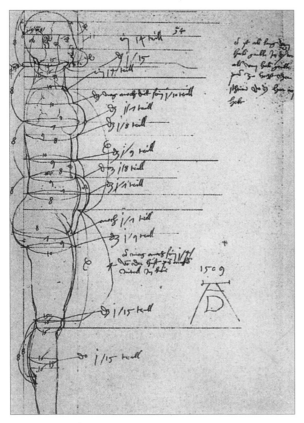

Albrecht Dürer (1471–1528): Studies on proportion with woman of eight head lengths, 1509.

THE PRINCIPAL PROPORTIONS OF THE BODY

When constructing a figure from life, knowledge of the body's proportions – and calculations based in them – play a crucial role. They form part of the basic practical artistic workshop tools, and have various purposes and uses. The most famous examples from an artistic and instructive standpoint are those of Leonardo da Vinci (top left) and Albrecht Dürer (bottom left). We can be grateful to both artists for their work because their methods, which are based on the observation of the organic structure of the figure, are still useful today. To clarify our understanding it is helpful to compare the same or similar long dimensions, using measurements from a life model, and so discover the following points of reference (see the illustration opposite):

• The symmetrical line through the centre of the standing figure (marked as a thick red vertical line). This can be divided on the female body into equal upper and lower parts at the pubic bone or the greater trochanter at the top of the thighbone or femur (marked on the diagram with the red arrows).

• The lower half (the length of the legs) is broken by the intermediate shape of the knees. The lower edge of the kneecap or patella (indicated on the diagram by the thick black arrows) marks the centre of the lower half, and therefore also marks a quarter division.

• In the upper half, the axis of the nipples (marked on the diagram with thin black arrows) is most often situated below the upper body quarter (broken line).

• Often, the point of the chin divides the topmost quarter in half (thick black arrow).

From this we can derive the general law, or canon of proportion that the head takes up one eighth of the entire length of the body, which is a suitable basic module on which to base further calculations about height and depth (see also the profile figures in this respect).

The organisation of the body into quarters allows us to deduce that the height of a woman sitting on a chair is reduced by a quarter (the length of the upper leg), while the height of a woman sitting on the ground is reduced by half.

The widest point from one greater trochanter (on the head of the thighbone or femur) to the other measures almost a quarter of the body height.

Note: The different types of arrows used on this diagram refer to different significant reference points: the red arrow is a primary division, dividing the body in half, the thick black arrows come next, then the outlined arrows and finally the thin black arrows.

THE CONTOURS OF THE MALE BODY

The process of comparing similar or equal lengths is used here to show the relationships between height and width in the male figure.

In the diagram opposite the left figure is the result of establishing the horizontal axes of the vertical figure (see also pages 17, 19 and 27), organised according to anatomically defined measuring points. Starting from the idea that the model is proportioned according to the eight-head canon, one head height (H) has been marked out from both sides of the centre vertical axis to create a grid of H x H squares on which the figure is marked out. This also shows the maximum width extension of the male across the shoulders, namely a full or nearly full 2H (as opposed to about 1.5H in a woman). The only slightly defined waist in the male and his narrow pelvis make it possible to create a silhouetted contour similar to a wedge shape standing on its point.

In contrast to a woman, the greater trochanter (top of the thighbone) on a man is situated somewhat above the geometric centre, which shortens the upper part and increases the lower part of the body. The standing figure, opposite right, that includes the simplified skeletal shapes, identifies the main points in the contours and provides information for further work. Notice the following:

• The anterior (front) neck height from the tip of the chin to the hollow of the neck is 0.25–0.5H, while the nipple axis marks the upper quarter of the body.

• The navel is situated at 3H with the waist a little below it.

• The pubic bone (marked by a broken line) is just above the halfway point.

• The edge of the shin (tibia) is in the lowest quarter of the body, with the knee sulcus and the lower edge of the kneecap (patella) 0.5H above this.

• The inside of the ankle is situated 0.33H above the sole.

• The arm is 3.5H in length, with the end of the middle finger generally reaching below the middle of the femur, while the wrist reaches just below the greater trochanter.

• The distance between the nipples, between the outer edges of the knees and across the soles of the feet each measure 1H.

The other images provide further comparisons. Albrecht Dürer worked on the simplification of forms through stereometrical figures in his Dresden Sketchbook (meaning that he organised the shapes by volume). The Spanish artist-cum-anatomist Christomo Martinez built up the Vitruvian man with labels for the bones and muscles, while the Dutchman Samuel Hoogstraten contrasted a skeletal and a muscular man.

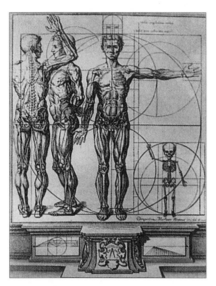

Albrecht Dürer (1471–1528): Stereometric structure of a male figure, 1515–1519.

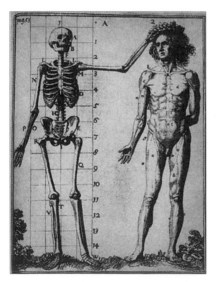

Christomo Martinez (1628–1694): Anatomical proportion, print c. 1780.

Samuel Hoogstraten (1627–1678): page from *The Advanced School of Painting*, 1678–1780.

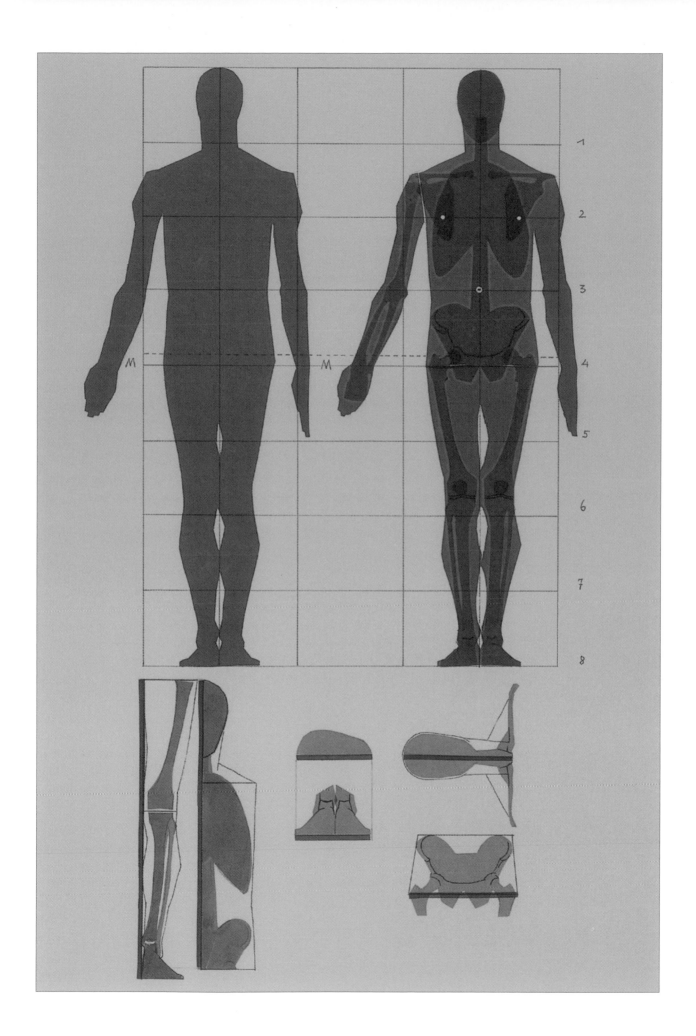

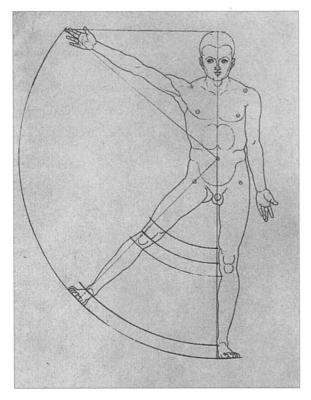

Albrecht Dürer (1471–1528): Male front view, drawn in a circle, after 1520.

BUILDING THE STRUCTURE FOR A MALE FIGURE

The purpose of the diagram opposite is to show further possibilities for organising the male form in relation to its living, varied manifestation, starting with the front view, with clearly defined contours. The basic principles for indicating corresponding lengths are maintained.

Notice that the horizontal arm position of the grey figure reaches with the fingertips to the vertical edge of a potential square of half body height (yellow shading). The vertical and horizontal grey bars mark the half-height length and width while extended horizontal lines are used to mark the height in quarters.

The grey frontal figure (similar to the Dürer figure left) shows the basic geometrical forms of the body: the torso akin to a rectangle, the intermediate form of the stomach, the trapezoid of the thighs, the squarish intermediate form of the knee, etc.

In addition, this proportional figure has been given secondary forms layered over the main or basic forms (line contours) and further inner forms. The outline of the whole figure coloured in grey, represents the consistent relationships of forms, which is the fundamental purpose in arranging the figure.

The further additions to the leg are the first indication of the static construction starting from the top of the hip joint:

• The weight-bearing line (broken) slanting downwards in the same direction as that of the main leg joints.

• The centre line (unbroken line) of the femur (thigh) and tibia (shin) bones, which run at an obtuse angle.

The back view of the right-hand figure emphasises the difference in form from the front view:

• The trapezoidal deviation of the back shape from the square-like front view of the thorax region.

• The horizontal fold under the buttocks situated a little way below the public bone (broken line).

Dürer's proportional figure, based on Vitruvius, has something in common with our illustration in the lifting of the arm in a sweeping movement, similar to that in the famous drawing by Leonardo da Vinci. The common centre for a circle using the sweep of the arm and leg is the navel.

Hoogstraten makes use of the basic measurement of one half of a head height when presenting the proportions of men of different heights (top of the head to the optical axis) using a canon of 7½ and 8H.

Samuel Hoogstraten (1627–1678): Male proportional figures with basic dimension of half head height from *The Advanced School of Painting*, 1678–1780.

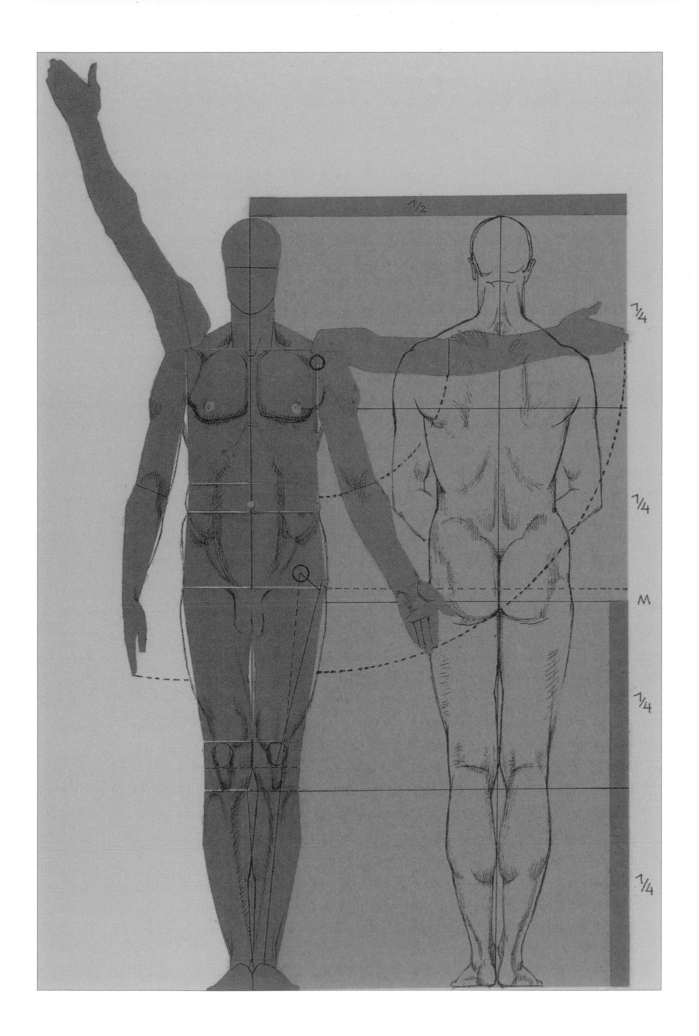

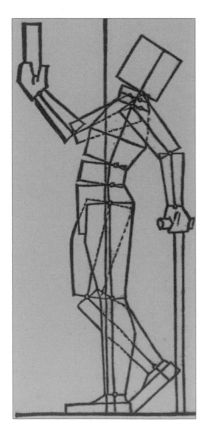

Albrecht Dürer (1471-1528): Contours of a stereometrically drawn man (detail) c. 1527.

THE MALE FIGURE BROKEN DOWN INTO GEOMETRICAL SHAPES

The process started on the previous page is taken up again here and shown from a flat, abstract viewpoint. Capturing proportion is the preparation for understanding the behaviour of sections of the body under functionally static conditions (see page 73).

The sections that have been emphasised in the illustration opposite derive from relatively self-contained, constant groups of shapes, such as the triangular nape of the neck, the upper body square, the waist-hips trapezoid, or variable intermediate forms, such as the front, lateral and rear abdominal wall (indicated by broken lines on the right-hand figure). When a figure bends or moves, the interrelationships between the positions of the groups of forms change, as you can see in Lautensack's illustration:

• When a figure bends over, the body shapes come together on one side and produce a compression of the soft, variable intermediate forms.

• On the opposite side, where the distances increase, the soft shapes are extended, so that the underlying frame is more easily seen.

If you believe that you can draw the figure without simultaneously creating or keeping in mind these simplified, geometric, structured sections, you run the risk that you will not express functionality, or may do so only weakly.

If you do not take into account the axes of the body in the standing form, you will weaken the connections between one side of the body and the other and may fail to pay attention to the points of reference.

The two vertical bars next to the left-hand figure indicate the distinction between the upper and lower parts of the body: the shorter bar is the height of the upper part, above the greater trochanter, while the longer bar is the height of the lower part of the body.

Dürer also broke down the profile figure into stereometric forms (i.e. showing the different volumes of the body) in the Dresden Sketchbook, a preliminary sketch for the proportional figures shown on page 14. Moreover, the fact that Dürer also thought about demonstrating the displacement in sections when they move is confirmed by Heinrich Lautensack, who adopted the Dürer profile figure for the instructional presentation of backward bending, showing the divergence of elastic parts and the telescoping of the compressed side of the body.

Heinrich Lautensack (1522–1590): Proportional figures from
Instructions on the Correct Use of the Circle and Straight-Edge
(detail), 1564.

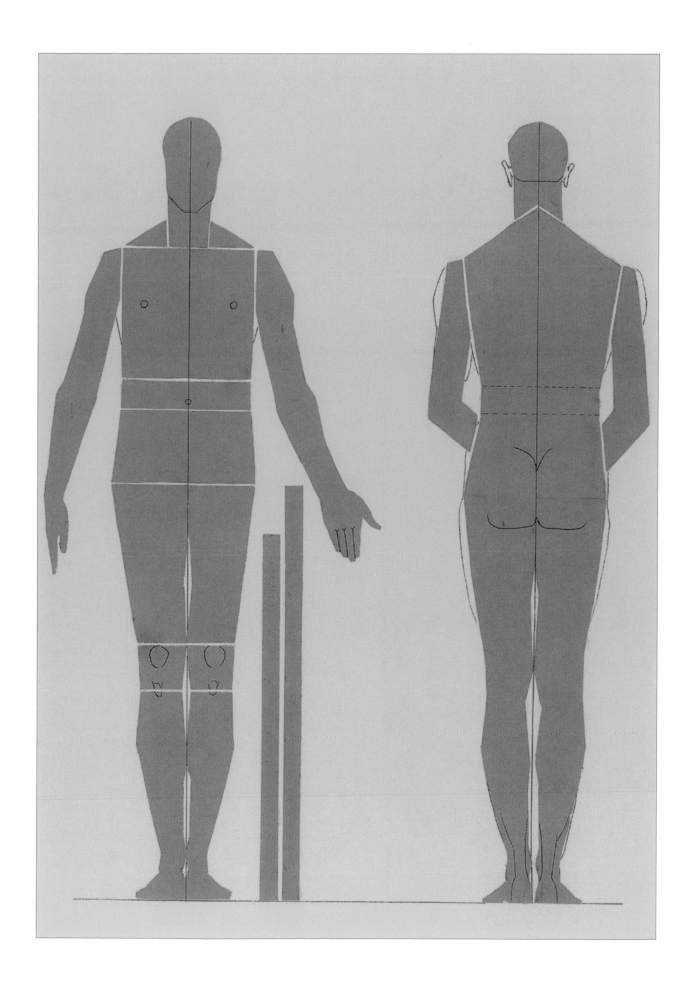

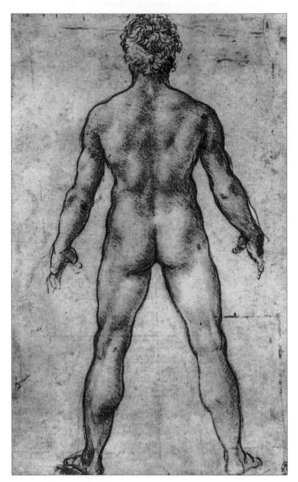

Leonardo da Vinci (1452–1519): Male nude, rear view.

Wilhelm Rudolph (1889–1982): Male nude, rear view, and standing woman, front view.

THE MALE FIGURE: STRUCTURAL ISSUES AND EXERCISES

The illustration opposite compares the previous standing pose with another standing pose in the context of previously discussed issues of proportion:

• The imaginary centre of mass is given at two different heights:

S1 (grey dot) indicates the centre of gravity when the feet are standing together.

S2 (red dot) is the lowered height as a consequence of the standing position with the legs spread out (providing an increase in stability).

• The surface of weight distribution is marked with a red line beneath both the left and right figures.

• The broken red line shows the vertical from S down to the support plane, which is the line of gravity.

• The crucial pivots, marked on the right-hand figure – the jaw, shoulder, hip, knee and ankle joints – are arranged around the line of gravity.

The right-hand profile figure has the same proportions and posture as the frontal figure standing with feet together and it establishes the rhythm of physical motion.

Exercises

1 Cut strips of coloured paper to any length (for the moment), so that three strips stuck next to each other are equal to the width of a man's torso at shoulder height (see page 22).

2 Cut a length to describe the approximate centre of the body from the top of the skull to the pubic bone. Attach a strip on either side of this, starting at shoulder height and converging from the hips down to the feet; remember that the upper body is shorter than the lower body (see illustration, page 19). Cut and arrange lengths for the arms.

3 Try the same procedure with a flat brush and transparent paint, as shown on page 23. The important thing here is to assess the figures to be painted with vertical, parallel brushstrokes. Also try the profile view and deal with the orientations of the masses, referring to the profile figure on page 21. Using the same method, try painting gentle deviations in the postures of the figures.

4 Now apply the main shapes of the proportions and their orientations in a similar way, using the brush. If these require correction or if you wish to add some details, you can do this using linear pen contours (page 24, top).

5 Practise putting the figure together using dry-brush technique and working from the centre outwards. Do not use any under-drawing (page 25, top). Also try the rear view with a flat brush, paying attention to the deeper level of the horizontal buttock fold.

6 If you are working outdoors, record the contours of the figures in a rapid, linear fashion. The emphasis should be on proportional values and the clarity of the orientations of the limbs (pages 24 and 25, bottom).

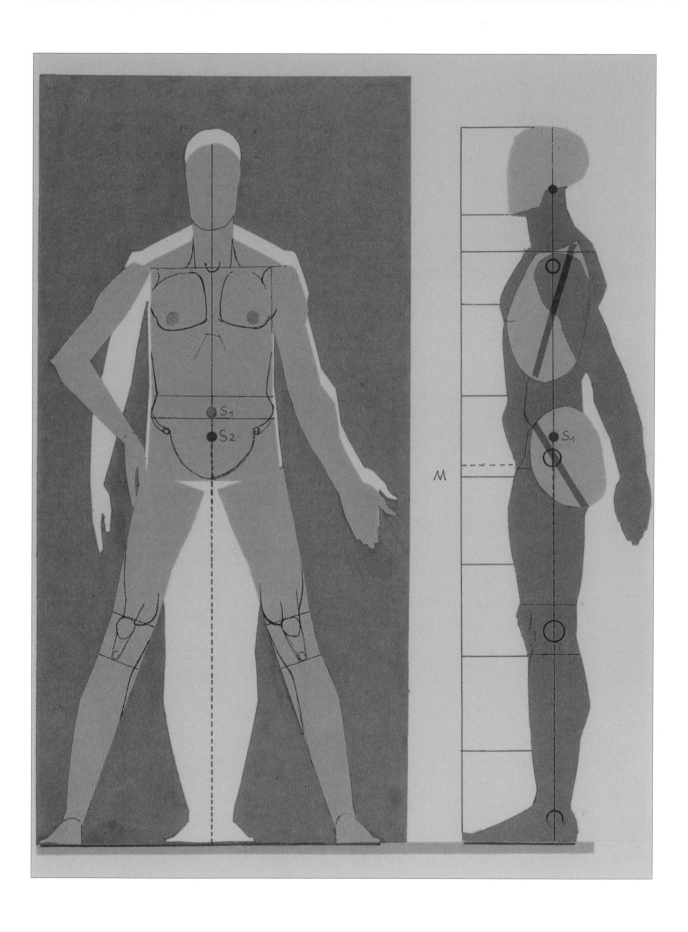

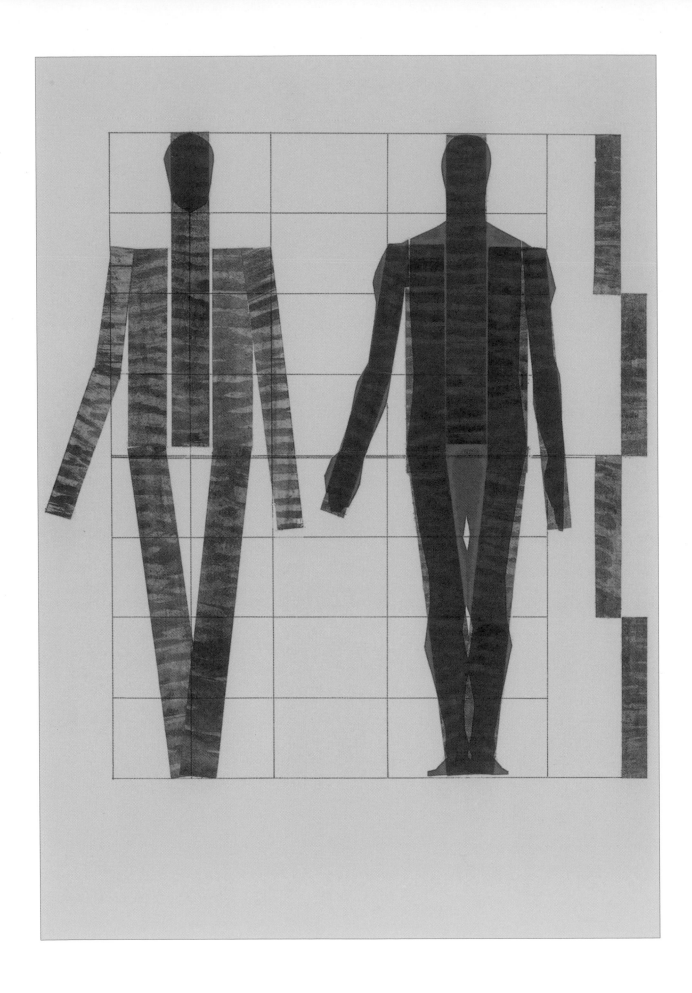

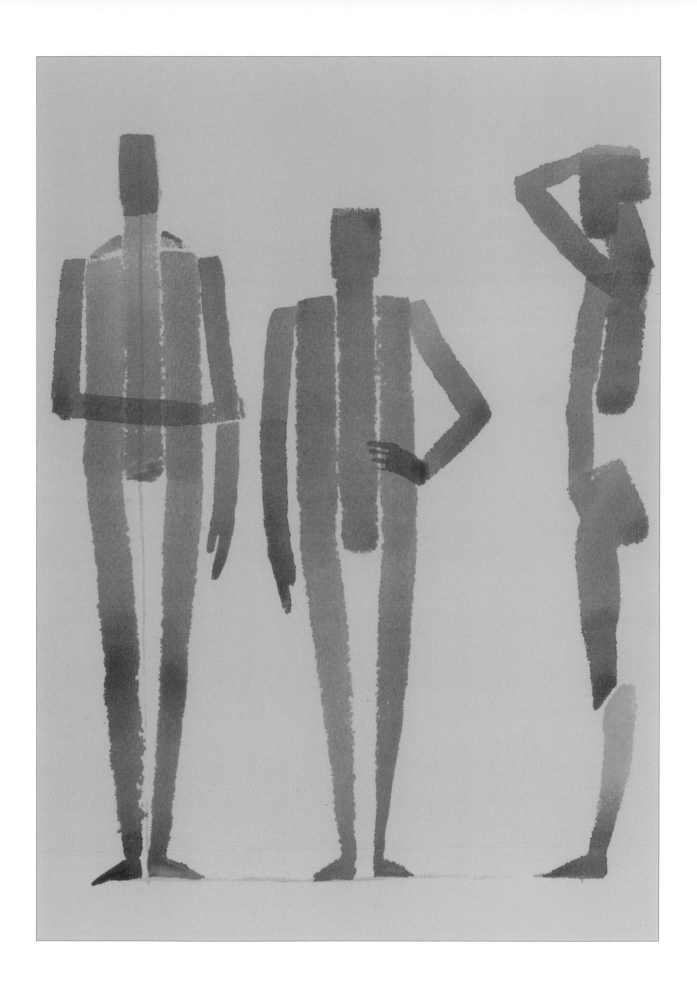

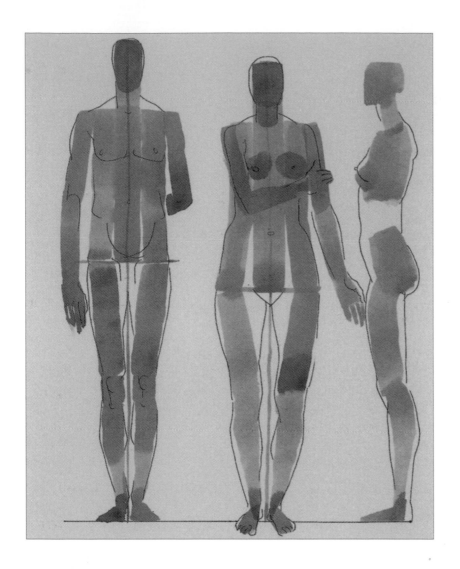

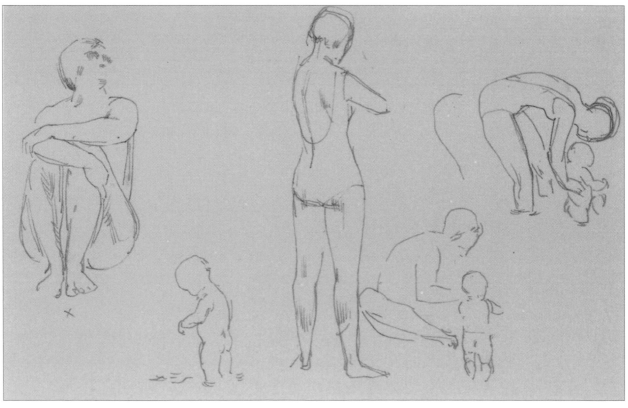

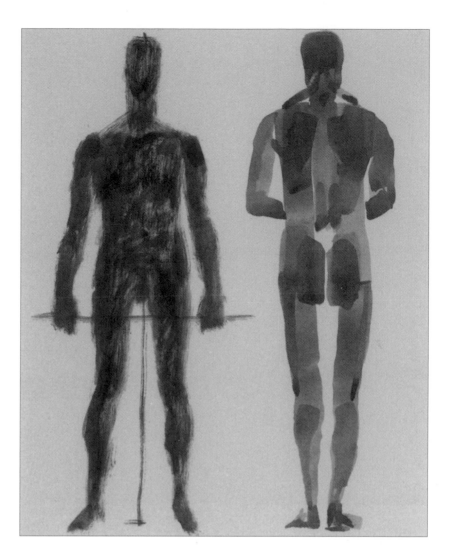

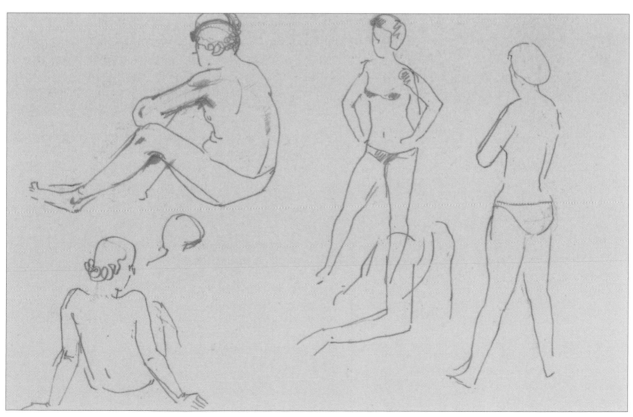

Gerd Jäger (born 1927): Walking male figure.

FURTHER EXERCISES ON THE MALE FIGURE

Exercise on proportion
Page 27:
The diagram opposite, top left, presents the main sections of the limbs. You are advised to use this to work through the following measurement stages with a model:

1 Draw the vertical body symmetry axis and then define its length across the top of the head (1) and the soles of the feet (1). Mark in the centre of the body (2), the nipples (3), the ridge of the shinbone (4) and the pubic bone axis (5).

2 Now add further subsidiary structures (6–12).

3 Use 2H to create the control square for the width extensions.

4 Use measurement to decide the widths of the horizontal axes that subdivide the height.

5 Connect the strategic points to create the outline of a proportional figure from geometric shapes.

Page 28:
The two examples on page 28 show variations between two different models, but the method remains the same as described above. Further steps are:

• Noting the individual model type (e.g. the left figure is athletic; the right figure is tall and thin).
• Enriching the volumes of the main forms with individually defined subsidiary forms.
• Inserting the first spatial manifestations in the figure with carefully observed intersections.
• Indicating the most important internal forms (do not attempt to make the head a portrait).
The task has been successfully completed if the structure you have drawn unmistakably embodies that particular model.

Page 29:
A useful exercise, shown on page 29, is to try producing a flat figure outline by spreading colour from the inside towards the edges:

• As in stage 1 of the drawing on page 27, start with indications of rough subdivisions, following suggestions from the control square.
• The drawing materials should be gradually spread out from the centre of an area, such as the pelvis or thorax towards the edge (see the arrows) while always strictly observing the proportions of the model.
• This allows you to record outward and upward growth movements while making adjustments and working with empathy. In this way you will first create a suggestive overview of the figure.
• Once you have produced complex coordinated figure outlines, add characteristic model features (right-hand figure) and suggest a few internal forms, but with restraint.
This task will fail if you first draw the outlines and then mechanically fill in. Also in this case, the personal bodily physiognomy must be clearly recognisable (for this, see the left-hand example on page 28).

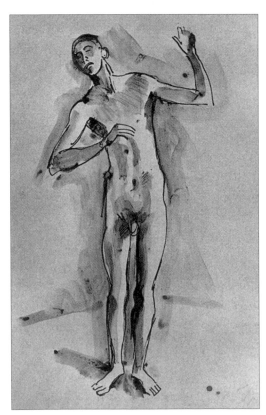

Karl Hofer (1878–1955): Male nude study.

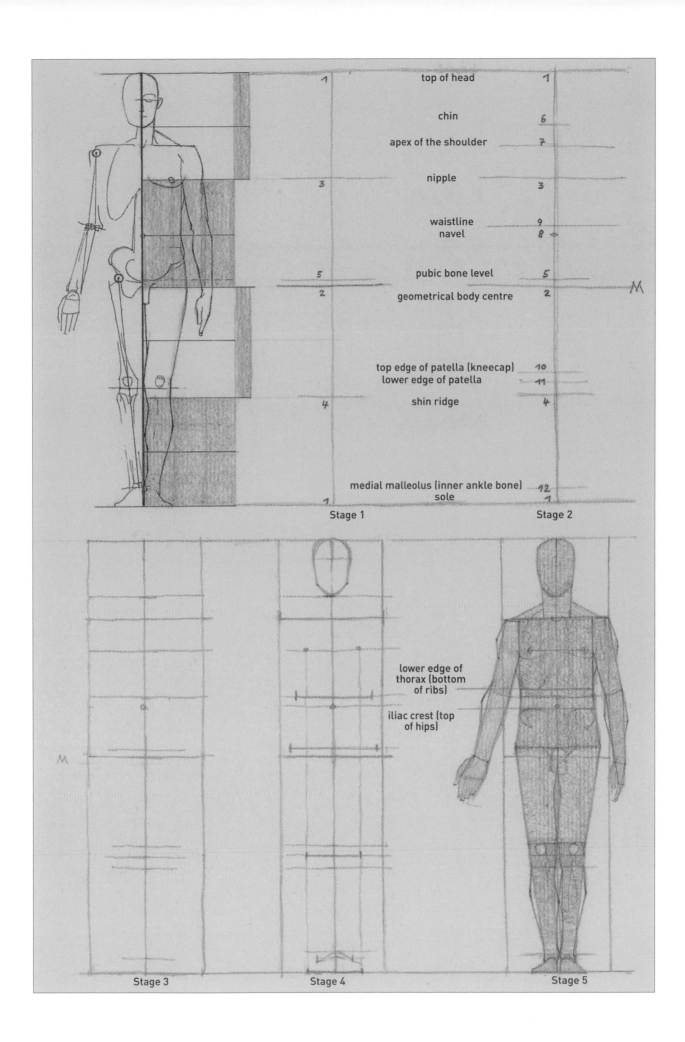

top of head

chin

apex of the shoulder

nipple

waistline
navel

pubic bone level

geometrical body centre

top edge of patella (kneecap)
lower edge of patella

shin ridge

medial malleolus (inner ankle bone)
sole

Stage 1

Stage 2

lower edge of
thorax (bottom
of ribs)

iliac crest (top
of hips)

Stage 3

Stage 4

Stage 5

Study of Proportion **27**

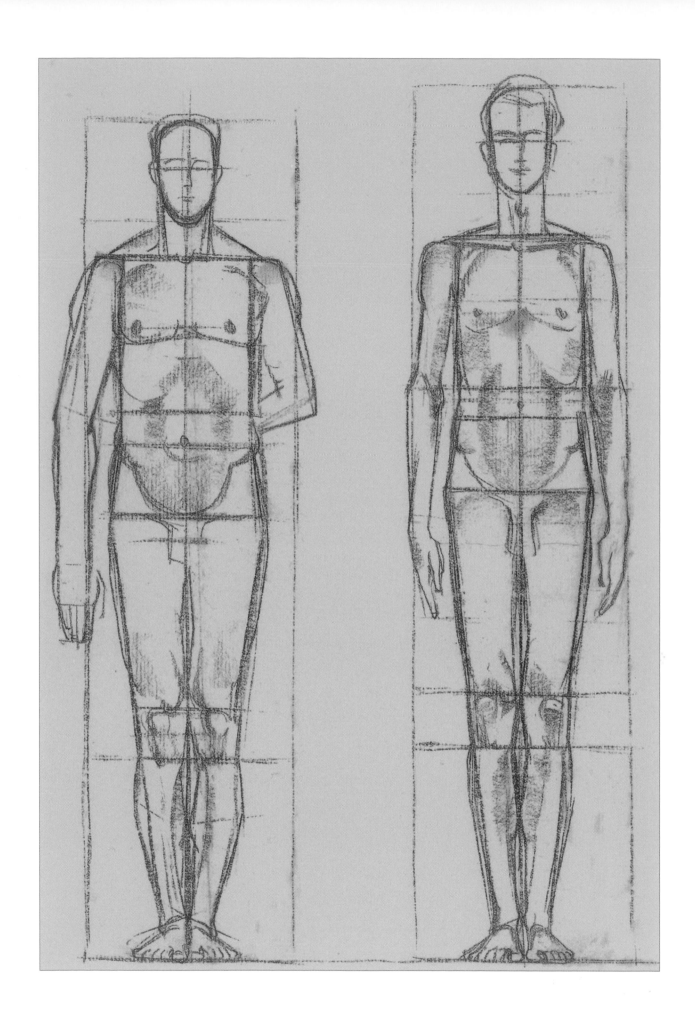

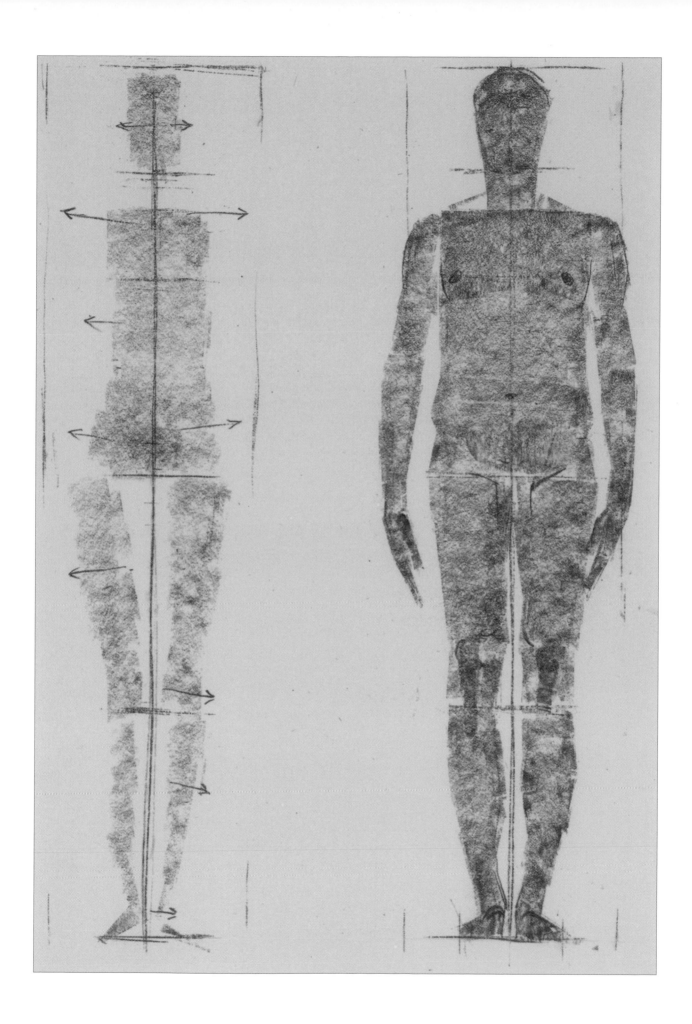

THE MALE FIGURE IN PROFILE

The issues considered in the profile figure on page 21 are taken up again here, presented as flat, simplified forms, with the skeleton clearly shown in the central example at the top(opposite). Notice the following points:

• The bilateral symmetry of the front view does not extend to the profile.

• The equilibrium is maintained by the changing unloading of body masses before and after the central vertical line.

• The balanced masses shift and create a 'hidden symmetry'.

• If we link the deepest 'scores' in the outline forms together, we find a chain of internally and reciprocally coordinated points in the framework of the shapes. (For example, a vertical line falls from the nape of the neck to the heels: all low points create a continuous line.)

Such observations also apply to the connections between swinging movements, as you can see in the sketch by Auguste Rodin, and to fully developed three-dimensional drawings as in the drawing by G. A. Hennig.

Profile exercises
It is always necessary to ensure with profile views that the weighty masses are not simple piled up vertically like so many building bricks. For this reason, the following preliminary exercise is important for basic self-instruction. Refer to the illustrations opposite, bottom.

1 Draw a vertical plumbline when presenting rough proportional divisions.

2 Use wide strips of paper to define the volumes as you did for the exercise shown on page 22.

3 Cut the leg, pelvis, thorax (rib cage) and head lengthways.

4 Place the more-or-less square head as the crown above the vertical column of the legs (first figure).

5 Pay attention to the bent sequence of the thorax and pelvis (first figure).

6 Unite these basic forms and orientations by adding the lumbar region and the neck (second figure).

7 Incorporate the foot as a triangular base and as the opposite pole to the top of the head (second figure).

8 Transform the basic shapes and orientations with the outline forms of the living model (third figure).

In order to strengthen the clear overview and to make your work easier, the geometrical centre of the body is balanced, and the quarters of the body have been staggered on the right-hand border.

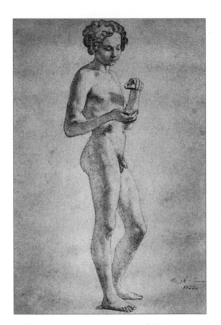

Gustav Adolf Hennig (1797–1869): Standing boy in left profile, 1822.

Julius Schnorr von Carolsfeld (1794–1872): Nude boy, 1822.

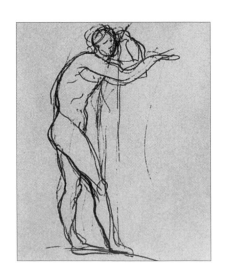

Auguste Rodin (1840–1917): Demonstration sketch for classical and post-classical statuary, c. 1902.

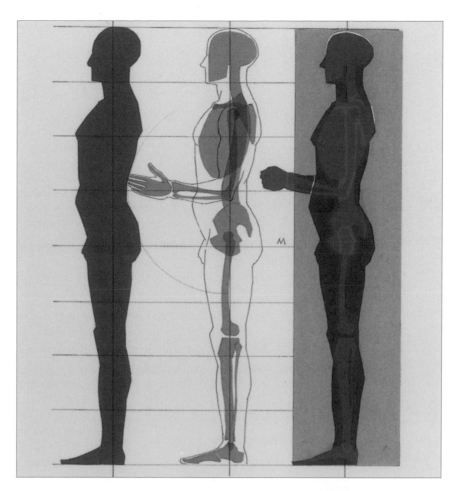

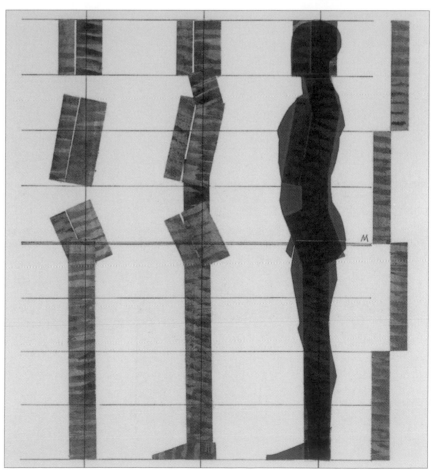

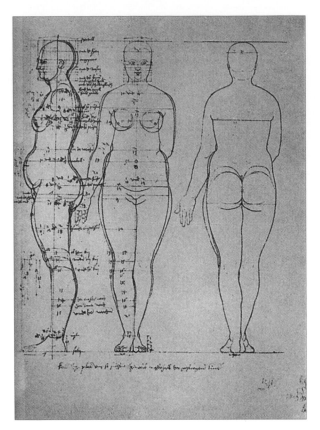

Albrecht Dürer (1471–1528): Powerful woman of 8H construction, c. 1513.

THE FEMALE FIGURE

One can consider the process of studying proportion to be elastic only if it can be applied to any form. For this reason the standardised figure presented on page 13 must be applicable to any female body. We can therefore restrict ourselves to the following insights (central figure):

• The maximum extension of the arms from one end of the middle finger to the other is, with great regularity, the same as the entire height, and can therefore be placed in a square.
• The pubic bone is the precise centre of the body.
• When the arms are lifted horizontally to the sides, the breasts are raised and the axis of the nipples is aligned with the upper quarter of the body.
• The cord of the upper chest, lifted upwards and sideways, forms the armpits, which are accentuated in front by the large chest muscle (pectoralis major), and behind by the broadest back muscle (latissimus dorsi).
• The waist is just above 3H, while the navel is just below 3H.
• The pubic bulge is below the centre of the body.
• The lower edge of the patella is the centre of the leg.
• The hips form the dominant width of the body.
• The wrist is level with the greater trochanter (top of the thighbone), while the tips of the fingers barely reach the middle of the femur.
• There is a special store of fat below the patella (capsule fat).

The left-hand figure explains the external outline forms through the skeletal framework:

• The skull and clavicles (collar bones), whose width depends on the narrowness of the thorax.
• The thorax, which defines the width of the upper body.
• The wings of the ilium and both the greater trochanters defining the width of the hip area.
• The width of the knee skeleton defining the width of the knees and the swinging edge of the shinbone (tibia) defining the swing of the lower leg.
• The bones of the ankle, notably the protrusions of the medial and lateral malleoli (inside and outside ankle bones) and tibia (shinbone) affecting the shape of the lower leg.

The right-hand figure deals with soft shapes. Notice the following:

• The two lumbar dimples and the sacrum point which create an equilateral triangle.
• The hip fat.
• The vertical gluteal cleft between the buttocks and the horizontal gluteal fold underneath them, sometimes with a second fold.
• The creases at the back of the knees, which always move from the inside to the outside, on the inside bordered by a deep knee space and on the outside by a flat knee space.
• The shoulder-blade dimple at the inner beginning of the shoulder blade and the elbow dimple to the side of the rear of the elbow.

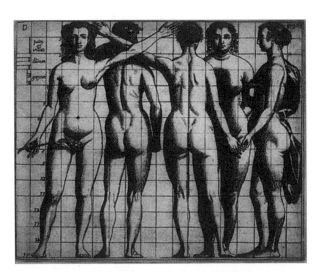

Samuel Hoogstraten (1627–1678): Female proportional figures of 7.5H with basic dimension of half head height, from *The Advanced School of Painting*, 1678.

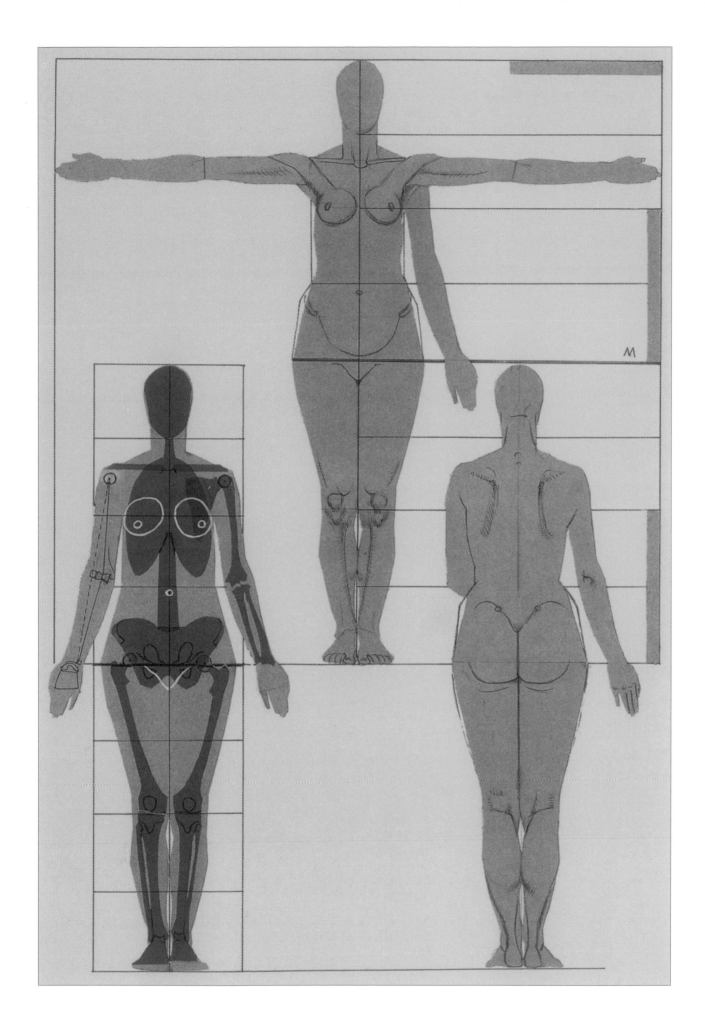

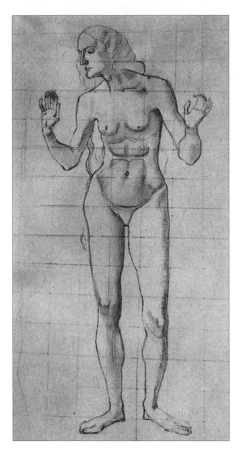

Ferdinand Hodler (1853–1918): Study of a woman by a stream, c. 1803.

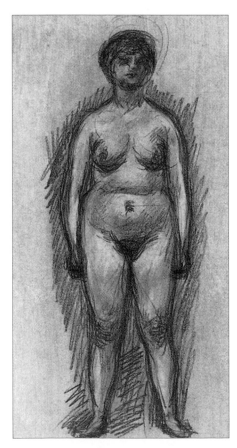

Wilhelm Rudolph (1889–1982): Large standing nude woman, frontal view, undated.

EXERCISES ON DRAWING THE FEMALE FIGURE

Page 35, top and bottom left:
Developing the method of measurements shown in the diagram on page 27, we are providing an additional means of verification here in the form of plumblines from the nipples, which pass the outer knee and the edges of the feet (top left). Notice the following on the bottom-left figure:

• Geometrical sections of the limbs have been shown in order to avoid the risk of drawing undefined, random contours.
• The placement of the fleshy deposits characteristic of a woman have been shaded in red chalk.

Page 35, top and bottom right:
The goal we are after in the right-hand figure is to capture the whole, essentially while not making use of the divisions we have used until now. These divisions should nevertheless always be present to your inner vision. Bear the following in mind:

• The articulation of the hip area in order to emphasise the foundation for the upper structure.
• The fleshy deposits to the side of the hip area and under the greater trochanter on the femur, so that in this particular model the bones of the hips form a dip.
• The characteristic bend in the female leg due to the skeletal structure (as shown in the figure on page 33, bottom left).
• The use of formal accents, which are not to be abandoned despite the broad approach, particularly in the area of the ankles, because formal accents contribute significantly to the stability of a figure.

The entire sequence of exercises, carried out with a wide variety of models, teaches us not to reduce everything to the same schematic level or turn the established canon into the norm.

Page 36:
The two studies on page 36 provide only limited indications of the proportional framework. Most of all, we need to practise our ability to appraise proportions, so that we can devote ourselves without distraction to the overall impression.

Page 37:
In this case, the studies almost entirely leave out the proportional framework. Depth is expressed on the left-hand figure by thickening the white chalk shading on those areas that come forward. On the right-hand figure, the model's pose, which lifts the thorax, shows the functional activity of sinking the abdomen.

Page 38:
If you want to work with a broad, flat brush, you should create the figure from horizontal strokes.

Page 39:
This plate can be viewed as a provisional summary of the skills we have acquired so far, in which both exterior and interior forms combine to approach the living appearance. Because full front, back and side views are spatially not very rewarding, it is essential to pay the utmost attention to even the most apparently insignificant intersections.

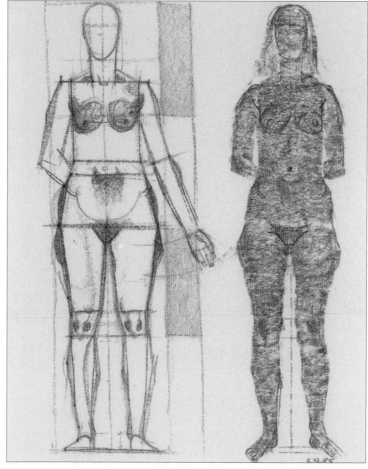

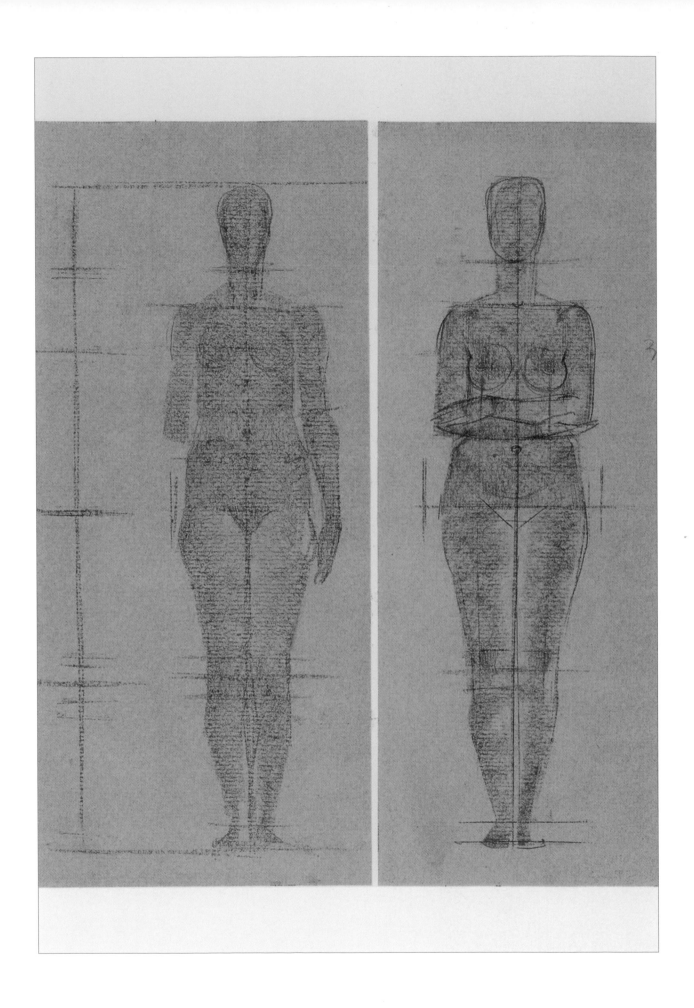

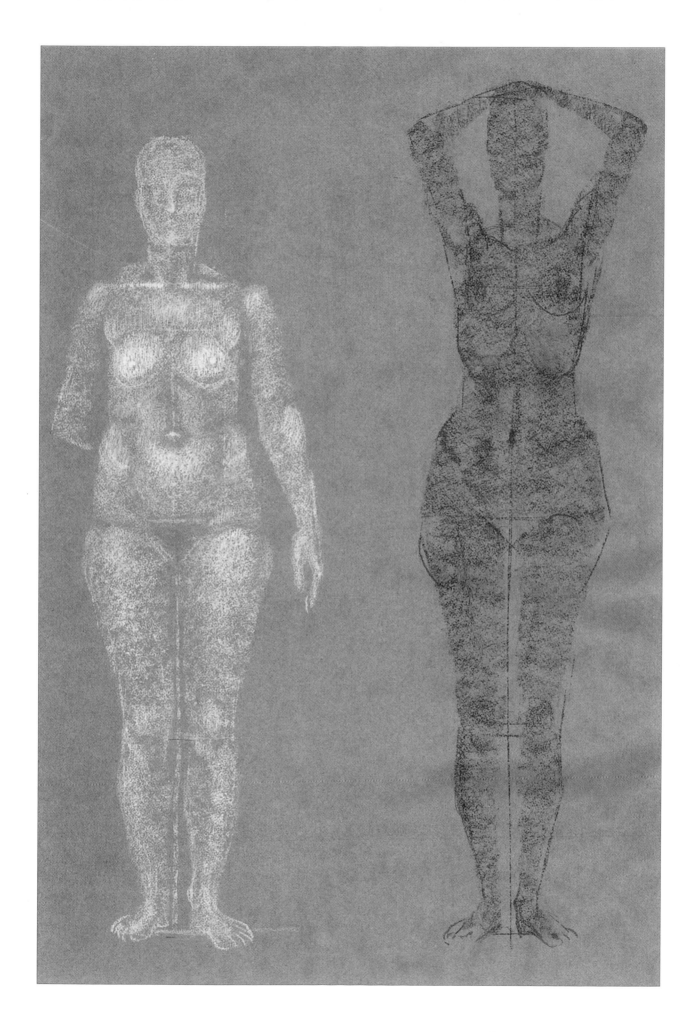

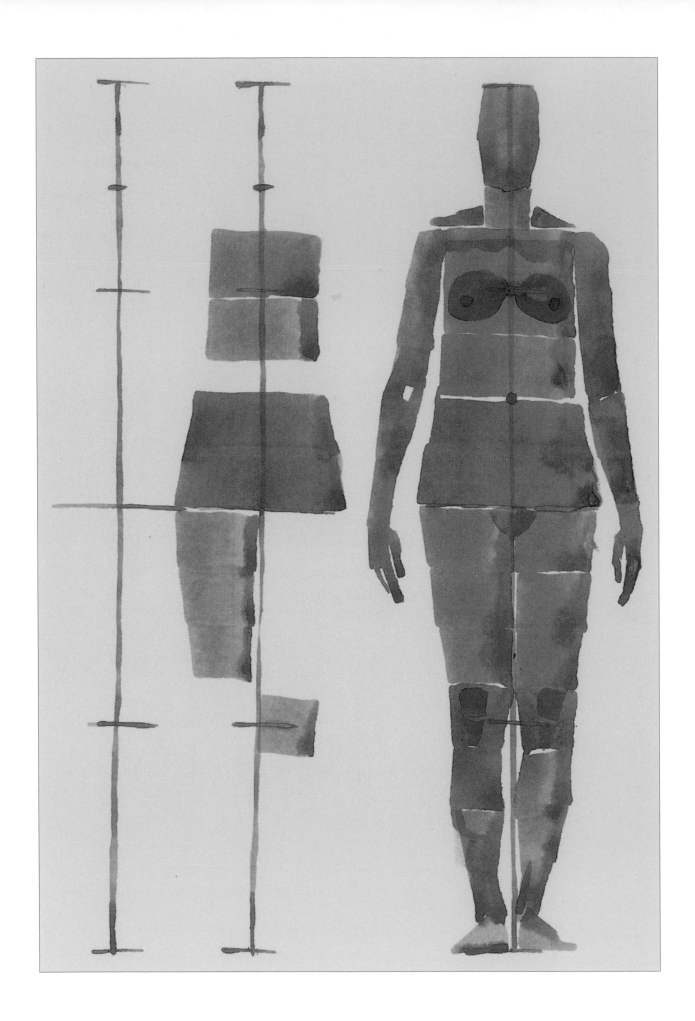

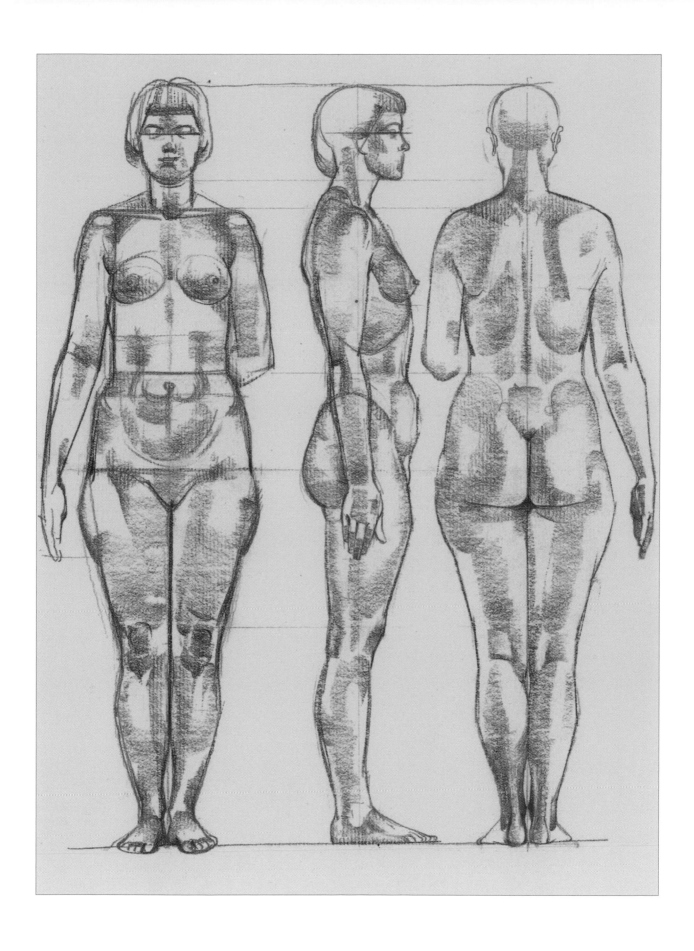

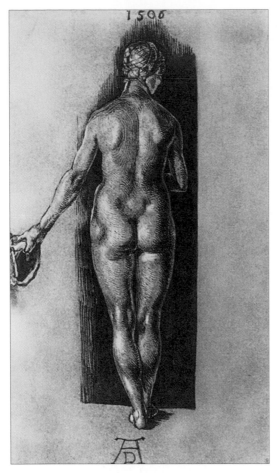

Albrecht Dürer (1471–1528): Nude from rear, 1506.

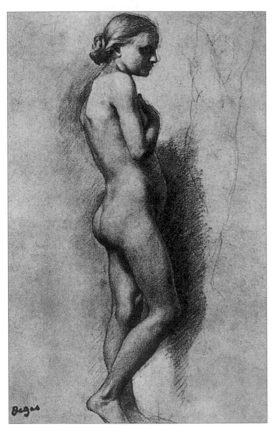

Edgar Degas (1834–1917): Standing nude girl in right profile, undated.

STUDIES OF THE FEMALE FIGURE WITH FURTHER EXERCISES

Exercise on drawing the profile

Page 41:
This first exercise is carried out in three stages (see the illustration opposite) using the profile view, and is based on the indications in the figure on page 21. You are advised to follow this sequence:

1 Set out the vertical figure height with a rough orientation of the proportions and diagonal axes of the chest and pelvis (left).

2 Add the three-dimensional volumes (centre).

3 Join up the modelled volumes and develop the alternating positions of the main masses of the buttocks and leg. Notice the rhythm (right).

Page 42:
An alternative is to draw with a few fingers dipped in graphite dust and place the mutually contrasting, projecting volumes in their different orientations by means of the dust-covered fingers. Do not do any under-drawing.

Page 43:
The same procedure applies to using a loaded round brush. Put down a ready-made shape with a single 'press' of the brush and so build up one form after another (top). Do not include any outline effects. You can also apply subsidiary shapes such as the breasts or stomach to primary shapes that are already dry (bottom).

Page 44:
Once you have acquired the skills to capture larger masses, you should switch materials, which will allow you to add to the image with details and modelling: for example, pencil in combination with broadly applied graphite.

Page 45:
Alternatively, you can play with lines and blotches (top), either by making blotches as you please and containing them with lines, as shown, or by drawing a few sweeping lines first and then adding some brushed spots of wash in order to enhance physicality. You can even interchange the two methods (bottom left), but do not highlight these.

Entirely different again is a rendering of physical space by drawing free-ranging parallel pen strokes over the paper and here and there introducing spatial depth to give a strong and decisive emphasis to orientations, finally adding another few contours to define the shapes more precisely (page 45, bottom right). Even if you have a little too much of a good thing with the pen strokes, this is not too serious. One can always tone this down again without much trouble.

It is important with this approach not to use too small a format for you to apply the strokes sensitively and, at the same time, with sheer enjoyment of the physical movement—work large if you can.

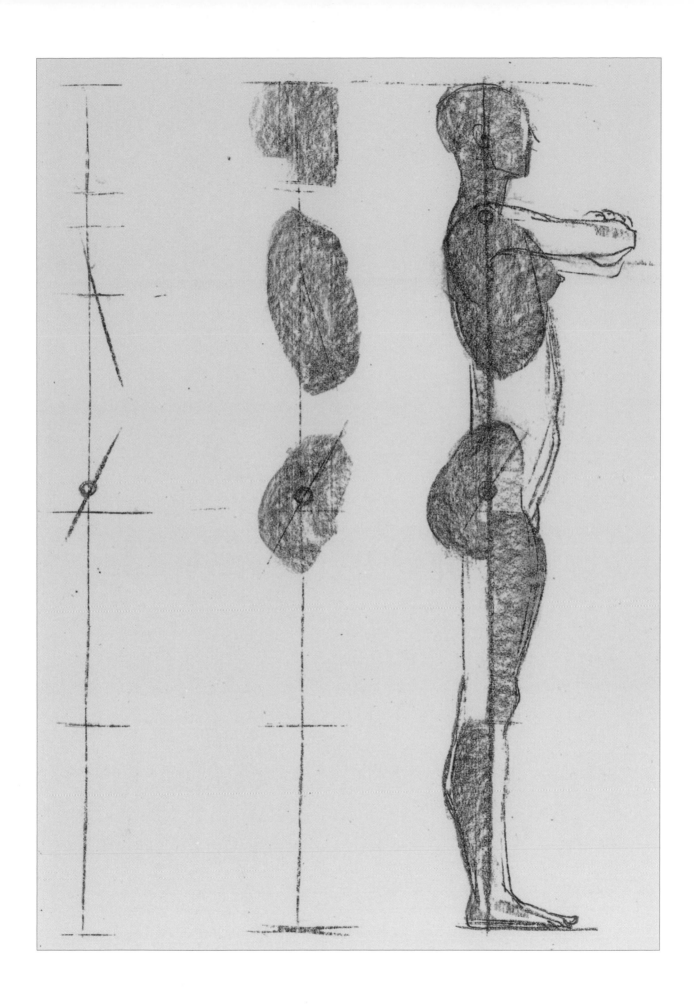

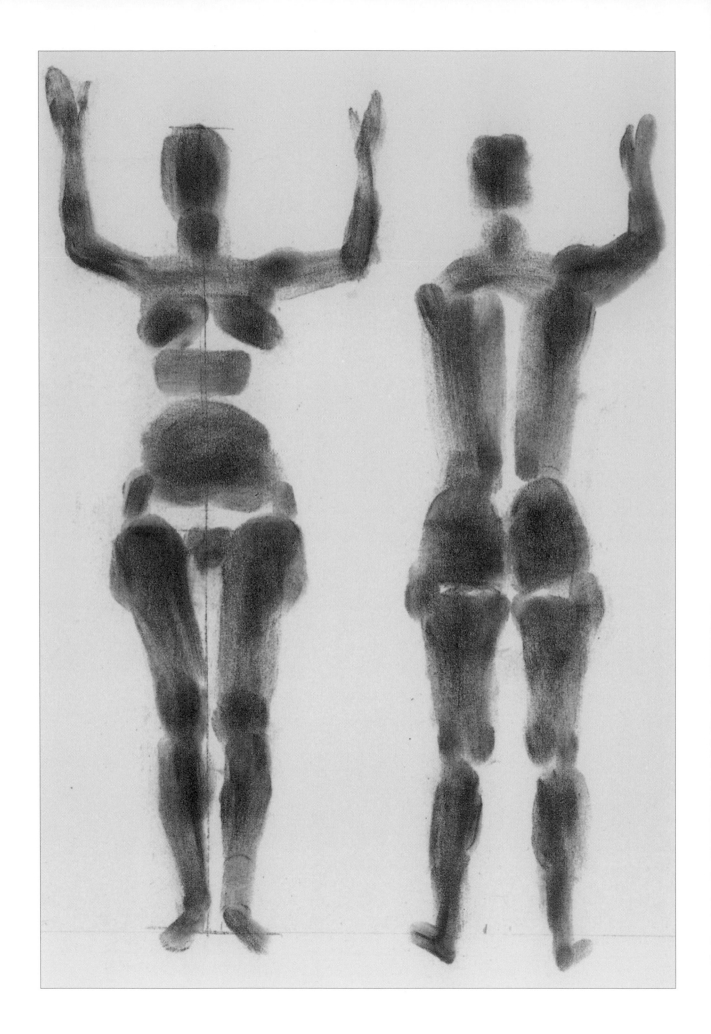

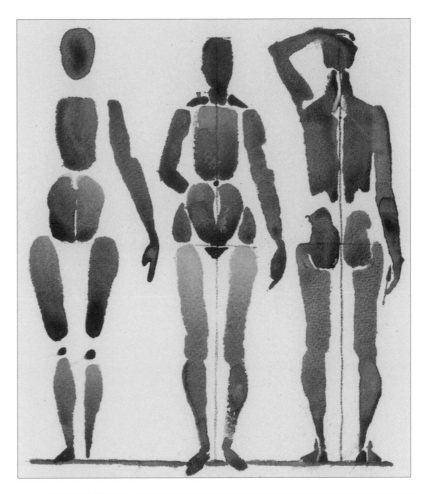

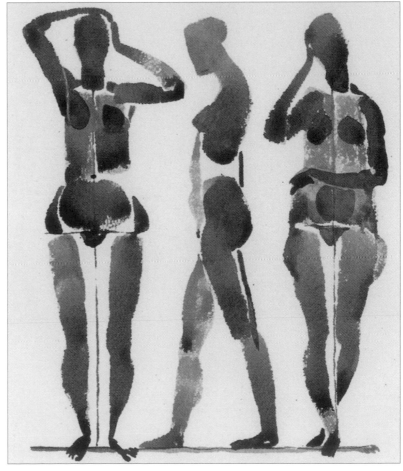

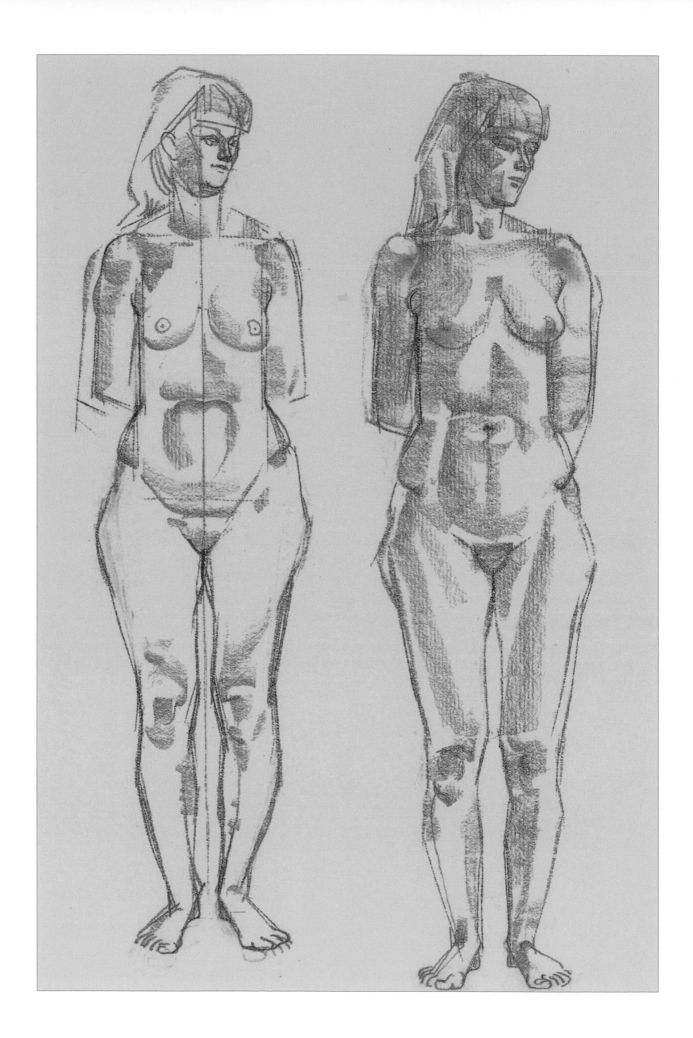

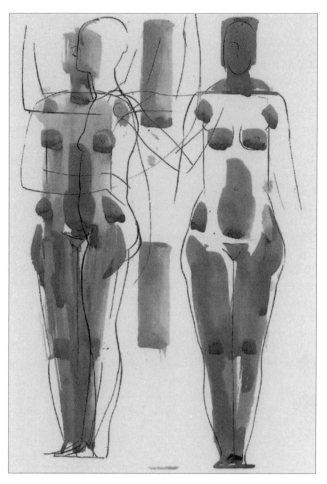

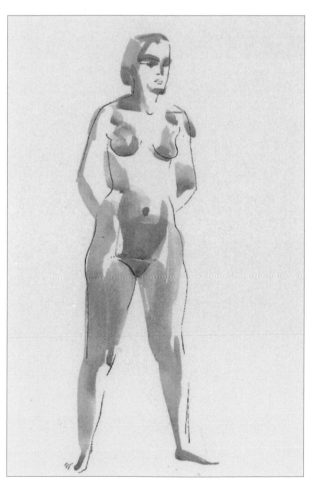

THE YOUNG FEMALE FIGURE

The proportional figures on pages 47-49 are the result of precise anthropometric measurements according to the age, total height and width of the figure in centimetres, following the canon and important measuring points for artistic purposes. Beyond this, the proportions between the upper and lower parts of the body have been precisely established. With the exception of subject 41, all the proportional figures exhibit the second phase of puberty, with a significant formation of secondary sexual characteristics, and the transition to maturity.

Page 47, left-hand figure:
The vertical structure, from the sole of the foot upwards, can be read off in centimetres from the already known measurement points. The same figure is shown again on the right with the addition of the head-height divisions (8H canon). The grey vertical bars show the ratio between the upper and lower parts of the body, while the horizontal bars show the relationships between the most important widths.

Page 48, top:
This diagram shows two distinct stages of development at virtually the same age. Subject 41, when compared to subject 39, has not yet reached the second phase of puberty, with its development of the characteristic female fatty layers. The body widths are lagging behind,

so that the body tends to look delicate. The right-hand figure, on the other hand, appears compact (match this against the horizontal bars at top right).

Page 48, bottom:
The two figures from the previous diagram are again presented, along with the specifics of the canon: both figures stand out because of the small head (left 8.35H, right 8.4H = the total height). The control square, which derives its width from 2H, makes it clear that the left-hand figure is quite evidently very far removed from a possible 2H hip width, which is the broadest width of the female body, while the right-hand figure is clearly approaching this value.

Page 49, top:
The comparison with the previous proportional figures makes clear the particularly well-developed relationship with the waist and therefore also the tendency of the female body towards an hourglass form. Subject 43 shows a surprisingly powerful shoulder width, giving the shoulder area a somewhat masculine look; the distinction between the hip and shoulder width is minimal. The details become even more evident when the same figures are presented as dark on a light background (page 49, bottom).

The anthropometric data shown here, and modified for artistic purposes, confirm the practical nature of the process, despite the very different proportional features of the subjects. Whereas we would have otherwise gained information about proportion by comparing dimensions visually, here we have achieved precision by using a yardstick.

Gottfried Schadow (1764–1850): Proportional figures of young women. Full-sized representation of the Rhineland yardstick from the author's work on proportion *Polyklet*, 1834.

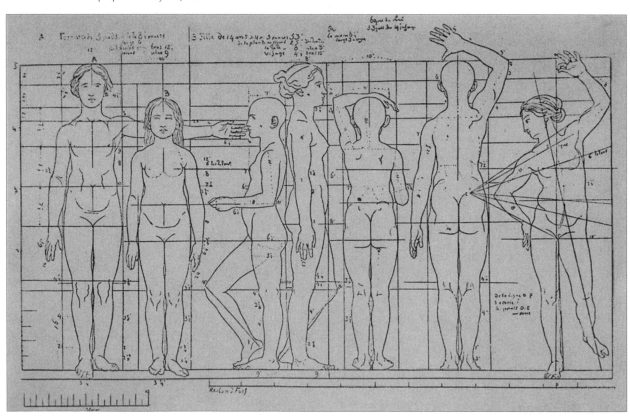

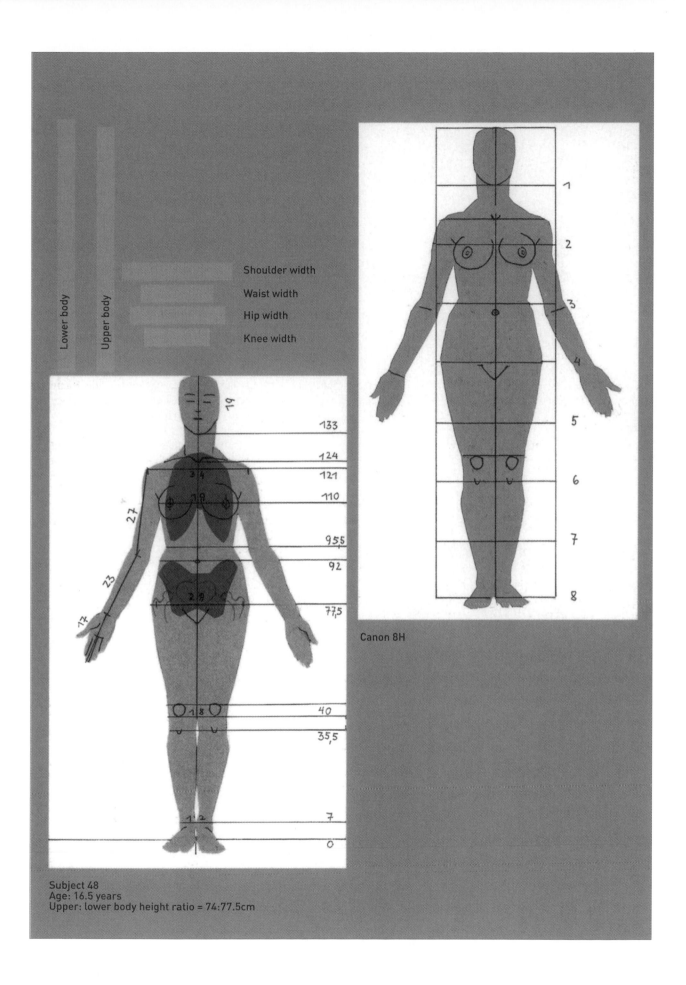

Lower body

Upper body

Shoulder width

Waist width

Hip width

Knee width

Canon 8H

Subject 48
Age: 16.5 years
Upper: lower body height ratio = 74:77.5cm

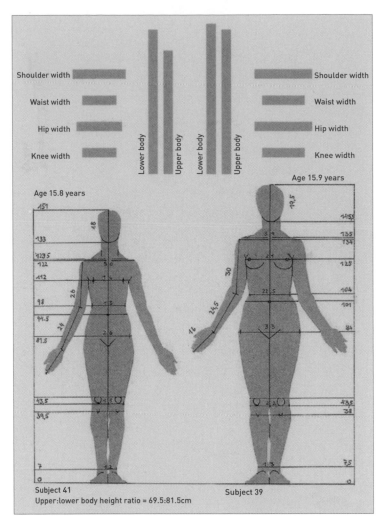

Shoulder width

Waist width

Hip width

Knee width

Lower body

Upper body

Lower body

Upper body

Shoulder width

Waist width

Hip width

Knee width

Age 15.8 years

Age 15.9 years

Subject 41
Upper:lower body height ratio = 69.5:81.5cm

Subject 39

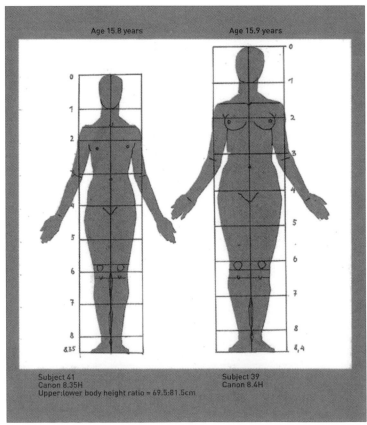

Age 15.8 years

Age 15.9 years

Subject 41
Canon 8.35H
Upper:lower body height ratio = 69.5:81.5cm

Subject 39
Canon 8.4H

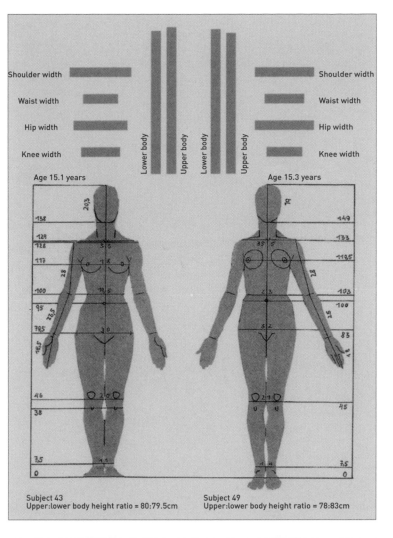

Shoulder width
Waist width
Hip width
Knee width

Lower body Upper body Lower body Upper body

Shoulder width
Waist width
Hip width
Knee width

Age 15.1 years

Age 15.3 years

Subject 43
Upper:lower body height ratio = 80:79.5cm

Subject 49
Upper:lower body height ratio = 78:83cm

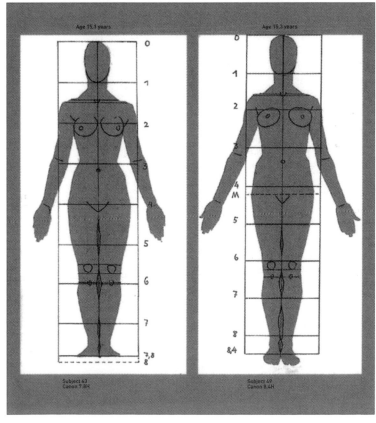

Age 15.1 years

Age 15.3 years

Subject 43
Canon 7.8H

Subject 49
Canon 8.4H

Richard Scheibe (1879–1964): Standing nude girl with the head inclined towards the left shoulder, 1930.

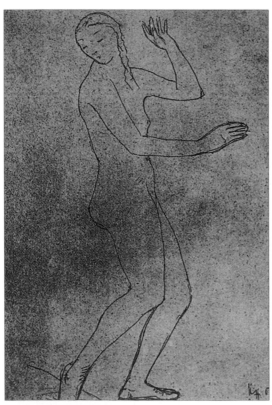

Karl Hofer (1878–1955): Female nude stepping out of water, 1907.

STUDIES OF THE YOUNG FEMALE FIGURE WITH EXERCISES

We now want to apply the explorative methods we have developed more and more freely, above all so that we can now devote ourselves fully to experiencing the impression values that are governed by proportion. Information about the procedure we are going to use will be helpful here.

Exercise on drawing the figure
Page 51, left:
1 State the total height of the figure.

2 Mark the direction of the central axis.

3 Mark the centre of the body.

4 Plot the shoulder axis and the contours of the torso.

5 Provide information about the orientation of the limbs.

Page 51, centre:
6 Further develop the basic framework that you have already created.

7 Undertake more refined gradations of the directions and changes in direction without blurring the shapes at their high points (accents) by rounding them off and so weakening them.

8 Achieve real physicality by paying attention to the most important intersections.

Page 51, right:
9 Change the view and work with a different shape of the torso as seen from the back. Continue to draw with firm lines when you incorporate the specific surface textures of the skin.

Page 52:
• It is absolutely crucial that you use your understanding of body rotations and rhythms when creating the profile view; only after this can you build up your work further.
• As regards the head, don't lose yourself in the details, but do aim to express the entire physiognomy and the person you are depicting.

Page 53 (left figure):
You should attempt to present physicality only after having acquired solid skills in drawing proportion:

• The use of broad materials (in this case pieces of graphite) is recommended in order to form flat areas into shapes. Not using the point of a pencil helps to prevent becoming involved in minor details.
• When representing the physical body, in particular as viewed from the rear, you must concentrate on the basic facts of the forward and backward motion of the body. Performing simple studies of this is useful for one's understanding of these fundamental principles (top centre).
• In order to restore and refresh your vision, you should also make use of breaks in the modelling session to take rough notes and assess other poses (right).

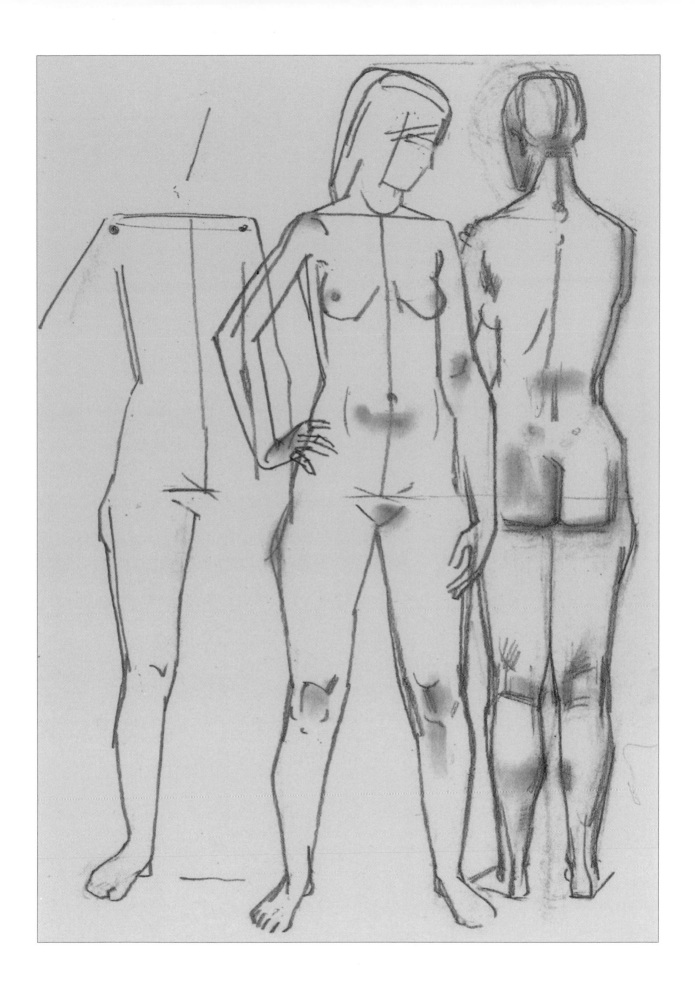

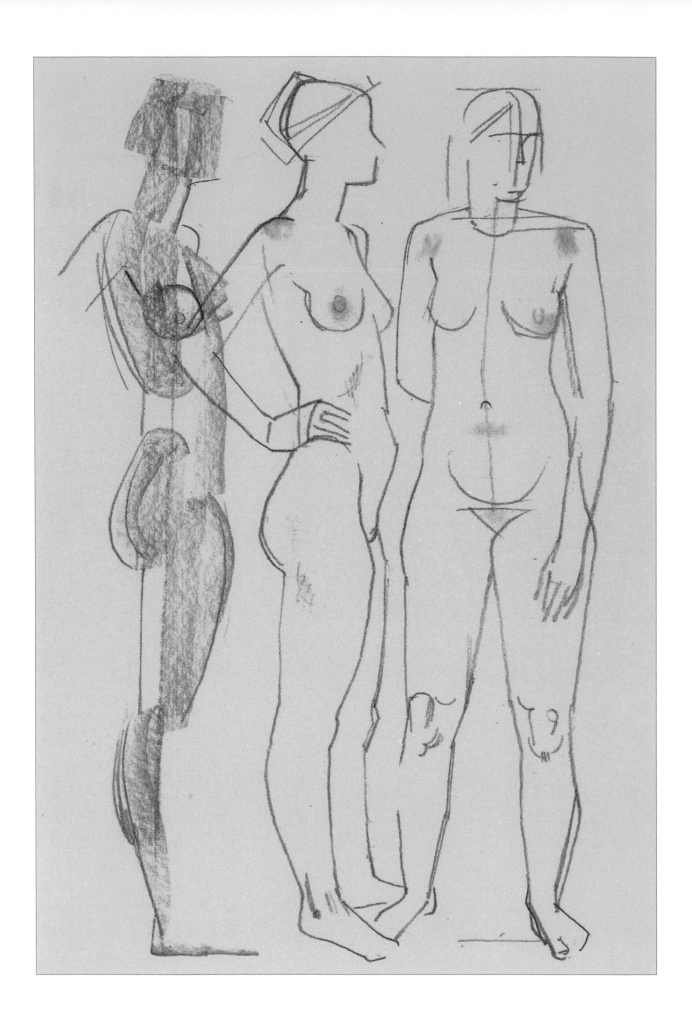

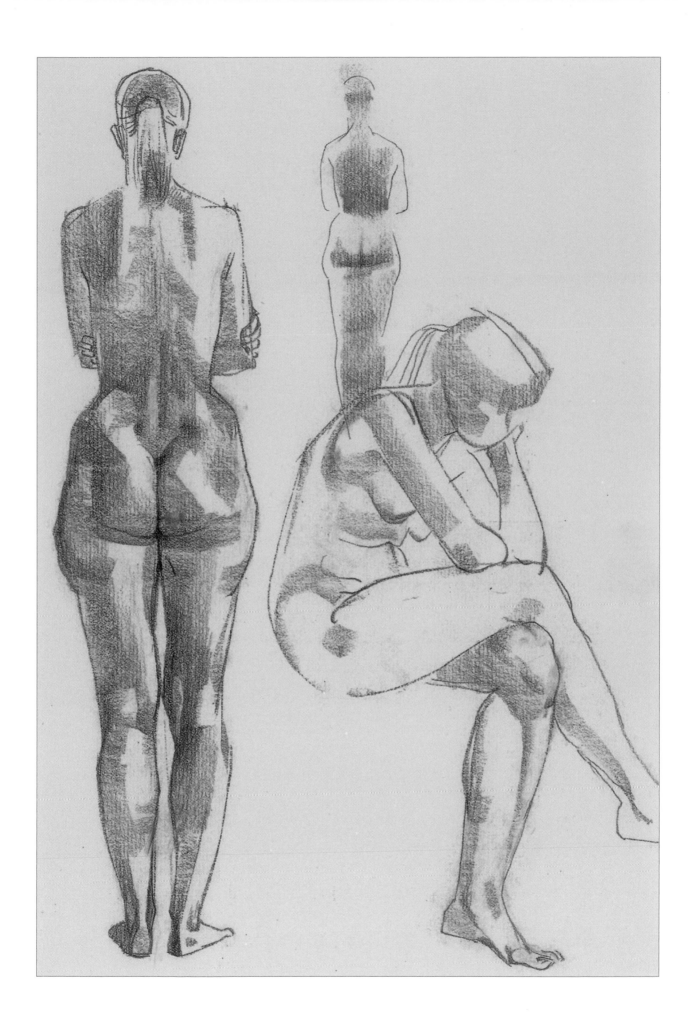

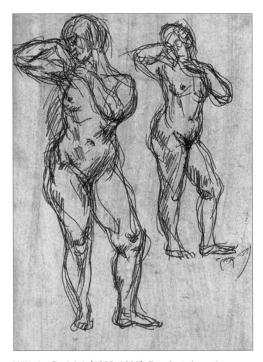

Gustav Klimt (1862–1918): Female nude study, c. 1900.

Wilhelm Rudolph (1889–1982): Two female nudes
standing half turned round, undated.

SKETCHBOOK WORK

Pages 55–57:
Working with a sketchbook – which should be your constant
companion – means collecting impressions that help us to store
our repertoire of forms and ensures that we do not forget what
we have seen. Events of all kinds, objects, landscapes and images
are quickly set down and so gradually turn into an irreplaceable
treasure of personal, visual participation. Capturing rapid
impressions should not, however, be something fleeting in the
sense of something vague without any commitment. Successful
sketchbook work which records figural subjects must include an
acute awareness of what we wish to create from many possible
impressions, because it has to be quick. When applied to drawing
people, this means that:

• We do not concentrate on anything for the moment but the
impression of the figure in its large and striking totality. This is the
most important thing to observe.

• You need to follow the trails of the figure's features rapidly.
Engage and then let go, if need be for a second and third time.

• It is important to ensure that you make the few things you record
visible as integral parts of the scene. For example, a standing
position needs to be seen straight away as a specific type of
standing (solid, casual, loose, freezing, etc.) in connection with the
build of the subject (page 55, top).

• It is often necessary to find a shorthand on the grounds of speed
and need (e.g. the position of the feet, page 55, bottom). Not every
part needs to be abbreviated.

• The trace of a movement or an activity needs to be captured in
continuous strokes. Generally one needs only the slightest feature
to define the pose of the whole.

• The movements of the limbs must again be captured decisively in
all their directions (page 55, bottom). Bent joints must be defined
in all their angularity, or else they turn into rubber sausages.

• When we lightly sketch figures in bathing costumes, we should
not miss the opportunity to show how tapes, waistbands and
trousers adapt to the form of the body (pages 55–56). Body curves
will thus be incorporated by the most economical means.

• In the case of postures that can be held for some time, you can
also add sculptural relief to the body surfaces in addition to what is
shown here (page 56, bottom).

• If there is no risk of change in the lingering pose of the model,
you can also try to hurry things for once and record the image
quickly in bare outline next to the more elaborate version (page 57).

The more training one has, the more likely it is that one will
be successful.

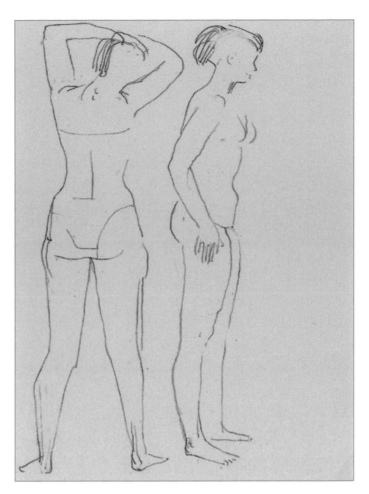

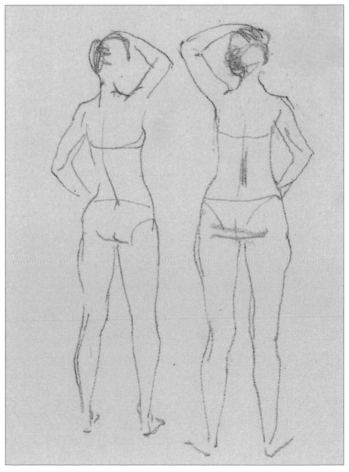

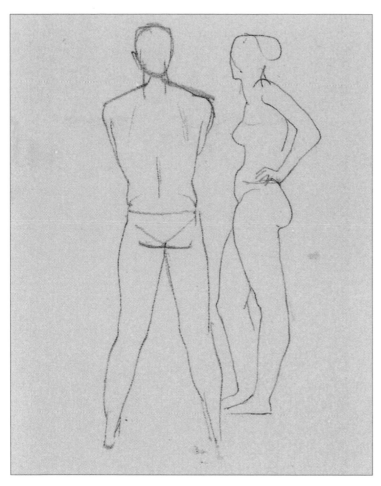

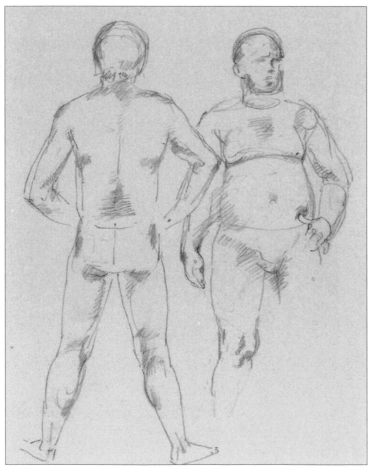

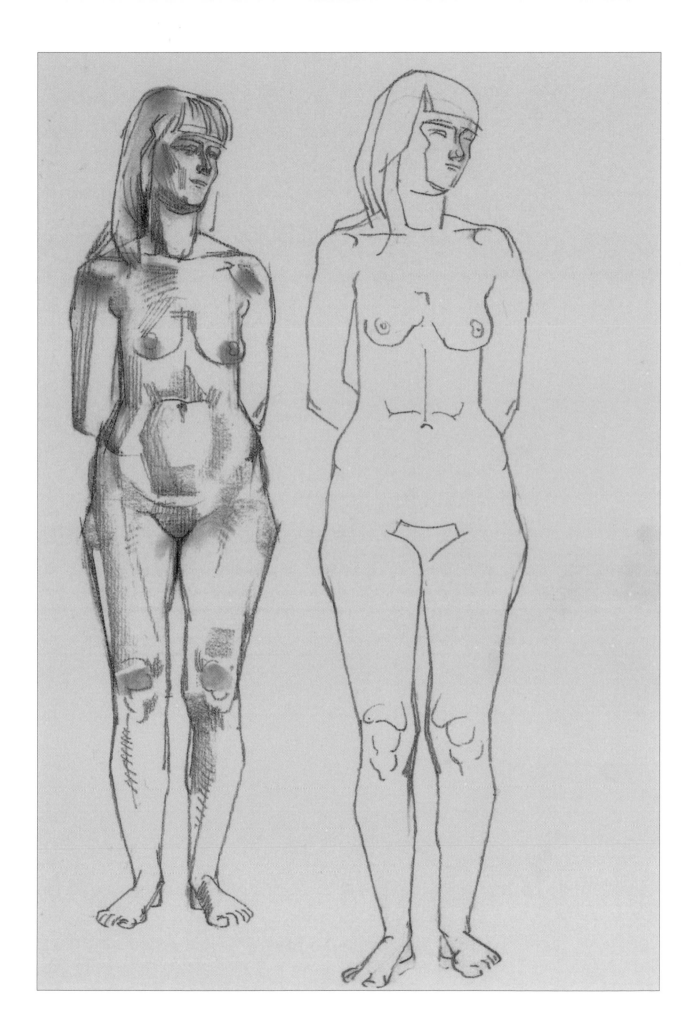

Hans von Marées (1837–1887): Figure composition, undated.

THE YOUNG MALE FIGURE

The figure on page 29 made us familiar with the characteristic proportional features of the youthful form of a growing male. As with the young female figure (pages 46–49) the examples here show precise anthropometric data. The following points about the adolescent male body should be considered:

• The maturation phase starts between the ages of 17 and 19 or 20. During the second phase of puberty, the body of the young male, which is less developed than that of a girl of the same age, will catch up with the girl, especially in height.
• Around the age of 16 or 17, we see a coarsening of the limbs in boys, especially of the hands and feet. The 'all knees and elbows' look is characteristic.
• The lanky shapes make the structure of the skeleton particularly conspicuous.
• The muscular cover of the whole body has not yet reached its entire fullness (impression of thinness).
• The proportions of the upper and lower parts of the body have altered in favour of a clearly extended lower part (see the vertical bars next to the figures).
• The length of the arms goes beyond the middle of the femur.
• The widths of the torso (shoulder girdle and pelvis width) have become typically less alike: the bony shoulder width is close to or fully 2H (top-left and lower-left figures).

The choice of proportional figures is affected by an illustration of two very different qualities of build: subject 101 has a canon of 7.3H and therefore appears more compact, while subject 96, with his small head, has a canon of 8.5H. The overall impression thus creates an elongated appearance. Hence an important rule is: the smaller the head, the more massive the general appearance, while the larger the head, the more compact or even childlike the physiognomic effect.

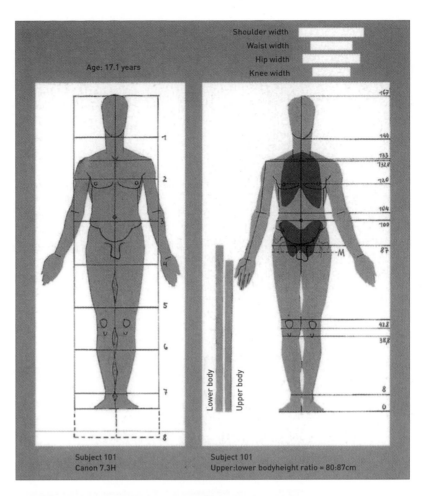

Age: 17.1 years

Shoulder width
Waist width
Hip width
Knee width

Lower body
Upper body

Subject 101
Canon 7.3H

Subject 101
Upper:lower bodyheight ratio = 80:87cm

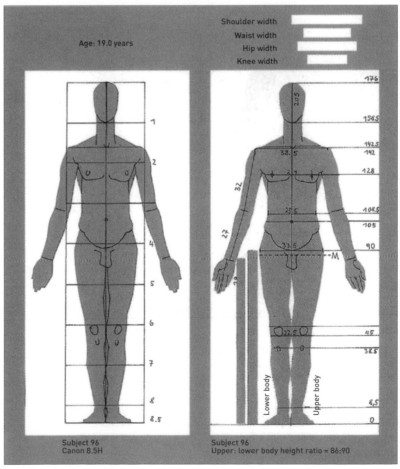

Age: 19.0 years

Shoulder width
Waist width
Hip width
Knee width

Lower body
Upper body

Subject 96
Canon 8.5H

Subject 96
Upper: lower body height ratio = 86:90

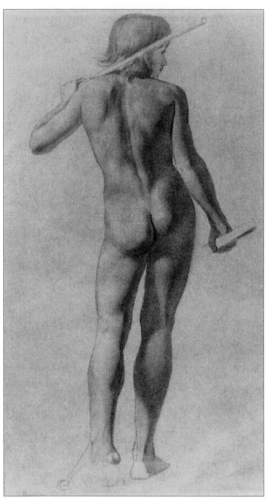

Ludwig von Hofmann (1861–1945): Nude boy, undated.

THE CHILD'S FIGURE

With regard to youthful figures, including those of children, there is no such thing as the form of a child as such, but rather always typical formations of certain stages of development. The youthful stage of development of a girl in the first phase of puberty occurs at age 10½–13½ years old. What features determine these forms?

• The upper and lower parts are the same length, so the pubic bone is the body centre (see the analogies we have used previously).
• Incipient widening of the pelvis.
• Female fatty layers are appearing, rounding the buttocks and hips and filling the inner thighs.
• Initial growth of the breasts, first appearance of pubic and armpit hair, rapid increase in vertical growth.
• The canon is about 7H – the facial shape is clearly changing its aspect ratio.

Apart from the obvious analogous lengths of the leg and the upper body, the chest width measures 1H.

Exercises on the boyish figure
The pictorial representation in the example opposite is based on a 12-year-old boy in the pre-pubescent phase. Look at the following through study of this particular age group:

• Precisely defining the canon as criterion for a childlike appearance – here 7H.
• Establishing the centre of the body – pubic bone level – above and below which the length of the body is equal.
• Noting the level of the wrist in relation to the greater trochanter.
• Determining the shoulder and hip widths, which are virtually the same.
• Developing of the entire figure, viewed from the front, with its parallel contours.
• Emphasising the angularity of the forms due to paucity of muscle and skin padding; lack of armpit and pubic hair.
• Highlighting the changes in shape between the upper and lower leg, which further reinforce the boniness of the intermediate knee shape.
• Capturing the still childlike oval form of the face with the use of face outlines.
• Establishing the axis through the eyes and noting that the lower half of the face is still somewhat shorter than the upper half – the head as a whole has not yet lost its soft, childlike forms. The forehead still has a protruding angle.

All these features, taken together, produce an image in which the boy's body resembles that of a girl in its proportions and its soft details.

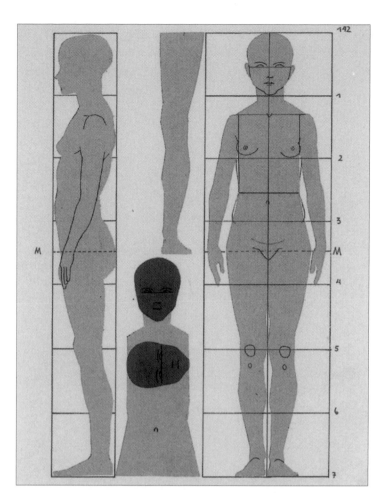

Proportions of a 12-year-old girl: body height about 142cm (4ft 8in), canon 7H. This example shows a girl's figure in the first pubertal phase. Notice the similarity in length between the legs and the torso.

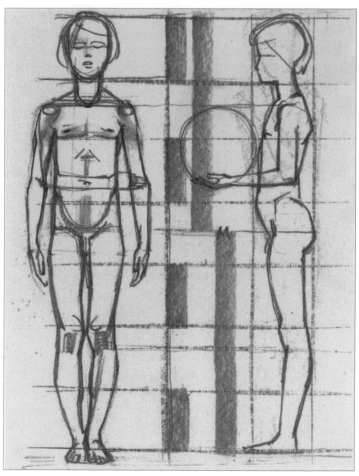

Proportions of a 12-year-old boy, canon 7H.

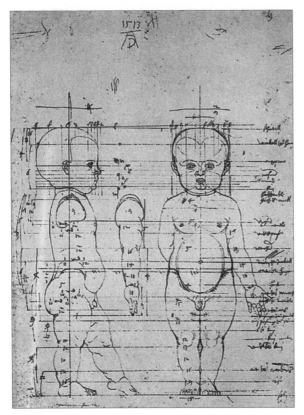

Albrecht Dürer (1471–1528): Constructed body of an infant, 1513.

INFANTS (2–5 YEARS) AND PRE-PUBESCENT CHILDREN (7–10½ YEARS)

The charm of the infantile form can be readily seen in the explorations of artists from the Renaissance (Dürer) and reaches its peak in the works of Baroque artists (Rubens and Hoogstraten). What values does the impression provide here?

Left-hand figure (4 years old):

• The overall impression of the canon starts from roughly 5.5H at age 4.
• The forms are inclined sideways by the plump torso (stomach), with an additional tendency towards rounding out to the side (see the horizontal bars, which show width comparisons).
• The shapes of the face are soft, with a high skull and not yet fully developed facial bones (the axis of the eyes is still below the centre of the head; high overhanging forehead).
• The mass and length of the torso dominate the short legs and arms (pubic bone below the body centre–see the vertical bars, which show height comparisons).
• Presence of abundant fatty padding, creating numerous dimples and deep folds, and a small, distinctly barrel-shaped stomach.

Right-hand figure (approximately 10 years old, pre-pubescent schoolchild):

• Ratio of proportions when the upper and lower bodies reach equal length (the first change in shape is completed around the age of 7, with slenderness and further growth in the body dimensions but no significant alterations).
• First indication of narrowing of the waist shape.
• Canon of 6.5H is reached; pubic bone is therefore at 3.5H.
• Chest width at 1H; hip width somewhat greater.
• Distance from the optical axis to the tip of the chin is still somewhat shorter than that from the optical axis to the top of the head.
• Appearance of the face is generally thinner than of an infant.

Although one cannot read off the differences between boys and girls from the general body shape in the infant stage (neutral age), at school age children's shapes can already be clearly distinguished between boys and girls after the first change of form (bisexual age).

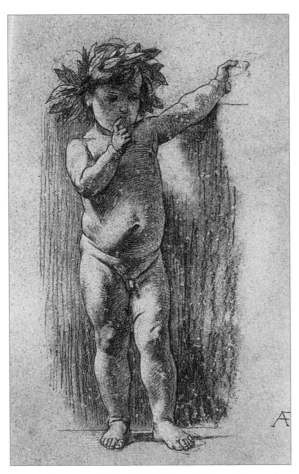

Anselm Feuerbach (1829–1880): Child study, boy with wreath, listening, undated.

Proportions of a 4-year-old and a 10-year-old girl

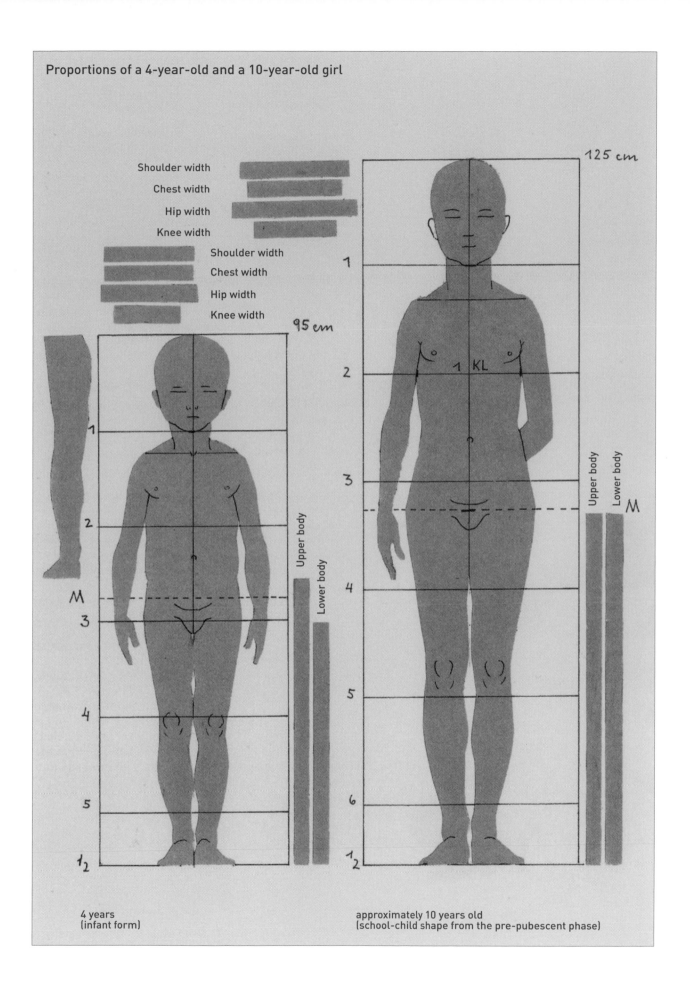

Shoulder width
Chest width
Hip width
Knee width

Shoulder width
Chest width
Hip width
Knee width

95 cm

125 cm

1 KL

Upper body
Lower body

Upper body
Lower body

M

4 years
(infant form)

approximately 10 years old
(school-child shape from the pre-pubescent phase)

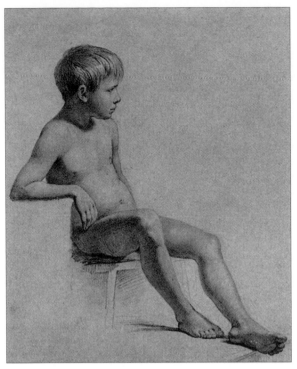

Eduard Meyerheim (1808–1875): Seated boy looking to the right, undated.

YOUNG FIGURES IN SKETCHBOOK WORK

Pages 65–67:
It is generally more usual to sketch adult forms than those from specific ages such as childhood and adolescence. As we have already said, there is no such thing as the child or the child form as such, but only the typical forms for specific ages. We can also recognise age groups from gestures and movements such as the way they stand and sit, but the characteristics that make the most impression have to do with body proportions. Note the following points:

• It is absolutely crucial to keep an overall view of the integrity of the body in one's mind's eye and then to assess the significance of the head size and length of the legs in that context.
• There is usually no time to sight and measure the proportions visually with your pencil because the subject moves all the time, therefore you have to guess carefully (interaction between age and proportions).
• Before starting to draw, it is necessary to learn how immature forms develop on the basis of natural laws, either intellectually or in practice.
• You need to follow this simple rule: the larger the head, the closer we are to the infantile form, and the smaller the head, the closer we approach the developed adult form.
• The lengths, power and musculature of the limbs (smooth, soft, delicate, full, defined) need to be assessed and dealt with according to the subject's age.
• As regards the posture and gesture of infants there is a strikingly typical feature: they are not yet able to straighten their knees completely (see page 67 top) and the curve of the loins is still flat.
• It is best not to ask adolescents who are in transition to the young male or female stage to pose, because they will generally lose their naturally free and graceful bearing.

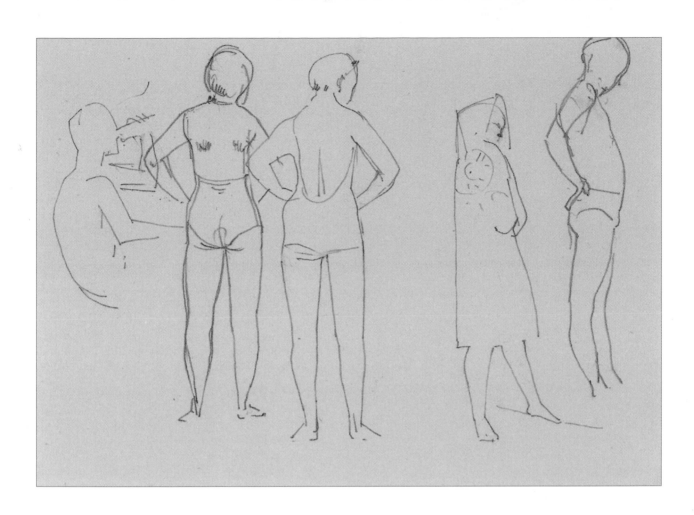

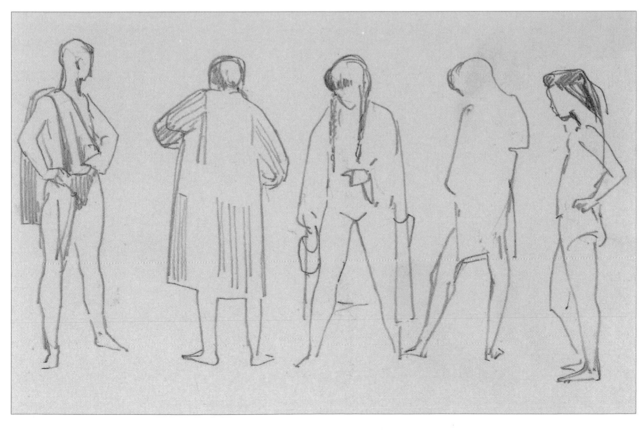

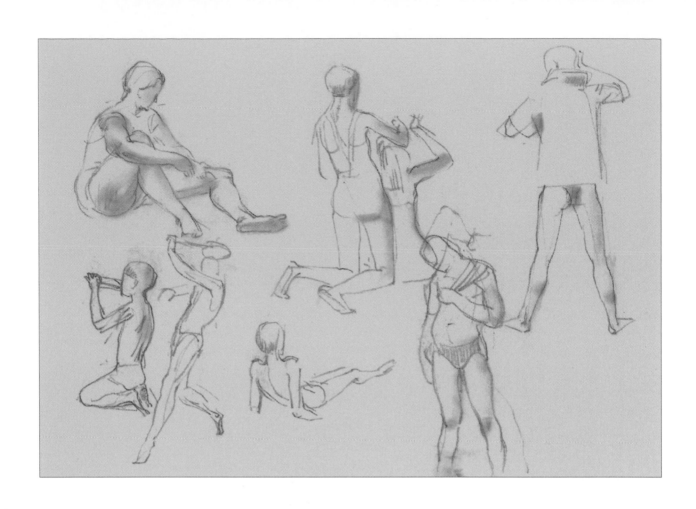

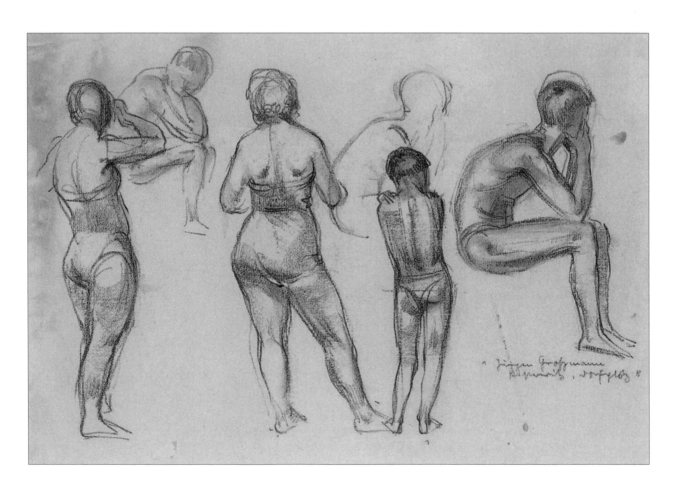

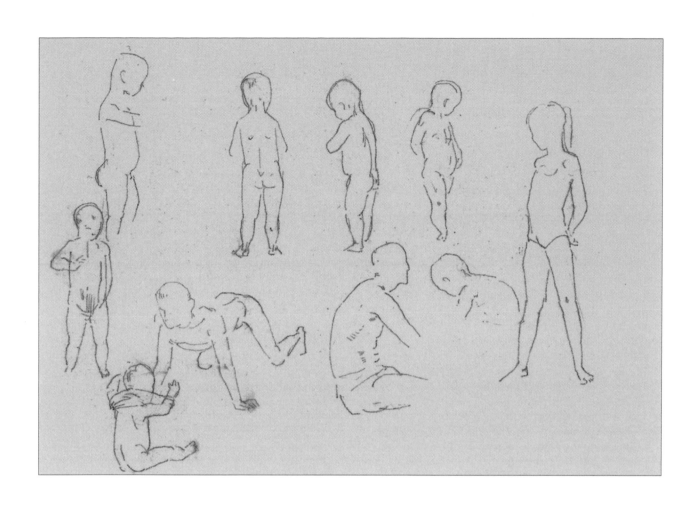

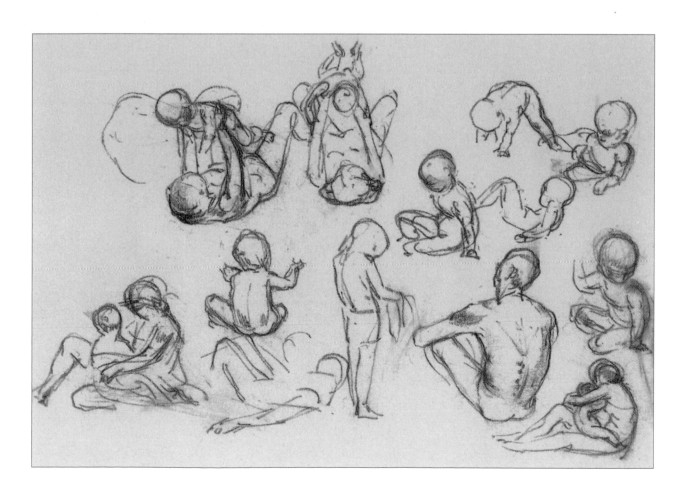

Rest and Movement

STUDIES WITH A BRUSH

We will now develop our skills in the study of proportion in the context of movement.

The simplified illustrations opposite provide useful visual information about the stable and unstable maintenance of equilibrium, i.e. balance. We will provide some basic demonstrations, which represent the relevant visual and physical experiences. Consider the following concerning the illustrations on page 69:
• All figures with red colouring or in a C-shaped, vertical, lying or sitting position, are able to keep their balance (resting position) because they are able to contain their centre of gravity.
• The bottom row in yellow illustrates the inevitable loss of a state of equilibrium (falling, tipping over, doing acrobats sporting activities).

Exercises in brush
Page 70:
Here we will seize on the expressions in posture and movement, which need to flow from the brush with instantaneous strokes. These figures only show a punctuated rhythmic sequence of resting and moving postures as our subject, with no intention of recording their physical expressions. The reader will quite easily be able to identify the same positions in the figures from page 69 on page 70, where they have been transposed into free brushstrokes.

Making a dynamic template of proportion
Page 71:
Those of you who are not confident enough to try the above exercise should cut out the individual sections of the body in a material that is suitable for making prints based on the proportional figures. The sections must have overlaps and holes for pivoting. Then make prints of these (the individual shapes have been taken apart on the left while the right-hand figures have been put together again).

V. V. Lebedev (1891–1967): Nude study, 1926.

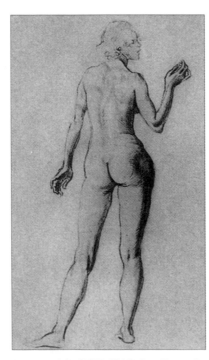

Augustus John (1878–1961): Standing nude in contrapposto, c. 1906.

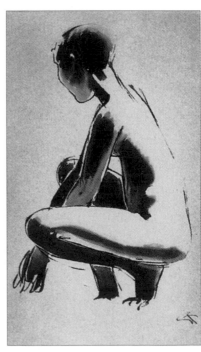

Georg Kolbe (1877–1947): Female nude, squatting, undated.

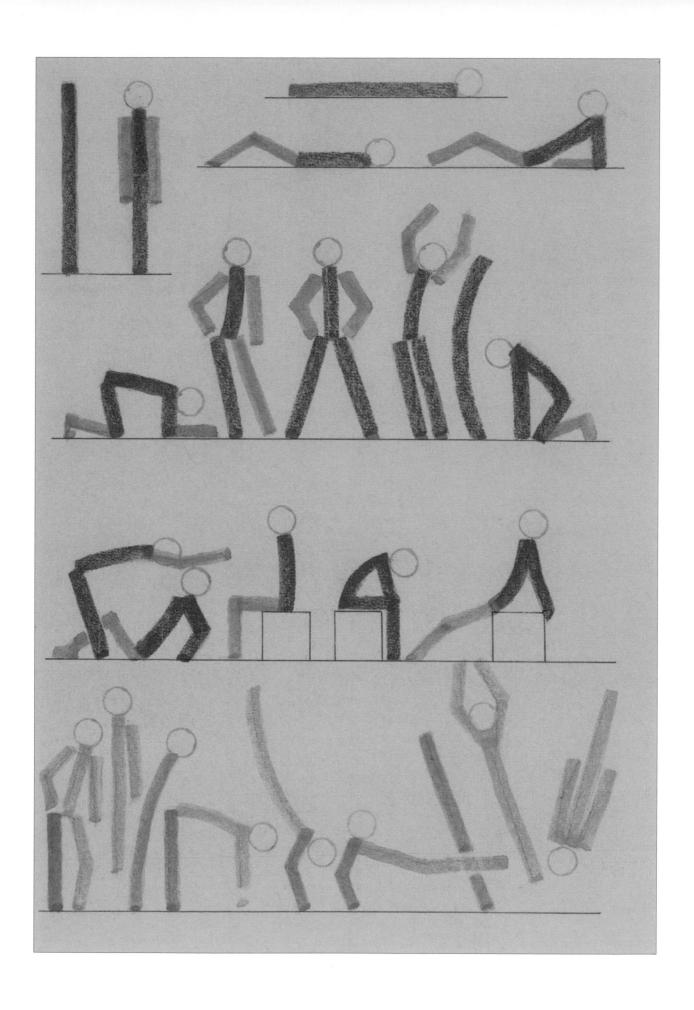

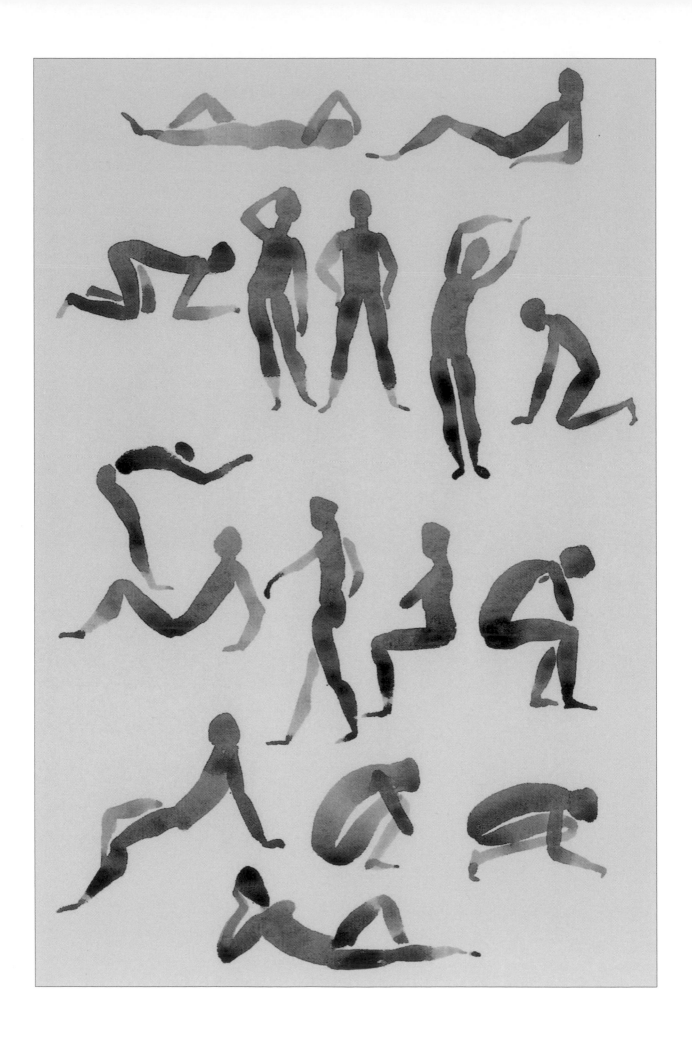

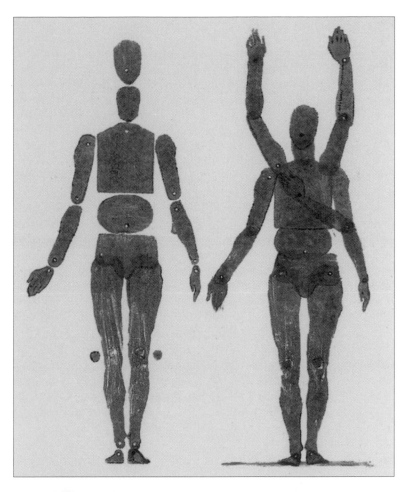

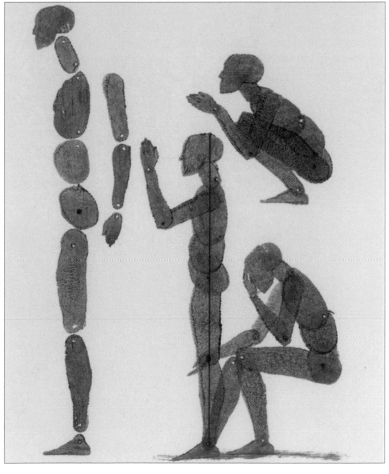

THE CONTRAPPOSTO STANCE

The contrapposto stance (with the weight on one leg) is based on the need to take the weight off one leg and to place it on the other one. This mechanical event then has major consequences across the rest of the body.

Left-hand figure (weight-bearing forms in maroon):
• Standing on equally loaded feet: centre of gravity is at S1 between the two feet.
• The symmetrical axis is vertical (spinal column), while the other axes (pelvis, shoulders) are horizontal.

Central figure:
• The relieved free leg (grey) does not offer any support, therefore the centre of gravity is shifted by moving the pelvis from S1 to S2 across the centre of the residual support area (half a sole width).
• Severely slanted standing leg position due to the shift in the pelvis: dropping of the pelvis on to the unsupported side, with balancing position of the relieved leg.
• If the upper body did not adopt a balancing position, it would appear as in the linear representation shown here.

Right-hand figure:
• Stability is restored when the spinal column bends back above the lumbar region and so returns the upper body to a position of equilibrium.
• This balancing act results in a curve of the spinal column, where the concave side points to the standing leg.
• The shoulder girdle follows this tilt (the axis drops towards the standing leg).

The line of gravity usually passes through the pit of the neck. However, the decisive criterion for a balanced (well-considered) contrapposto stance will always be the relationship of the centre of gravity within the pelvis to the residual support, otherwise the figure will fall over. The ever-changing play of weight-bearing and supported forces, of compressed masses (standing leg side) and stretched, flowing forms (free leg side) has been a theme since the time of Polycletus (5th century BC) until now and has provided a construction method for drawing dynamic figures which finds perfection in the harmony of its counterpoints (see page 68 centre).

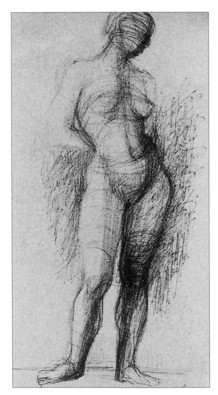

Helmut Heinze (b. 1932): Female nude in contrapposto anterior view, undated.

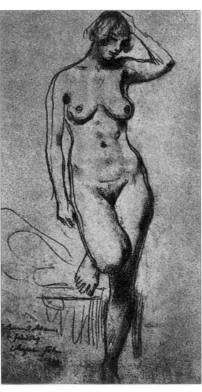

Augustus John (1878–1961): Nude girl with raised foot.

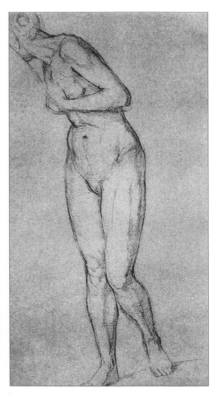

Alfred Rethel (1816–1859): Nude study on the 'Queen of the Langobards' undated.

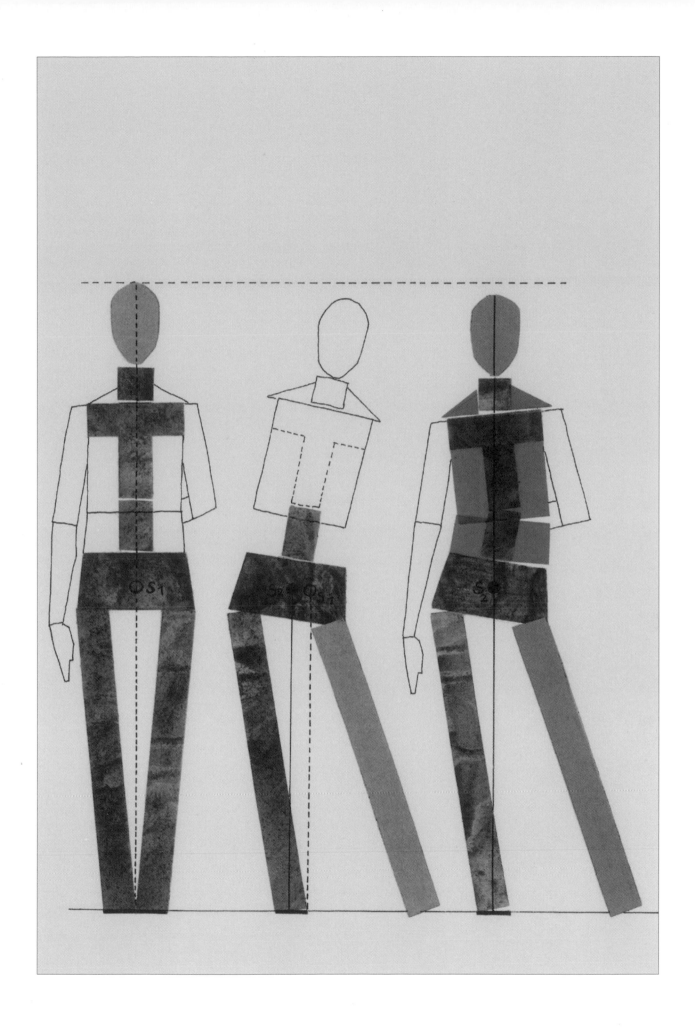

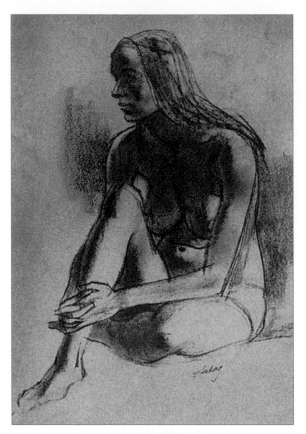

Ron Steenberg (Scotland): Seated, 20-minute sketch.

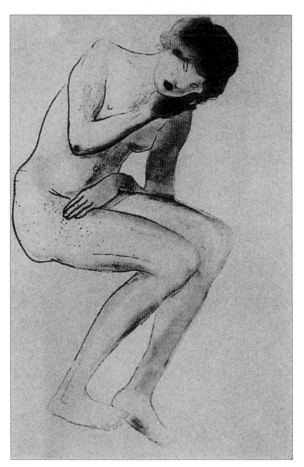

Théophile-Alexandre Steinlen (1859–1923): Seated nude, 1898.

EXERCISES AND SKETCHBOOK WORK

Page 75, top row:
The graphic construction of the contrapposto stance is based on the stages set out opposite. This is a framework that should not be adopted as a ready-made scheme, but rather needs to be derived from the relationship between the centre of gravity and the area stood on.

Page 75, bottom row:
The construction of the contrapposto pose using the dynamic template of proportion shown on page 71 is essentially equivalent to the stages shown in the top row. From a teaching point of view, it is important to show the development of the posture in relation to the weight-bearing foot and the balancing posture of the pelvis.

Page 76 top:
As in the case of the illustration on page 29, the figure is dealt with as a study in proportion, but now with the added weight-bearing calculations that were shown in the development of the contrapposto pose (bottom). Try to record this with a half-dry bristle brush using paths that are mainly driven by the arm's motion and without any initial drawing (perform the first stage as on the left).

Pages 77–81:
The sketchbook studies on pages 77–79 and 81 deal with the widely varying forms of both standing and sitting rest positions, where the action leaves out spatial modelling to the extreme and rather accentuates the essentially static motif in linear form (fundamental guidelines on sketching have already been provided on pages 54 and 64). However, in general one should question one's own sense (regardless of the pose) whether the standing or sitting position as drawn evokes discomfort in us, because the posture at rest has not been convincingly expressed (with a tendency to topple over). If this is the case, there is no other solution but to reassess the relationship of the centre of gravity to the support areas thoroughly.

Anyone who believes that they can express themselves more rapidly or more energetically, capturing the essence in a more decisive way than with a pen, should try to demonstrate their powers of abstraction in the most concise manner (page 79, bottom). Also, using Indian ink in brush exercises, which are then rubbed with the finger moistened with saliva (page 80, top) can, to some extent, create three-dimensional modes of expression, which are exciting because they are improvised. One can also achieve similar effects with a ballpoint pen handled in a playful way (page 80, bottom right).

Pages 82–83:
When making studies of outdoor life we also seek to represent the three-dimensional organisation of people and groups of people in an unrestricted space (page 82). Where people are concentrated in groups, individuals lose their visual significance. We then need to integrate the group into a complex arrangement (page 83 bottom).

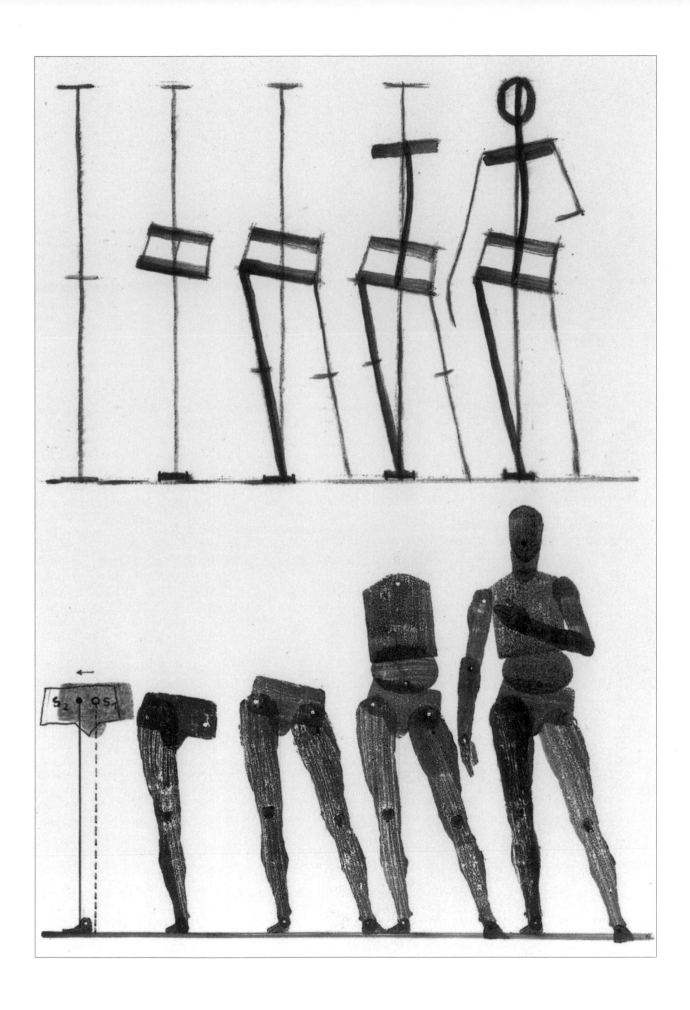

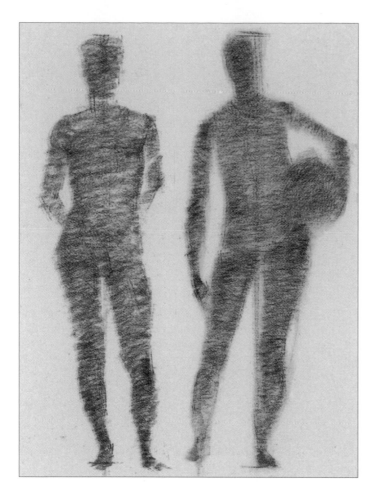

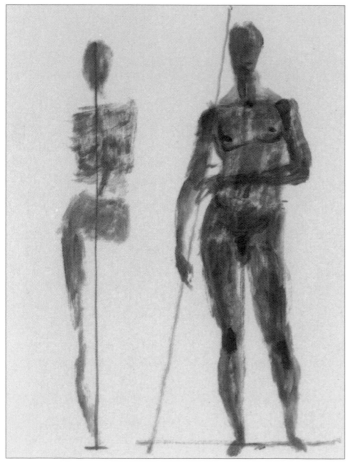

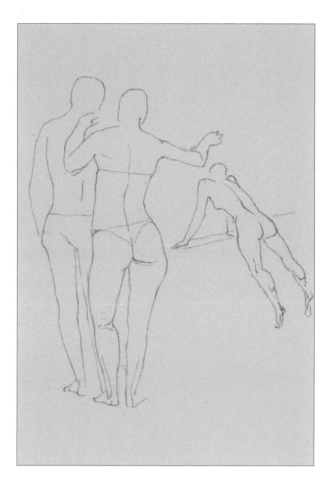

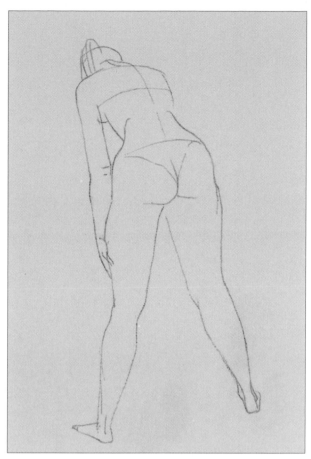

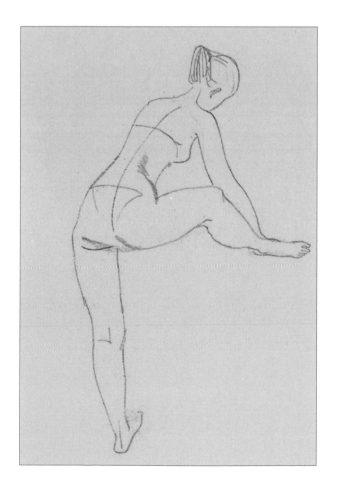

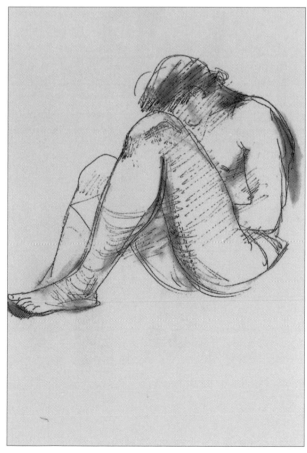

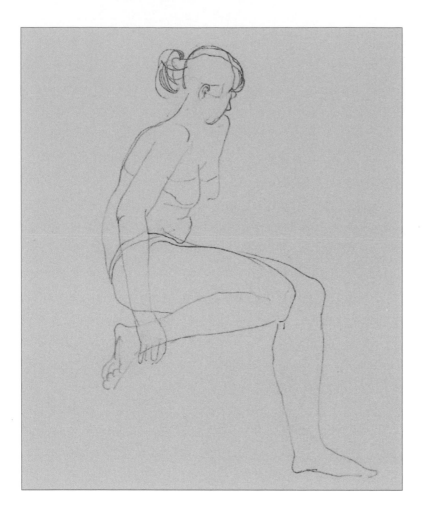

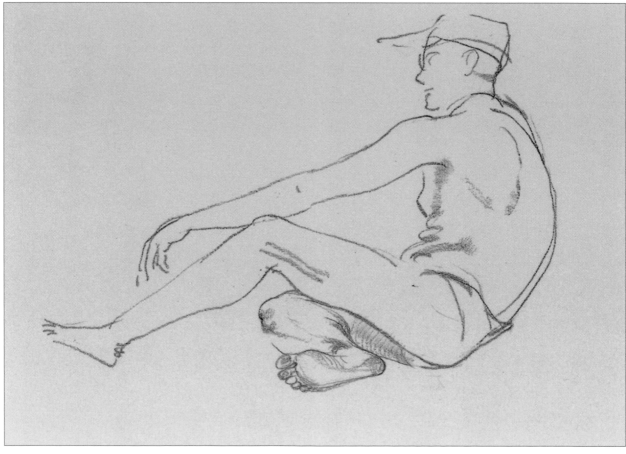

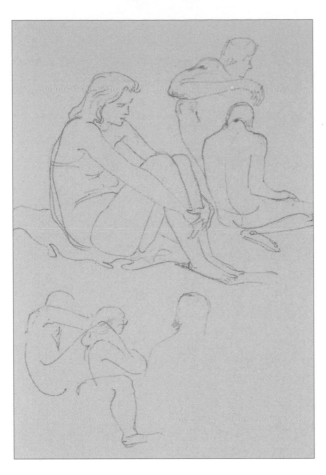

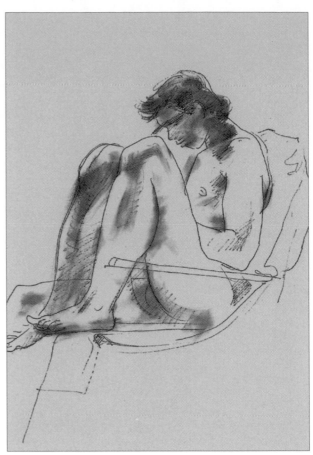

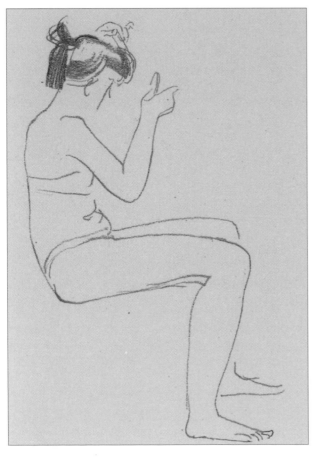

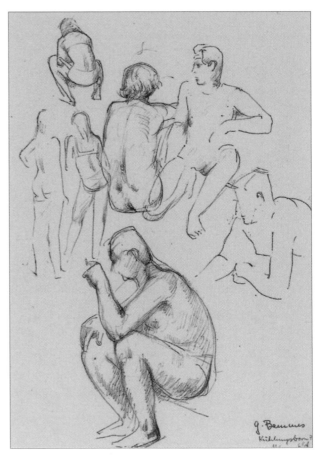

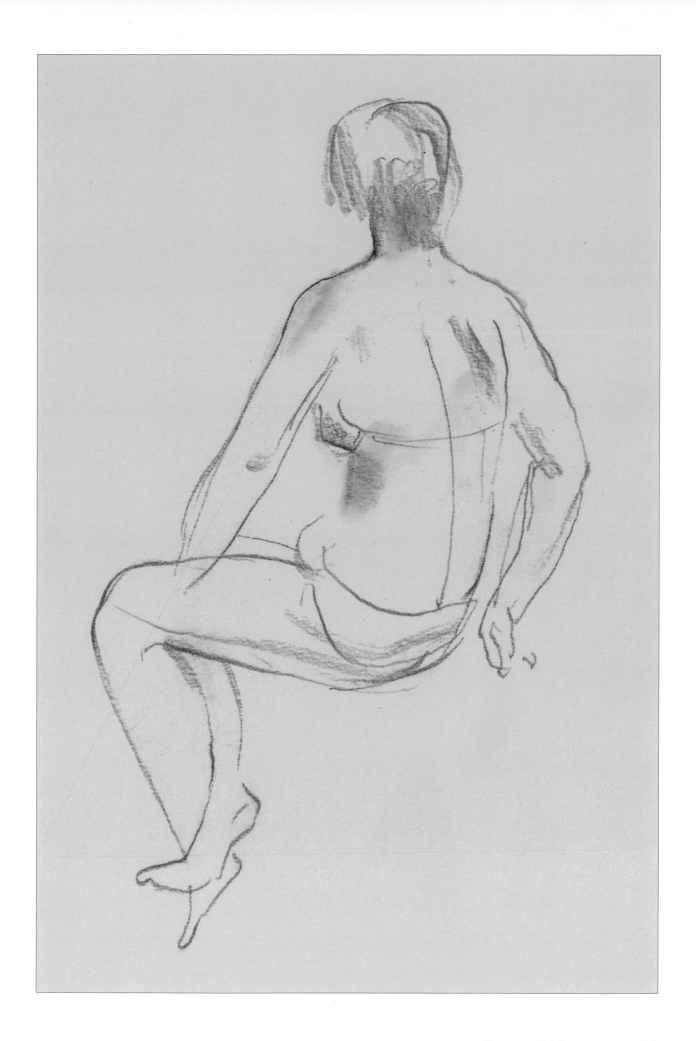

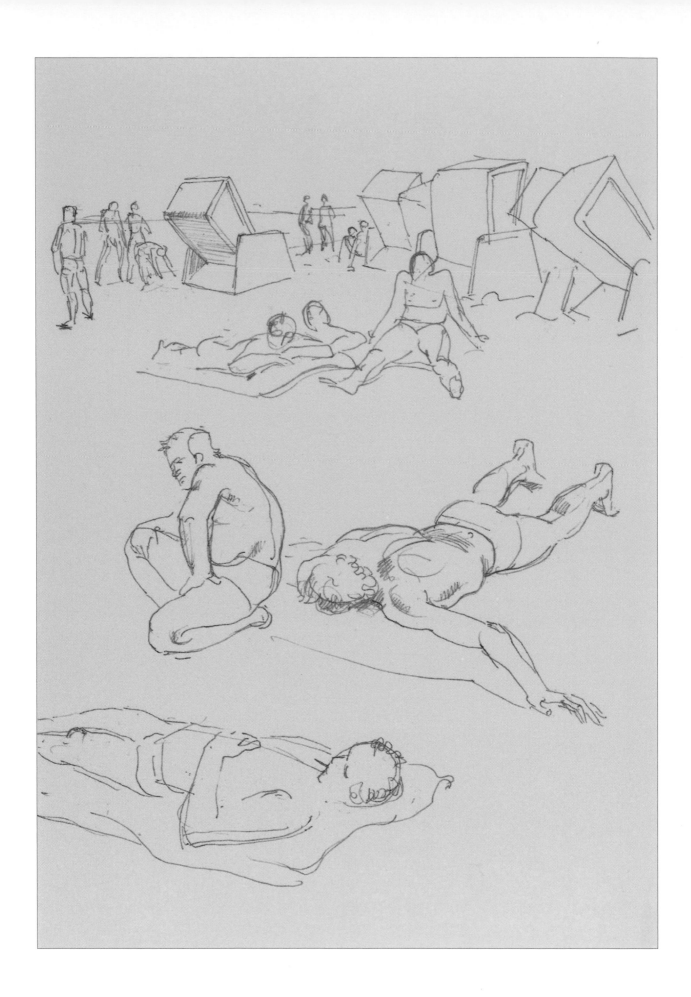

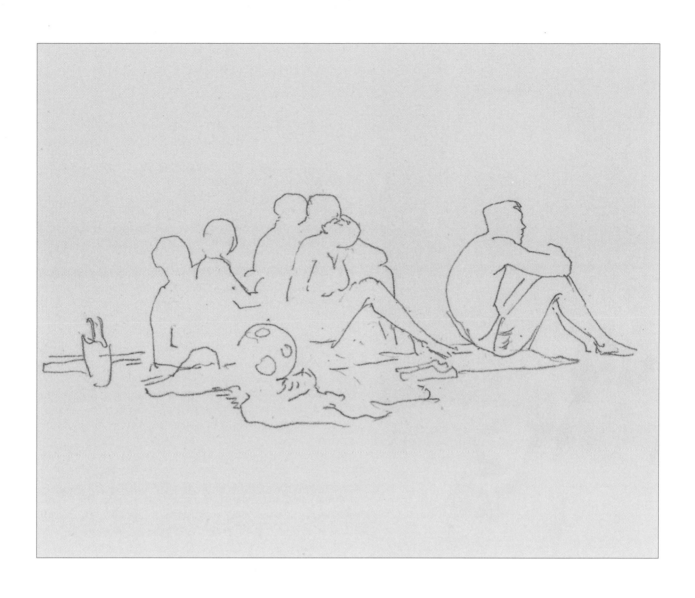

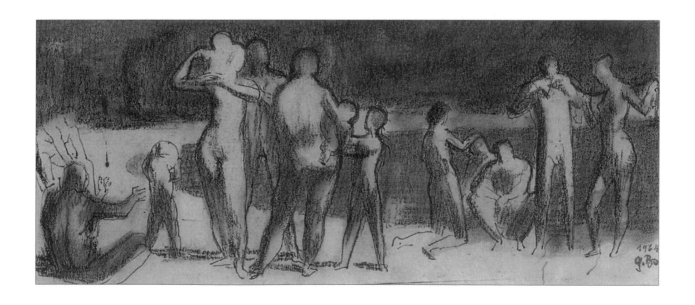

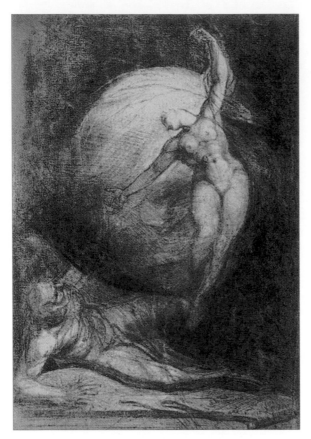

Henry Fuseli (1741–1825): Hovering woman before reclining man; 'Dream of Socrates'.

EXERCISES RECOMMENDED FOR LOCOMOTIVE MOVEMENT

The precondition for locomotive movement (stepping, running, jumping) is to move the centre of gravity out from the standing area, so that the body will inevitably fall if it is not caught.

Page 85, top row:
• Starting posture is in an upright position (far right) with plumbline above the sole of the foot.
• Then there is a preliminary shift of the centre of gravity towards the toes.
• Next the centre of gravity is pulled forward by leaning the upper body over in a falling tendency with preliminary swinging of the free leg.
• The free leg is extended forward, ready for landing.
• The centre of gravity is placed centrally above both supporting legs.

Page 85, bottom row:
Here we see a running movement with suspension phase (line drawing); a rapid stride with extreme body lean, and apparent movement with no perceptible falling tendency (smaller, subsidiary figure).

Sport is training in movement skills, agility and increased power and endurance. The forms of movement arising from sports as illustrated are not all necessarily linked to locomotive movement (pages 87, 89, 91, top, and 92). The decision whether there is, in fact, a shift in the sense of directional movement or whether this is an 'apparent movement' (with the possibility of retaining stability while in that position) can only be answered by looking at the relationship between the centre of gravity and the sole of the supporting foot.

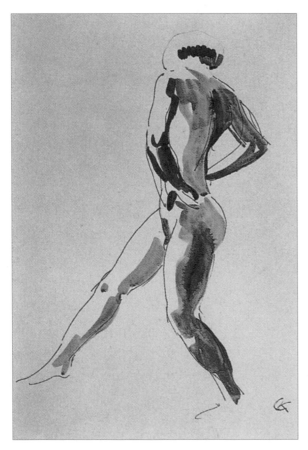

Georg Kolbe (1877–1947): Walking female nude.

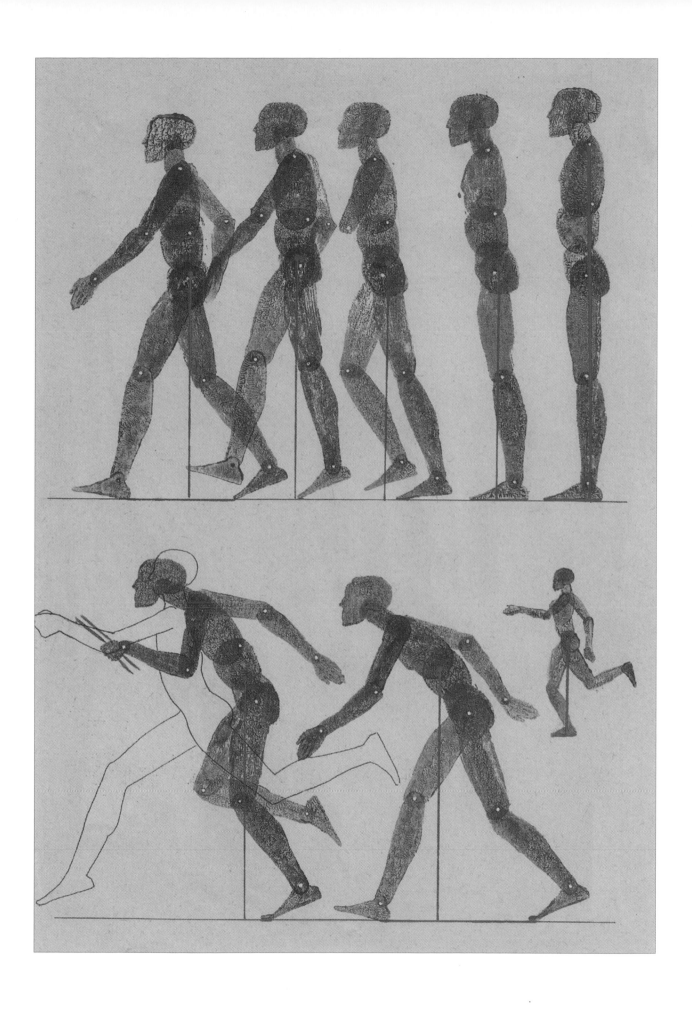

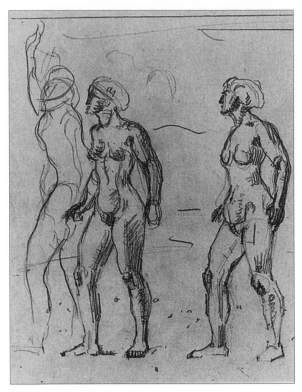

Ferdinand Hodler (1853–1918): Detail from four nudes walking to the left from the theme series 'View of the infinite', 1910/14.

EXAMPLES OF DIFFERENT MOVEMENTS AND SOLUTIONS

The recommended method of representation does not derive from a random variation of techniques, but rather from the focused selection of the most successful and appropriate solution.

Page 87:
These quick renderings show resilience in boxing movements. They are drawn in broad graphite, chiefly to depict attack and defence with the least possible effort.

Page 88, top:
Brushstrokes are used here to capture fleeting flying movements on the parallel bars.

Page 88, bottom:
The somersault, in its highly aesthetic phases of physical control, are captured here using sharply defined angles in red chalk.

Page 89:
Multi-angled fencing movements are expressed with simplified geometric shapes using pulling and turning strokes with black chalk, which requires a great deal of practice.

Pages 90 and 91:
Long jump, discus throwing and shot put, stretching, weightlifting, running and hurdling, are described in flowing brushstrokes.

Page 92:
The gracious movements of classical dance are rendered here using pen technique with clear strokes on a dark brown ground.

Page 93:
The expressiveness of forward and backward stretching, sliding, pulling, pushing and lifting is captured here using only a few tones, carefully positioned. Compare this with the suggestive pen-style drawing shown left.

These are all suggestions. If you know of a technique better suited to the occasion, you should use it.

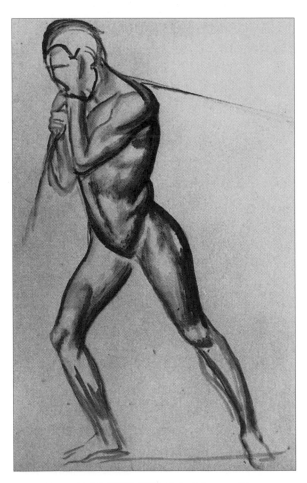

Kusma Petrov-Vodkin (1878–1939): Naked figure pulling a rope, 1914.

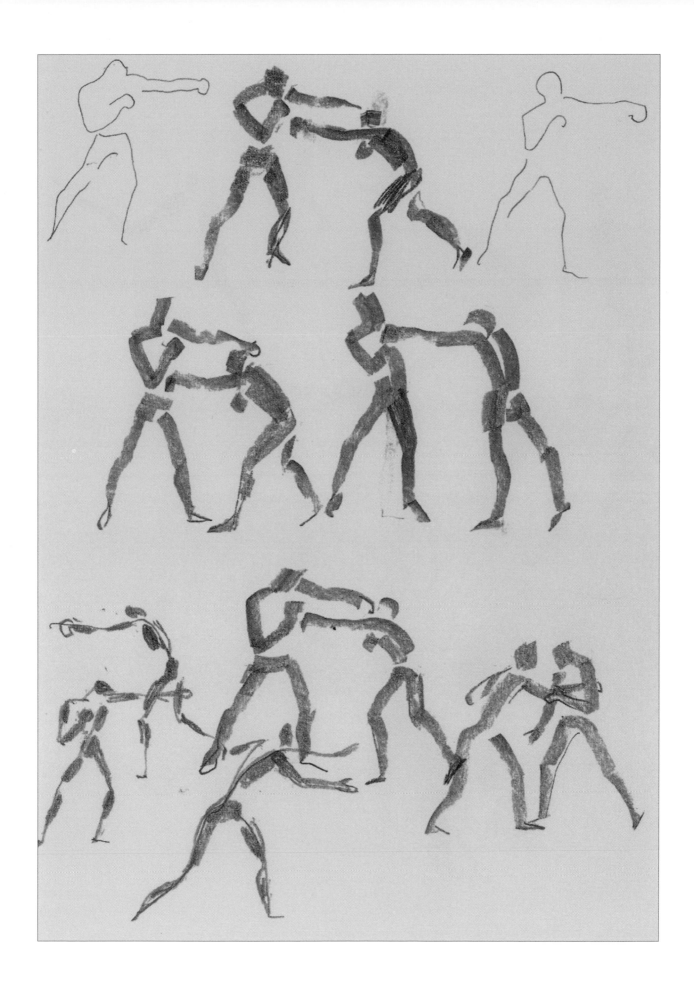

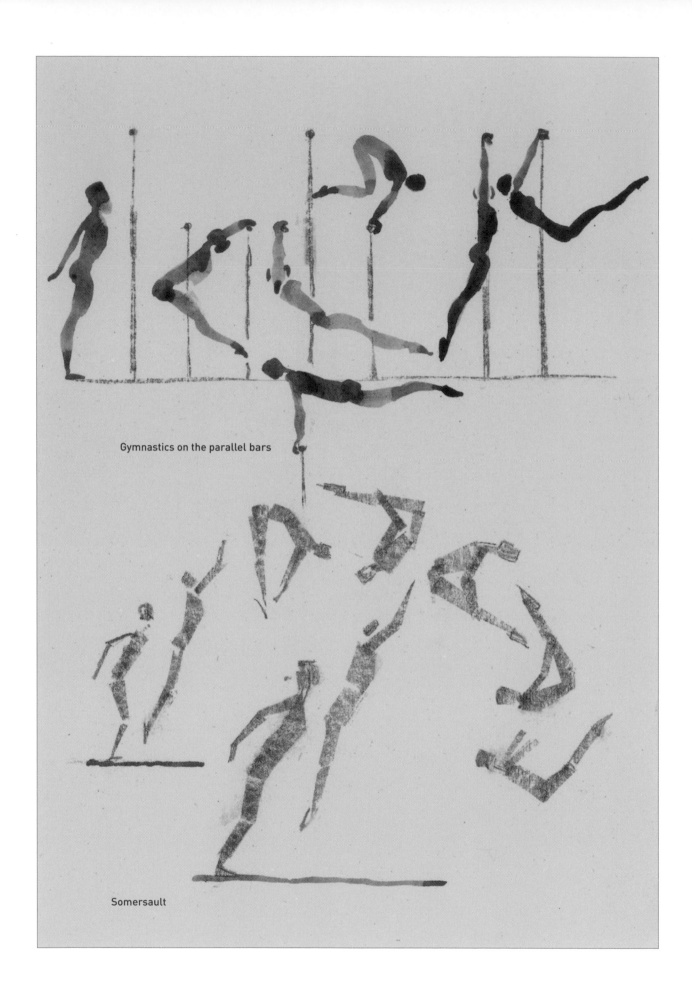

Gymnastics on the parallel bars

Somersault

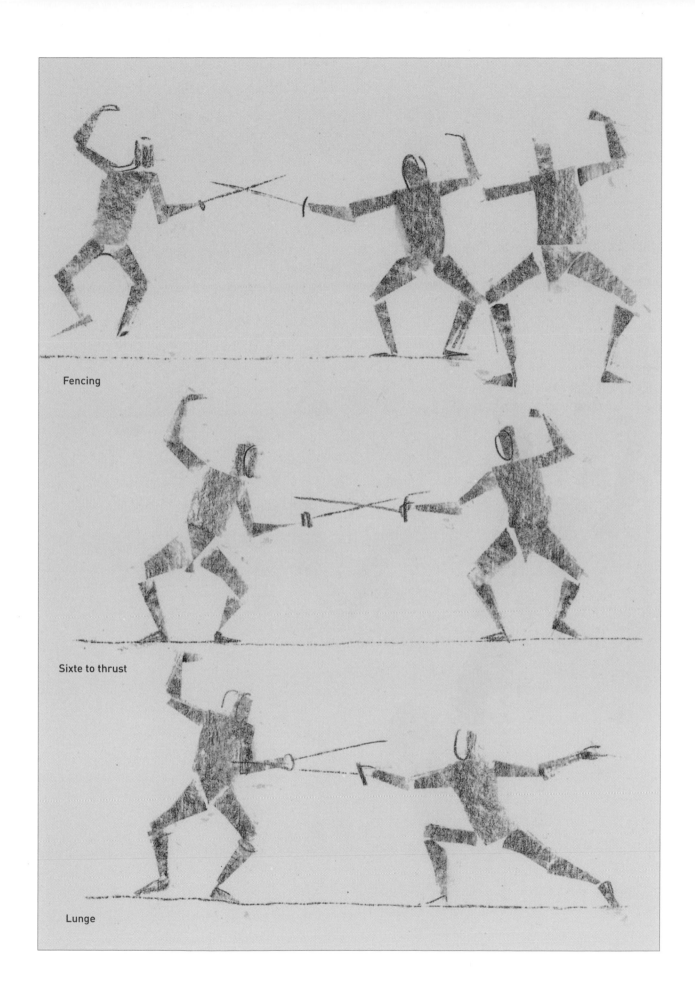

Fencing

Sixte to thrust

Lunge

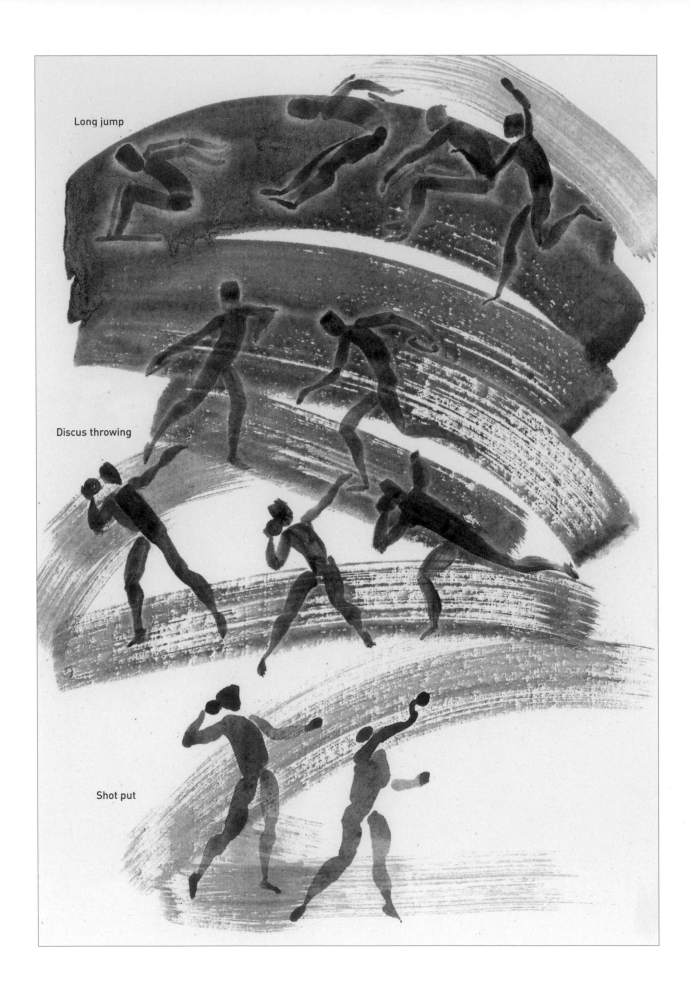

Long jump

Discus throwing

Shot put

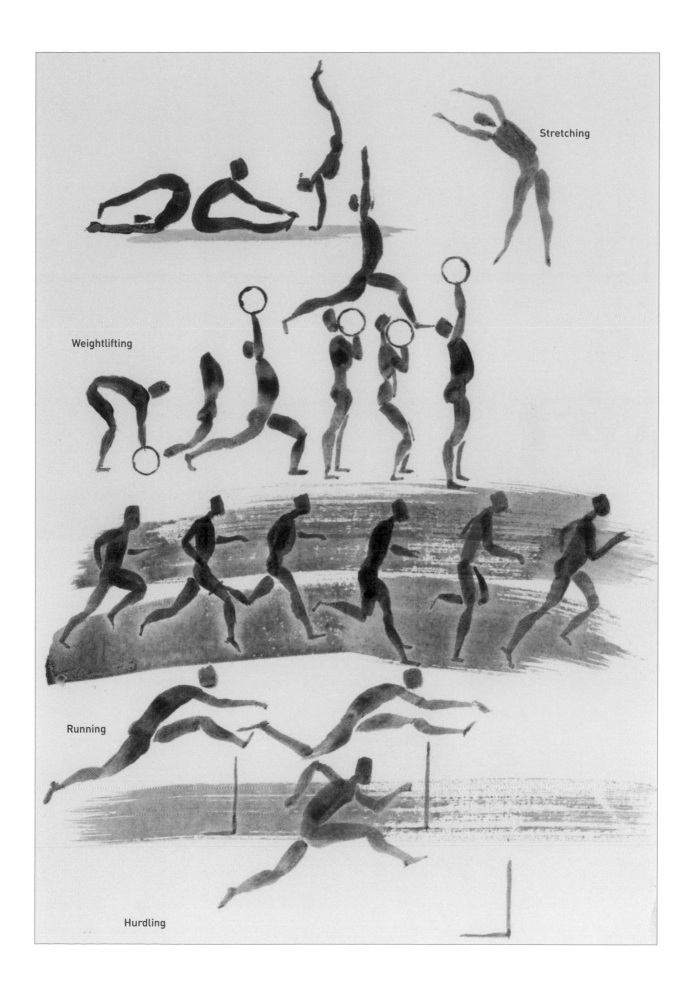

Stretching

Weightlifting

Running

Hurdling

Rest and Movement **91**

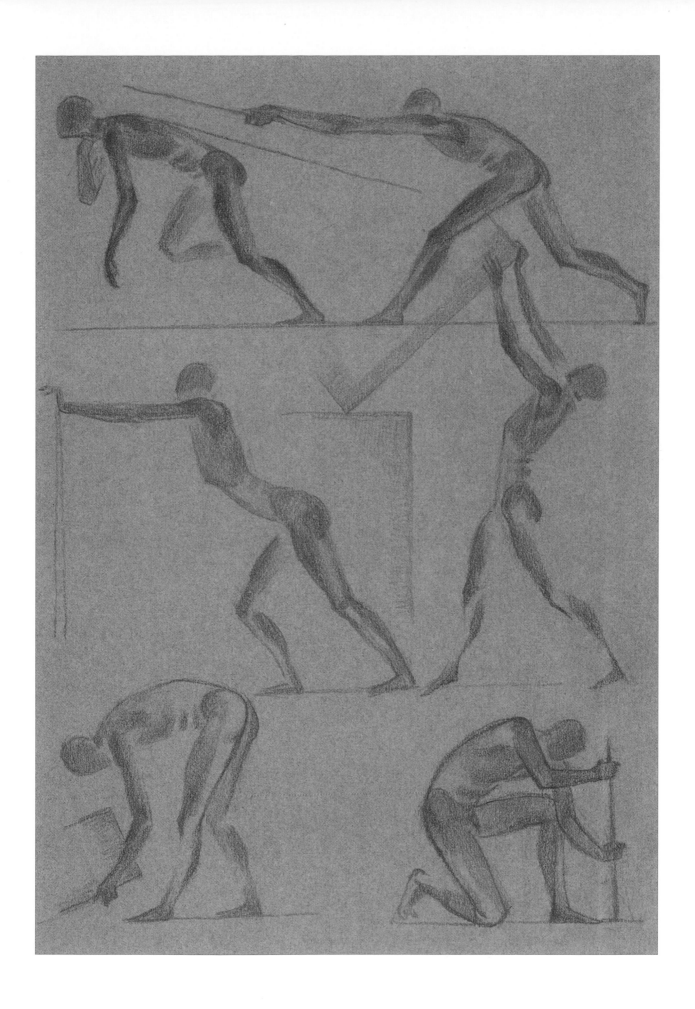

Legs and Feet

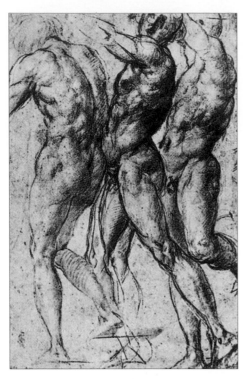

Jacopo da Pontormo (1494–1557): Three male nudes, undated.

OVERALL STRUCTURE AND RECOMMENDED EXERCISES

Your task here will lead to the clarification of the overall structure of the leg seen from the front and side. There are several points of note to draw from the illustrations opposite.

Forward-facing figure:
• From a stable base (pelvis) the body has a freely swinging leg action.
• The weight of the upper body is transferred via the pelvic girdle, through the hip joint, on to the leg.
• Three main joints (hip, knee and upper ankle joint) as moving parts, are arranged on a common weight-bearing line (broken black line) that converges towards the arch of the foot.
• The divergence of the femur shaft (thigh bone) from the weight-bearing line, causes the exterior angle of the leg.
• There is a serial arrangement of joints with diminishing degrees of freedom: hip joint (tri-axial joint) with forward and backward swinging (transverse axis), pulling and pushing (depth axis) and inner-outer rotation (longitudinal axis); knee joint with transverse rolling for bending and stretching and additional rotational potential when bent; and upper ankle joint with transverse axis for raising and lowering the toes.

Standing figure in profile:
The transverse axes required for continuous movement and bending/stretching are all situated on the plumbline (broken red line).

Seated figure:
The knee joint opens up the joint cavity during bending. The body's centre of gravity shifts upwards now, as both the ischium bones of the pelvis serve as the supporting seating planes.

Studies of the pelvis, pages 96–99:
1 First try depicting the pelvis in a simplified form as a hemisphere at the lower end of the torso (page 96).

2 Now turn this simplified form step by step from a solid block to a hollow body (see the right-hand column on page 96).

3 Develop the structure further. When drawing the structure of the pelvis, the directions of the three spatial axes are the main things that need to be clarified (page 97). You need to develop the critical angles of the funnel shape and the three-dimensional points (shown in red, page 97).

4 The pelvis is the lower three-dimensional core of the torso and the enclosed ring-like centre of movement in the centre of the torso (also see page 103, right). You should therefore try some analytical drawing from the nude model in order to understand the pelvis in its positioning and orientation as the foundation of the whole hip area (pages 98–99).

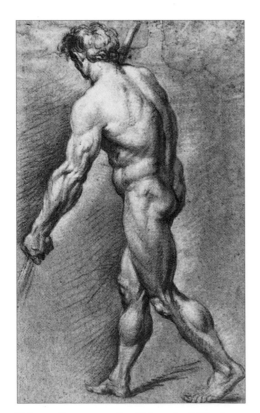

Unknown Baroque master: Male nude striding to the left, from behind at an angle, undated.

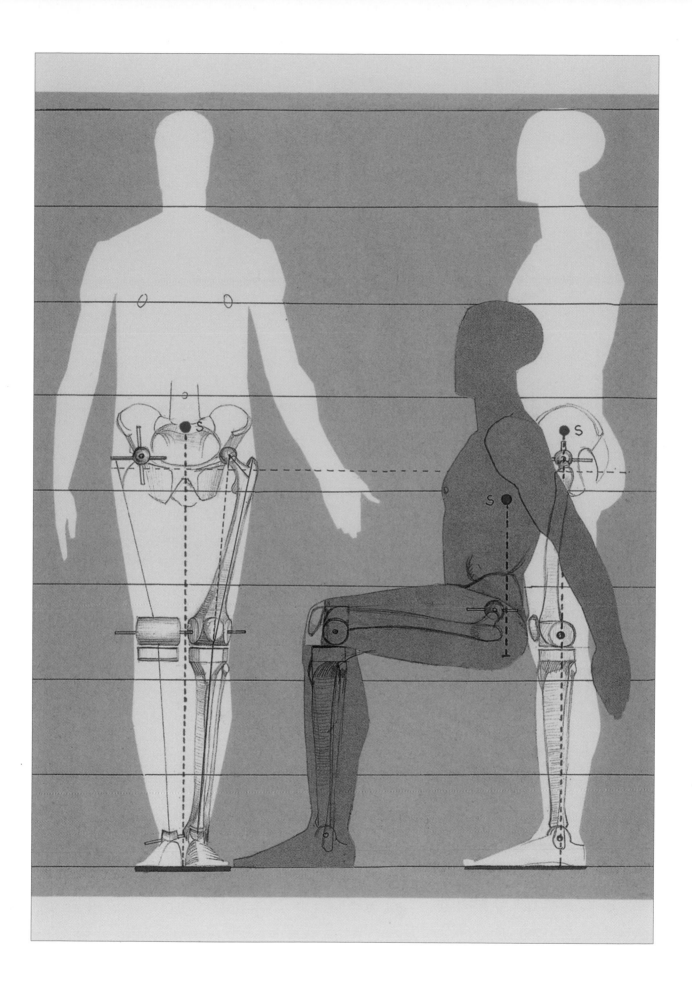

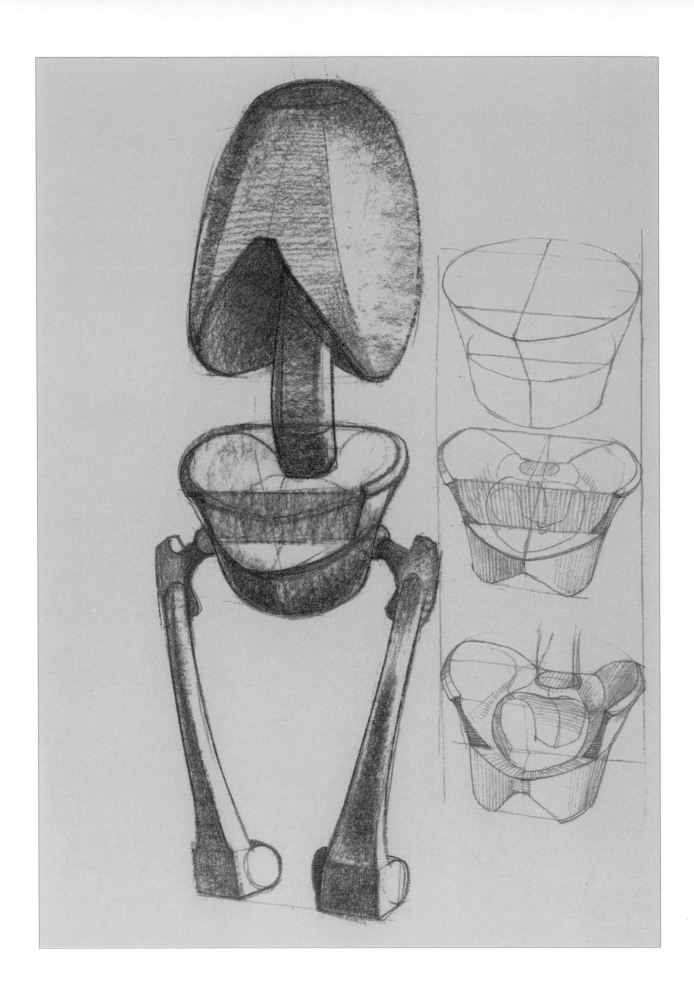

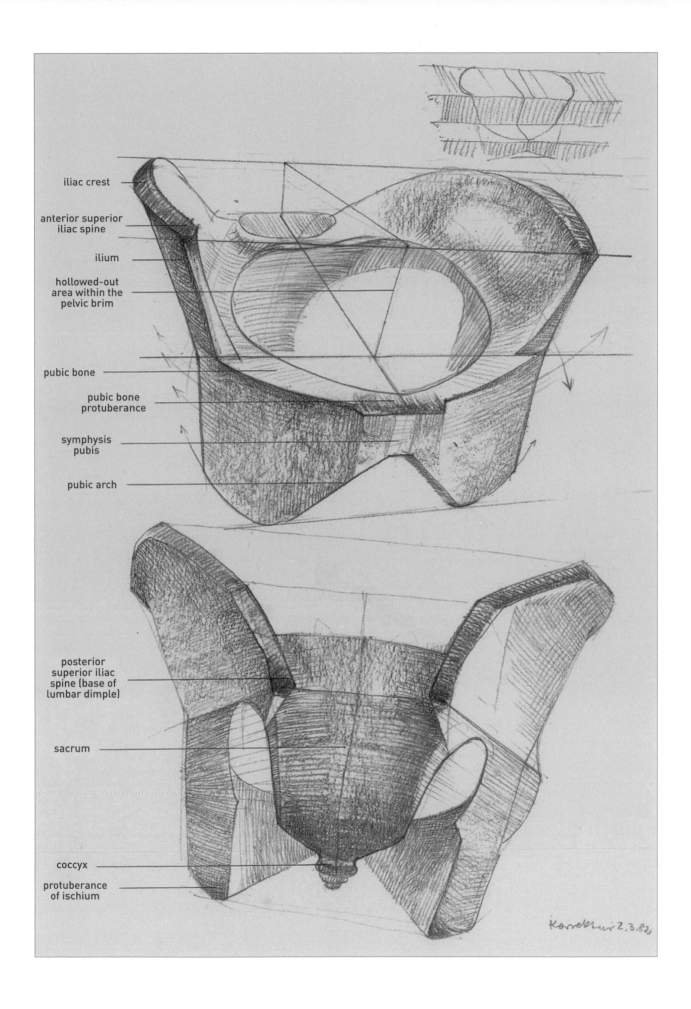

iliac crest

anterior superior
iliac spine

ilium

hollowed-out
area within the
pelvic brim

pubic bone

pubic bone
protuberance

symphysis
pubis

pubic arch

posterior
superior iliac
spine (base of
lumbar dimple)

sacrum

coccyx

protuberance
of ischium

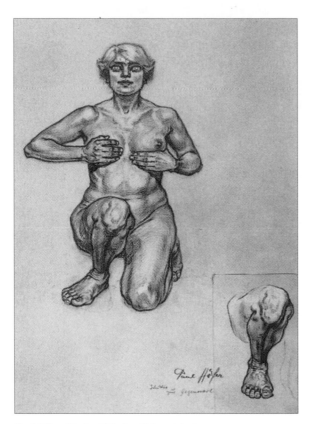

Paul Höfer: Study of 'Modernity', undated.

STRUCTURE AND MECHANISM OF THE KNEE JOINT

Pages 101–103:
The essential nature of the widely variable three-dimensional forms of the knee joint can be understood only if you have some prior anatomical knowledge. See, for example, the illustrations opposite, noting the following:
• The joint is built up from a cylinder (the condyle, or rounded part at the end of the thigh bone) and a bearing surface on which it moves (tibia plateau).
• These two joint bodies are firmly fused with the levers of the thigh and shin.
• The less than perfect fit of the joint bones to each other (incongruence) naturally creates a slight cavity within the joint that opens up conspicuously when the joint is bent (see page 95).
• For moving and guiding the patella (kneecap) in front of the condyle, there is another formation (protuberance) linked to the condyle (page 101, top, shaded grey).
In order to master the complex mechanical and spatial actions more easily from a graphic viewpoint, one should first deal with the rectangular formation at the end of the femur(thigh bone), always stressing the faces of this cuboid and then rounding them off.

Page 102:
Skeletal features have been added to the various leg positions (printed with the template of proportion shown on page 71) to make it possible to understand the mechanical processes during movement:
• The gap in the joint opens up when the knee bends over (top).
• There is a strong rolling motion of the condyle with strong flexion and greater opening of the articular cavity.

Note: While the kneecap can touch the femoral condyle, it can never slide upwards because it is anchored by the straight patellar ligament.

The arrangement of muscles at the knee and hip joints, page 103:
• The skeleton accounts for the greatest part by far of the sculptural form of the knee. A significant mass of the upper leg is taken up by the muscles extending from the knee.
• The group of extensor muscles (quadriceps extensor of the knee joint) is situated in front of the transverse axis of the knee joint, while the flexor muscles are situated behind the transverse axis.

Right-hand schematic figure, page 103:
Here we see an illustration of the pelvis (dark grey shading) as the centre of movement from which muscle groups extend upwards to the torso skeleton and downwards to the shin bone (muscles with tensor function in blue and flexor function in red).
• Knee muscles are positioned relative to the hip joint (double articulated muscles), as a result of which the knee muscles are able to activate the hip joint in a subsidiary function (swinging forwards and backwards).

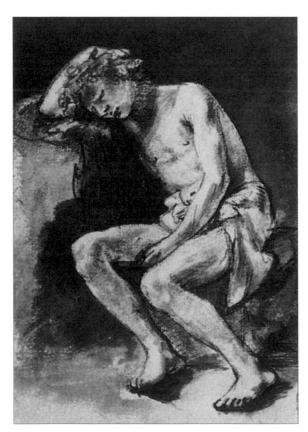

Rembrandt Harmenszoon van Rijn (1606–1669): Seated youth with leaning head.

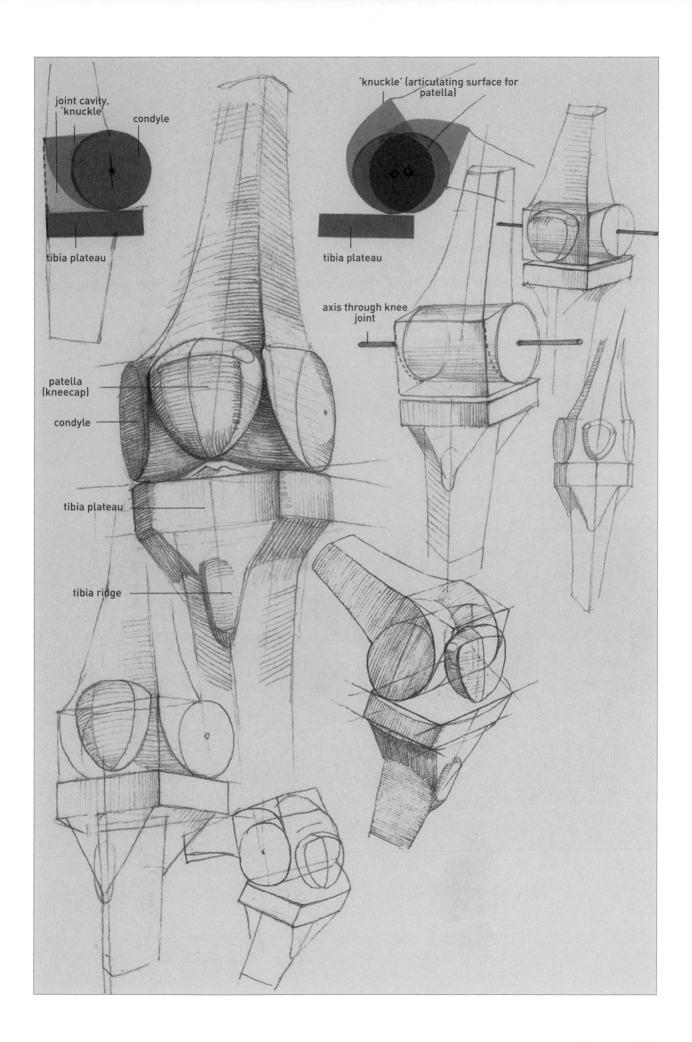

joint cavity,
'knuckle'

condyle

tibia plateau

'knuckle' (articulating surface for
patella)

tibia plateau

axis through knee
joint

patella
(kneecap)

condyle

tibia plateau

tibia ridge

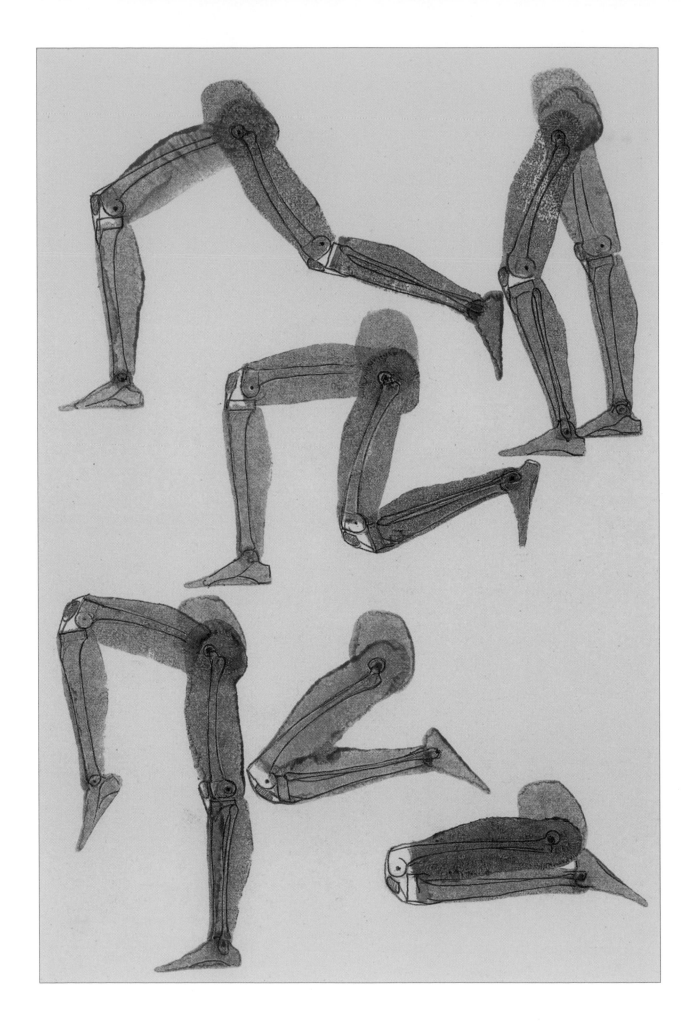

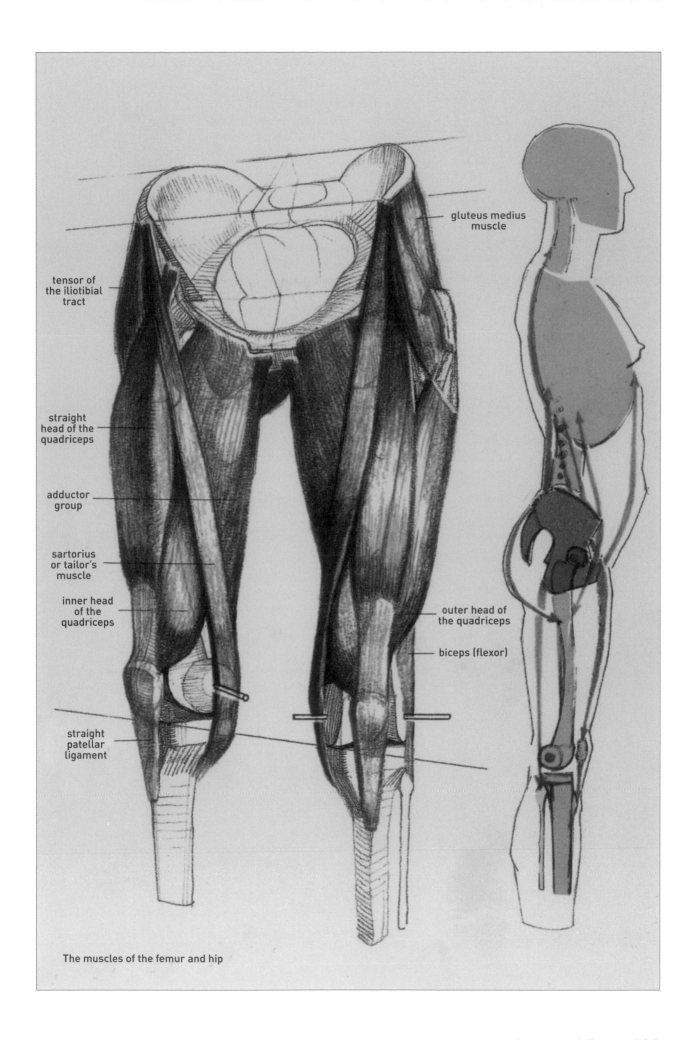

tensor of the iliotibial tract

gluteus medius muscle

straight head of the quadriceps

adductor group

sartorius or tailor's muscle

inner head of the quadriceps

outer head of the quadriceps

biceps (flexor)

straight patellar ligament

The muscles of the femur and hip

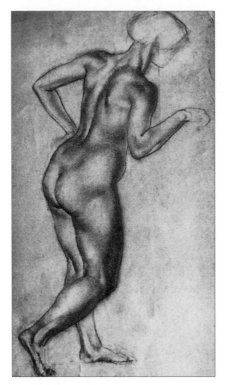

V. V. Lebedev (1891–1967): Female nude study in right profile and partly from rear, 1915.

Michelangelo Buonarroti (1475–1564): Study of a male left leg, with the right leg sketched in and tucked under; possibly dating from his thirties.

EXERCISES IN DRAWING THE THIGH AND KNEE

General advice, fundamental to all studies, pages 105–107:
• Decide on the viewing angle to be adopted, i.e. fix the horizontal sightline of the artist and his viewpoint – from above, frontal view, etc. – and draw the spatial axes.
• Create unambiguous viewing planes – inner, top view, frontal planes and so on (see page 106, top left and bottom left).
• Avoid direct viewpoints such as front, side and rear view, because these do not offer sufficient physical and spatial features.
• Include virtual cross-sections to support the physical representation, in order to establish the slant of the body surfaces in space very clearly (see all exercise examples for this).
• Do not present individual muscles, but rather pay attention to the muscle mass groupings.
• If it is necessary to stress physicality with cross-hatching, above all follow the course of the imagined cross-sections as a coordinating factor (but do not 'knit' the shape together: use counter-movements instead).
• In the case of difficult foreshortening, simplify the forms (page 106, bottom left), treating the thigh and shin like cylinders at a more or less angled position towards each other.
• It is best to make crisp edges at the bending points (see page 106, bottom right), rather than producing inexpressive bent 'sausages'.
• Visualise the behaviour of the kneecap and draw this in a simplified cuboid shape as an ending or protruding shape in front of the simplified cylinder-shaped thigh.
• Do not single out the kneecap and its straight patellar ligament with dissecting lines, but deal with it as an integrated mass.
• Look at the combination of the kneecap and the straight knee ligament as a single unit.
• Make it clear how the diagonal fold in the thigh created by the tailor muscle (sartorius) reaches the inside of the shin bone. Then continue the fold in the shin through the exposed inner shin-bone surface into the medial malleolus or inner anklebone.
• Always visualise the mechanical processes in the knee (the power of the rolling movement of the thigh cylinder, the expected width of opening of the articular cavity), in order not to put down shapes you do not understand.

Studies of the knee require a great deal of knowledge to express the knee's essence.

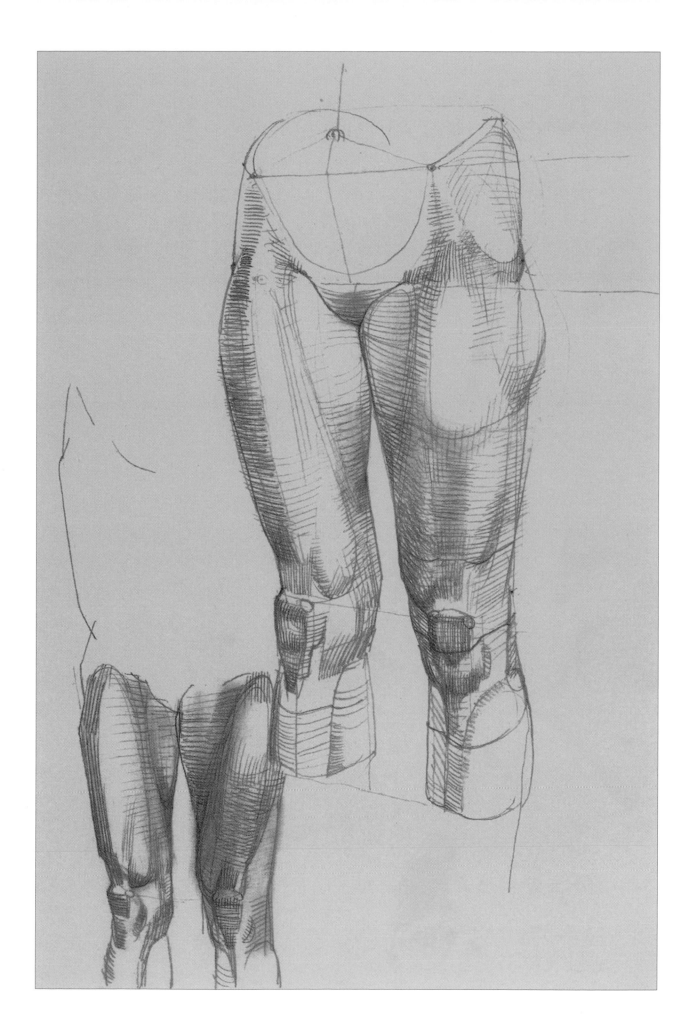

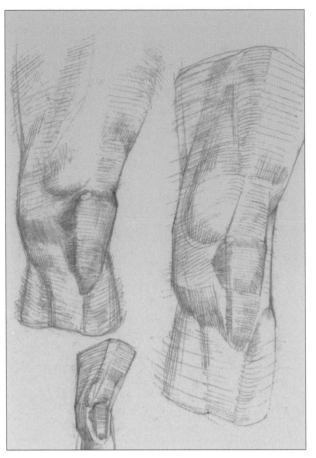

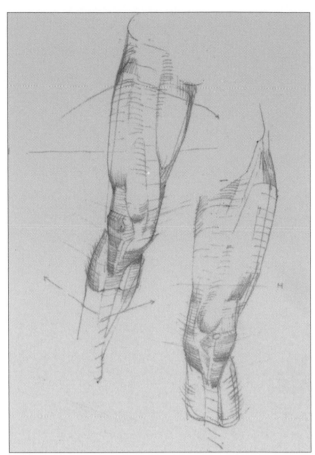

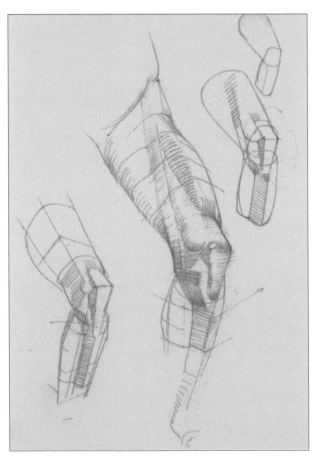

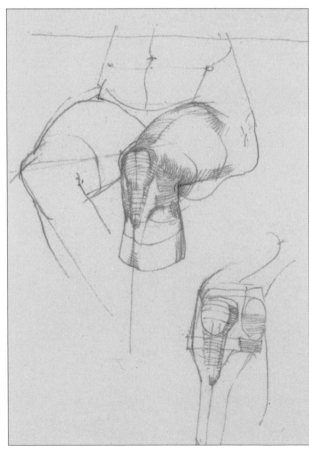

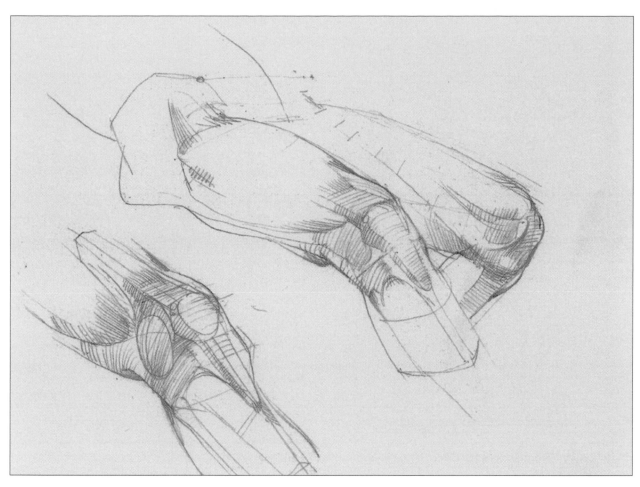

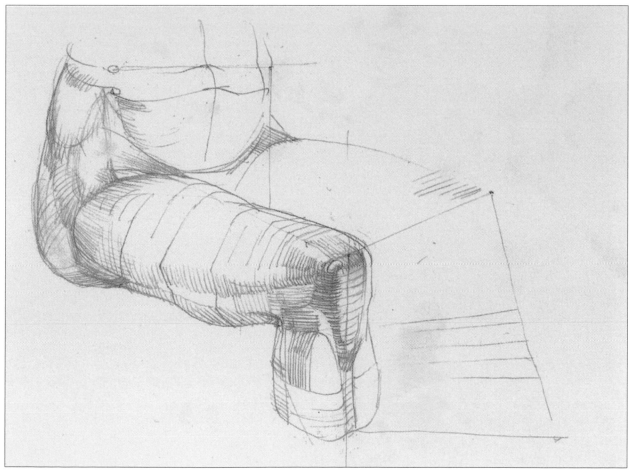

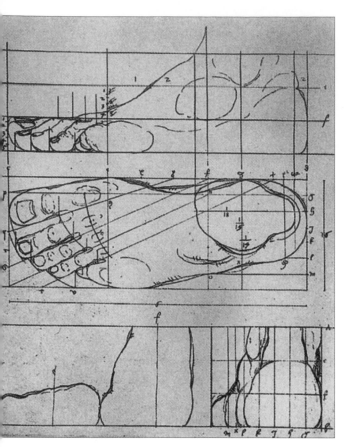

Albrecht Dürer (1471–1528): Constructed left foot, with basic views and proportional markings, 1513 or a little later.

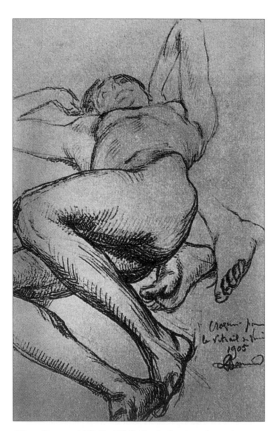

Albert Besnard (1849–1934): Reclining female nude, rotated and foreshortened, 1905.

STRUCTURAL SHAPE OF THE FOOT SKELETON

Pages 109–110:
The factor that defines the animate foot is its skeleton. It would be artistically meaningless to treat it as a 'still life with bones'. We perceive the quintessence of a shape through the substance of its construction:
• The skeleton of the foot can be seen as a vaulted arch (see also page 110) with a three-point support consisting of the heel and the large and small toe pads.
• This is echoed by the strong longitudinal arch of the free weight-bearing inner side and the flat curve of the outer edge of the foot.

The inner edge of the foot, with its semi-cylinder anklebone (talus), lies on top of the cylinder-shaped heel bone, which continues the line of the outer edge of the foot. This means:
• The inner side of the foot makes an acute angle with the direction of the outer side.
• The directions of both these edges, converging towards the heel and diverging away from the end of the metatarsus (the collective name given to the long bones in the centre of the foot), are easily recognisable in the actual foot.
• The metatarsal bones fit into the curvature of the foot – where the top of the arch is situated more towards the inner side of the foot.
• The 'cylinder' of the ankle bone, which protrudes from the top of the foot arch, is enclosed by the medial malleolus of the shin bone (inside leg) and the lateral malleolus of the fibula (controls the direction of the movement when raising and lowering the end of the foot).
• The strong curvature of the arch is reduced in the instep towards the flatter front end of the metatarsus. The toes have no constructive significance for the arch of the foot.
• The medial malleolus (inner ankle bone) is always higher and further forward than the lateral malleolus.

An exercise on drawing the foot
Page 111:
You can build up the structure of the arch of the foot from the longitudinal and transverse curves, but the following simplifying process is also recommended:

1 Create foot shapes from prismatic structures (top).

2 Flatten off the top of the wedge back on the heel bone (second illustration from top) and round off the front of the foot around the little toe.

3 Add the longitudinal curves to this initial shape and build up the semi-cylinder of the ankle bone (third illustration from top).

4 Mark the sharp top point of the transverse curve near the ankle bone in the completed shape.

5 Indicate the different inclines of the feet by means of cross-sections – vertical on the heel-bone exterior, steep diagonals at the ankle bone, flatter inclines towards the outer edge of the foot, etc. – up to the end of the metatarsals (bottom illustration).

All the factors mentioned here will produce a lifelike drawing.

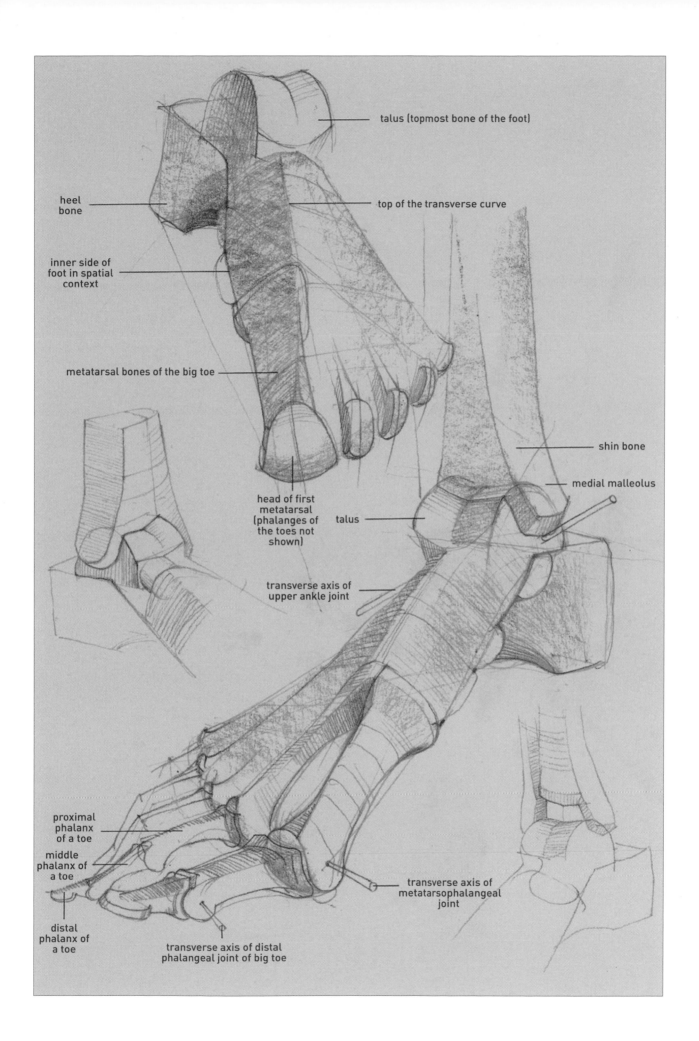

talus (topmost bone of the foot)

heel bone

top of the transverse curve

inner side of foot in spatial context

metatarsal bones of the big toe

shin bone

medial malleolus

head of first metatarsal (phalanges of the toes not shown)

talus

transverse axis of upper ankle joint

proximal phalanx of a toe

middle phalanx of a toe

distal phalanx of a toe

transverse axis of distal phalangeal joint of big toe

transverse axis of metatarsophalangeal joint

Legs and Feet **109**

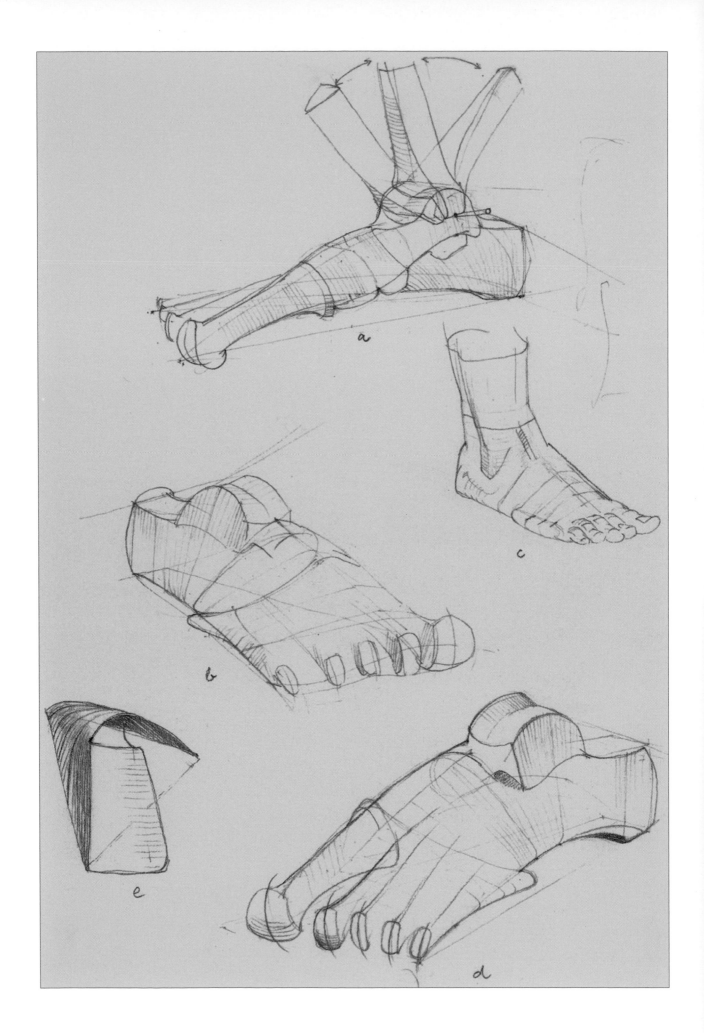

a

b

c

d

e

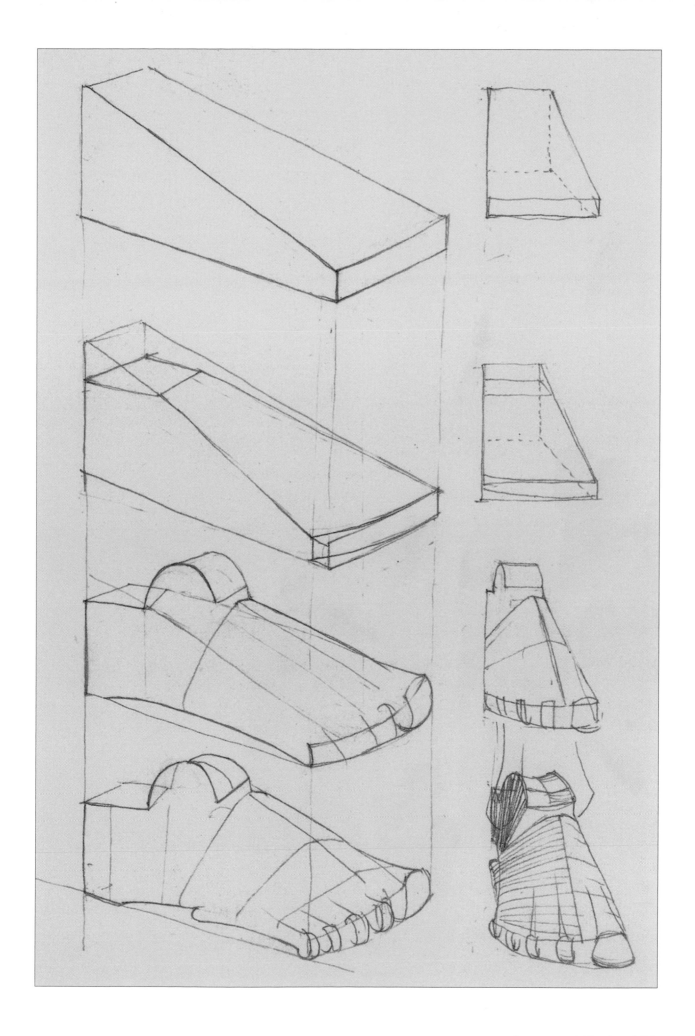

Raphael (1483–1520): Musician, undated.

EXERCISES IN DRAWING FEET

Page 113:
Further examination of the structure of the foot (see also pages 108–111).

Page 114:
The juxtaposition in the first stages as preparation for drawing the animate foot makes it easier to understand the stages:

• Start with the spatial ground plane of the three-point support, a; b and c are the basic presentations of the arching, which can be discerned from all further studies of the feet.

• You can move on from the clarifications in c to drawing the construction of the foot skeleton.

• The appearance of the animate foot can be derived directly from the principles we have established in c. The intermediate stages in the drawing of the skeleton will, however, create a more consistent resemblance to the living form.

• The ankle accents are clarified with e and f, which flank the top of the arch. It is absolutely essential to depict the inner edge of the foot within the context of the inner ankle and the plane derived from the inner shin bone (the tibia).

• The top of the instep (e) creates an intersection with the outer edge of the foot.

• You need to express the gradient angles of the inner and outer inclines of the foot arch.

• The toes need to be understood as the divided and articulated continuation of the metatarsal ends (see also page 109).

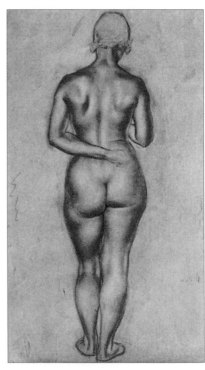

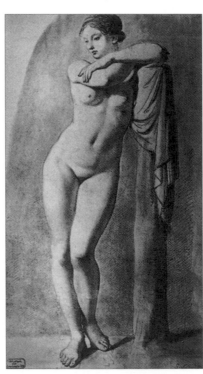

N. I. Altmann: Seated female nude, 1927.

Gottfried Schadow (1764–1850): Study of nude leaning on a pillar, undated.

V. V. Lebedev (1891–1967): Female nude from the rear, 1915.

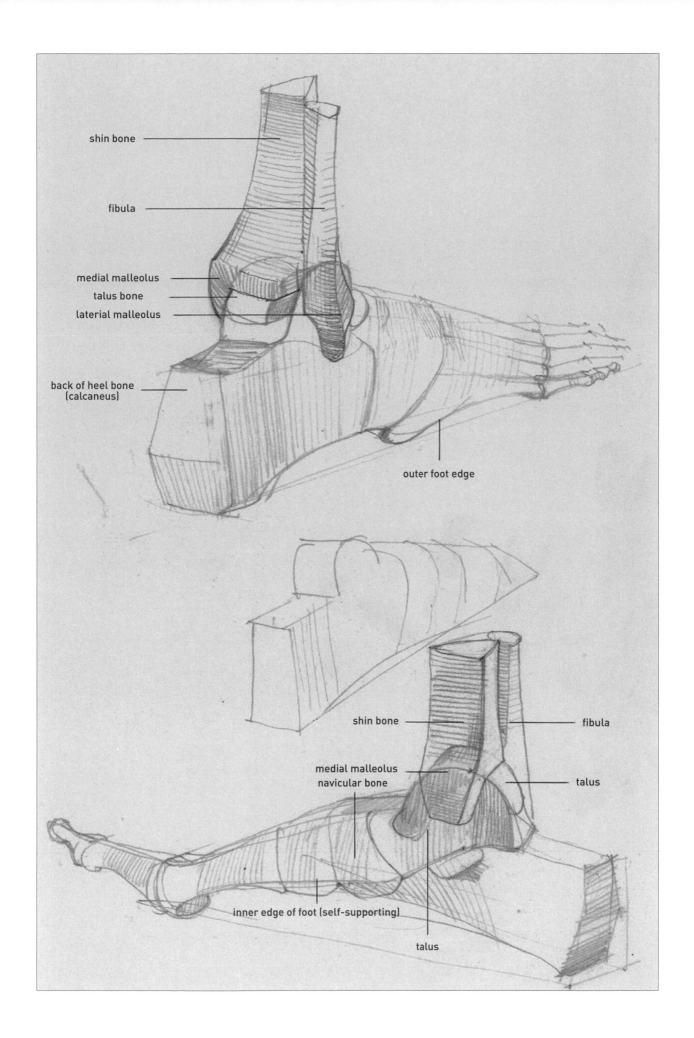

shin bone

fibula

medial malleolus

talus bone

laterial malleolus

back of heel bone
(calcaneus)

outer foot edge

shin bone

fibula

medial malleolus
navicular bone

talus

inner edge of foot (self-supporting)

talus

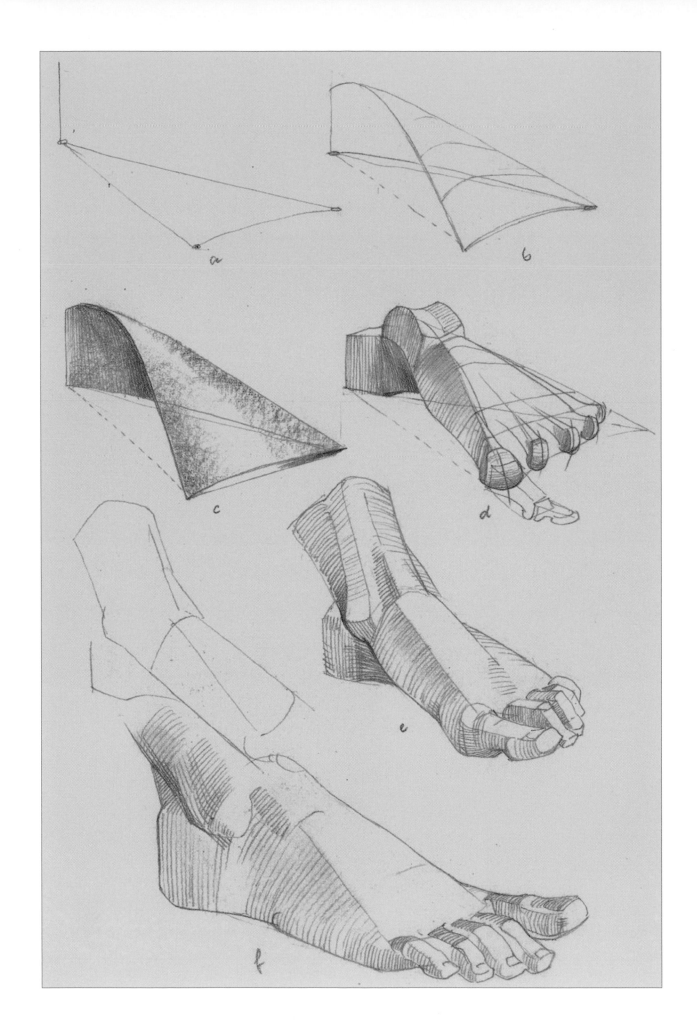

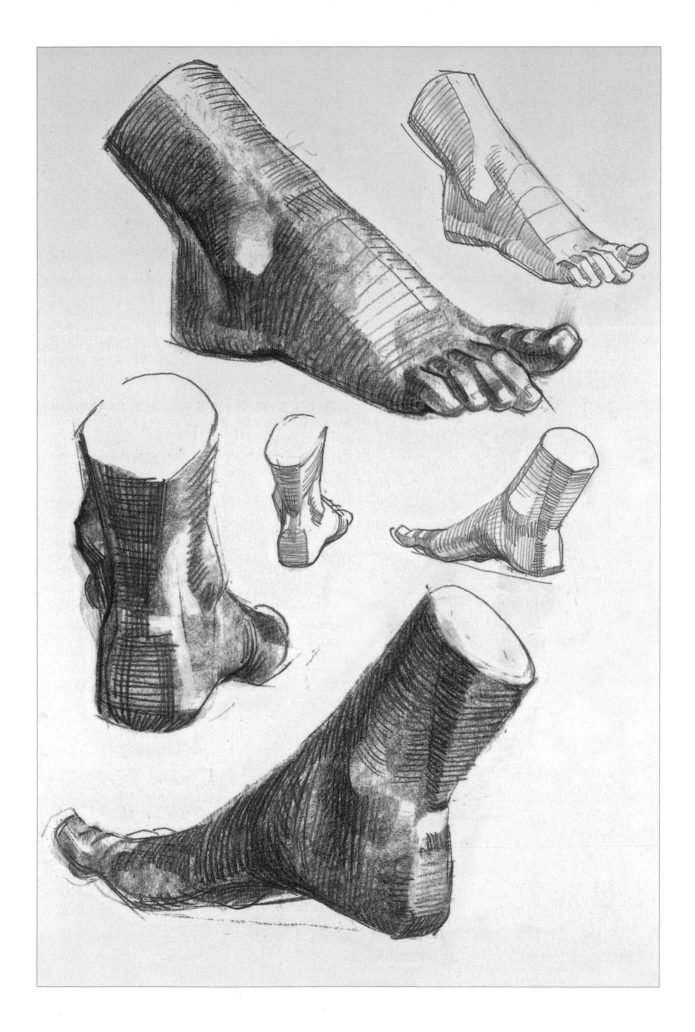

Daniel Chodowiecki (1726–1801):
Standing male nude, undated.

THE LEG AS A WHOLE WITH ITS MUSCLE GROUPS AND MASS

In order to provide more precise information about the positioning, origins, connections and functions of muscles, it has been necessary to exaggerate the illustrations in many ways. From a teaching viewpoint, the most significant functions of these illustrations are:

Front view, page 117:
• The muscles which are shown on the right-hand diagram as long fibres reveal their functions by their position in relation to the joint axes and their tensile direction (arrows).

• The individual muscles can be combined into groups that correspond loosely to the architectural form of the living body (left-hand diagram).

• The insertion of cross-sections shows the inclined planes of the mass and clarifies the disposition of the shapes.

Rear view, page 118:
• The central drawing shows the shape and angles of the leg skeleton as a guide to the mass of muscle overlay.

• The left-hand diagram shows how the leg is shaped by individual muscles.

• The right-hand diagram shows the actual appearance (with cross-sections drawn in).

Profile view, page 119:
• The right-hand drawing shows the muscles as long fibres with the tensile direction indicated (arrows), from which one can deduce their functions in relation to the joint axes.

• The left-hand diagram shows how the leg is shaped by individual muscles.

• The cross-sections drawn in make it clear how the masses counterbalance each other in space and so set up sculptural interactions between them.

• The profile view here is particularly expressive because of the functionally configured masses, which create the dynamic and rhythmic form in contrast to the statically defined character of the frontal and rear views, which show the leg as a conical pillar.

Georg Kolbe (1877–1947): Kneeling female nude, undated.

Franz Man (1880–1916): Wood-carrier, undated.

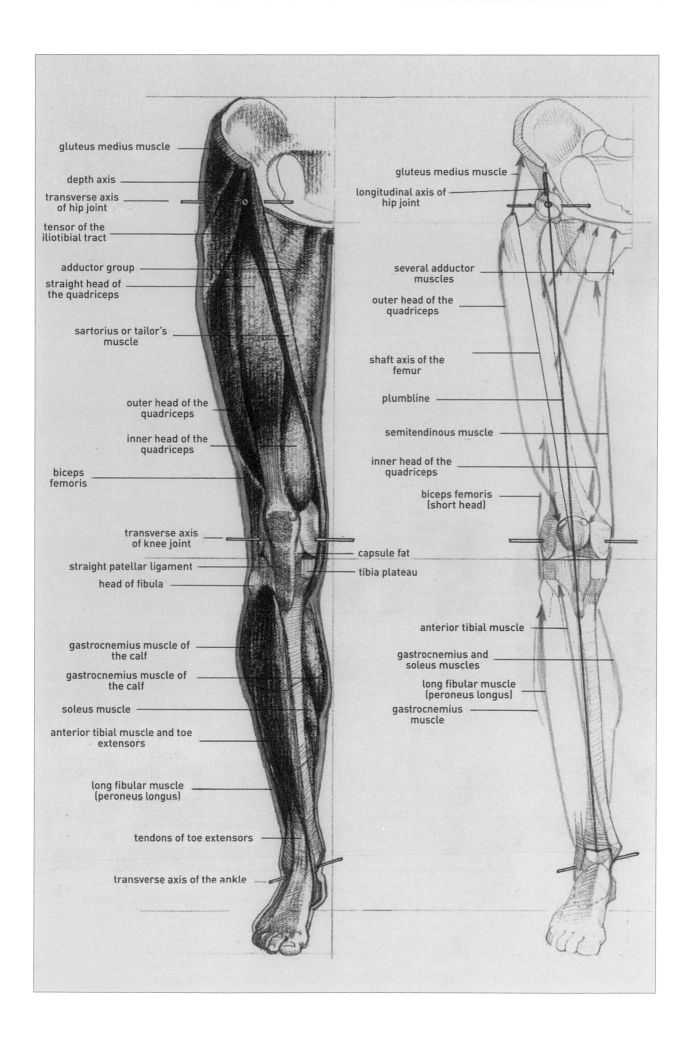

gluteus medius muscle

depth axis

transverse axis
of hip joint

tensor of the
iliotibial tract

adductor group

straight head of
the quadriceps

sartorius or tailor's
muscle

outer head of the
quadriceps

inner head of the
quadriceps

biceps
femoris

transverse axis
of knee joint

straight patellar ligament

head of fibula

gastrocnemius muscle of
the calf

gastrocnemius muscle of
the calf

soleus muscle

anterior tibial muscle and toe
extensors

long fibular muscle
(peroneus longus)

tendons of toe extensors

transverse axis of the ankle

gluteus medius muscle

longitudinal axis of
hip joint

several adductor
muscles

outer head of the
quadriceps

shaft axis of the
femur

plumbline

semitendinous muscle

inner head of the
quadriceps

biceps femoris
(short head)

capsule fat

tibia plateau

anterior tibial muscle

gastrocnemius and
soleus muscles

long fibular muscle
(peroneus longus)

gastrocnemius
muscle

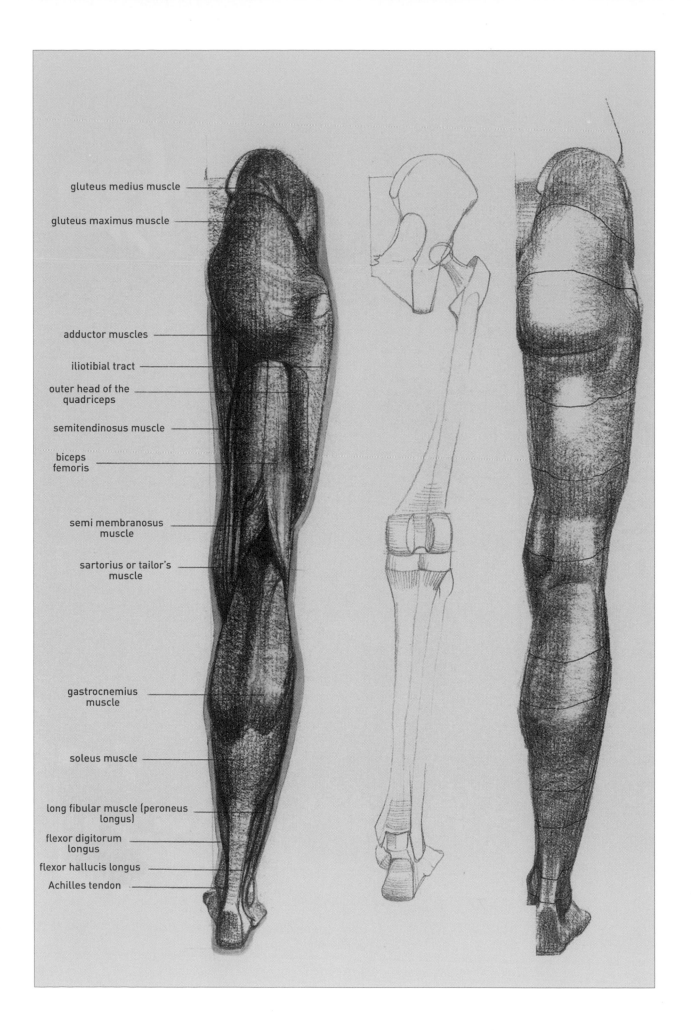

gluteus medius muscle

gluteus maximus muscle

adductor muscles

iliotibial tract

outer head of the
quadriceps

semitendinosus muscle

biceps
femoris

semi membranosus
muscle

sartorius or tailor's
muscle

gastrocnemius
muscle

soleus muscle

long fibular muscle (peroneus
longus)

flexor digitorum
longus

flexor hallucis longus

Achilles tendon

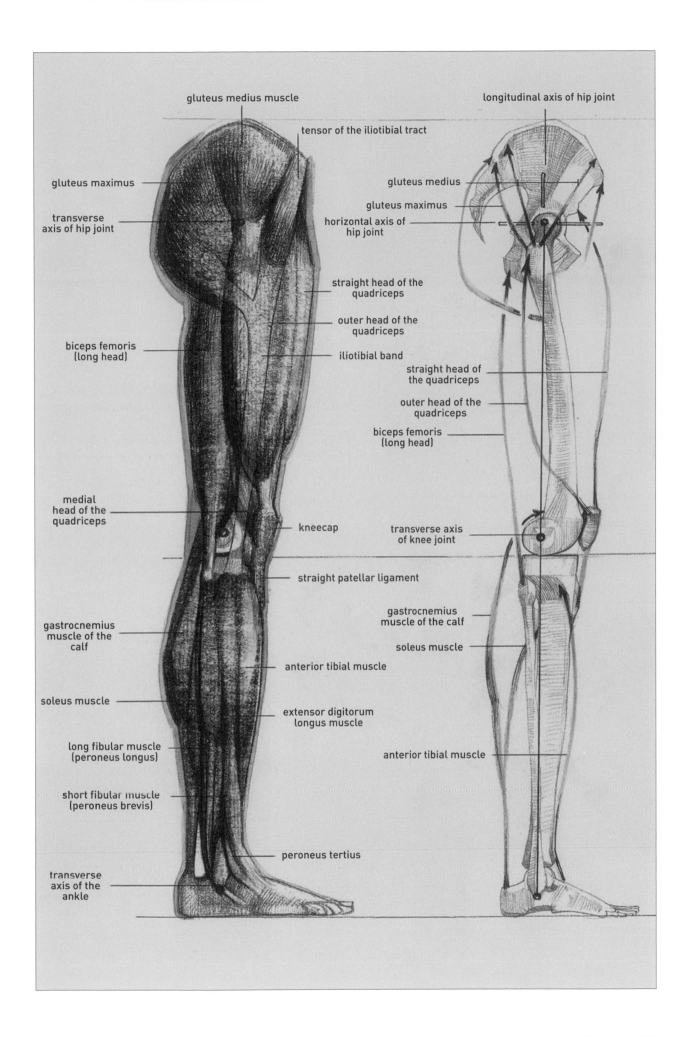

gluteus medius muscle

tensor of the iliotibial tract

longitudinal axis of hip joint

gluteus maximus

gluteus medius

gluteus maximus

transverse axis of hip joint

horizontal axis of hip joint

straight head of the quadriceps

outer head of the quadriceps

biceps femoris (long head)

iliotibial band

straight head of the quadriceps

outer head of the quadriceps

biceps femoris (long head)

medial head of the quadriceps

kneecap

transverse axis of knee joint

straight patellar ligament

gastrocnemius muscle of the calf

gastrocnemius muscle of the calf

soleus muscle

anterior tibial muscle

soleus muscle

extensor digitorum longus muscle

long fibular muscle (peroneus longus)

short fibular muscle (peroneus brevis)

anterior tibial muscle

peroneus tertius

transverse axis of the ankle

Legs and Feet **119**

William-Adolphe Bourguereau (1825–1905): Female nude in contrapposto, frontal view, supported by right hand.

EXERCISES FOR STUDIES OF THE LEG

Page 121:
• Visit a dance school and draw the figures according to the models and from your visual memory.

• Highlight the rhythm of the moving leg with brush strokes and pen details.

Pages 122 and 123:
• Start by giving the legs clear angles, simplified sections and clear directions (top). Only then should you attempt further refinement (bottom).

Pages 124 and 125:
• Tirelessly practise the simplest shapes – the stretched leg is a column, while the bent leg is a broken column. What kinds of cylinder shapes arise from this?

• Constantly try out the views and foreshortening which the leg cylinders provide.

• Do not neglect intersections as a factor in the creation of space.

Pages 125 and 126:
• Always try to express whether the leg is carrying a weight and what it has to bear in the process. Try out on yourself what the model literally has to bear. Find out what the free leg experiences.

• When drawing both legs, do not ignore the mutual spatial relationship. Check in this respect the shared standing planes formed by both soles of the feet.

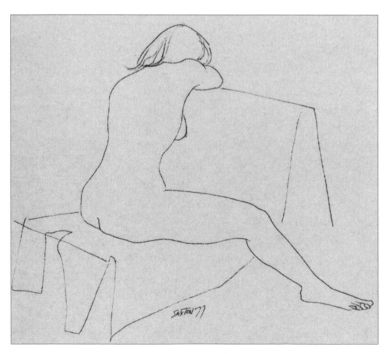

Saxton: Seated sideways, with legs spread out, 1971.

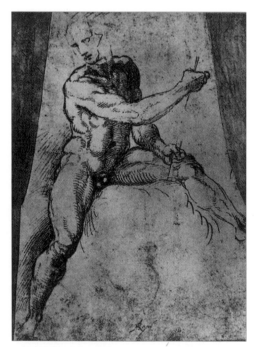

Raphael (1483–1520): Male nude study for the Faresina frescoes.

120 Legs and Feet

Page 127:

• Try your hardest to understand particularly complicated spatial situations, such as foreshortening, by simplifying down to the geometrical shapes (top).

• Always strive for constructive rather than illustrative drawing.

• Relaxed, apparently effortless work will come of its own accord (bottom).

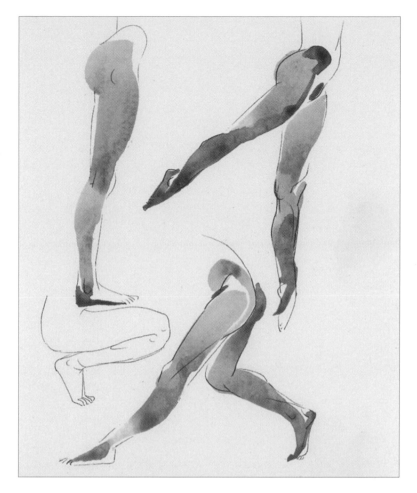

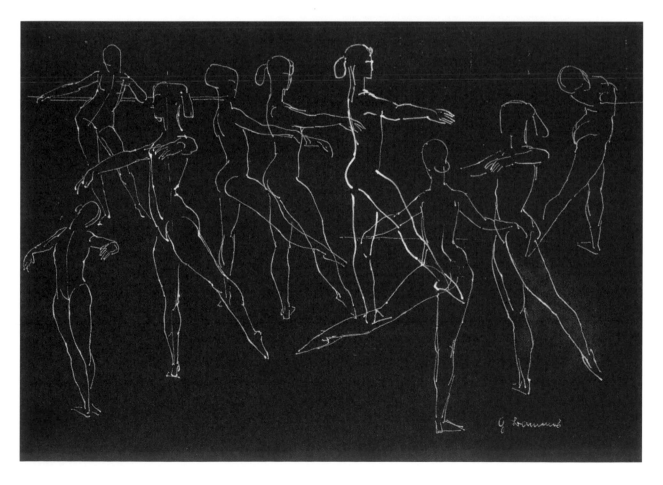

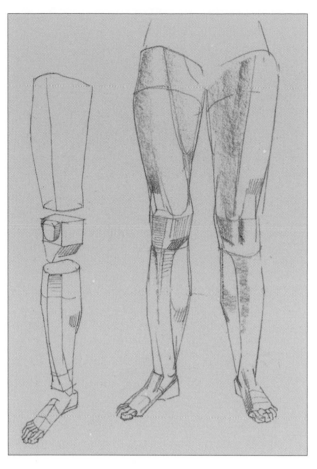

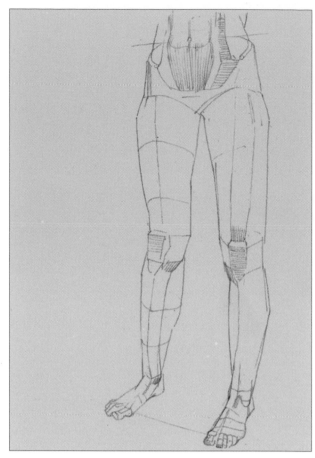

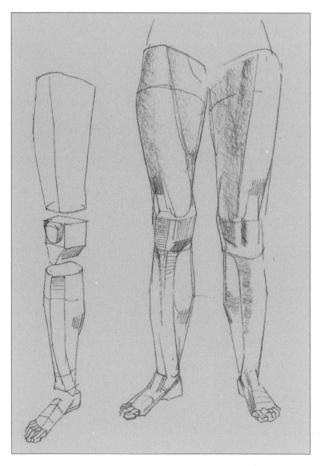

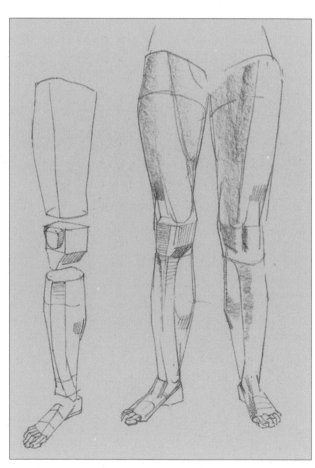

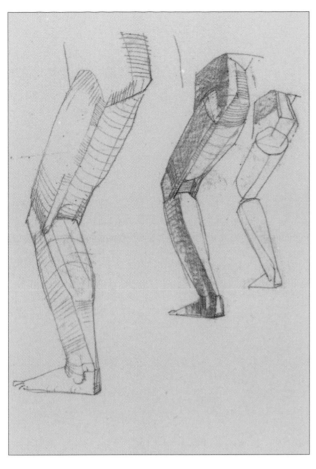

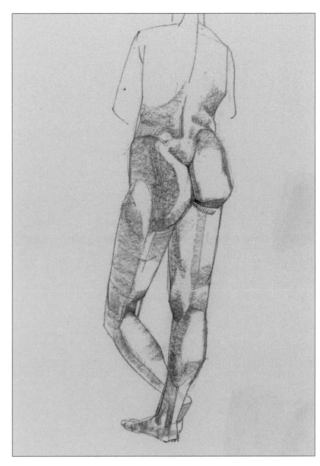

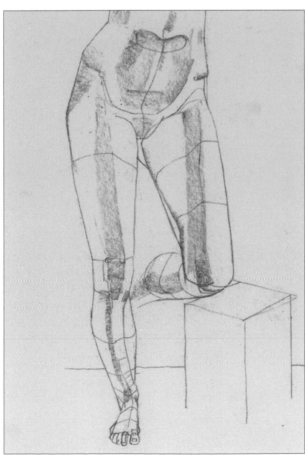

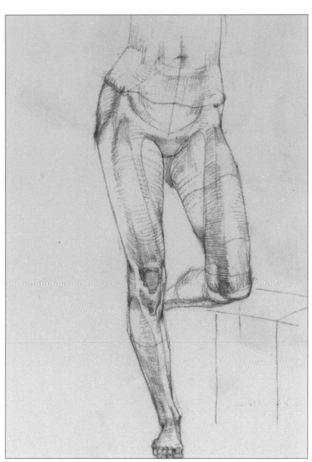

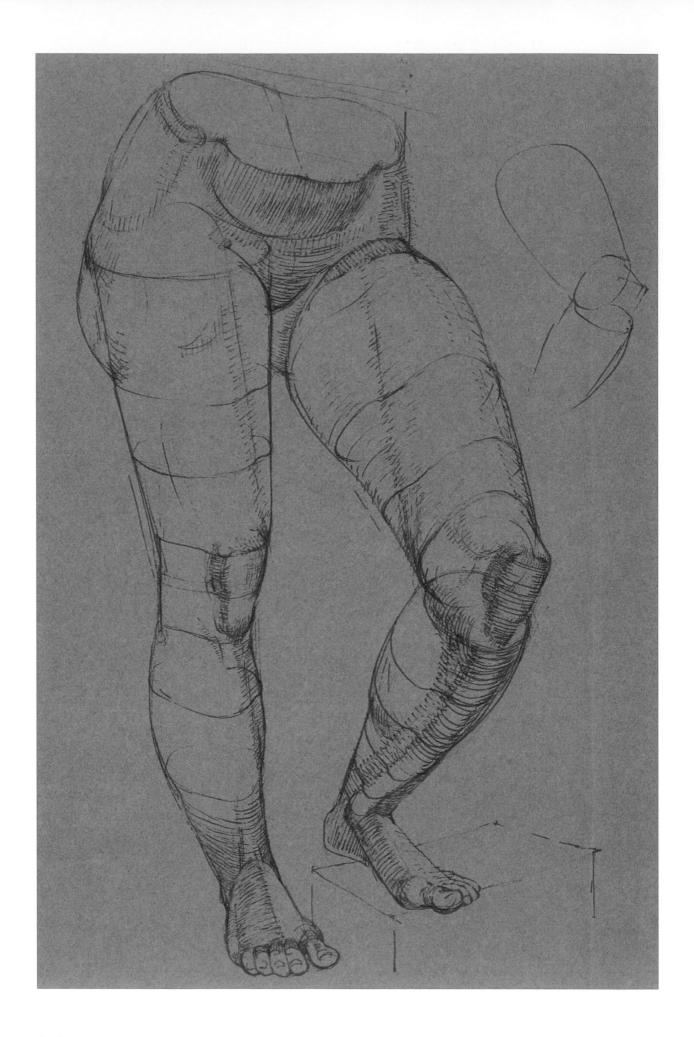

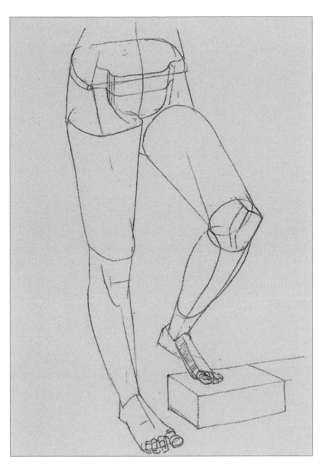

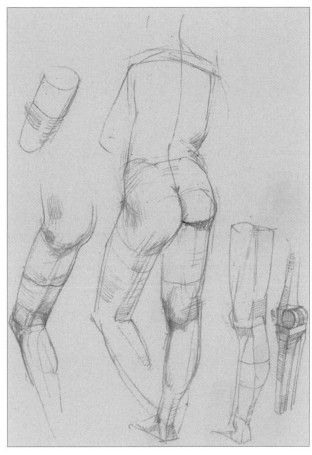

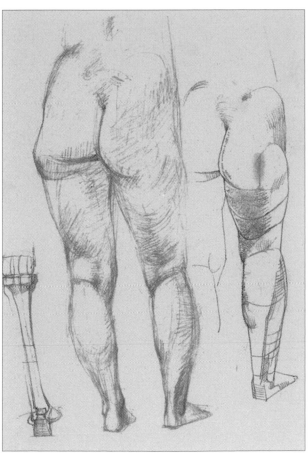

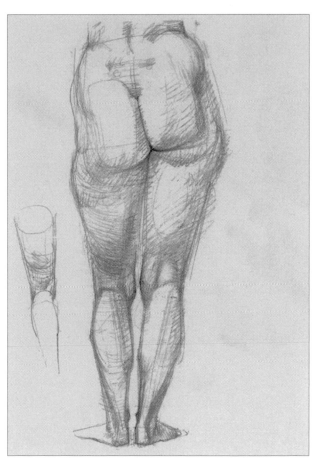

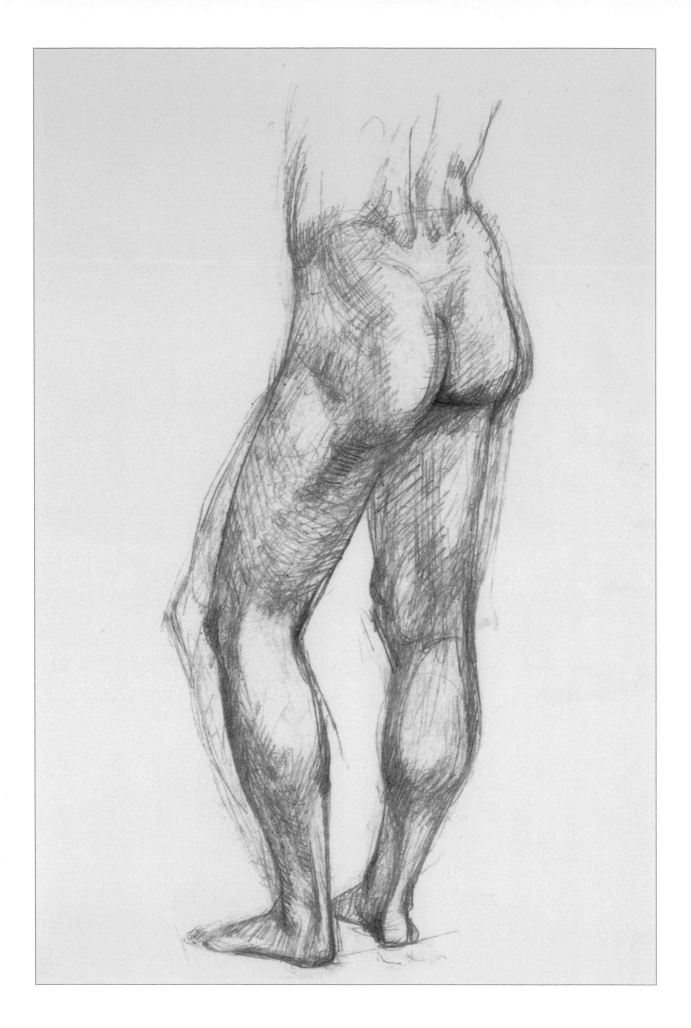

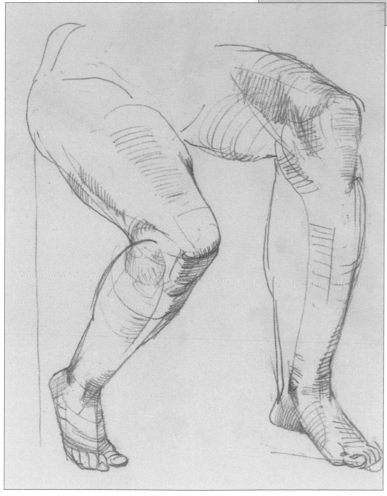

Torso and Shoulder Girdle

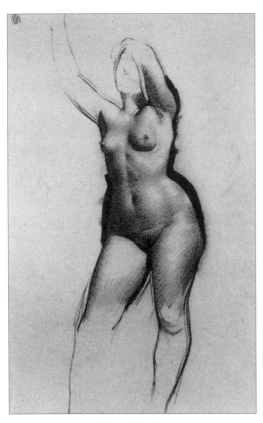

Karl Stauffer-Bern (1857–1891): Torso of standing female nude, undated.

FROM THE BASIC SKELETAL SHAPE TO THE DEVELOPED FORM

The shoulder girdle serves as the dynamic base of the arm.

Pages 129–130:
The shapes, simplified for teaching purposes, derive from elementary facts:

• The rib cage and pelvis are three-dimensional ovoid cores, which close off the torso at the top and base.

• Both dome shapes are attached by a flexible connection via the spinal column and assume a bending stance towards each other, which is of great significance for understanding drawing from life.

Page 130:
• The top row shows a step-by-step modulation of the simplified basic shape (front view) of the block-like closed shape to the hollow vessel of the rib cage and pelvis.

• The bottom row shows the same development for the rear view.

• In the centre is an additional drawing of the rib cage seen from above.

The red arrows point to accentuated forms and to significant points of the structure.

Page 131:
• The top row shows a step-by-step variation of the basic form of the profile view, and a three-dimensional view from half front.

Angled views show the important formal characteristics of the body more clearly than full-front or back views.

• The drawing at bottom left is a depiction of a flattened front rib cage as a complex synthesis of the sternum and rib cartilage, bordered by a curved facet which swings out sideways and downwards; the curve of the rib cage into the deep dimension starts here.

• The drawing at bottom centre shows the spatial opening out of the front part of the pelvis, which emphasises the closed nature of the pelvic ring at the front with the freely positioned pubic bone (centre-front of the pelvis).

• The drawing at bottom right shows the back of the rib cage with a flat scallop to each side of the spinal column.

The red arrows on pages 130 and 131 highlight significant forms. In order to understand all the functional processes in the nude figure, we must view the body's three-dimensional core as the centre of the form.

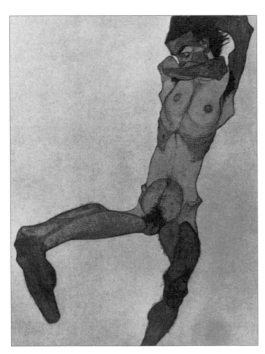

Egon Schiele (1890–1918): Seated male nude, 1910.

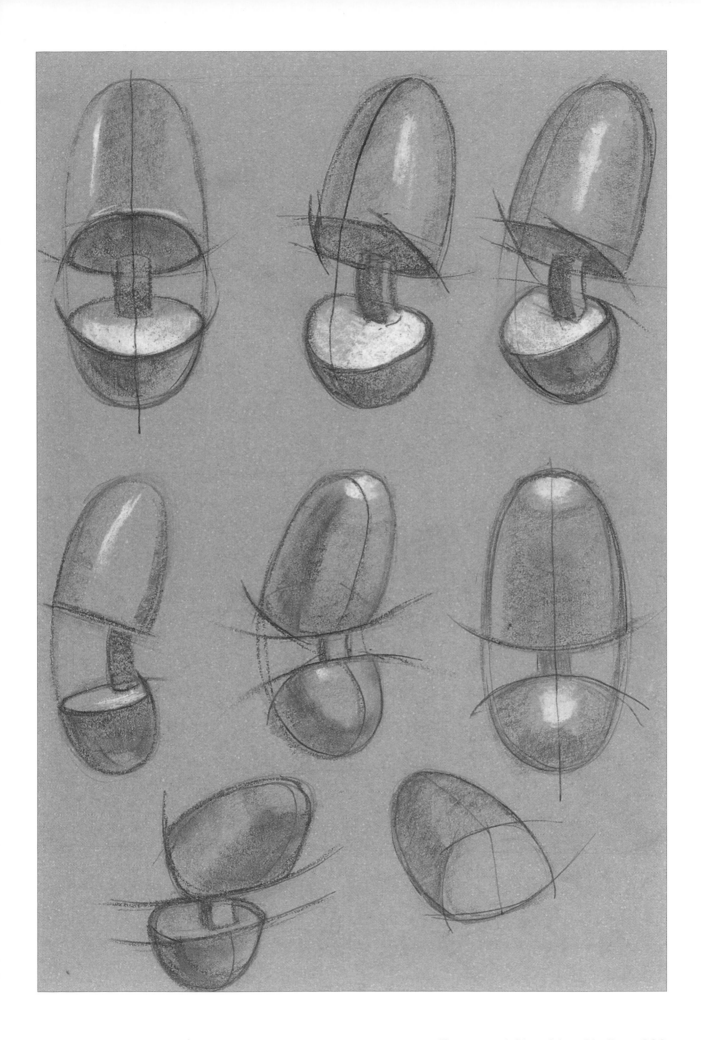

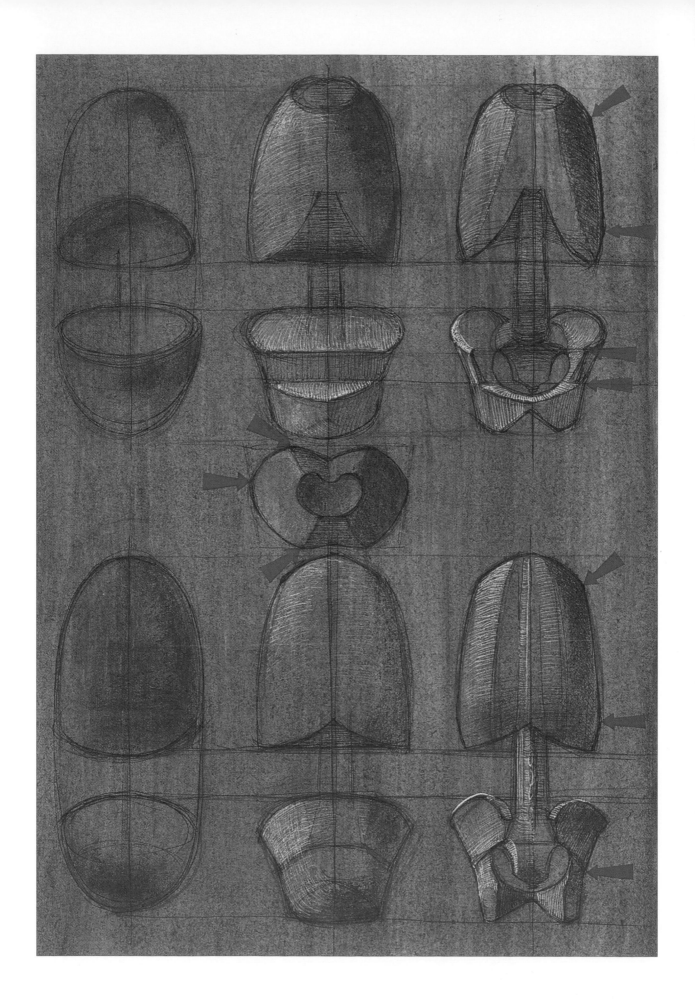

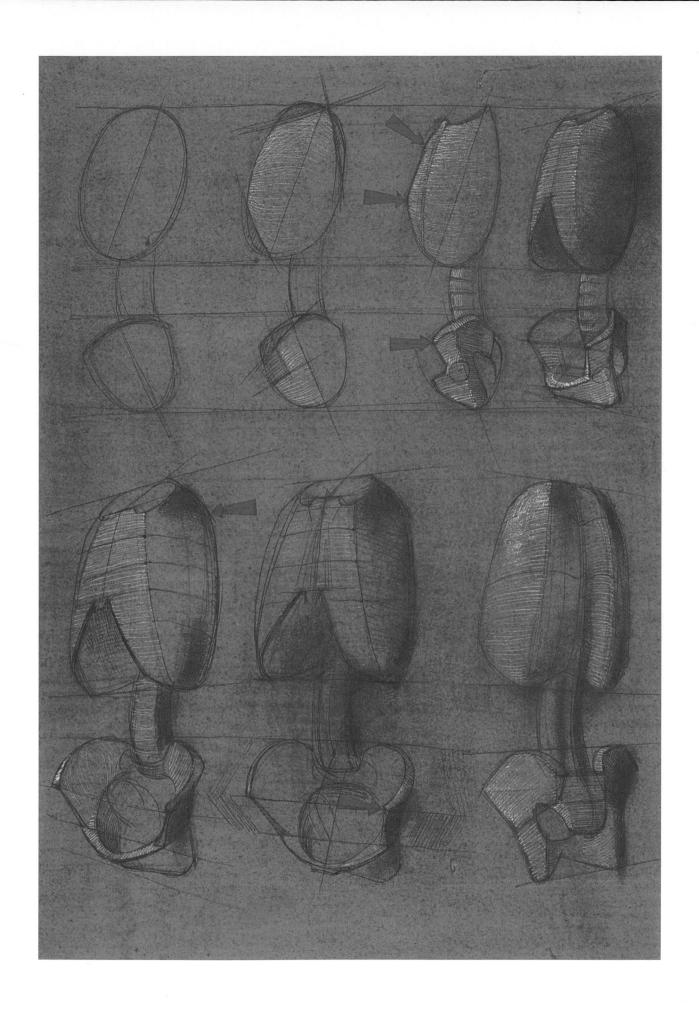

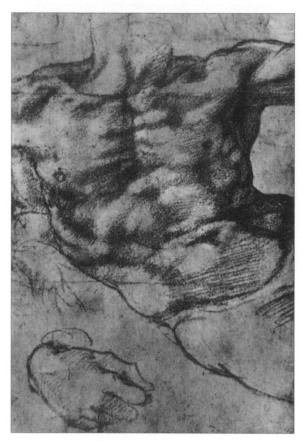

Michelangelo Buonarroti (1475–1564): Detailed study of Adam's rib cage for the ceiling frescoe in the Sistine Chapel, which was painted in 1508 to 1512.

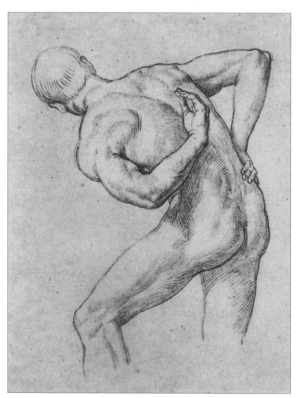

Helmut Heinze (b. 1932): Torso of young male, undated.

EXERCISES ON DRAWING THE SKELETON OF THE TORSO

In order to project the skeletal shape successfully into the torso of the live body, I recommend modelling a rib cage following the stages shown on pages 129 to 131.

Page 133:
• Practise drawing the basic form of the rib cage from various angles, foreshortening as necessary.

• Clarify the relationships between the angles that determine the spatial axes. Draw these first!

• Clearly set out the basic spatial condition (position of the body in space) by first reducing the rib cage to a geometrical body, because the planes of view can then be depicted with much greater accuracy.

Page 134:
• Make the effort to draw imaginary views of the skeleton of the torso from various angles and foreshortened in different ways, based on the views of the pelvis (see pages 96 and 97) and the rib cage.

• Do not worry about the accuracy of the anatomical details. This is in the first place about creating spatial and functional sense.

• Also pay attention to the most fundamental aspects of the shapes.

Page 135:
If at all possible, studies should be drawn from an available skeleton or model:

• Concentrate on the three-dimensional form of the skeleton, preferably with broad drawing material such as chalk or charcoal, by emphasising the sloping planes and hence the views.

• In particular, be sure to show the corresponding spatial points on the two sides of the pelvis; the best way is to compare them with lines of axis.

• Show the sloping scallops of the three-dimensionally significant ilium wings on the funnel-shaped pelvis.

• Depict the spatial properties of the hollowed-out front of the pelvis very concisely because the forward and backward movements of the stomach and its fixed pivotal points are determined here.

• Try to draw in the simple shapes of the skeleton in studies from a live model and so account for the spatial relationships of the abdomen. Be sure to treat these, like the chest muscles, as additional layered masses.

Constructive drawing from the inside to the outside increases our understanding.

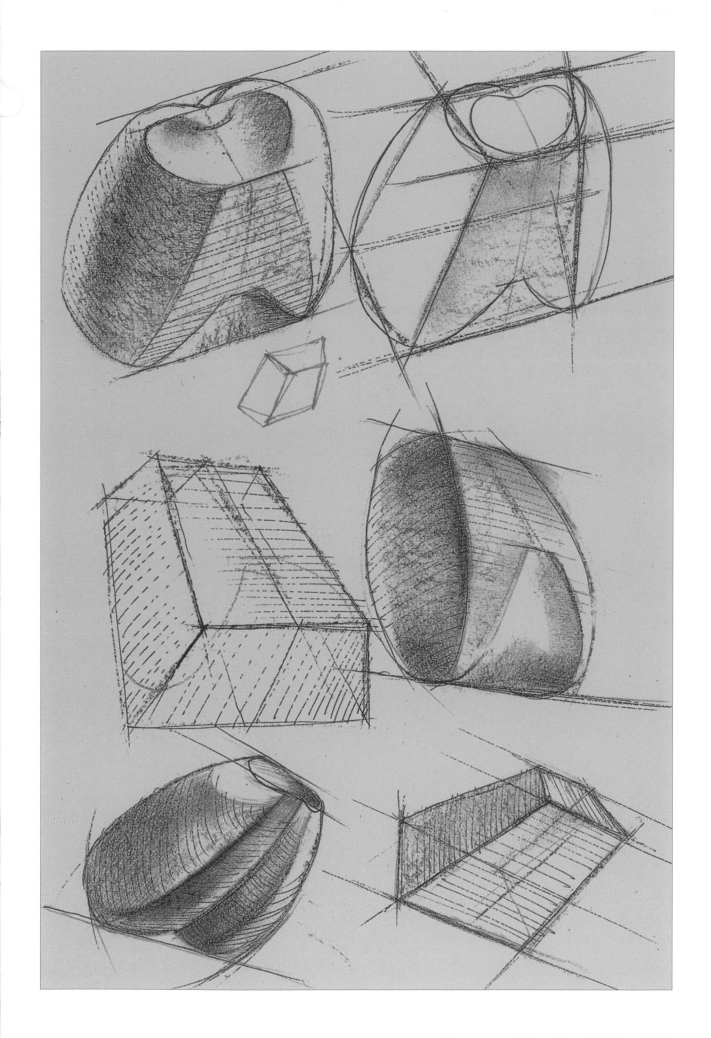

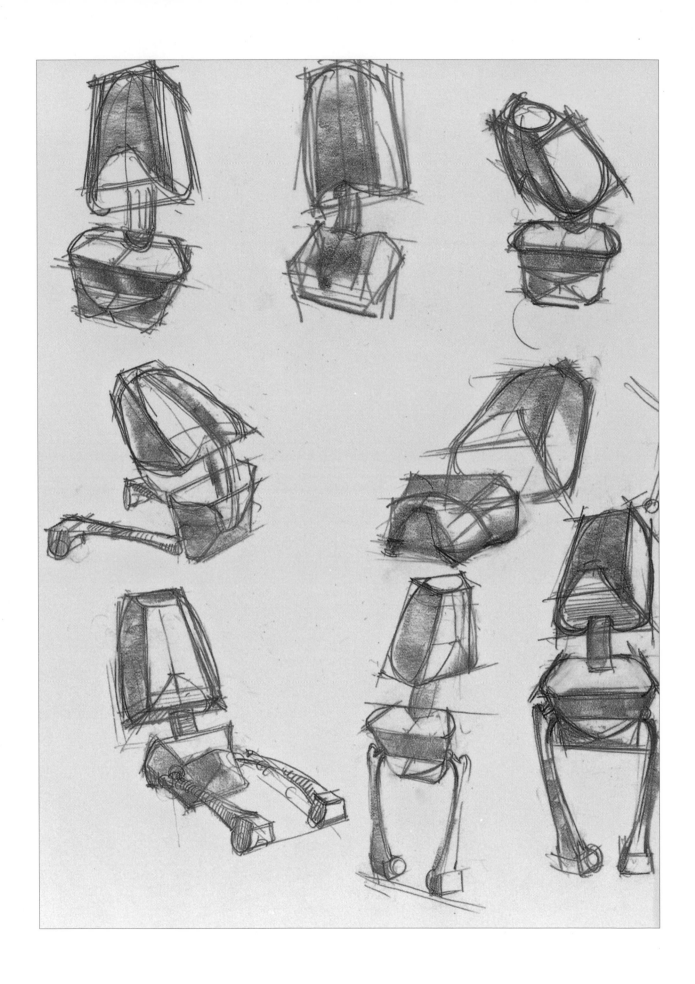

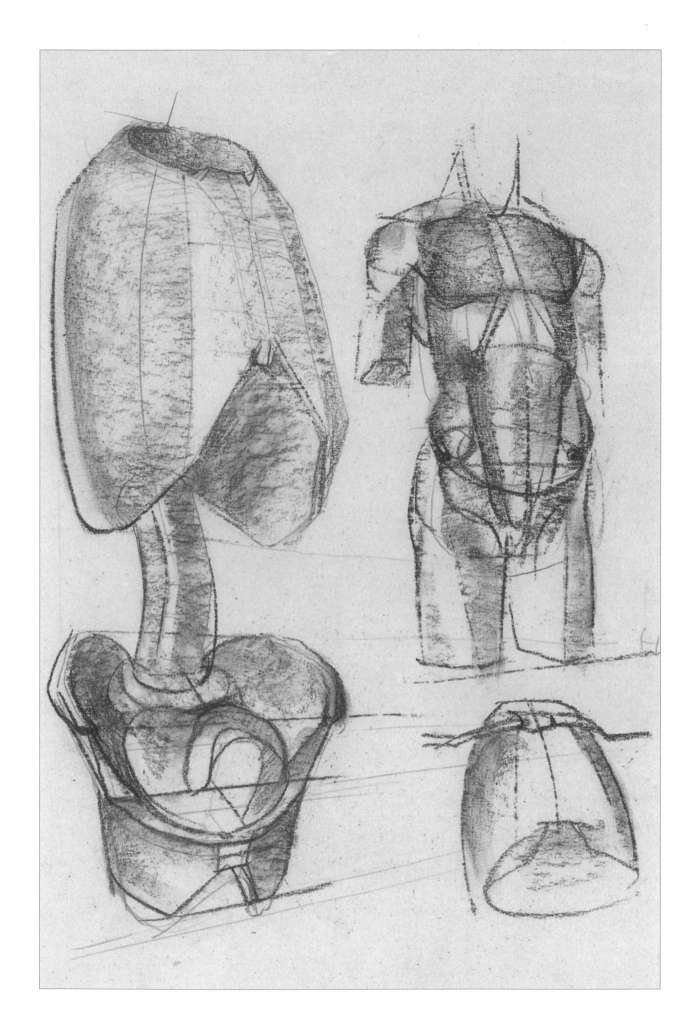

SHOULDER GIRDLE AND RIB CAGE

The shoulder girdle consists of the shoulder blade (scapula) and the collarbone (clavicle), which are articulated above the shoulder joint and so constitute the crest of the shoulder. The only bone connection to the rib cage consists of the articulation (internal clavicular joint) of the clavicle at the manubrium sterni (broad upper part of the sternum). The shoulder girdle as a whole is open at the back and provides a dynamic base for the freely swinging arm. What do these illustrations tell us?

Page 137:
• On the left we see the resting position of the shoulder blade or scapula on the rib cage and its connection to the collarbone within the shoulder crest.

• The diagram top right shows the swinging movement of the left shoulder blade, which causes the glenoid cavity (where the end of the scapula meets the humerus in the arm) to face upwards.

• The diagram centre right shows what happens when the shoulder blades are pulled apart horizontally.

• The diagram bottom right shows the opposite, when the shoulder blades are pulled together horizontally.

• The contours emphasised in black correspond to the three-dimensional processes which always feature on the model.

Page 138:
• The half-front view, a, from slightly below, shows the S-shaped swing of the clavicle, its connection to the shoulder blade and to the sternum at the front of the rib cage (see also b), as well as the flattening of the frontal plane of the rib cage in the complex of sternum plus rib cartilage.

• The cross-sections drawn in the rib cage characterise the spatially inclined planes.

• In c we can see the shoulder girdle being pulled up from the resting position, which causes the clavicle to move up at the shoulder-blade area; d gives a schematic view of this motion with the pivot point in the inner clavicular joint.

• We can compare the shape of the shoulder girdle to a Baroque façade constructed over the body of the rib cage (lines are emphasised in black in e, with a view downwards from top back).

Page 139:
The drawings on page 139 show the skeleton of the torso, including the shoulder girdle, from various angles and in various positions.

• Observe the relationships between the views, emphasised by the axial lines that have been added.

• Notice the internal relationships between the three-dimensional cores.

Spatial and axial progression, and skilled representations of skeletal sections, make the three-dimensional relationships between the muscles and the skin easier to understand.

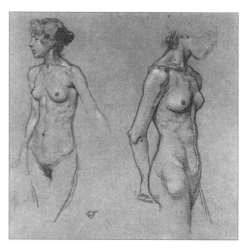

Johann Friedrich Matthäi (1777–1845): Male half nude, undated.

Wilhelm Volz (1855–1901): Nude study of a girl (upper body), undated.

Franz Stuck (1863–1928): Seated male nude with a fully bowed upper body, undated.

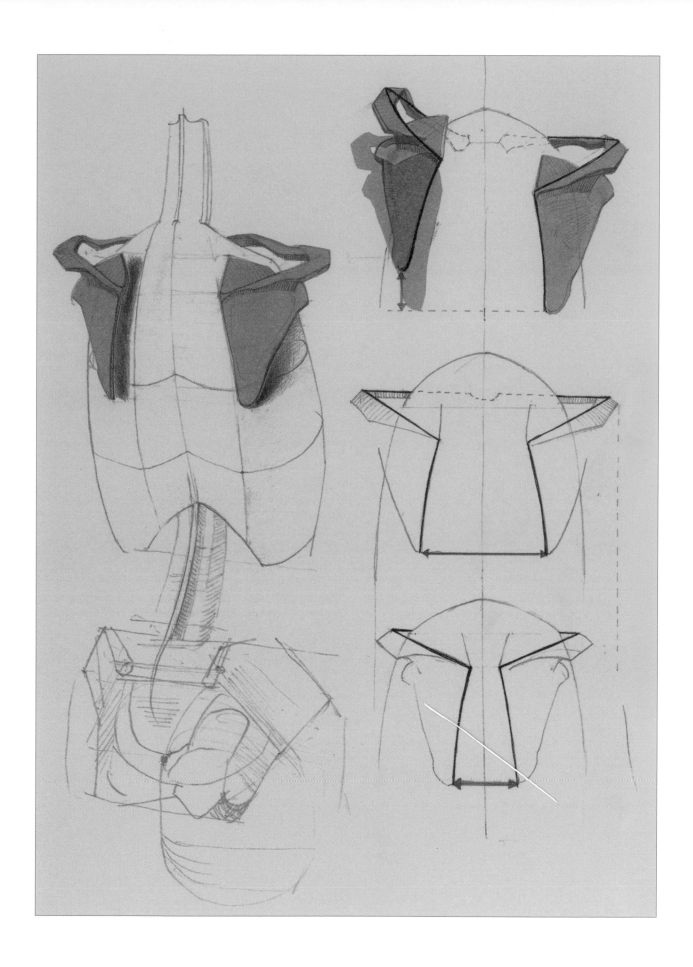

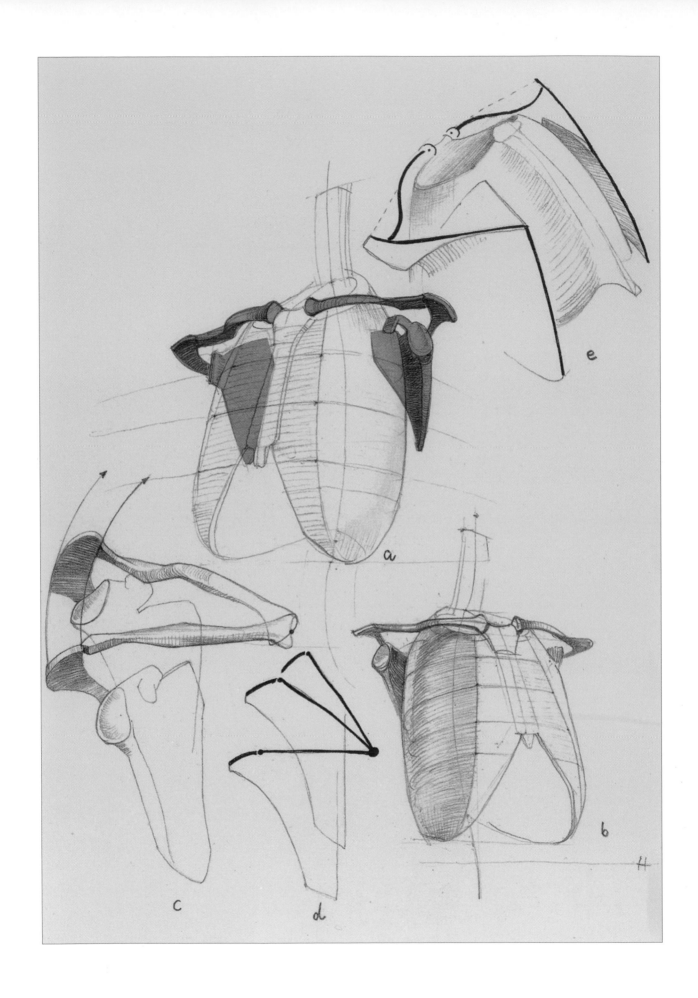

a

b

c

d

e

Ferdinand Jagemann (1780–1820): Seated youth, undated.

THE TORSO MUSCLES

The torso muscles are those muscles whose job it is to close up the gaps between the rib cage and the pelvis and to position these two in relation to each other by moving the spinal column. They are flat, broad muscle tissue, which produce major three-dimensional changes because of the way they operate (see page 145).

The three most important muscles in the torso are:
• The rectus abdominis or abdominal muscles (originating at the pubic bone and inserted into the rib cage at the point of the sternum – the six pack). They help with posture, assist with breathing and protect and support the internal organs.

• Erector spinae or back muscles, the counterbalance to the abdominals (originating in the back of the pelvis and with attachments to the back of the ribs and the spinal column). These straighten the upper body, hence their Latin name.

• External oblique abdominal muscles (running from the end of the ilium (pelvis) to the tendinous fasciae of the straight abdominal muscle and with saw-tooth attachments to the sides of the eight lower ribs). Their main function is in lateral bending and rotation of the upper body.

The operation of the muscles depends on their orientation towards the sagittal plane (the axis which divides the body into left and right sides) of the spinal column. See also the illustration on page 103, which shows the basic presentation of these muscles and a cross-section of the spinal column).

The abdominal muscles:
• In men, the outer oblique abdominal muscle is folded over the edge of the ilium, and creates an interspinous line at the foremost point of the pelvis, the anterior superior iliac spine.

• A vertical fold (lateral fold) is created where it connects to the straight abdominal muscle, which curves further forwards.

• The sinewy depressed centre line or linea alba (white line) of the straight abdominal muscle (rectus abdominis) helps the artist to see how the symmetrical line of the sagittal body plane runs.

If one depicts the large chest muscles – the pectorals – that complete the frontal view, we obtain a foundation from which we can bring the upper body together into a rectangle (visually strengthened by an analogous shading which draws the flanks together).

Page 142:
This representation of the torso muscles in half-side frontal view shows:

• The origins and attachments of the abdominal and lateral muscles.

• The enclosing function of the muscles (keeping the organs of the body in position).

• Spatial gradation of the front-to-side abdominal wall (for this, also see the schematic view in the additional drawing).

Page 143:
This illustration reinforces this three-dimensional disposition of the abdominal wall and brings it into even greater prominence.

Ron Stenberg: Female standing nude with additional study, undated.

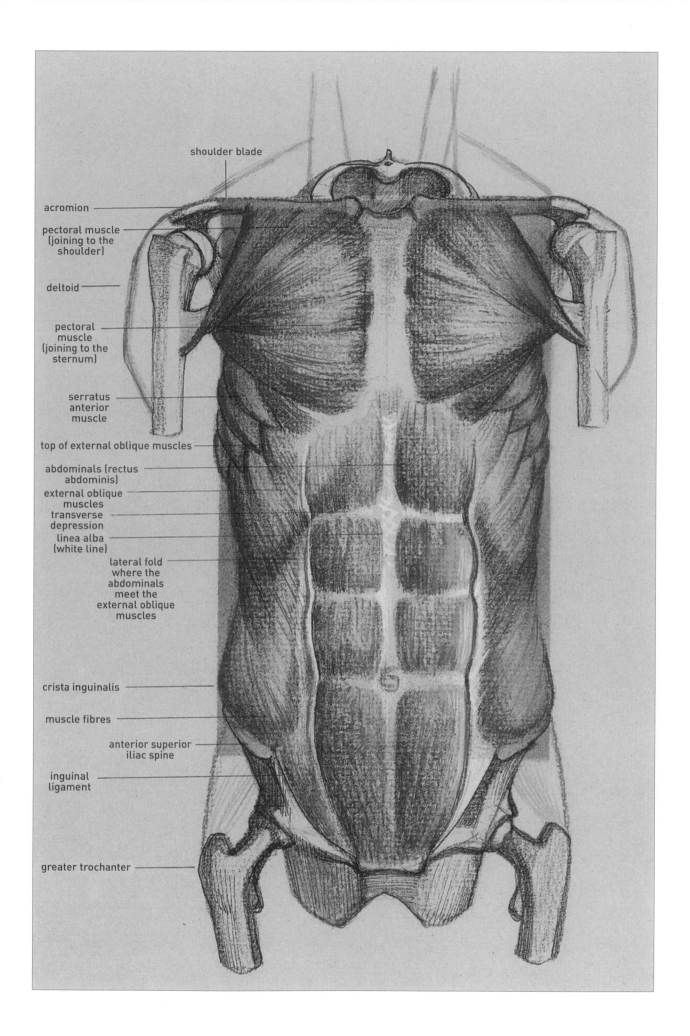

shoulder blade

acromion

pectoral muscle
(joining to the
shoulder)

deltoid

pectoral
muscle
(joining to the
sternum)

serratus
anterior
muscle

top of external oblique muscles

abdominals (rectus
abdominis)

external oblique
muscles
transverse
depression

linea alba
(white line)

lateral fold
where the
abdominals
meet the
external oblique
muscles

crista inguinalis

muscle fibres

anterior superior
iliac spine

inguinal
ligament

greater trochanter

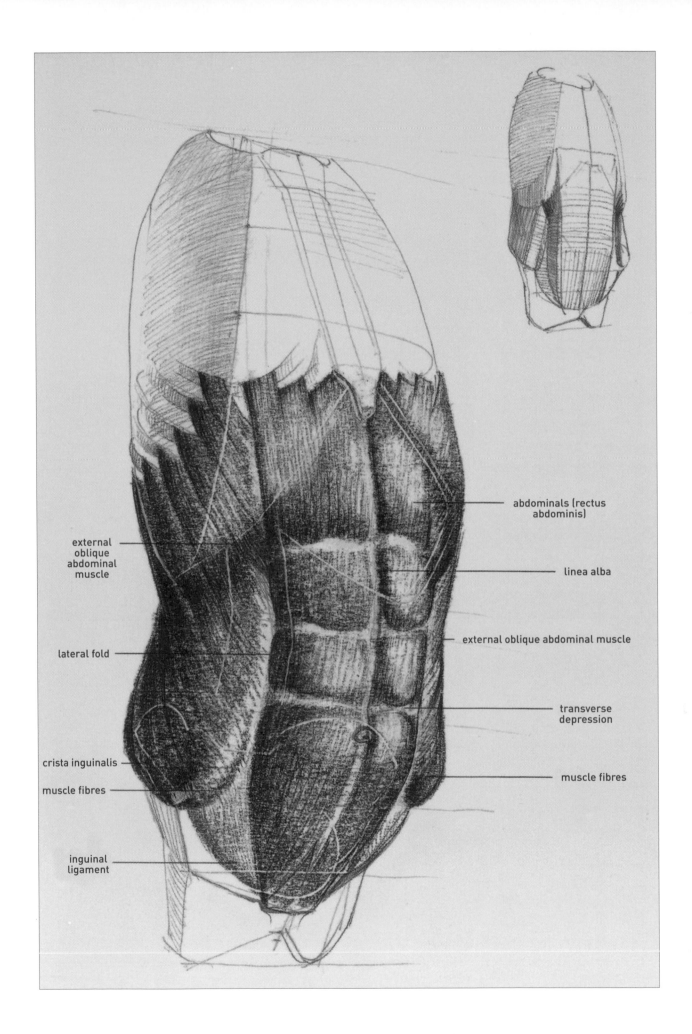

abdominals (rectus abdominis)

external oblique abdominal muscle

linea alba

external oblique abdominal muscle

lateral fold

transverse depression

crista inguinalis

muscle fibres

muscle fibres

inguinal ligament

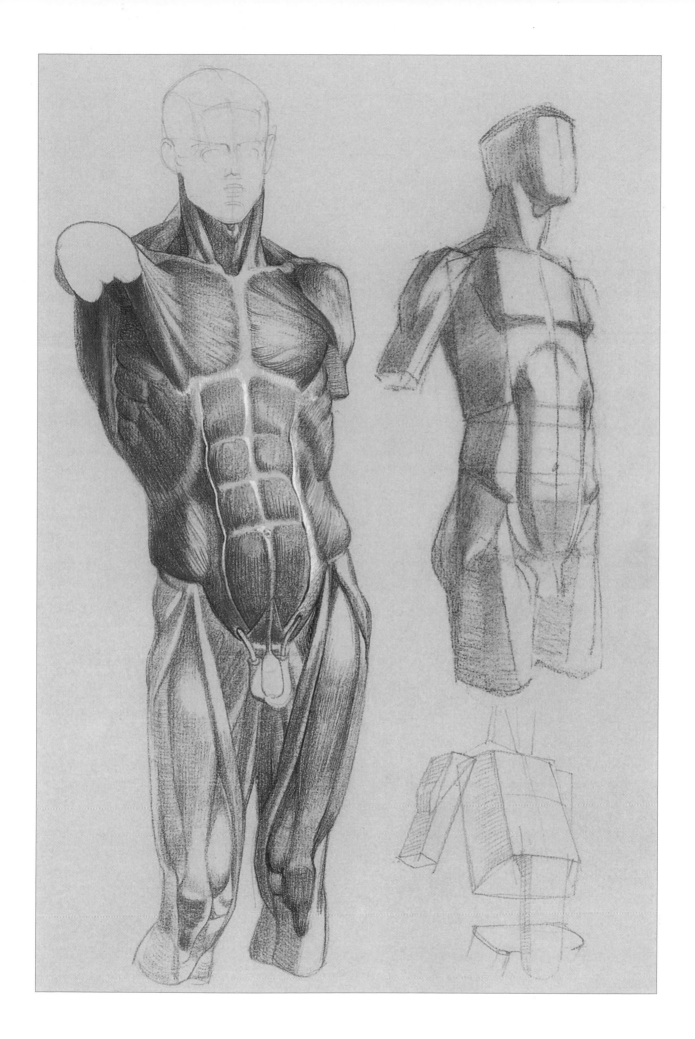

Paul Höfer: Seated woman in left profile with raised right arm, undated.

FUNCTION AND RELIEF FEATURES OF THE ABDOMEN

The illustration on page 145 shows simple forward and backward bending of the torso plus sideways and twisting movements. Notice the following:

• Compressions, which arise from surplus soft tissue, express themselves as an increased volume or as a crosswise fold across the direction of movement.

• Extended shapes lose volume and so make the skeletal form particularly prominent.

During movement, the muscles that bridge the gaps between the pelvis and the rib cage produce major changes in appearance:

• The rotation (torsion) of the rib cage over the pelvis results in a spiral-diagonal tensioning shown in diagrams a and b. See also page 152.

• The muscles situated behind their transverse axes (erector spinae muscle and the rear section of the external oblique abdominal muscle) flex the rear of the torso so that the front abdominal wall stretches as shown in c. See also pages 150, bottom left, and 151.

• The abdominal convergence between the pelvis and chest, when sitting bowed down, causes folds, compressing the front of the abdomen while the erector spinae (the long vertical muscles adjacent to and parallel with the spine) become stretched out, as shown in d. See also pages 150, bottom right and 152.

• Muscles with a lateral orientation to the depth axes of the spinal column cause the torso to bend sideways as shown in e. This creates compression of the external oblique abdominal muscles and contraction of the corresponding side of the common erector spinae muscle.

As well as the disposition of the muscles, the crossing arrows signify muscle compression, while the diverging arrows signify extension.

Adolphe la Lyre (1850–1935): Studies of woman stretching upwards, undated.

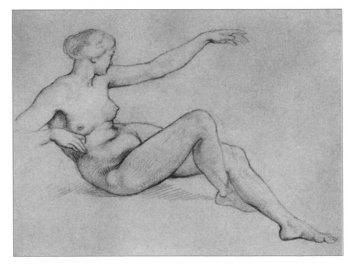

Friedrich Preller the Elder (1804–1878): Nude study for the Sirens, undated.

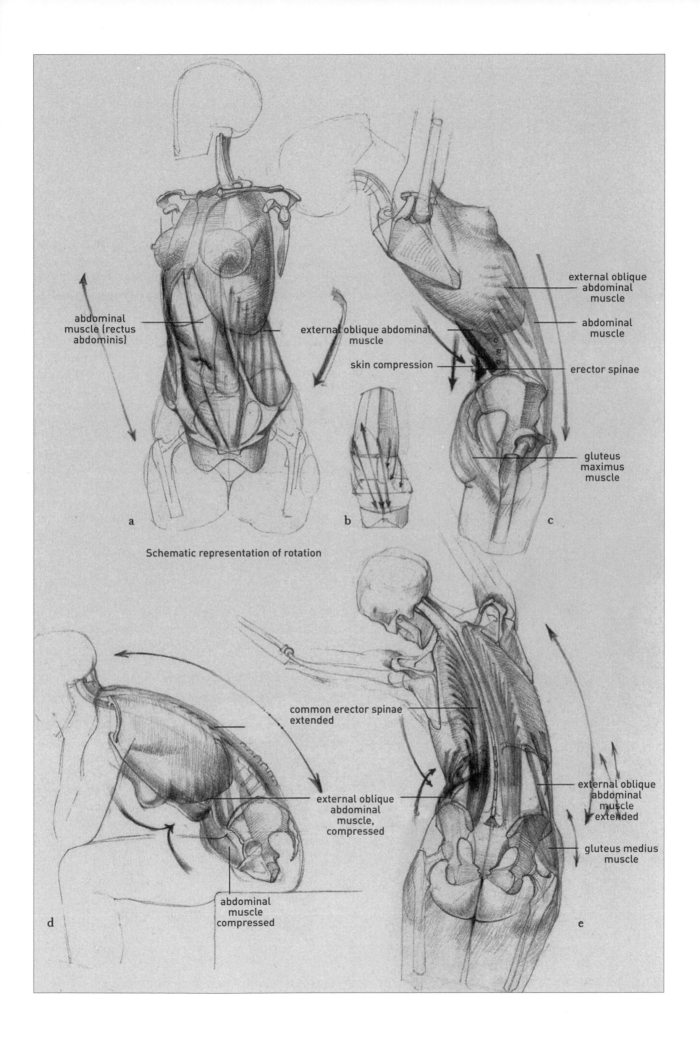

abdominal
muscle (rectus
abdominis)

external oblique abdominal
muscle

external oblique
abdominal
muscle

abdominal
muscle

skin compression

erector spinae

gluteus
maximus
muscle

a

b

c

Schematic representation of rotation

common erector spinae
extended

external oblique
abdominal
muscle,
compressed

external oblique
abdominal
muscle,
extended

gluteus medius
muscle

abdominal
muscle
compressed

d

e

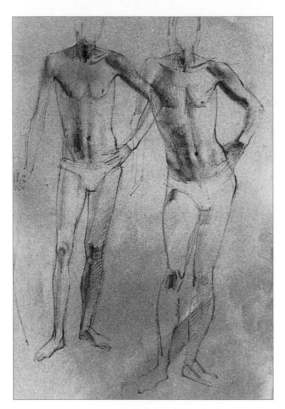

Ron Stenberg: Studies of standing male, undated.

EXERCISES ON STUDIES OF THE TORSO

Pages 147–153:
We start this section with drawing exercises based on the standing position of a model at rest in full three-quarter view, since full-front or back views would provide too few formal characteristics. The following concern us here:

• The clarity of the views that best represent the body as a mass (page 147, top and bottom).

• Creating a system of spatial relationships in which the central and horizontal axes of the body are drawn. See also page 137.

• Investigations, tending towards abstraction, of the modelling and spatial rhythm of the abdominal wall (pages 147, bottom and pages 148 and 149).

• An accurate assessment of the angular relationships and counterbalancing of shapes, making use of virtual cross-sections (page 149).

Exercises using seated poses
Page 150:
1 First draw the spatial orientations of the body with appropriately positioned hatching, and then draw in some modelling contours (page 150, top left).

2 Build up the volumes of the head and its surroundings (page 150, top right).

When poses stretch upwards, the elongating effect must be expressed (pages 150, bottom left and page 151) in contrast to sitting, with its folding of the abdomen (pages 150, bottom right and 152).

Note also that the folding is more pronounced when the skin is soft rather than firm (page 152, bottom right).

Treat the skin like drapery and underline the functional processes with pencil strokes that model the form, as, for example, with the twisted torso (pages 152, top and page 153).

The method used in the various studies shown here is motivated by their purpose and the best way of expressing it:

• If, for example, the treatment of volumes is the primary aim (pages 147, bottom, page 149, 150 top right and bottom left and page 152, bottom right), we will strive for a drawing which follows the general shape and subordinates detail.

• If we are emphasising the viewing planes, we can follow these with broader drawing materials (page 147, top).

• If the dynamic of a pose is particularly important, we may use a rather more flowing style (pages 148 and 157).

• If the body structure is particularly important (pages 150, bottom left and page 152, bottom left), we will follow its internal play. If the functional process is especially absorbing, we can let physical modelling take second place to the representation of movement.

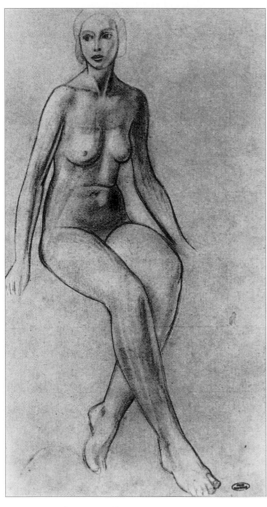

André Derain (1880–1954): Seated girl, undated.

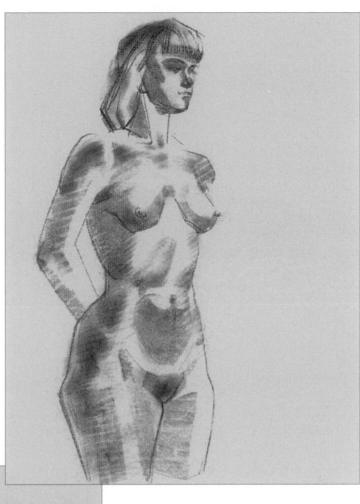

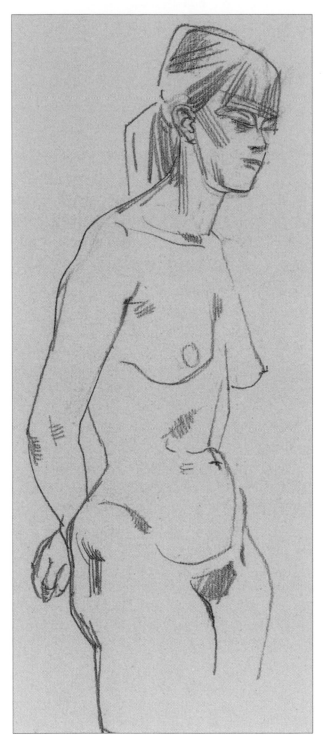

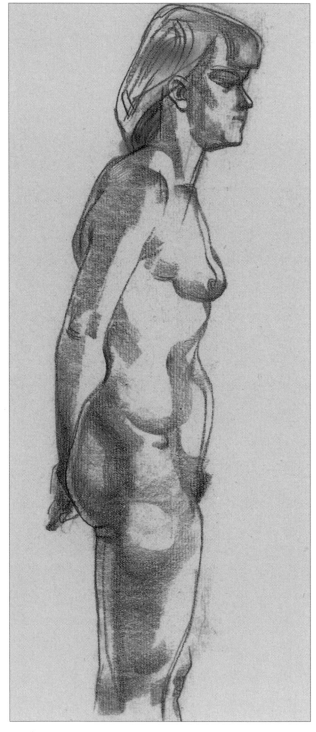

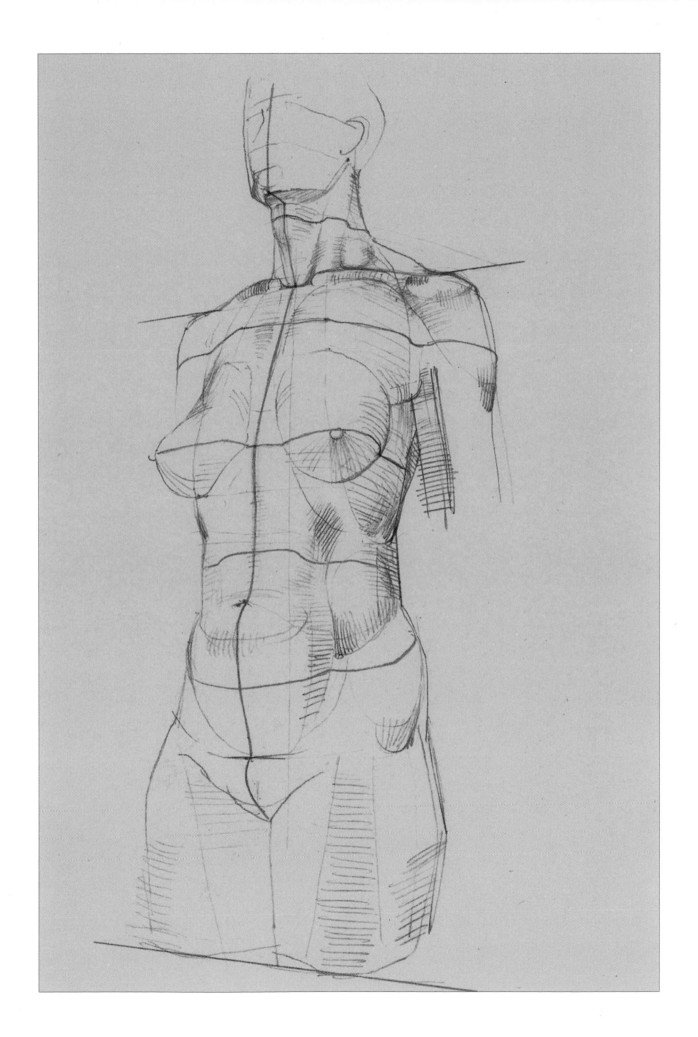

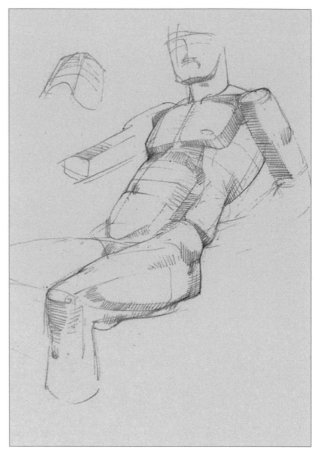

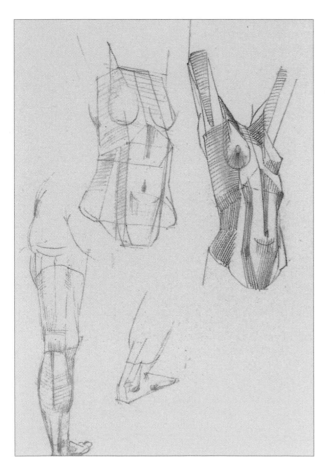

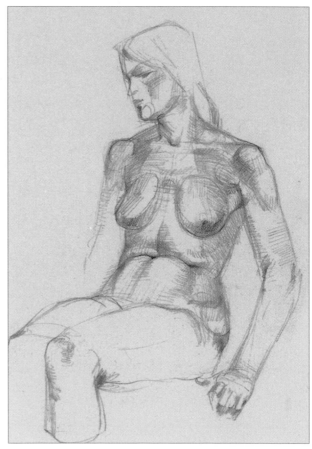

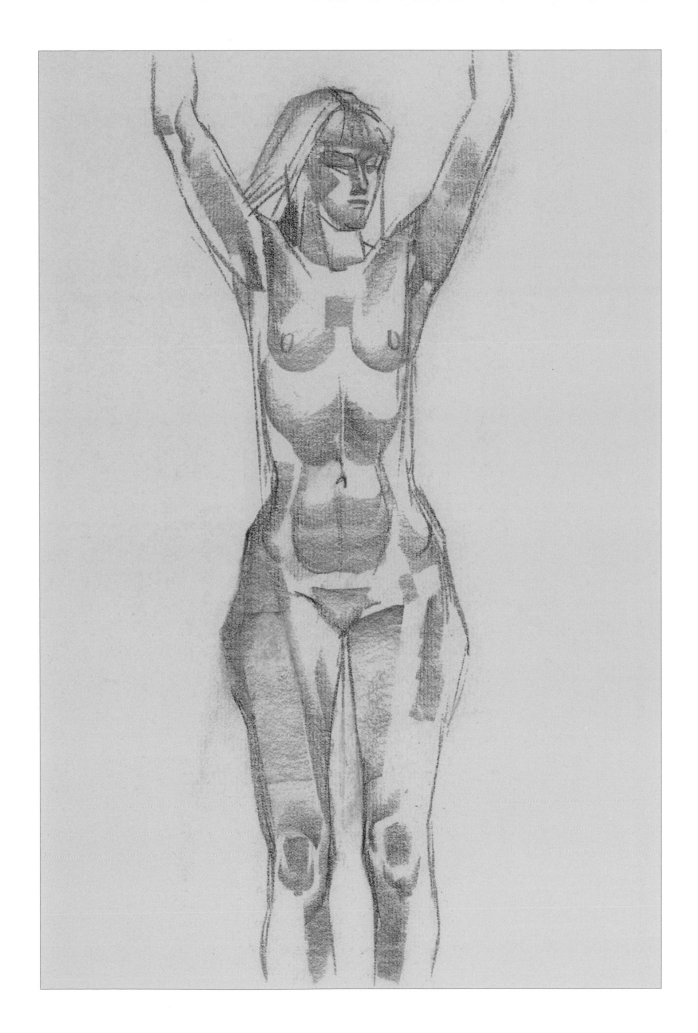

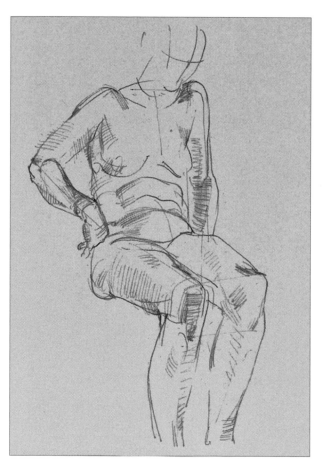

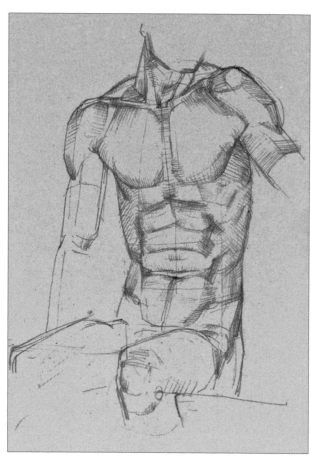

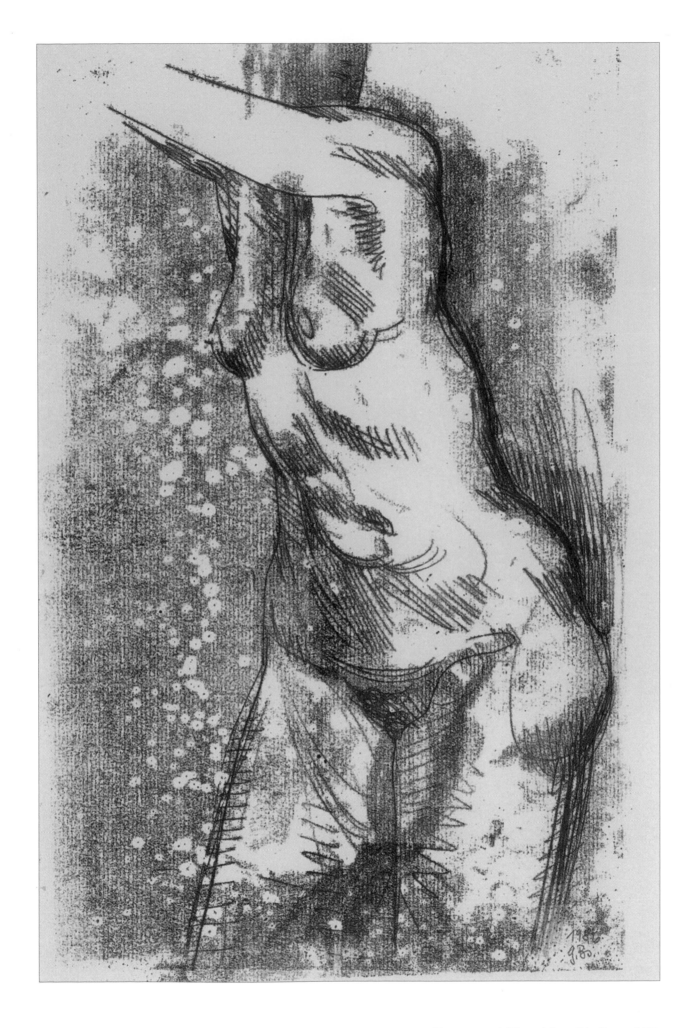

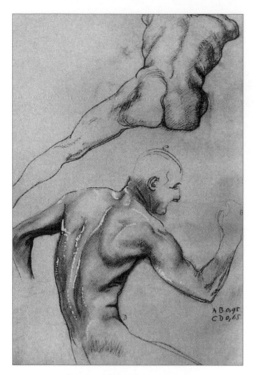

Max Klinger (1857–1920): Two male nude studies from different viewpoints, undated.

THE REAR VIEW OF THE TORSO

The illustration opposite includes the skull and it is necessary to involve the knee joint too in order to show the musculature of the torso with the transitions in the hip and leg areas. The structure of the body and of its deeper and surface forms can be read from putting the skeleton and musculature side by side. Note the following points:

• The trapezius muscle, one of the muscles extending from the torso to the shoulder girdle, connects from the occiput (back of the head) and the spinous processes in the neck and chest spinal column to the upper edge of the shoulder blades and, with one part angled forwards, to the outer clavicle. This muscle supports the arm and controls the movement of the shoulder blades: raising, lowering and contraction.

• The latissimus dorsi, the broadest muscle in the back, connects the pelvis to the spinous processes (7-12th vertebrae) and the inner surface of the upper arm to the thoracolumbar fascia. Like its counterpart, the pectoral muscle (group of torso-humerus muscles), it draws the arm (among other things) and pulls it downwards and backwards, though it is otherwise a muscle for pulling upwards. Together with the pectoral muscle, it forms the armpit, defining it from behind, while the pectoral muscle does so from in front (see page 159, bottom).

• The thinness of the latissimus dorsi allows the two ribbons of the common extensor spinae to show through in relief on both sides of the spinal column, particularly in the lumbar region. Here, where it keeps the body erect, the latissimus dorsi is so large that it places the spinal column in a deep longitudinal furrow.

• The external oblique abdominal muscle also makes the soft bulge over the ilium, which is usually more evident in the rear view.

• The deltoid muscle is not one of the torso muscles, but reaches from the lower shoulder blade ridge to the outer side of the upper arm (and is therefore a shoulder and upper-arm muscle). It raises the arm into a horizontal position, whereby it is compressed in the area of the shoulder crest and always presents a characteristic fold. When the arm is raised, therefore, the shoulder crest sinks between the attachment point of the trapezius and the origin of the deltoid muscle (a predictable phenomenon, shown on pages 159 and 162).

• The muscles covering the shoulder blade operate the shoulder joint from here and belong, like the deltoid muscle, with the shoulder and upper-arm muscles.

• The sacrum (large triangular bone at the base of the spine) and the shoulder blades reach the surface of the body without muscle cover.

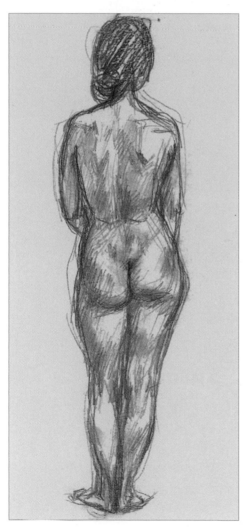

Wilhelm Rudolph (1889–1982): Female nude from rear in slight contrapposto, undated.

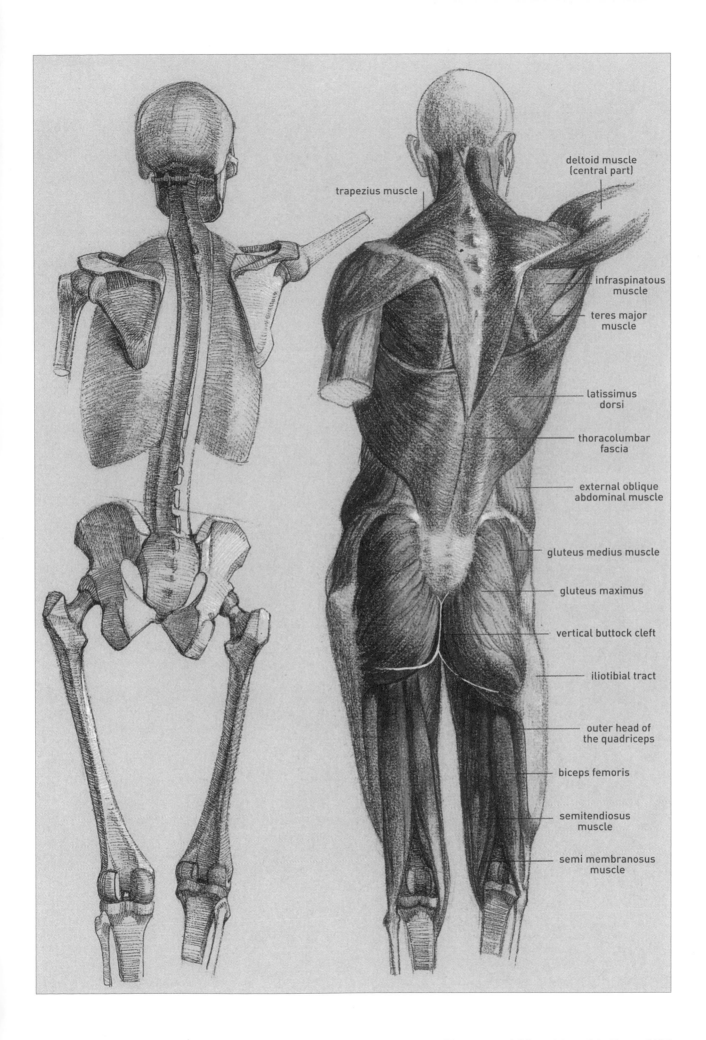

trapezius muscle

deltoid muscle
(central part)

infraspinatous
muscle

teres major
muscle

latissimus
dorsi

thoracolumbar
fascia

external oblique
abdominal muscle

gluteus medius muscle

gluteus maximus

vertical buttock cleft

iliotibial tract

outer head of
the quadriceps

biceps femoris

semitendiosus
muscle

semi membranosus
muscle

V. V. Lebedev (1891–1967): Kneeling female nude, rear view, 1916.

Unknown master: Seated male nude, rear view, undated.

EXERCISES ON DRAWING THE BACK VIEW

We will now leave the flat-on rear view of the torso, to which we deliberately restricted ourselves during our studies and exercises in proportion. The relief shown in the illustration on page 155 must be borne in mind, but without the intention of repeating an anatomical picture of the model's muscles. We simply use this in order to work with relative effortlessness on a concise but accurate outline of the body's structure. We can now leave the measuring phase of the studies on proportion behind us and use the artistic dexterity we have acquired to draw freely. We will use our knowledge of anatomy as a concentrated focus on what is important and for spatial explorations, defining the locations and the whys and wherefores of intersections. The following important guidelines must be followed:

• Pay attention above all to the expression of the posture (casual, expectant, lingering, tense, rigid, relaxed, released), which can be read from the position of the head, the line of the spinal column and the gesture of the arm.

• Initially, follow at least in part the line of the spinal column, particularly in the lumbar region.

• Offset the angular parts of the body (e.g. the contours of face, shoulders and elbows) against the rounded, full or extended parts.

• Plot the position of the inner shoulder-blade edge and the shoulder-blade point.

• Incorporate the evidence of intersections, e.g. those of neck and chin, nape (trapezius muscle) and side of the neck (sternocleidomastoideus), ilium and outer oblique abdominal muscle, lumbar region (erector spinae) and hip, etc.

Accomplishing a task by largely linear means requires visual discipline, powers of abstraction and a defined purpose.

Alfred Stevens (1818–1875): Studies of woman kneeling and bending slightly forwards, undated.

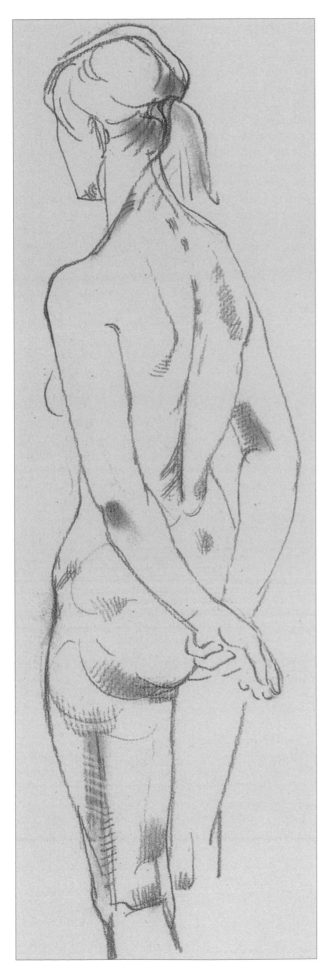

Helmut Heinze (b. 1932): Study of male body mass, front view, 1964.

FURTHER ADVICE AND EXERCISES

It is necessary to depict the deltoid muscle and its collaborators and antagonists in order to fill out the drawing of the torso. The deltoid muscle appears as a compact ring around the shoulder crest and operates the shoulder joint (shoulder and upper-arm muscle) through its insertion in the outer side of the upper arm.

Opposite, top left:
An inner central section of the deltoid is shown in a rest position on both the inside and the outside of the depth axis (black point circled in white), whose function is to pull or raise the arm horizontally and sideways; its antagonist (pulling the arm in) is the latissimus dorsi, as shown.

Opposite, right:
Another adductor of the arm is the teres major muscle with its origin at the point of the shoulder blade, which is also on the inside of the depth axis. Raising the arm vertically and horizontally moves the volume of the deltoid muscle in a swelling from the lower edge of the shoulder blade and around the shoulder crest. This creates the predictable double fold (see also page 161).

Opposite, bottom left:
The vertical lift of the arm stretches the pectoralis major muscle of the chest and covers the deltoid muscle to a large degree by intersecting with it. The latissimus dorsi (as shown) is also found in the same stretched extension (closure of the armpit from behind). The upper arm is enclosed on the front and back (important intersection).

Exercises on drawing the torso
1 Start by thinking of function and interpretation in order to express muscle extensions and contractions and understand the different tensions in their contrasting forms (page 148).

2 Develop spaces, paying particular attention to the abundant variations in the armpit (page 160).

3 When the arms and upper body are stretched upwards, emphasise the inward sinking of the soft shapes (waist) by extending them and making the three-dimensional cores visible (page 161 and 162).

4 Now do the opposite by suspending the body between the supporting arms in a backwards-leaning sitting posture, for a decisive, primal expression (pages 163, 164 and 165).

5 Note that only after these aspects have been drawn will it be possible to develop the composition further (pages 163, bottom, and 164).

The basic elements such as the curve and the sagging of the back must be drawn strictly with three-dimensional inclines (page 165).

Saxton: Study of a man's upper body, 1961

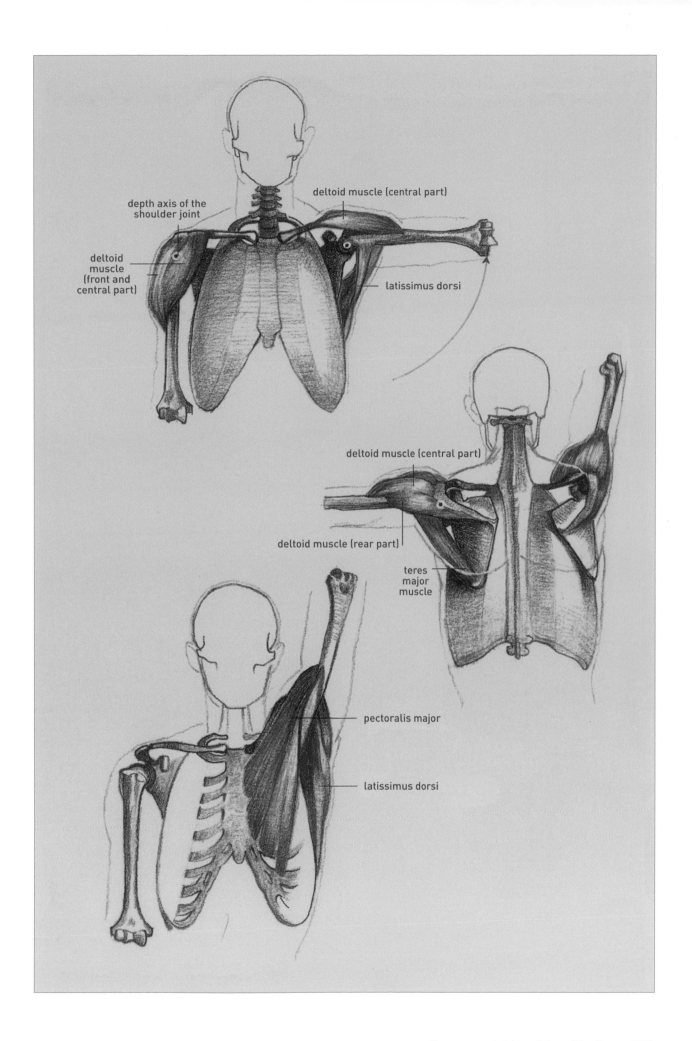

depth axis of the
shoulder joint

deltoid muscle (central part)

deltoid
muscle
(front and
central part)

latissimus dorsi

deltoid muscle (central part)

deltoid muscle (rear part)

teres
major
muscle

pectoralis major

latissimus dorsi

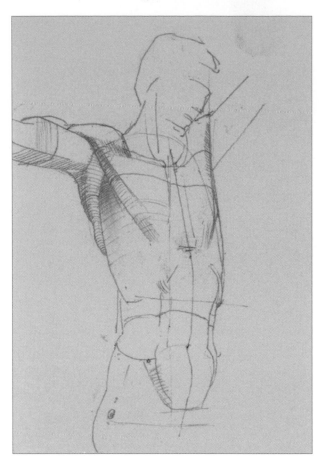

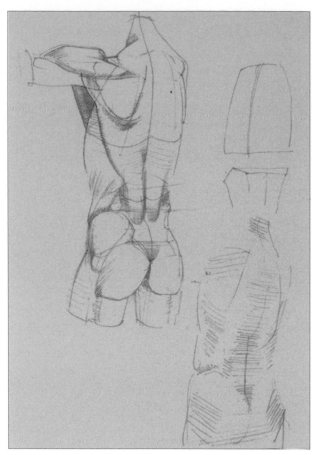

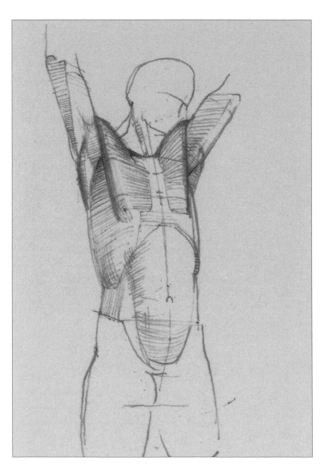

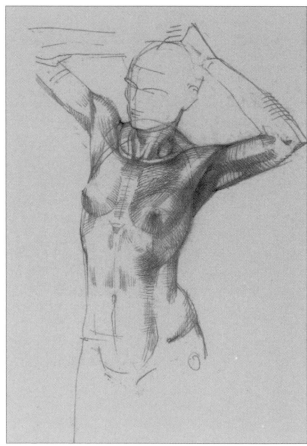

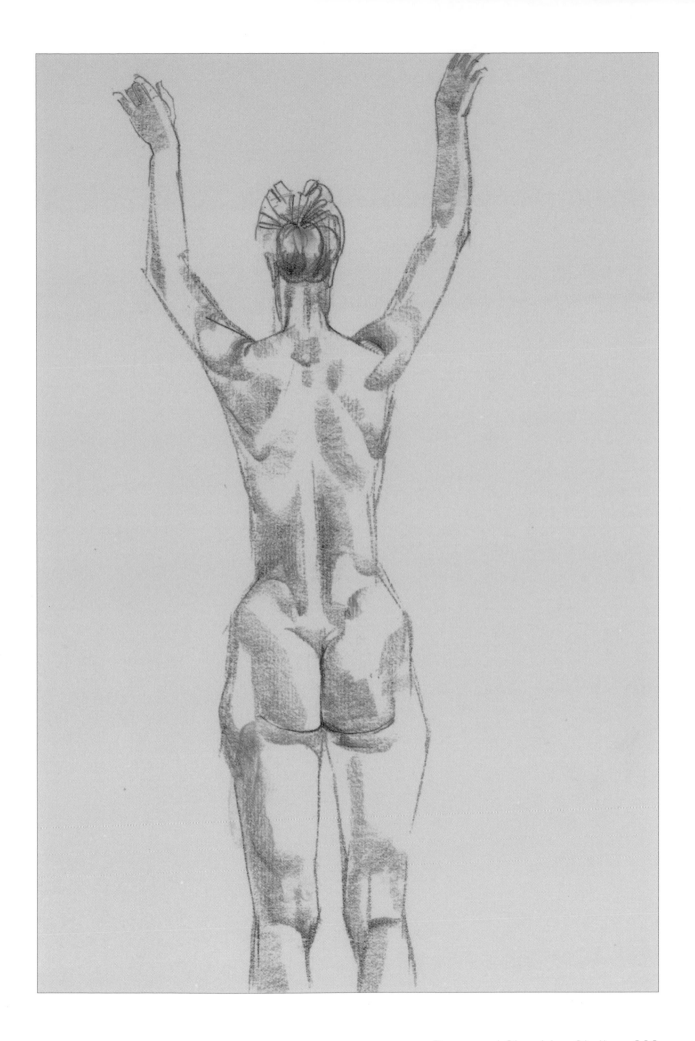

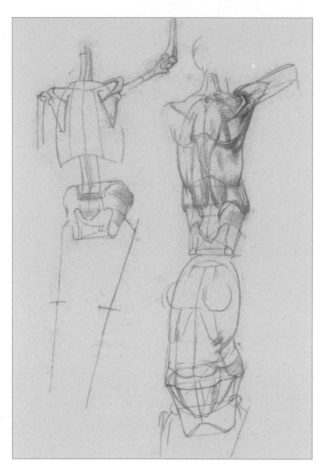

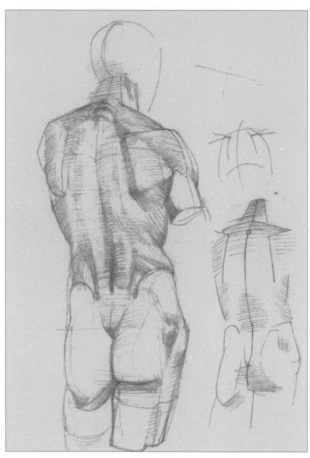

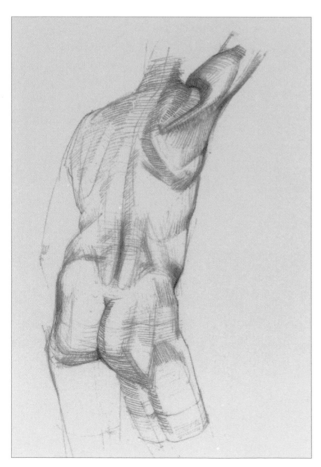

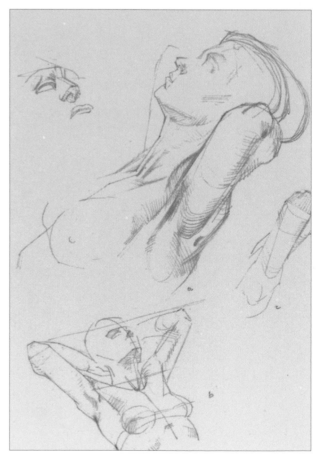

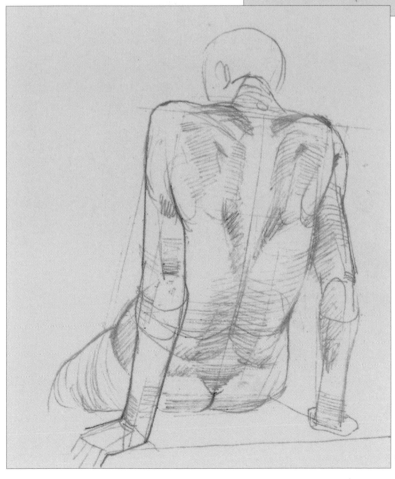

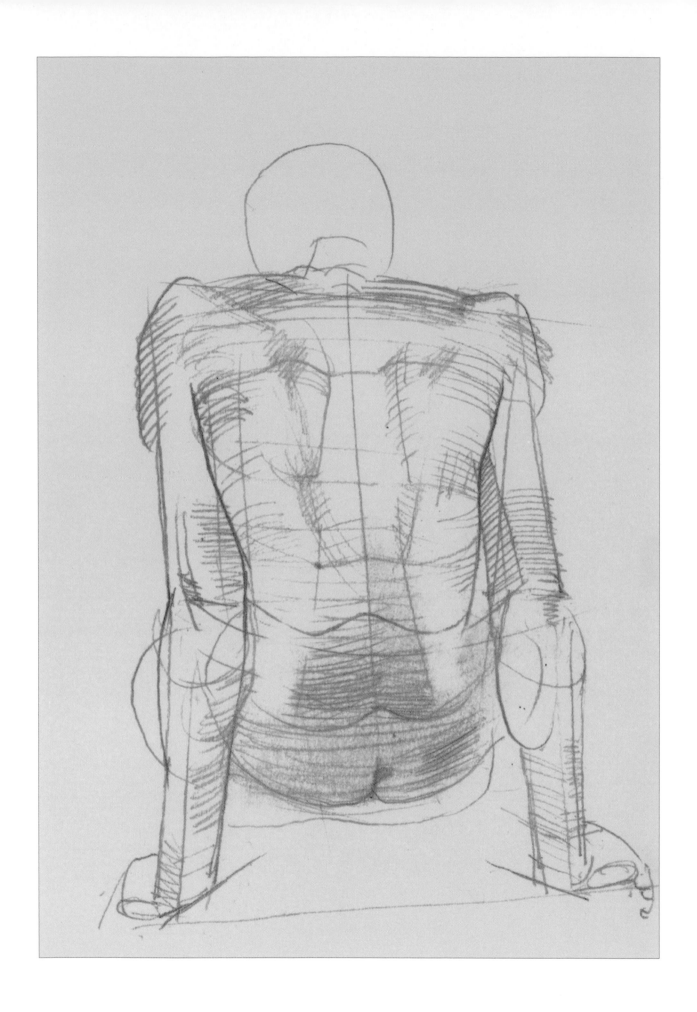

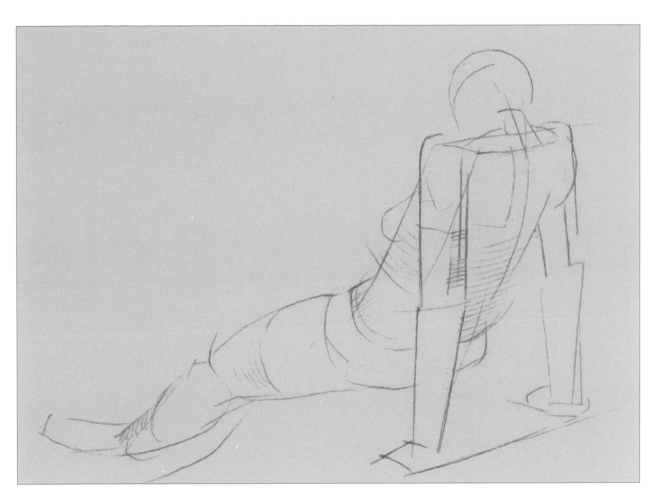

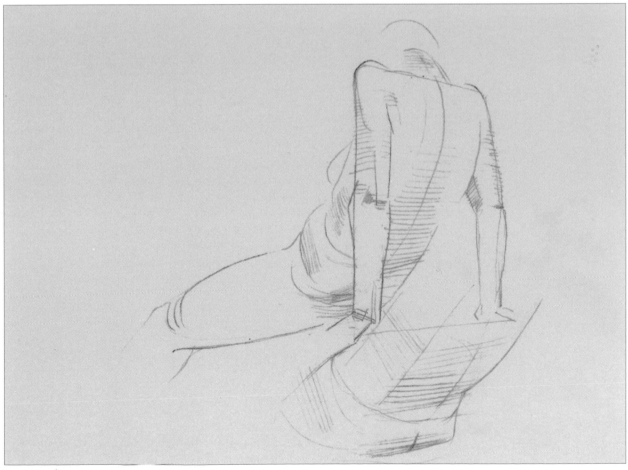

Arms and Hands

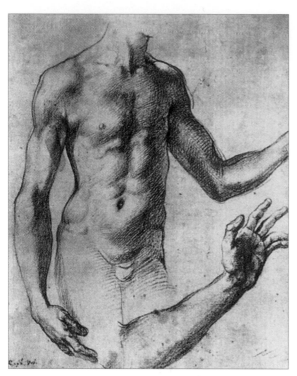

Raphael (1483–1520): Study of a youth's torso, undated.

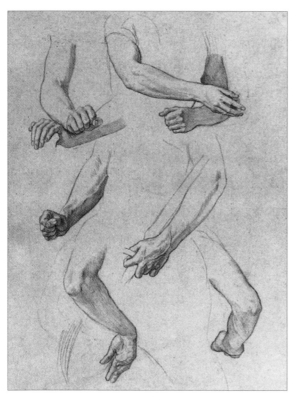

William Cadenhead: Studies of the arm and hand, undated.

PROPORTIONS AND OVERALL STRUCTURE OF THE ARM

You have to understand the function and construction of the arm to make a correct drawing of hands.

Opposite, left, the articulation of the arm in relation to the torso:

• The arm starts immediately below the crest of the shoulder blade.

• The suspended upper arm runs vertically, parallel to the side of the torso.

• The forearm bends outwards, starting almost exactly at waist level (3H from the top of the head). The outer angle of the arm is shown with a red dotted curve.

• The shifting of the shoulder girdle increases the active range of the arm.

• The upper arm is always longer than the forearm.

Opposite, right, the overall construction of the arm including the shoulder girdle:

• The hand's movements involve twice as many joints as those of the foot.

• The sternoclavicular joint connects the upper part of the sternum to the clavicle or collarbone, the acromioclavicular joint connects the clavicle to the shoulder blade, and the glenohumeral joint is the ball-and-socket joint in which the head of the humerus fits into the glenoid cavity of the shoulder blade.

• The elbow joint, a hinge joint, connects the humerus of the upper arm to the radius and ulna of the forearm (see pages 168–171 for further details).

• The radiocarpal joint connects the radius (the forearm bone furthest away from the body) to the carpal bones of the wrist, giving mobility to the hand.

• An imaginary longitudinal axis (continuous red line) runs through the entire arm from the centre of the ball-and-socket joint of the upper arm for the purpose of the in-out rotation of the upper arm and the mobility (supination-pronation) of the hand. This line goes through the elbow to the lower end of the ulna.

• All the swivel joints ranged along the common longitudinal axis are simultaneously combined together, so that the hand can rotate through almost 360°.

Bottom right:
Here we see the shoulder joint under its protective crest with its transverse axis drawn in, enabling the upper arm to swing forwards and backwards. The outer angle of the arm is always visible (most clearly in women and when viewed with palms facing forward).

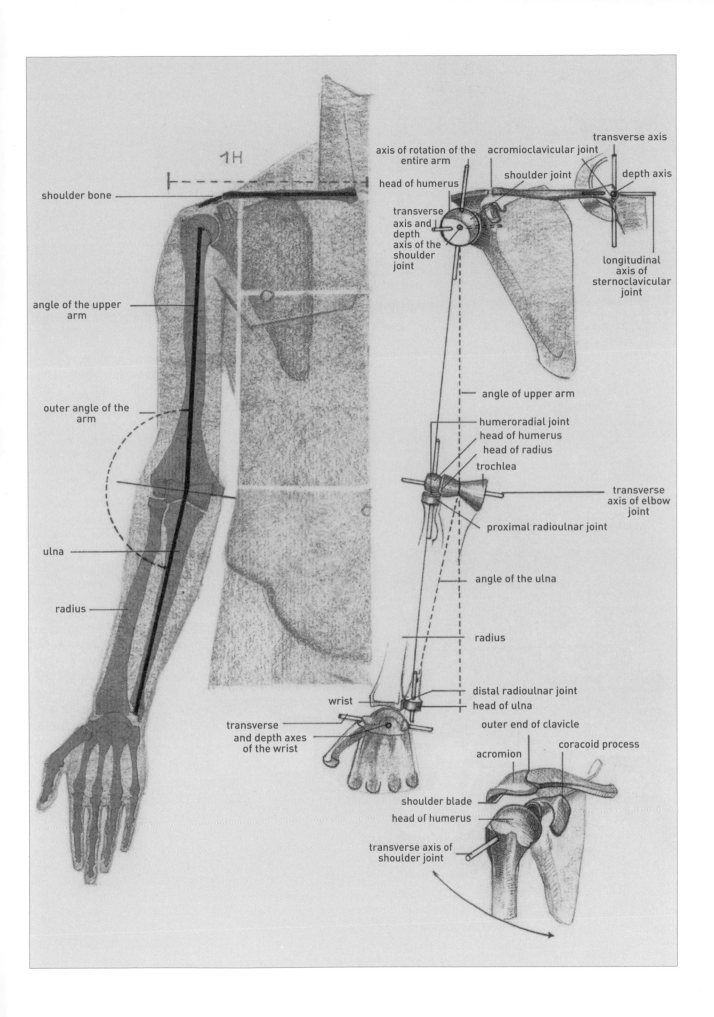

1H

shoulder bone

angle of the upper arm

outer angle of the arm

ulna

radius

axis of rotation of the entire arm

head of humerus

transverse axis and depth axis of the shoulder joint

acromioclavicular joint

shoulder joint

transverse axis

depth axis

longitudinal axis of sternoclavicular joint

angle of upper arm

humeroradial joint
head of humerus
head of radius
trochlea

transverse axis of elbow joint

proximal radioulnar joint

angle of the ulna

radius

distal radioulnar joint
head of ulna

wrist

transverse and depth axes of the wrist

outer end of clavicle

coracoid process

acromion

shoulder blade

head of humerus

transverse axis of shoulder joint

Arms and Hands **167**

D. N. Kardovsky (1866-1943): Female nude leaning forward on one knee and arm, 1901–1902.

Ludwig von Hofmann (1861–1945): Seated female nude, rear view.

THE ELBOW JOINT (RIGHT)

In contrast to the knee joint, the elbow joint is a congruent joint, in which the joint bodies are designed to fit accurately. Since it is a complex joint, there are several joints included in the elbow joint capsule: the humeroulnar joint (where the humerus of the upper arm meets the ulna of the forearm) the humeroradial joint (humerus and radius) and the proximal radioulnar joint between the ulna and radius. The plate shows the actual arrangement:

Rear view of the extended joint, a:
The elbow lies above the transverse axis and creates a flat triangle along with the medial and lateral epicondyles (the distinctive bumps at the end of the humerus, one on each side).

Detail of the joint, b:
The transverse pivot (trochlea) of the upper arm with its guiding notch is shown separately alongside the head of the humerus as the cradle of the radius head.

Rear view of the elbow joint bent in a right angle, c:
The elbow protrudes from the olecranon fossa of the elbow, so, in contrast to illustration a, the epicondyles and elbow triangle now stand out clearly.

Rear view with forearm raised, d:
When the elbow is acutely angled, the elbow itself is almost invisible.

• Notice that the outer facets of the humerus end are always free of muscles (source of the elbow dimple). See also a and c.

The mechanism of the humeroulnar joint, e:
Here we see a profile view of the joint with the lower arm in various positions.

• The joint flexes and extends over the transverse hinge (marked in brown). See also b.

• The grey shading marks the various positions of the elbow, which correspond to the illustrations a, c and d. The radius end holds the first carpal row of the hand in a depression (the ulna is somewhat shorter).

Front view, f:
This three-dimensional constructive drawing shows the elbow joint viewed from the front, bending at a near-right angle.

What are the spatial reference points in the elbow joint?

• The medial epicondyle marking the end of the inner side of the upper arm and the bend of the forearm against the upper arm and which is always situated deeper than the lateral epicondyle.

• The lateral epicondyle (on the end of the humerus) on the outside of the upper arm forming the source for the elbow dimple.

• The elbow where the mechanism of the moving elbow triangle referred to is asymmetrical.

The elbow looks most striking when it is bent at right angles because it creates a sharp-edged angular shape. Many misconceived drawings of the elbow turn it into a sharp pine-cone shape that looks the same from both the side and the front.

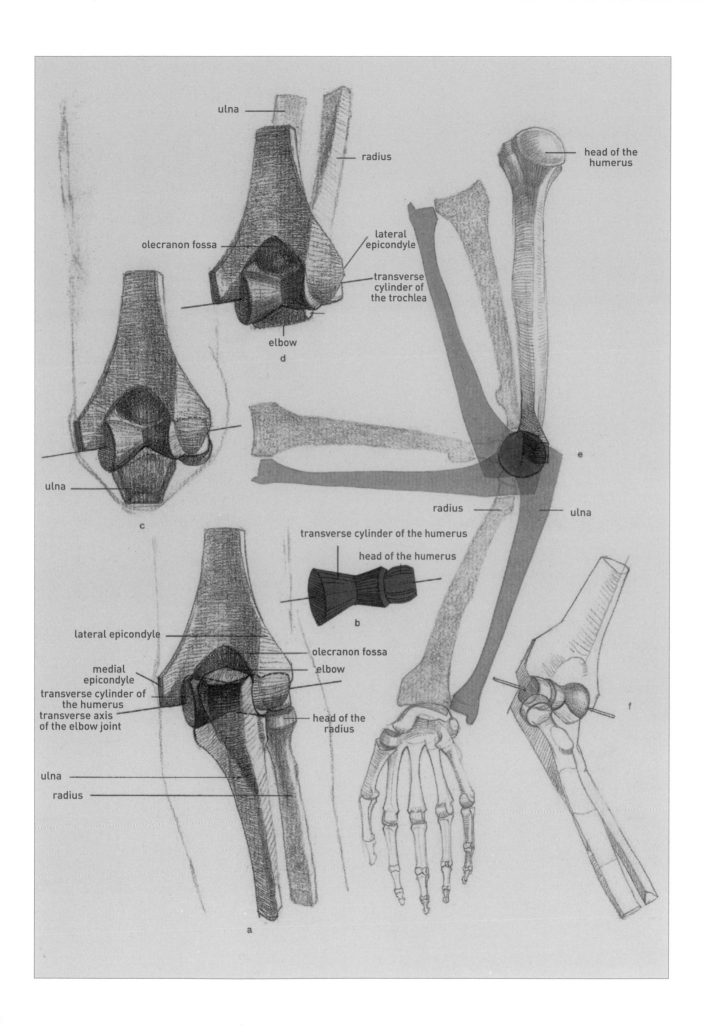

ulna

radius

head of the
humerus

olecranon fossa

lateral
epicondyle

transverse
cylinder of
the trochlea

elbow

d

ulna

c

e

radius

ulna

transverse cylinder of the humerus

head of the humerus

b

lateral epicondyle

olecranon fossa

medial
epicondyle

elbow

transverse cylinder of
the humerus

transverse axis
of the elbow joint

head of the
radius

ulna

radius

a

f

Theodor Grosse (1829–1891): Study of a seated female nude and her left arm, undated.

THE SKELETON OF THE ARM (RIGHT)

The illustrations opposite seek to remedy the lack of real arm skeletons and provide clear images of the dynamic relationships between form and function in the arm.

Opposite left, extended arm seen from the front:

• The guide groove (semilunar notch) and smaller protuberance (coronoid process) of the ulna fit into the notch on the transverse pivot of the humerus.

• The head of the radius fits into the ulna's bearing surface and adapts to the head of the humerus.

• The radius turns outwards, so that the palmar side faces forward (supination).

• The skeletal palm is expressed as the concave side of an arch.

• The first and second rows of the carpus (group names of carpal bones) are fused together as one and connected in the same way to the base of the metacarpus.

• The outline of the live model's arm has been lightly sketched in to show the parts of the skeleton that define the three dimensions.

Opposite centre, naturally extended arm seen in profile:

• The ulna and the radius intersect to some extent.

• The lower arm is connected to the hand by the wide shape of the radius. The styloid process of the radius on the thumb side is an important three-dimensional location in the live wrist.

• The direction of the radius and its facets continues into the index finger via the transverse arch of the wrist and the metacarpus. When we realise this, we can see that the thumb is a variant form.

• Owing to the position of the radius, the hand is in an intermediate position between supination and pronation.

Opposite right, the same arm view, but with the crossover of the ulna and radius at its most complete:

• The back of the hand is turned forwards in the direction of the swing of the arm (pronation).

• The way that the radius is turned inwards across the ulna in this position makes the wrist appear narrow on the side of the little finger.

• The forearm muscles, which have to follow the rotation of the radius, have a twisted spiral shape.

• The cone-shaped process on the ulna (styloid process) is a significant bony three-dimensional counterpart to the styloid process on the radius in all three drawings.

The important functional action of turning the hand requires a simplified depiction.

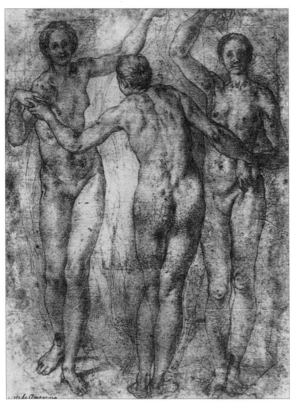

Jacopo da Pontormo (1494–1557): The Three Graces, study for a composition, 1535–1536.

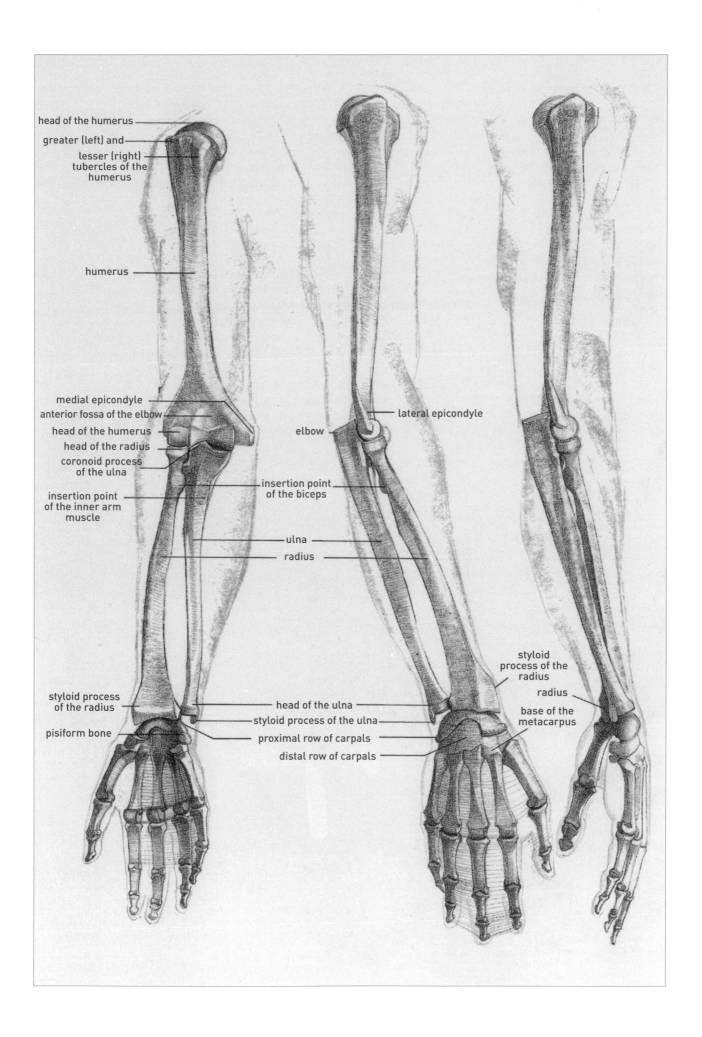

head of the humerus

greater (left) and

lesser (right) tubercles of the humerus

humerus

medial epicondyle

anterior fossa of the elbow

head of the humerus

head of the radius

coronoid process of the ulna

insertion point of the inner arm muscle

styloid process of the radius

pisiform bone

lateral epicondyle

elbow

insertion point of the biceps

ulna

radius

head of the ulna

styloid process of the ulna

proximal row of carpals

distal row of carpals

styloid process of the radius

radius

base of the metacarpus

SIMPLIFYING THE SKELETON AND MECHANISM OF THE FOREARM AND WRIST

A simplification of the lower-arm skeleton by drawing the ulna and radius as one shape, as shown in the sequence a–d, is appropriate because it creates a malleable rectangular shape that makes the graphic orientation easier.

Opposite, top row:

• Diagram a shows the ulna and radius in three dimensions, seen from the front, with closure against the wrist. The red axis is the axis of rotation of the radius around the ulna in the distal and proximal radioulnar joints (left forearm).

• Diagram b shows a complex abstracted representation of the same view and posture, where the slightly upturned hollow shape indicates the supination posture.

• Diagram c shows the propeller-like twist of the two bones, with moderate rotation of the radius around the ulna (left forearm).

• Diagram d shows the complete crossing overlap of the ulna by the radius; here the diagrammatic shape is slightly convex towards the back of the side of the hand near the wrist (pronation, left forearm).

Albrecht Dürer (1471–1528): Arm studies, 1504.

This rotating movement around a single axis is quite similar to the principle of a door hinge.

Opposite, bottom row:

• In diagram e, the supination and pronation phases of the left forearm skeleton have been drawn together; with the back of the radius first upwards, then turned downwards.

• In f, we see the analytically drawn right forearm skeleton in pronation, in which the transverse axis of the wrist makes flexion and extension possible. We see the axis of the back of the carpus on the palmar side and the lateral adduction of the hand in the direction of the ulna and radius.

• Diagram g shows the simplified left forearm skeleton with the palm turned upwards (supination) and with the same axes of the wrist as in f. The fingertips form an elliptical shape in the combination of both basic movements of the wrist, flexion-extension and adduction-abduction. When this is also combined with the rotating ability of the radius and the ulna, the fingertips can perform a circular rotation.

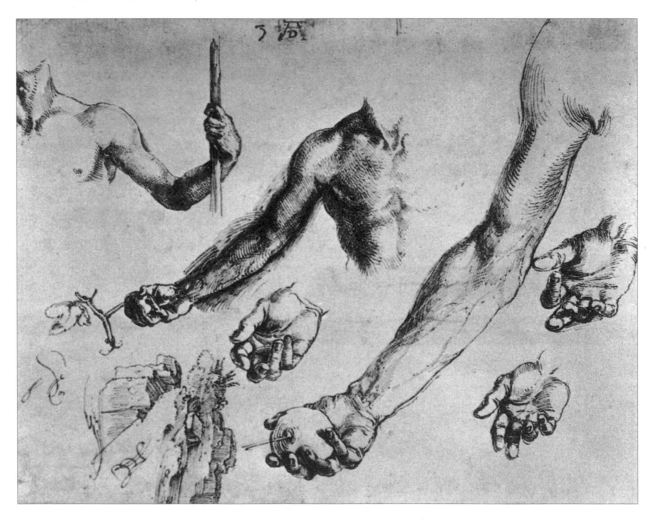

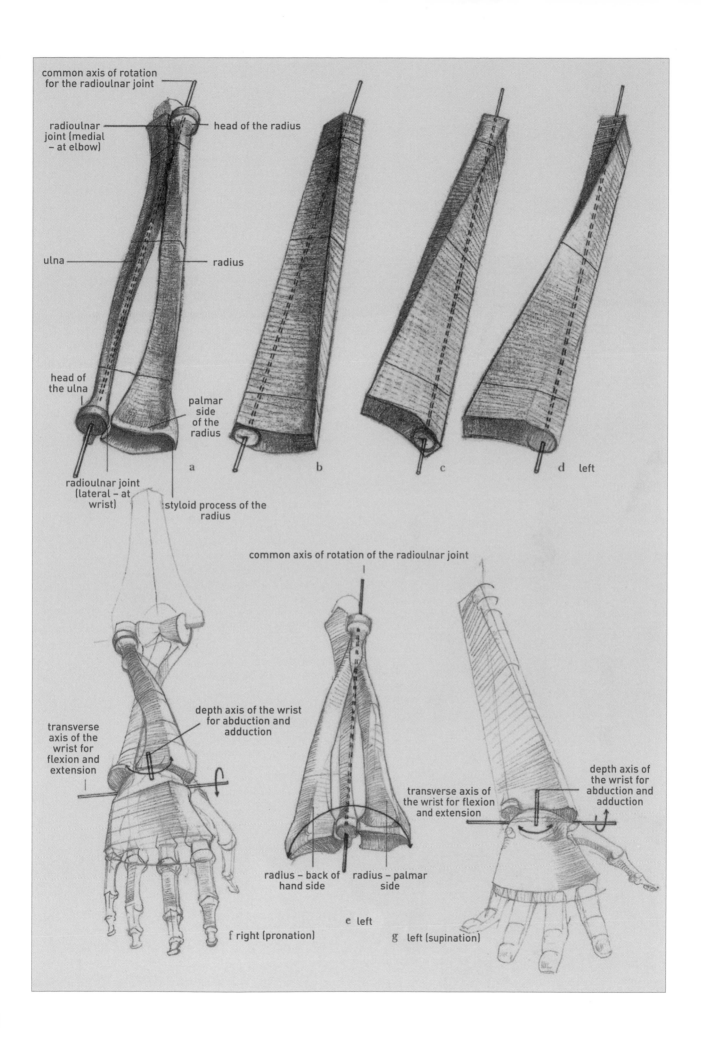

common axis of rotation
for the radioulnar joint

radioulnar
joint (medial
– at elbow)

head of the radius

ulna

radius

head of
the ulna

palmar
side
of the
radius

radioulnar joint
(lateral – at
wrist)

styloid process of the
radius

a

b

c

d left

common axis of rotation of the radioulnar joint

transverse
axis of the
wrist for
flexion and
extension

depth axis of the wrist
for abduction and
adduction

transverse axis of
the wrist for flexion
and extension

depth axis of
the wrist for
abduction and
adduction

radius – back of
hand side

radius – palmar
side

e left

f right (pronation)

g left (supination)

Albrecht Dürer (1471–1528): Proportional studies of the artist's left hand, c. 1513.

PROPORTIONS OF THE HAND

The method of exploring proportions by relating them to dimensions of comparable size, covered earlier with regard to the whole body, is also suitable for the hand. These principles come before any other important considerations, such as construction. The diagram opposite gives the following important information on the proportions of the hand:

• The entire length of the hand from the carpal joint to the fingertips can be divided into two major sections, marked in the middle by the head of the metacarpal bone of the index finger (at the knuckles).

• The longest metacarpal bone is that of the index finger, not the middle finger.

• This length is very similar to the width of the trapezoid-shaped metacarpus (the metacarpal bones as a unit) measured from the metacarpal head of the index finger up to that of the little finger (the equal distances in red).

• The width at the base of the metacarpals (between the carpals and metacarpals) is usually equal to the length of the metacarpal bone of the little finger (the equal distances in blue).

• The metacarpus, which broadens and flattens out towards the fingers, creates a flat curve at the end, which slopes down towards the side of the little finger.

• The fingers of the skeletal hand seem to be longer than those of the live hand because a membrane stretches between the root joints of the fingers.

• The curved ends of the metacarpals, where they meet the phalanges of the fingers, become visible only when the root joints of the fingers are made into a fist – the knuckles.

The following can be said about the divisions and structure of the hand:

• The transverse arch of the hand (the curve of the hand towards the palm side) already starts in the two rows of the carpus.

• The transverse curve of the hand continues in the metacarpus, where it is essential to pay attention to the top of the arch between the second and third metacarpals (index and middle finger), also in the live hand.

• The metacarpal bones are arranged according to the transverse vault – that is, each metacarpal bone is inserted radially.

• As a result, each finger adopts its own individual spatial position in the totality of the hand as the continuation of the metacarpus.

• The thumb with its saddle joint at the carpus already adopts an almost 90-degree position here in relation to the palm of the hand, which is why it is able to touch the hand, making it a grasping tool.

• Except for ball-and-socket type finger root joints, all other joints are purely hinged joints.

A well-observed drawing of the hand requires prior study of

Nicolas Tassaert (1800–1874): Hand studies, undated.

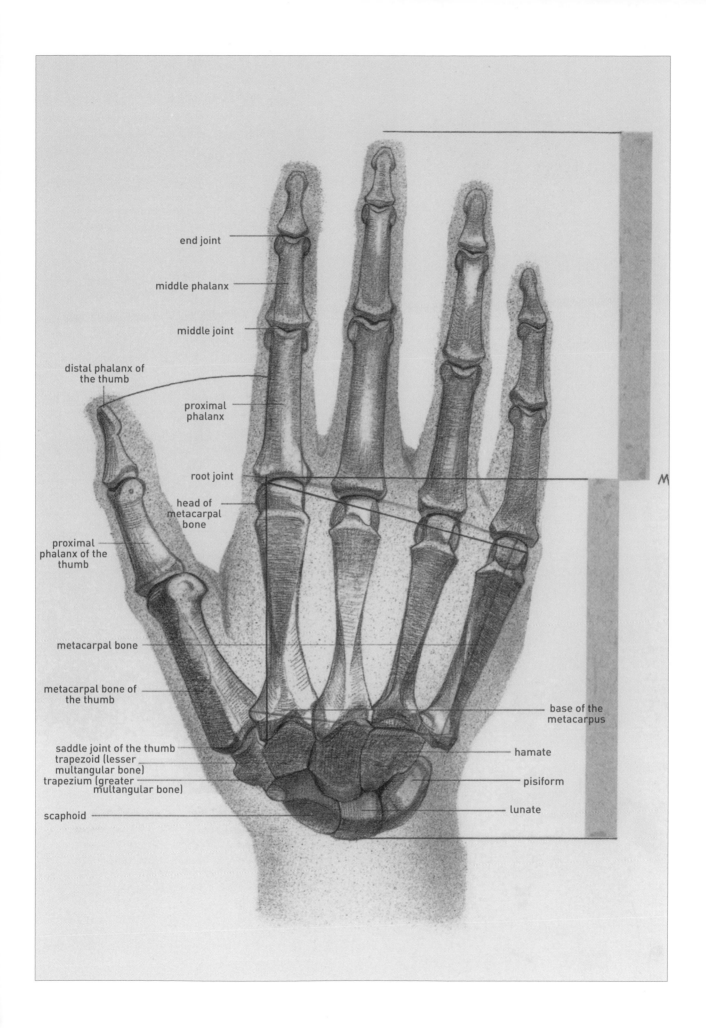

end joint

middle phalanx

middle joint

distal phalanx of
the thumb

proximal
phalanx

root joint

head of
metacarpal
bone

proximal
phalanx of the
thumb

metacarpal bone

metacarpal bone of
the thumb

base of the
metacarpus

saddle joint of the thumb
trapezoid (lesser
multangular bone)
trapezium (greater
multangular bone)

hamate

pisiform

lunate

scaphoid

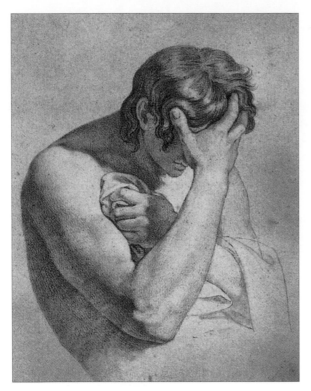

Johann Friedrich Matthäi (1777–1845): Male upper body, right hand supporting the head, c. 1820.

SCHEMATIC VIEW OF THE MUSCLES OF THE ARM (RIGHT)

Plotting the masses between the shoulder joint and the wrist along the joint's axes will help the artist to find his way around and to understand the volumes of the upper arm and forearm and their typical dimensions, given that there are so many muscles. In this respect, the functional groups must come to the fore, that is the flexor and extensor group on the upper arm for the elbow joint and the sinews on the forearm that move the wrist:

• In front of the transverse axis of the elbow joint are the two flexors (muscle fibres indicated in red).

• Behind the transverse axis are the two extensors (muscle fibres indicated in blue).

• In front of the axis of the wrist are the two extensors on the side of the back of the hand (band shown in blue).

• Behind the transverse axis of the wrist are the flexors (band represented in red).

For the muscles in the upper arm (opposite, left):

• The two muscle groups – the flexors and extensors – are arranged behind each other because of their position in relation to the transverse axis of the elbow joint, and therefore have greater depth and less width.

• These muscles originate at the shoulder blade (the biceps split into two heads) and on the anterior side of the upper arm (brachialis anticus).

• Their attachments are located near the pivot of the radius (biceps) and the ulna (brachialis anticus).

The muscles of the forearm:

• The wrist extensor starts at the extensor tuberosity (outer upper arm end) and is then attached to the base at the back of the hand, on the side of the ulna and radius.

• The wrist flexor starts at the flexor tuberosity (inner upper arm end) and runs to its attachment at the palmar side base of the metacarpus, on the side of the ulna and radius.

The positional relationship between the hand flexors and extensors in the depth axis also allows the hand to be pulled back towards the ulna and radius (see the drawing opposite). In the illustration (left) of pronation of the hand, the wrist extensors are turned towards the viewer. In the case of supination, they are turned away and the flexors on the palmar side towards the viewer (right picture). This results in the torsion of the lower arm muscles on account of the position of the radius (important for drawing the lower-arm mass). One must also bear in mind that the separate origins of the muscles on the outer and inner arms give them a broad width and limited depth extension. The dimensions of the upper and lower arm are therefore offset from each other.

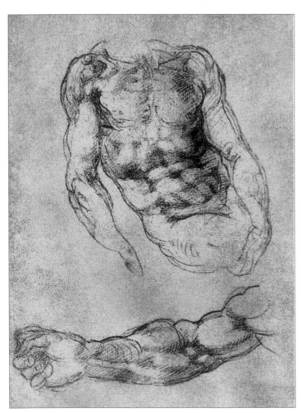

Michelangelo Buonarroti (1475–1564): Studies of the torso and right arm of a man for the Last Judgement, 1530s.

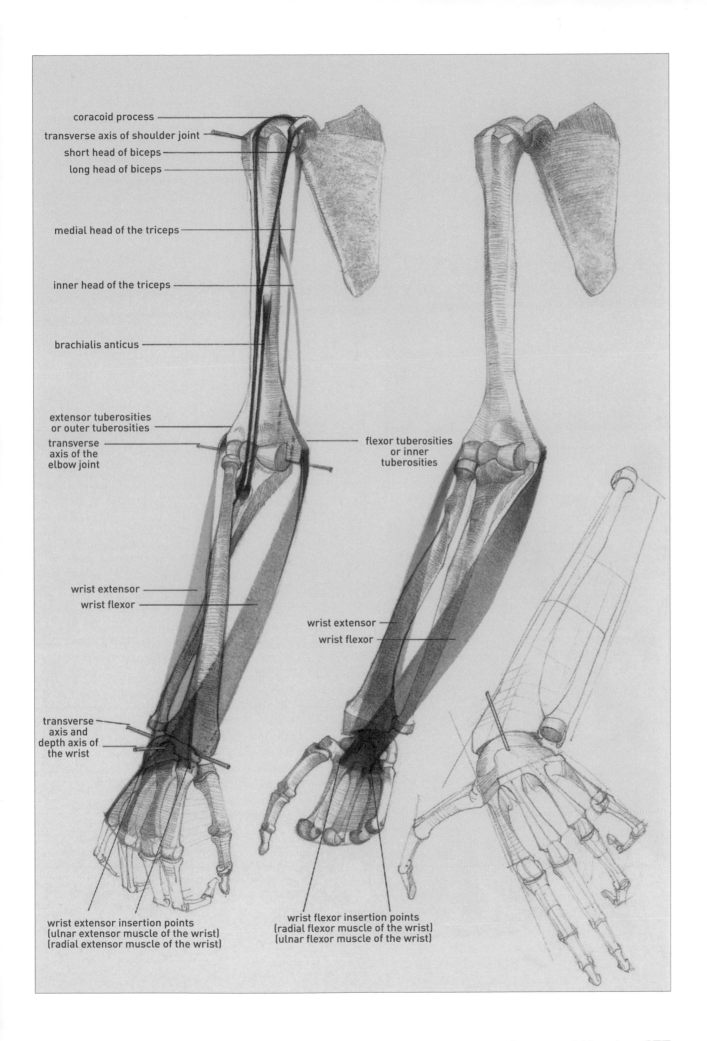

coracoid process

transverse axis of shoulder joint

short head of biceps

long head of biceps

medial head of the triceps

inner head of the triceps

brachialis anticus

extensor tuberosities
or outer tuberosities

transverse
axis of the
elbow joint

flexor tuberosities
or inner
tuberosities

wrist extensor

wrist flexor

wrist extensor

wrist flexor

transverse
axis and
depth axis of
the wrist

wrist extensor insertion points
(ulnar extensor muscle of the wrist)
(radial extensor muscle of the wrist)

wrist flexor insertion points
(radial flexor muscle of the wrist)
(ulnar flexor muscle of the wrist)

Arms and Hands **177**

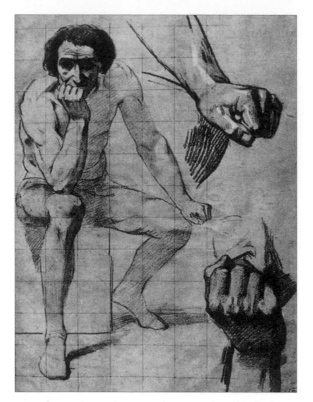

Bartolommeo Bandini/Bandinelli (1493–1560): Studies of a semi-nude male and his hands, undated.

J. Schnorr von Carolsfeld (1794–1872): Studies of a male upper body with fists pressed together in front of the chest, undated.

MUSCULATURE OF THE ARM

The principle of the muscle arrangement in relation to the joint axes of the arm is shown opposite three-dimensionally from two important viewpoints.

Left, anterior side with internal view:
• Covered by the compact deltoid muscle at their origin, the two flexors of the elbow joint, the biceps and brachialis anticus (inner arm muscle), come into view on the surface of the upper arm anterior side, with the biceps uppermost and the brachialis visible below on the inside and outside (both muscles being in front of their transverse axis).

• Behind these, on the back of the arm, (see also the illustration right) is the three-headed extensor (triceps) of the elbow joint. Note the laterally compressed form of all the upper-arm muscles.

• The flexor of the wrist originates as the biggest mass (with a central origin at the flexor tuberosity), crossing over the wrist on the palmar side while attached at the base of the metacarpus (covered by the annular ligament).

• The superficial finger flexor (flexor digitorum superficialis) fills up the internal space between the radius and ulna flexors.

• Next to the aforementioned flexors, as a long spindle-shaped muscle, lies the flexor of the radius, which moves the elbow joint together with the aforementioned flexors (also known as a weight-carrier, without having any effect on the wrist).

• The depth axis of the wrist makes it possible to work out that the flexor on the radius side is able to abduct towards the radius and the flexor on the ulna side is able to abduct towards the ulna.

Right, back with outer view:
• The back of the upper arm is three-dimensionally defined by the triceps (the layer behind the transverse axis of the elbow joint, therefore its extensor).

• The back of the triceps features deep, rigid layers of flat broad tendons (aponeuroses).

• The attachment of the deltoid muscles breaks in between the two flexors of the elbow joint.

• The extensor digitorum communis (finger extensor) lies in the internal space between the ulnar wrist extensor and the long and short radial wrist extensor (attachments at the base of the back of the metacarpus).

• The massing is completed on the inner side of the underarm by the ulnar wrist flexor, an indication that the wrist extensors are functionally subordinate to the wrist flexors.

The flexor and extensor group of the underarm form a permanently visible groove along the course of the ulna, which tells us about the bearing of both muscle groups.

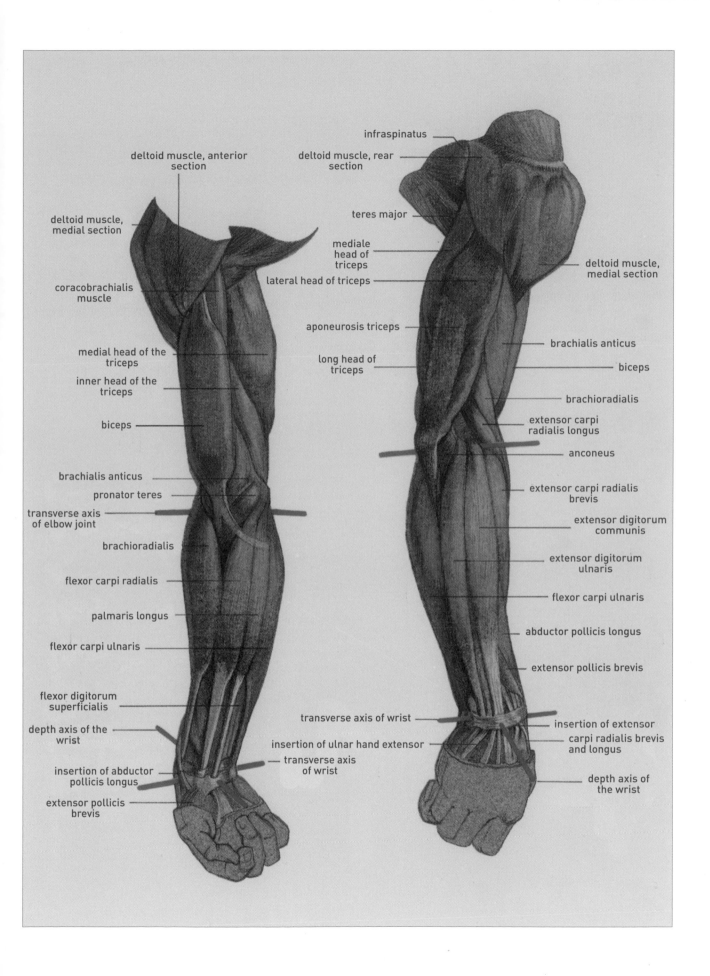

deltoid muscle, anterior section

deltoid muscle, medial section

coracobrachialis muscle

medial head of the triceps

inner head of the triceps

biceps

brachialis anticus

pronator teres

transverse axis of elbow joint

brachioradialis

flexor carpi radialis

palmaris longus

flexor carpi ulnaris

flexor digitorum superficialis

depth axis of the wrist

insertion of abductor pollicis longus

extensor pollicis brevis

infraspinatus

deltoid muscle, rear section

teres major

mediale head of triceps

lateral head of triceps

aponeurosis triceps

long head of triceps

deltoid muscle, medial section

brachialis anticus

biceps

brachioradialis

extensor carpi radialis longus

anconeus

extensor carpi radialis brevis

extensor digitorum communis

extensor digitorum ulnaris

flexor carpi ulnaris

abductor pollicis longus

extensor pollicis brevis

transverse axis of wrist

insertion of ulnar hand extensor

transverse axis of wrist

insertion of extensor carpi radialis brevis and longus

depth axis of the wrist

Arms and Hands **179**

Hermann Prell (1854–1922): Study of a Valkyrie, 1896.

THE MODELLING OF THE ARM BY MUSCLE GROUPS

Now that you have studied the muscle configurations and structural forms of the arm shown on pages 177 and 179, it is helpful to see the muscles grouped by function. As before, the idea here is to raise awareness of the varying dimensions of the muscle volumes on the upper arm and forearm.

The relaxed arm shown from two viewpoints, opposite, top, provides the opportunity to study the following:

• The transverse dimension of the deltoid muscle.

• Depth dimension of flexors (shown in red) and extensors on the upper arm (blue).

• The transverse dimension of the wrist flexors (red) plus extensors (blue), greatly reinforced by the brachioradialis muscle (brown).

• Variations in the volume of the flexors (particularly evident in the right-hand illustration), position of the flexors of the hand and finger joints.

The volumes of extensors and flexors start to diminish almost immediately above the wrist, particularly on the back of the forearm. The forearm skeleton is therefore presented in the drawing opposite, bottom, in a Cubist fashion and emerges now at the surface between the flexors and extensors.

The correcting studies of the raised arm concentrate on the following points (opposite, bottom):

• Development of the structural interplay between the skeleton and muscle forms (centre).

• Consideration of the functional processes involved in raising the arm – compression of the deltoid muscles, with a compressed form at the shoulder crest.

• Dimensions of the upper-arm volume as a narrow cube shape.

• Development of the muscle cone on the forearm, particularly near the elbow.

• Functional muscle groups on the forearm (left) with coloured highlights.

• Illustration of the same issue in a semi-simplified manner, emphasising how the extension of the forearm skeleton rectangle is distinguished from the surrounding flexor-extensor groups.

Now we have indicated the main features of studies of the arms.

Peter Paul Rubens (1577–1640): Studies of arms and hands, undated.

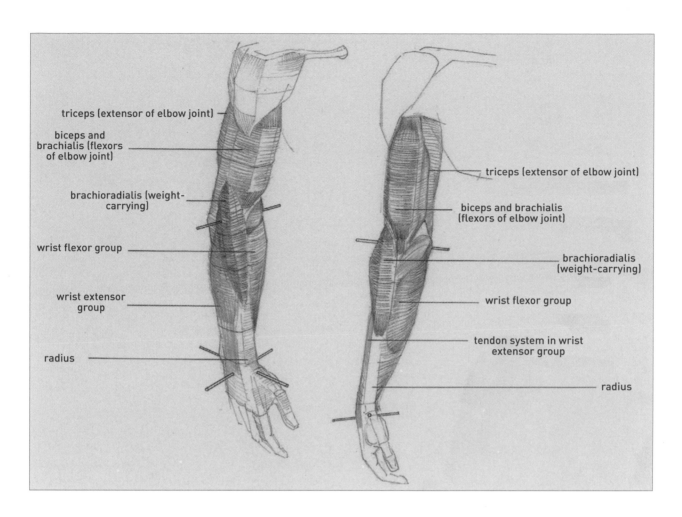

triceps (extensor of elbow joint)

biceps and brachialis (flexors of elbow joint)

brachioradialis (weight-carrying)

wrist flexor group

wrist extensor group

radius

triceps (extensor of elbow joint)

biceps and brachialis (flexors of elbow joint)

brachioradialis (weight-carrying)

wrist flexor group

tendon system in wrist extensor group

radius

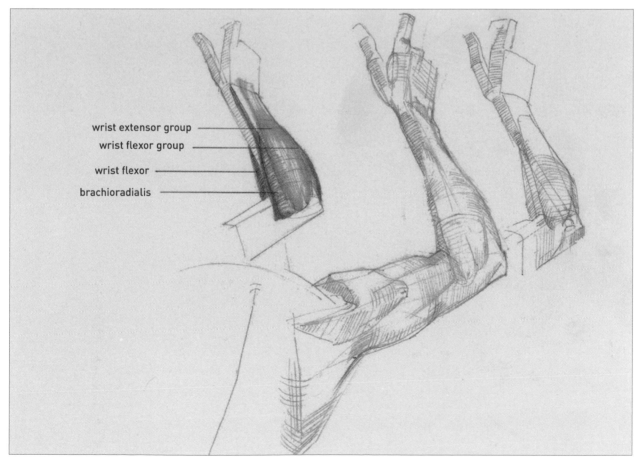

wrist extensor group

wrist flexor group

wrist flexor

brachioradialis

Käthe Kollwitz (1867–1945): Two hand studies, 1924.

EXERCISES ON DRAWING THE ENTIRE ARM

Pages 183–189:
All the biological information about the arm that you have just been given is necessary for the understanding of the structure of the arm and its functional expression. There is no action of the arm, even when it is just hanging down, in which its activity or passivity does not demand adequate expression. The following exercises will help you add life to your drawings:

• First capture the directions of the action, the spatial positions and the context; only then superimpose the subsidiary forms (page 183, top and bottom).

• Mark your spatial orientations by capturing the dimensions of the main masses (page 184).

• Make the difficult spatial angles (foreshortening, spatially varying positions of individual arm sections) easier to understand by means of simplification (page 185).

• Emphasise the angularity of the joints rather than make the arm into a rubber sausage (page 185, top left and right).

• Where the arm and hand move towards the viewer, have the courage to enlarge in the foreground (page 186).

• You should check the position of the arm on yourself, paying close attention to the functional processes at work here: for example, what does the forearm do when it rests on the hips, and how will you express the inward rotation of the forearm and the torsion of its muscles? (Page 187 top right and bottom left and also page 186, bottom left.)

• Do not forget to test your knowledge and skills by sketching from your imagination (187, top left). Which things are clear in your mind and which ones aren't yet?

• Do not simply draw the arm on its own, but investigate its transitions and connections to the trunk (pages 188, 189 and also page 187, top and bottom right).

• Move the top of the arm at the shoulder arch back in space relative to the position of the sternum.

• Make sure that the attitude of the arm expresses something quite distinct, whether relaxed, on the hip, supporting, grasping upwards, holding on to something, carrying an object, touching, stroking, resting, etc.

• Investigate the less-visible aspects (e.g. at the elbow).

• Draw shapes firmly, regardless of the section, rather than in a feeble and uncommitted way.

• Always remember that the volumes are not located in the centre of a section, but always shift their mass to the pivot closest to the trunk (centripetal tendency).

• Consider what the planes of view are in each case.

Josef Hegenbarth (1884–1962): My hands, early 1940s.

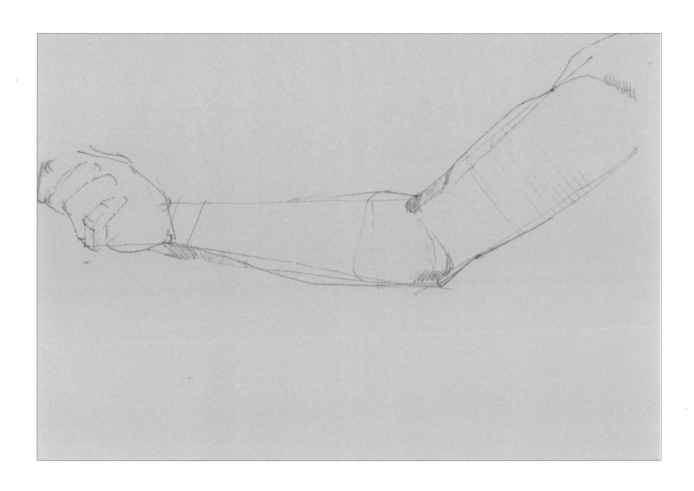

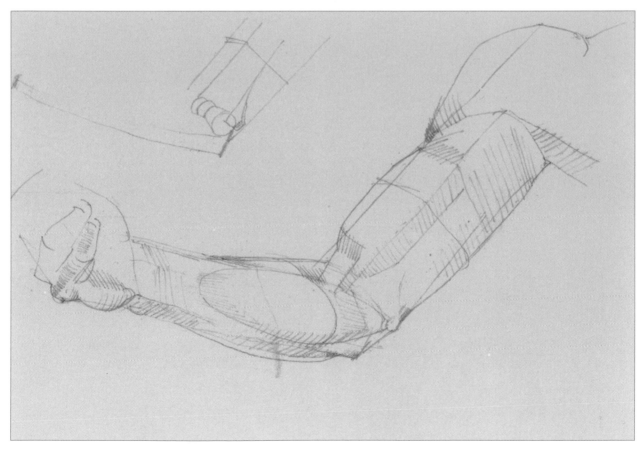

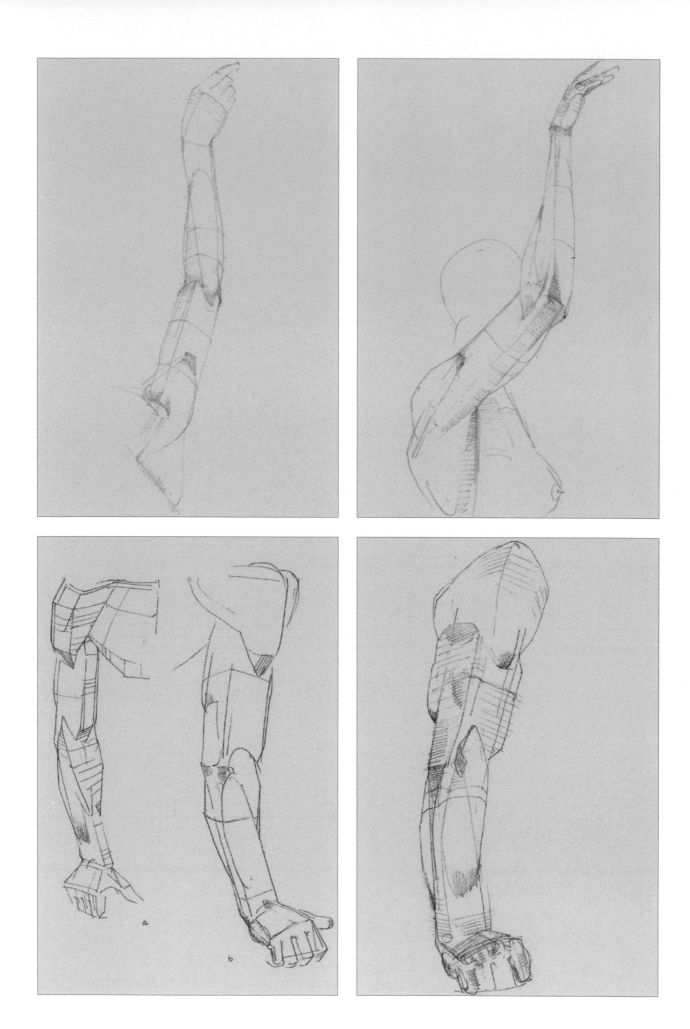

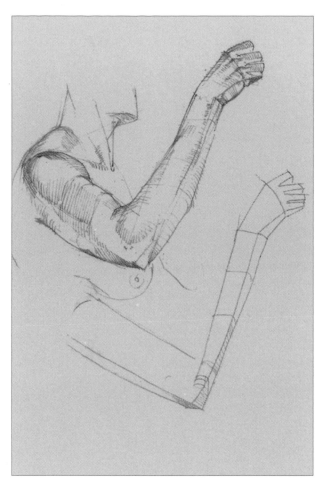

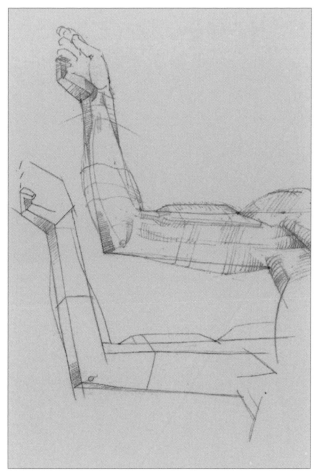

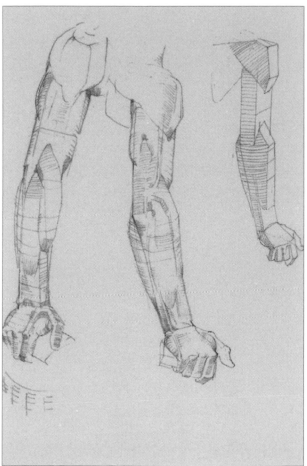

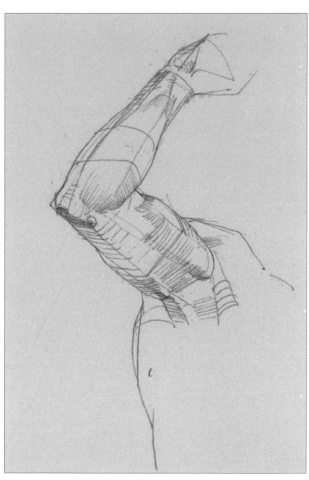

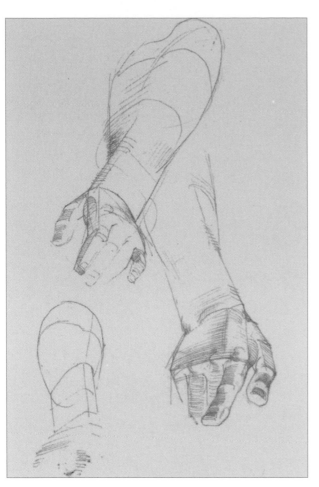

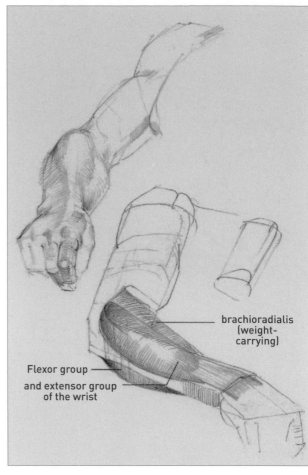

brachioradialis
(weight-
carrying)

Flexor group
and extensor group
of the wrist

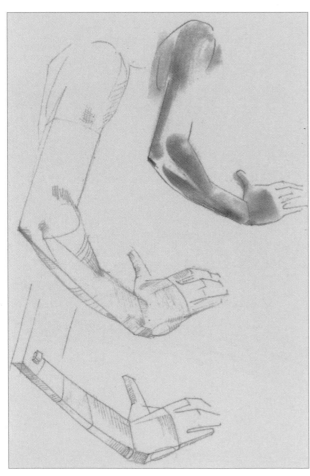

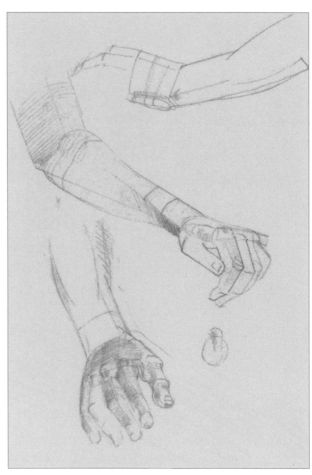

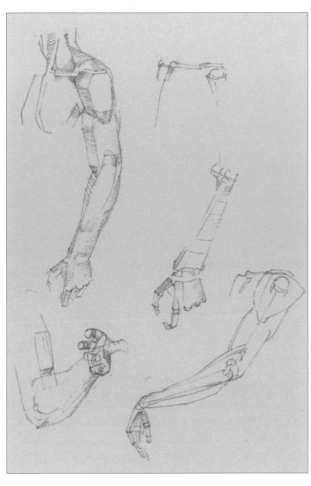

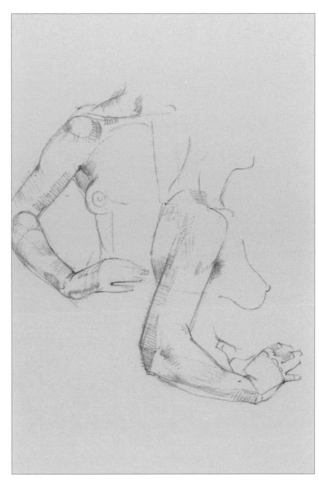

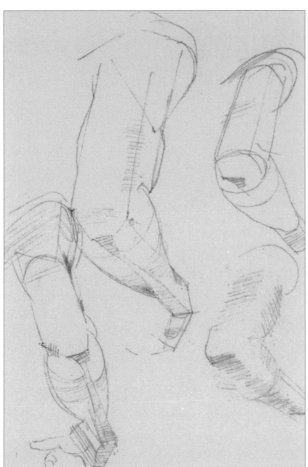

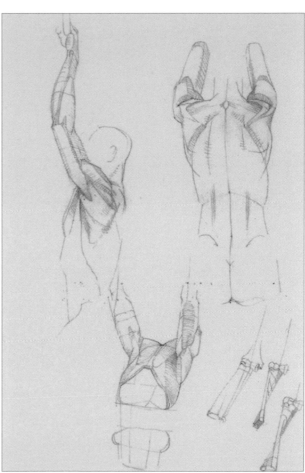

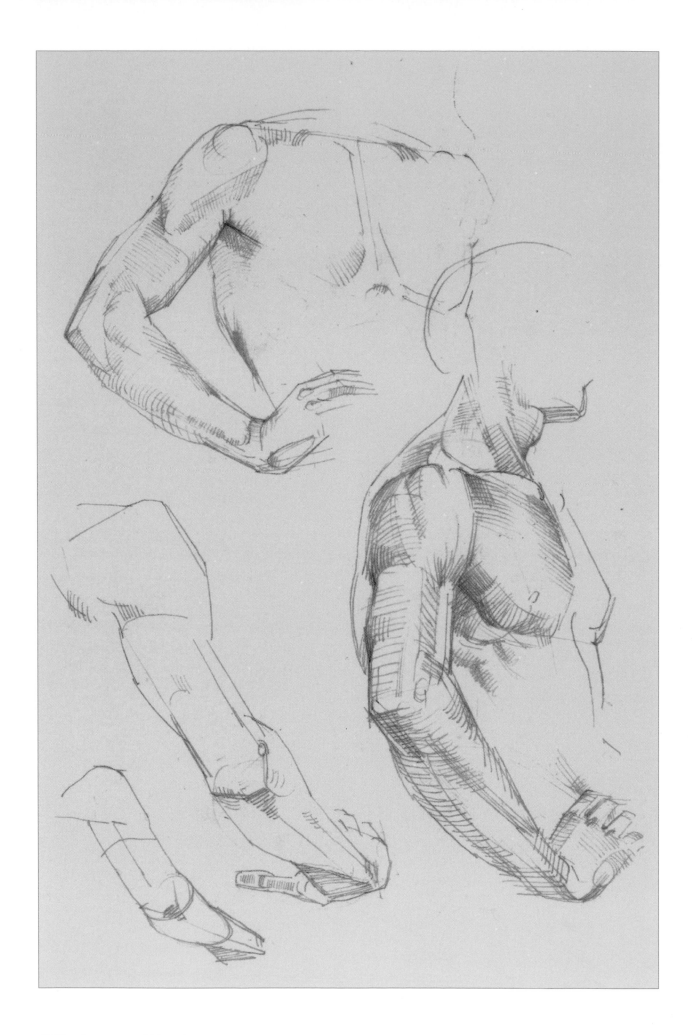

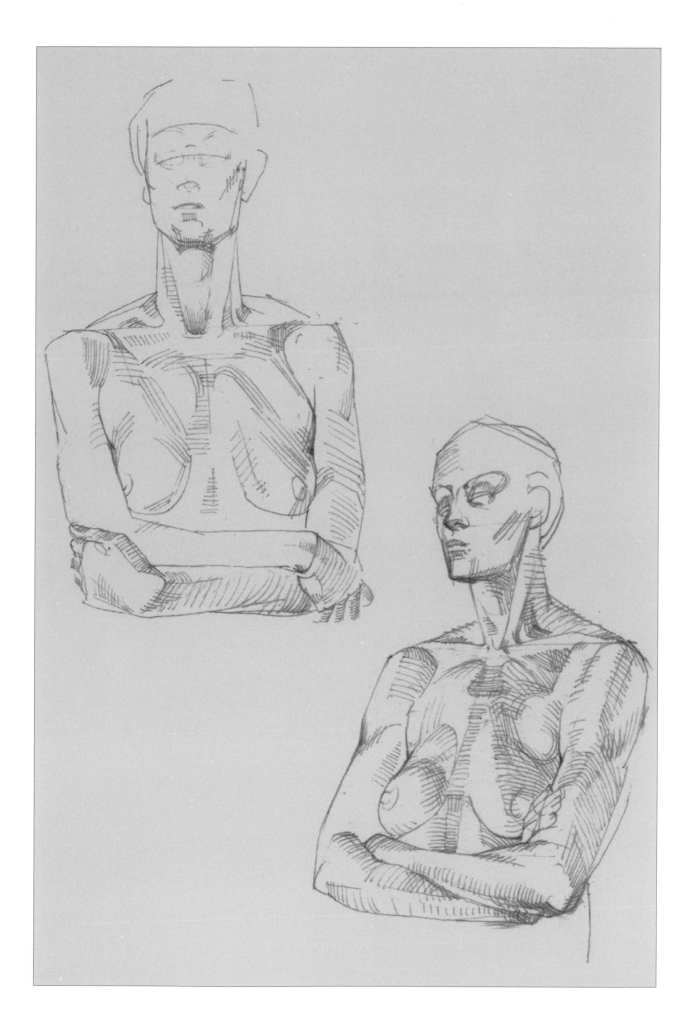

Andrea del Sarto (1486–1530): Studies of hands, undated.

HAND STUDIES – EXERCISES

Pages 191–199:
What I said about the need for expression in arm studies applies even more so when it comes to studies of the hands, which have a physiognomy as expressive as the face, showing thoughts and moods and revealing a person's age and sex. This is in addition to their dexterity in performing physical activities. In all these aspects, the same criteria for drawing the hands apply:

• Do not start with individual features or individual fingers, but first look at the proportions and the fan-like disposition of the hand (page 191 top).

• Only after this can you allow the softer shapes which belong to a female hand to express themselves (pages 191, bottom and 192) and try to draw these in different ways.

• Some activities (firm grip, supporting) require attention to the behaviour of the knuckles, whether and how these stand out under tension (page 193).

• Each individual finger is not only singular in its shape, but it also has its own spatial position because of the arching of the palm (page 194). Before depicting the fingers individually, one must make it clear that the fingers arise from a dish shape, to which their three-dimensional aspects and tapering shape correspond.

• Enrichment of the drawing with individual features comes last, assuming that the drawing has been worked through in a rational sequence of stages (page 195).

• The primary stages in this work include capturing the complex shape of the contours and planes (page 196 top), which in turn will encompass function and spatial problems (page 196, bottom).

• Difficult spatial and functional issues are mastered by using simplification achieved by combining the forms into complexes (page 197).

• Studies of hand gestures and their symbolic meaning are not a matter only of drawing from life, but also of the power of the imagination, which is why we should make use of media that respond to an idea. For example, improvised 'finger-painting' with graphite dust (page 198), shapes that flow from the head of a brush (page 199 top right and bottom) or the combination of watercolour washes and pen (page 199, top left).

Well-understood and controlled drawing by hand remains a reliable touchstone. 'Nothing ages as quickly as novelty' (Karl Hofer).

Ferdinand Jagemann (1780–1820): Two hand studies, undated.

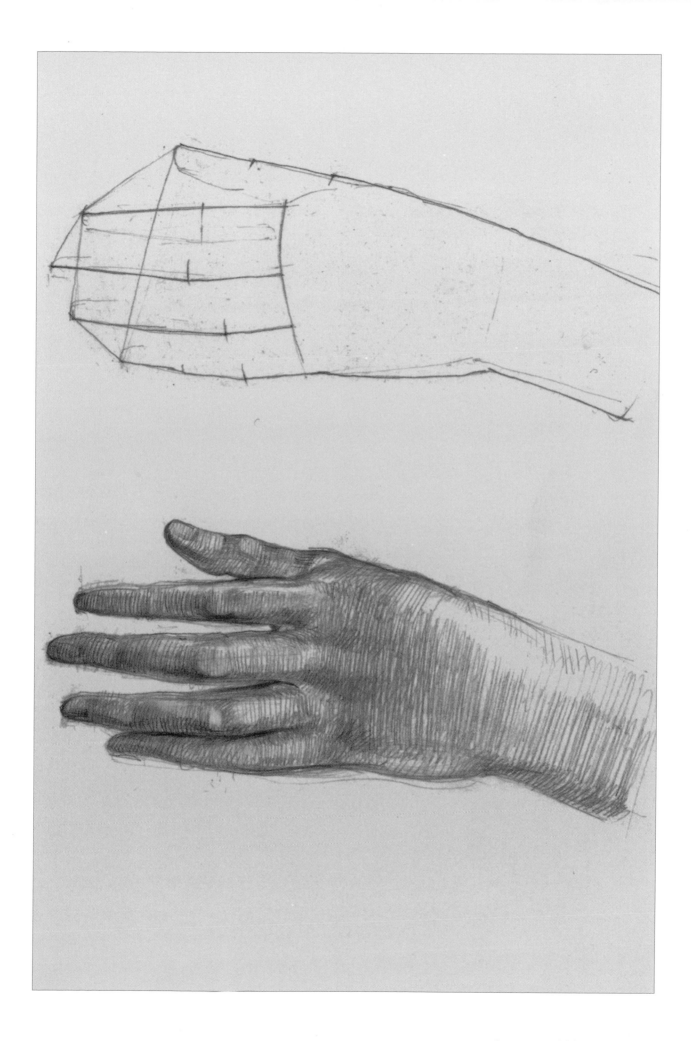

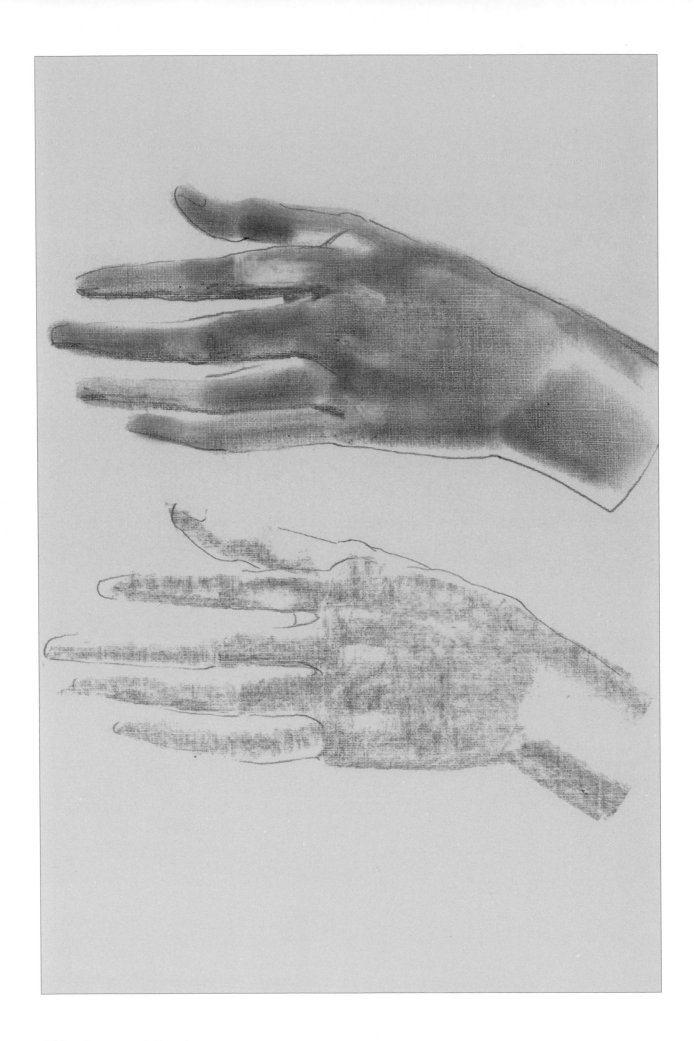

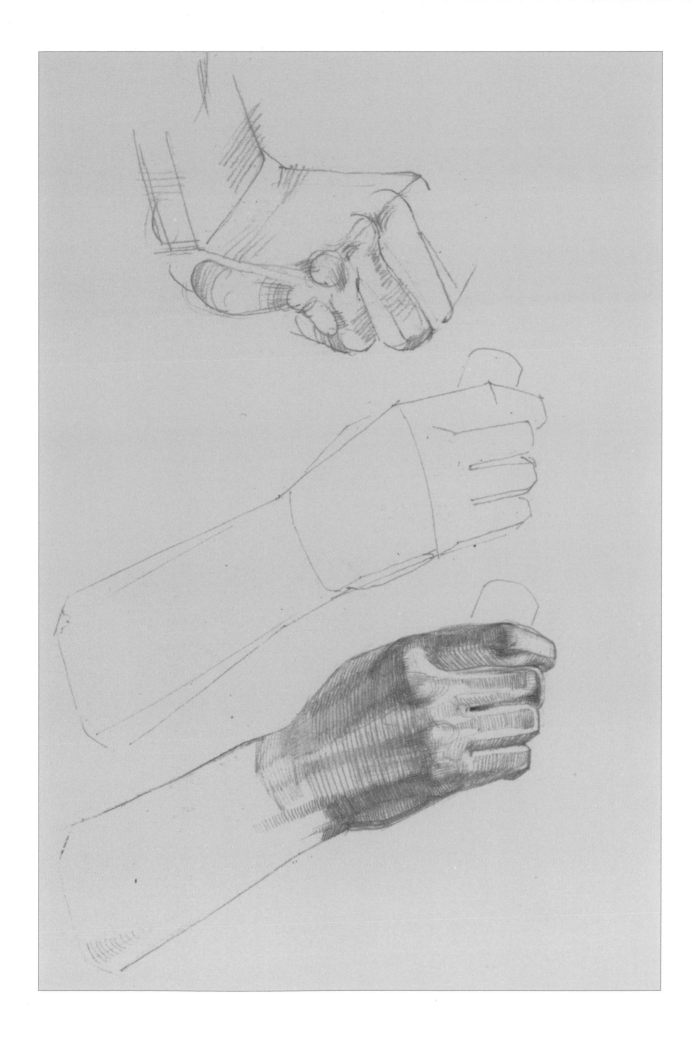

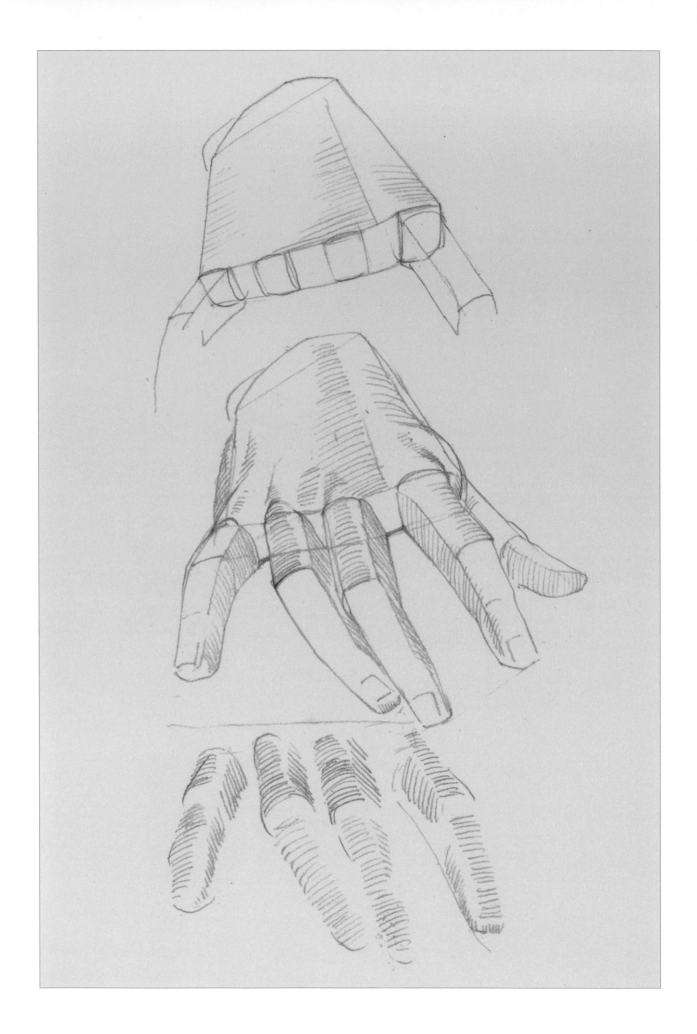

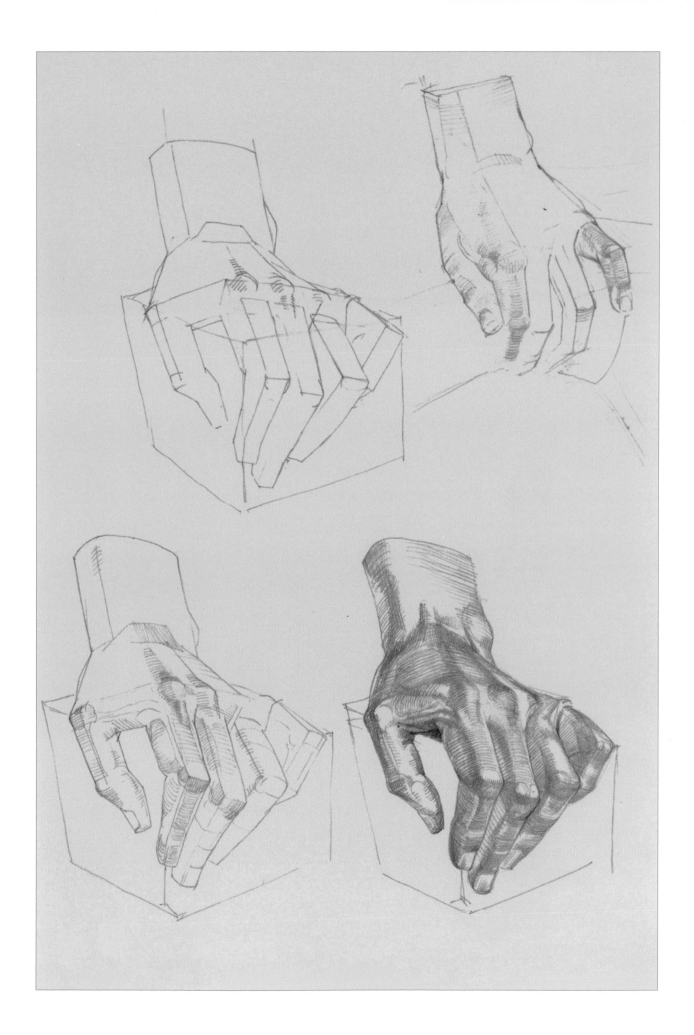

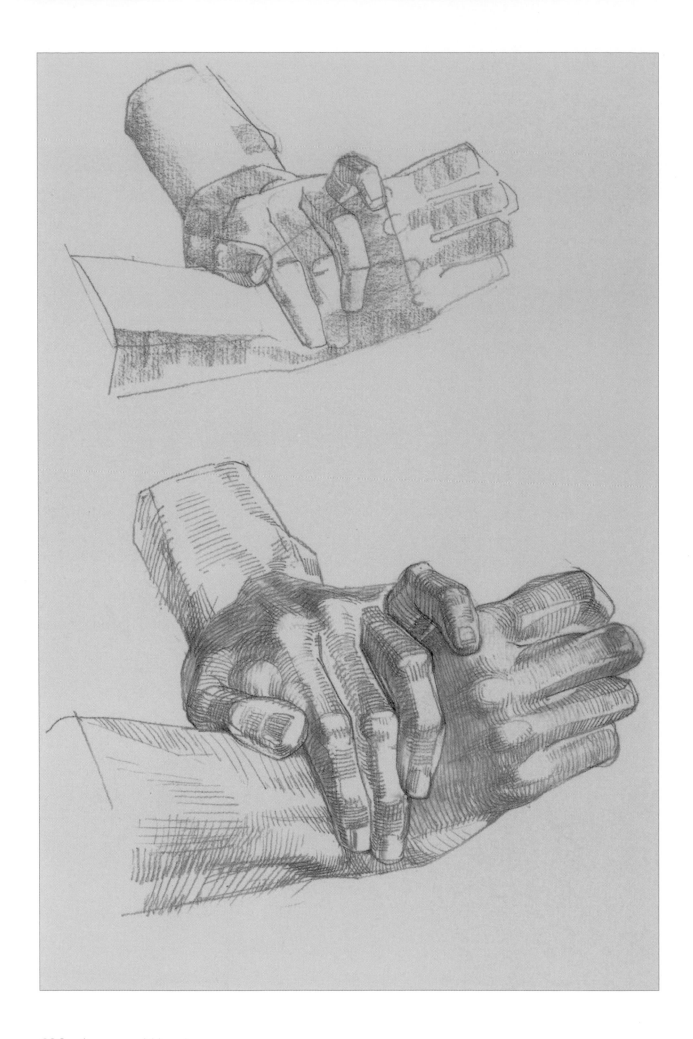

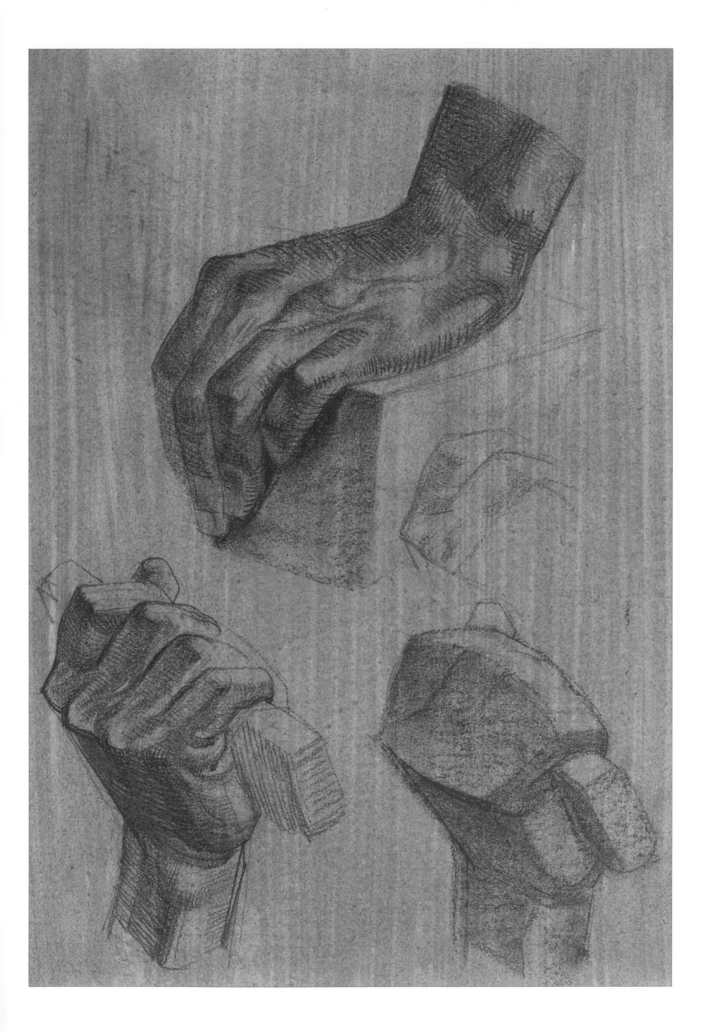

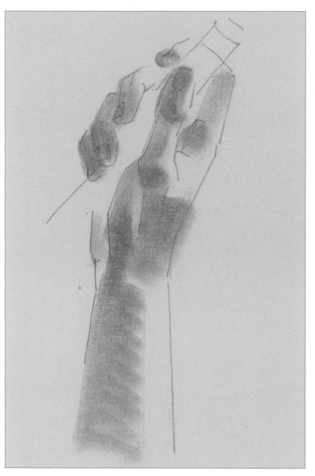

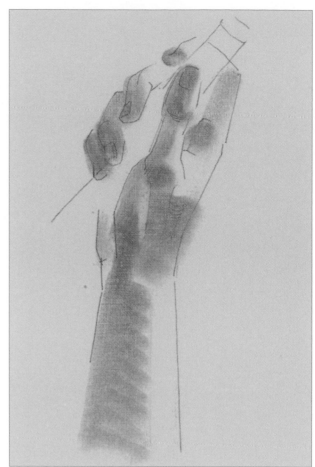

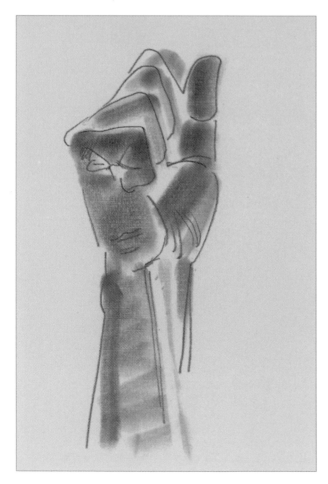

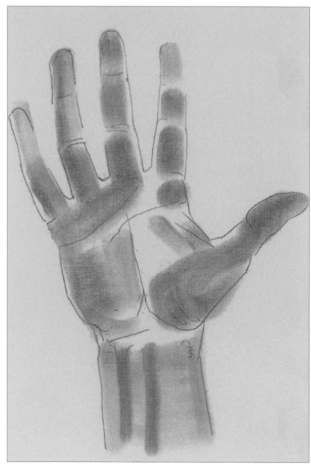

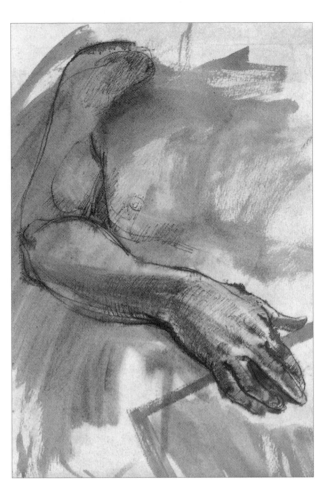

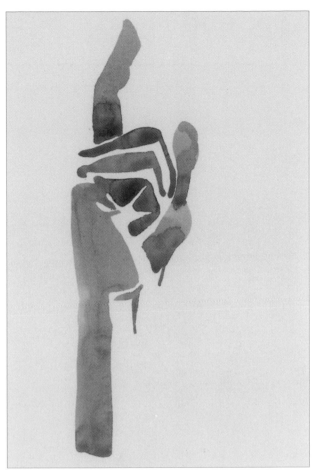

Head and Neck

Wilhelm Lehmbruck (1881–1919): Woman's head, undated.

BASIC PROPORTIONS OF THE HEAD

The typical proportions of an individual's head are key to creating a likeness. The exploration of relative lengths means that in terms of the vertical structure:

• The bisecting axis at eye level (bright red) lies halfway between the top of the head and the chin.

• The basic mass of the cranium (red shading) is roughly a circle whose centre is at $^1/_3$H (where H is measured on a vertical axis from the top of the head to the chin. The circle therefore intersects the central axis at $^2/_3$H, at the spine of the nose (just above the tip). This point is also the horizontal skull base.

• Most of the facial skull is in the lower part of the head, and the centre of its circle (greenish shade) in the middle of the line between the orbital axis and the tip of the chin (therefore at a quarter of the head height above the chin).

• The cranium and the facial skull intersect in a way that largely corresponds to the frontal view of the natural face.

• The fleshy nose, with its tip, is a little below the nasal spine.

• The mouth opening is always located above the centre of the line between the tip of the nose and the tip of the chin.

• The length of the ears is more or less identical to the length and situation of the nose (from nose tip to nose base).

• The hairline is situated more or less in the upper half of the circle of the skull (i.e. in the upper sixth).

In terms of the lateral structure we can say the following:

• The greatest width of the head (red circle) = two thirds of the head height.

• The length of an eyelid is approximately one fifth of the length of the bisecting axis at eye level.

• The gap between the eyes (from one inner corner to the other) is approximately the length of one eyelid = one fifth of the orbital axis.

• The width across the nostrils is more or less the same as the space between the eyes; the width of the mouth exceeds the space between the eyes.

The grey bars emphasise the proportions: the height and width of the cranium is $^2/_3$ of the head height; the shortest grey bar shows the lower quarter of the head and is the centre of the radius of the lower facial skull.

These proportions, as well as the oval-shaped head, are generalised and so may vary in individual cases.

Käthe Kollwitz (1867–1945): Self-portrait, 1937.

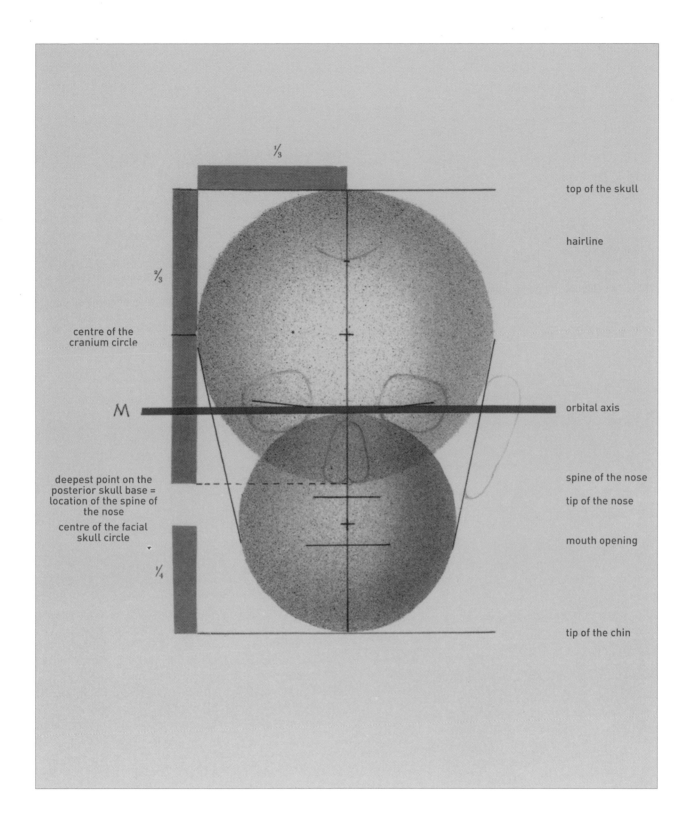

⅓

⅔

M

centre of the
cranium circle

deepest point on the
posterior skull base =
location of the spine of
the nose

centre of the facial
skull circle

¼

top of the skull

hairline

orbital axis

spine of the nose

tip of the nose

mouth opening

tip of the chin

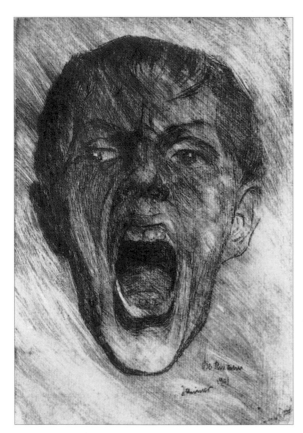

Hubertus Giebe (b. 1953): Self-portrait, 1978.

THE RELATIONSHIP BETWEEN THE PROPORTIONS OF THE HEAD AND THE STRUCTURE OF THE SKULL, FRONT VIEW

The proportional relationships shown in the illustration on page 201 and highlighted again here are related to the structure of the skull, whose larger and smaller bony shapes have a strong influence on the spatial appearance of the live head:

• The cranium, which takes up two thirds of the entire head height, is a largely closed, outwardly protective capsule, which deviates from the basic circular form in the front view and shows particular high points (see the additional grey shading).

• The smaller facial skull, which lies under the cranial capsule, is a supporting structure built up from inside the face to house the sensory organs, the eyes and nose, and forming the jaws and the mouth opening.

• The masticatory (chewing) pressure created in the facial skull is transmitted through the cranium via an intermediate facial column (the chin-nose column) and deflected into a horizontal direction from the teeth across the sides of the nasal passages into the area around the base of the nose and finally to the base of the skull.

• The eyebrow arch forms the boundary between the facial skull and the cranium. The lowest point of the horizontal skull base (see also the illustrations on page 211) is more or less identical to the base of the nose and the auditory opening.

• The masticatory pressure is transmitted by the horizontal maxillary branches of the lower jaw, which form the sides of the face, to the area of the temples, to which they are related in form and function.

• The cheekbones, which project from the central pillar of the face at the level of the nasal spine, on the one hand provide the lower frame for the orbits and on the other the horizontally protruding support for the origin of the masticatory muscles.

• A laterally projecting shape develops from the cheekbone to the auditory canal via the connection to a bony 'handle' on the cheekbone, the cheekbone arch (zygomatic arch).

• The bony ovoid shape of the downward-facing facial skull is bevelled off by the tip of the chin and the angled sides of the jaw.

• The inner angle of the lid crop lies on the orbital axis, the outer angle a little higher.

Drawing the skull (pages 223–225) must be approached on the basis of understanding of the structure and function of the skull. However, two-dimensional studies of the head can easily be attempted given some knowledge and understanding of proportion.

Max Beckmann (1884–1950): Self-portrait, 1901.

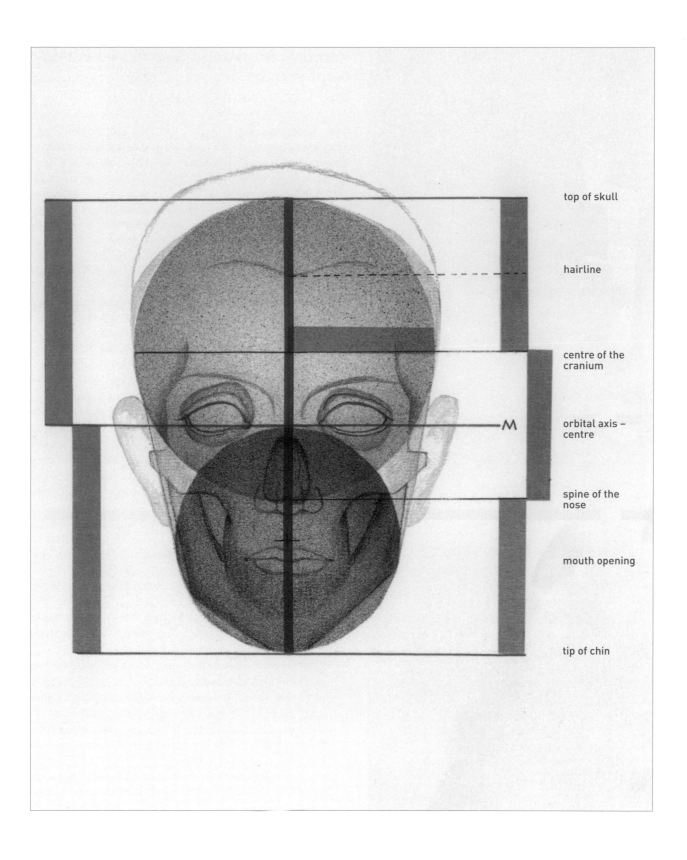

top of skull

hairline

centre of the cranium

orbital axis – centre

M

spine of the nose

mouth opening

tip of chin

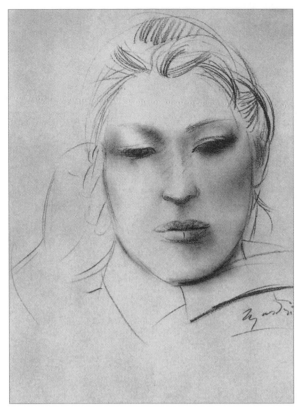

Giacomo Manzù (1908–1991): Portrait of Inge, 1952.

EXPLORING THE PROPORTIONS OF A LIVING FACE, WITH EXERCISES

Pages 205–209:
It is not necessary to have gone through the entire anatomy of the skull, the head and its constituent parts before attempting structured studies of the head seen from the front. Here are some tips:

• Start from the centre vertical line of the head and draw this running straight down from the top of the head to the tip of the chin (red horizontal bars).
• Use the eye level axis as the centre of the head.
• Put in the level of the hairline, about one sixth of the overall height below the top of the skull. The face height thus created is often based on a threefold division: top third from hairline to eyebrows, central third from eyebrows to tip of the nose, bottom third from tip of the nose to tip of the chin.
• Add the hair to the top of the skull.

Exercises

1 Make a preliminary drawing of the proportional framework for the head with vertical and horizontal divisions as explained above (page 206, top).

2 Dipping your finger into graphite dust, work playfully and pleasurably at building up the framework without feeling inhibited, without worrying about judgements of the vertical and horizontal forms that you have learned: do not worry about anatomical concerns (page 206, bottom).

3 Keep working on the different parts of the head with these minimal resources, letting the simple forms merge into each other through expansion and similarity of tone, and allowing the peaks and troughs to have their say (page 207).

4 Enjoy a change in medium (e.g. use wax batik). The process of building up the drawing remains the same. Naturally, if the face is turned or inclined, the entire framework of axes need to be angled accordingly (page 208).

5 Change over to a brush and practise the estimation of distances. Only indicate the top of the head, the tip of the chin and the orbital axis. Now put in the most simply structured shapes of the face, framed by the hair, without any underdrawing whatsoever. Do not attempt to incorporate any physical structure (page 209, top).

6 Now try to do without the last proportion reference points and simply use your judgment. 'Finger-painting' with graphite dust forces us to use the simplest forms, which do not necessarily require further elaboration of the shapes (page 209, bottom).

It is astonishing how simply knowing that the centre of the head is the orbital axis can be such a great help in studies of the head. We can adapt to the individual facial features of a person from more accurate proportional descriptions.

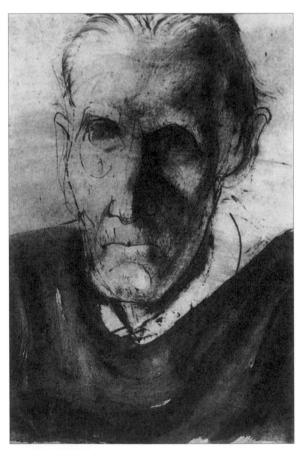

Josef Hegenbarth (1884-1962): Old lady, early 1930s.

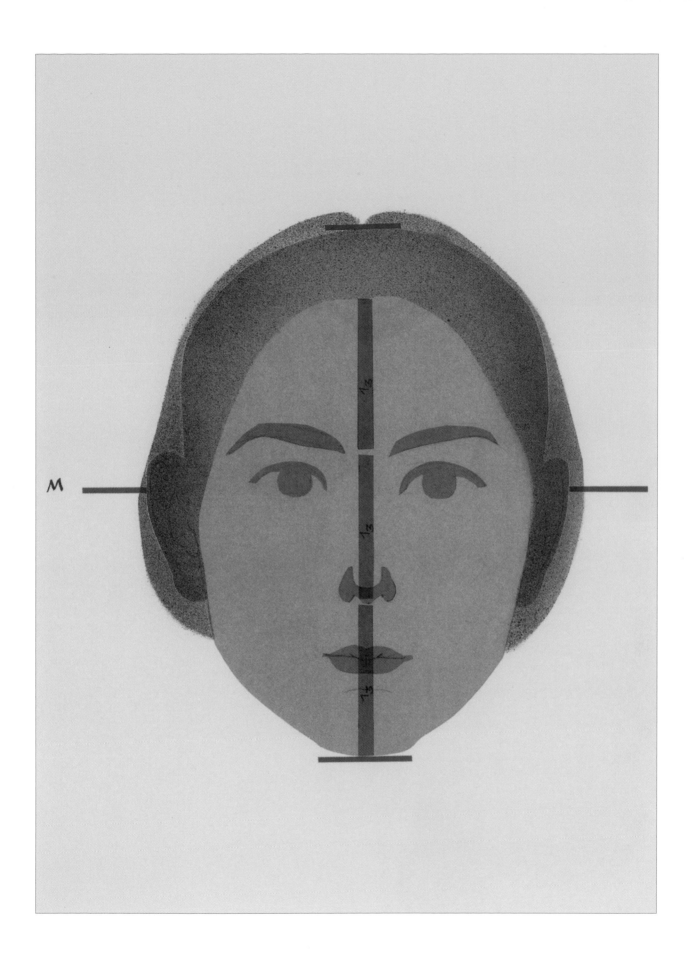

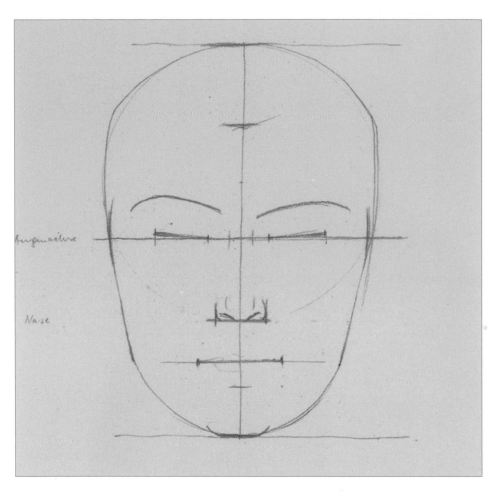

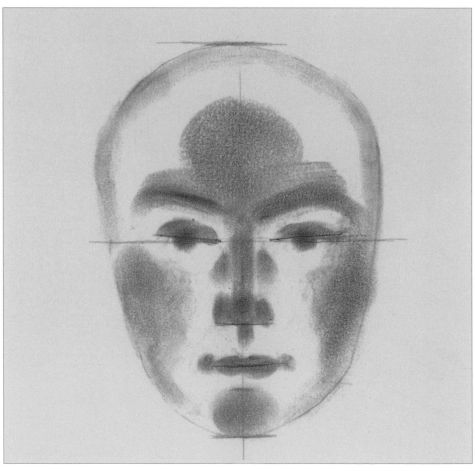

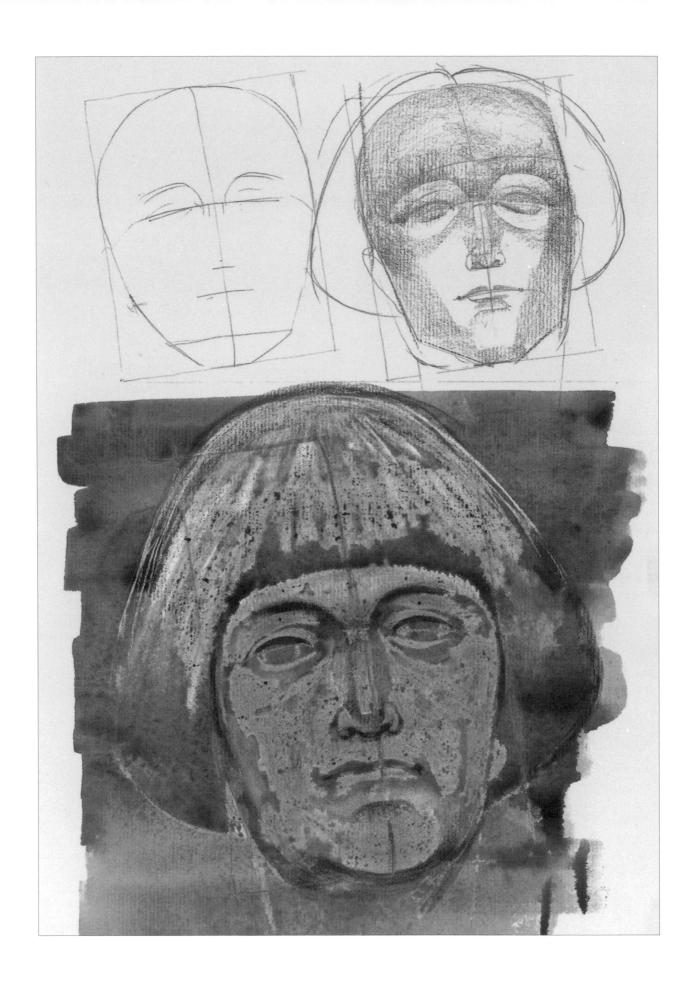

Pablo Picasso (1881–1973): Woman's head from a
sketchbook, 1923.

BASIC PROPORTIONS OF THE HEAD COMBINED WITH THE SKULL STRUCTURE, IN PROFILE

To tackle the profile we need to provide further generalisations regarding the two sections of the skull – the cranium and the facial skull – given their asymmetrical shapes. These are illustrated opposite:

• Building further on the two-thirds distance from the top of the head to the spine of the nose, we will first mark out the same length towards the back of the head (grey square). But because this distance is too short for the depth from the forehead to the back of the head, it needs to be extended.

• The upper square is again divided into three and that distance will be added towards the back of the head (+). In this way we have described the rough form of the cranium as a long rectangle.

• The oval form of the cranium is fitted into this cranium rectangle (page 211, top).

• We now bisect the longer side of the rectangle with a line (red vertical), which cuts through the auditory opening of the ear.

• 'Hugging' the auditory opening, we follow the pivot of the rising maxillary branch obliquely downwards and then make an obtuse angle (the jaw angle) with the tip of the chin.

• The anterior (front) part of the base of the skull rises upwards from the auditory opening to the eyebrow arch.

• The rear of the base of the skull is shown in an almost horizontal plane extending to the rear of the skull (page 211, bottom).

• The basic ovoid shape of the cranium is differentiated by further accentuation (grey tones), so that the rear of the skull becomes fuller and the entire cranium (with its blunter end at the rear of the skull) now resembles an egg tipped backwards on its base (bottom illustration).

• The profile of the face is slightly convex, with receding sections alternating here and there with projecting shapes.

• The handle-shaped cheekbone arch must now be drawn, with its top edge in a stretched, horizontal line (at the lowest point of the eye socket) up to the auditory opening. The cheekbone determines the width of the face.

• In profile, the European eye has a triangular shape within the foreshortened orbital socket (do not forget the curve of the upper eyelid).

• The ear lies at an angle to the side of the skull, like a continuation of the direction of the rising jawbone.

The dynamic path described by the facial profile is an unmistakable feature of each individual person, based on exact proportions.

Max Beckmann (1884–1950): Self-portrait, 1950.

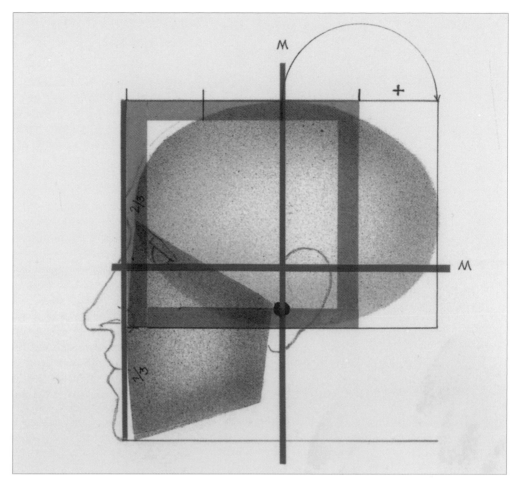

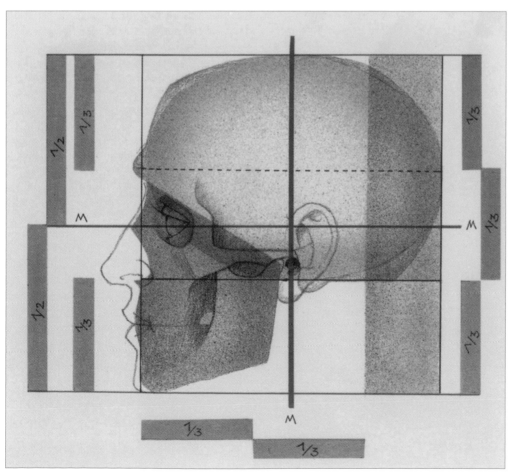

Ottavio Leoni (1578–1630): Head and hand studies, undated.

HEAD PROPORTIONS AT VARIOUS AGES

Regarding proportions in young people, we concluded that there is no generalised young person or child, but only their age-related figures. We also need to apply this fact to their head proportions and abandon the simplistic idea that the head of a child is simply smaller than that of an adult. The most significant differences can be found in the ratios between the cranium and the facial skull. What do we need to pay attention to?

Top and centre row:
• The orbital axis of a baby (opposite, left) is clearly below the halfway mark (broken line) between the top of the head and the chin.

• The same applies to the orbital axis of a six-year-old, but the orbital axis is closer to the centre of the head (centre illustration), because, when the teeth change, the dental alveoli (the sockets that secure the teeth) and therefore the length of the upper and lower jaw are elongated and the facial cranium lengthens downwards.

• The absolute size of the baby head is half that of the adult head, and with a six-year-old it is three-quarters of the length (see the broken line extending from the top of the head).

• The predominance of the cranium in babies and six-year-olds compared with adults can be seen from the clearly protuberant forehead in the former and the steep forehead of the latter. Girls also acquire a steep forehead when they grow up.

• The bridge of the nose in babies is flat and somewhat more upturned in a six-year-old.

• In general, one can see that the facial features are very soft, not least because of the weakly formed chin (the upper and lower jaws in babies are clam-shaped only because of suckling liquid food).

• The fatty pads (especially on the cheeks) are particularly evident in babies and infants.

• The lips are red and full and, in the case of a baby, like a Cupid's bow, with a small swelling in the middle of the upper lip.

Bottom row:
To reinforce the visual impression, the grey vertical bars show the distances between the orbital axis and tip of the chin compared with the entire head heights (baby, left, six-year-old, centre). The three right-hand bars show the actual head sizes of the three ages in relation to each other. The baby's head is distinguished by its high forehead, which lends it its human expression.

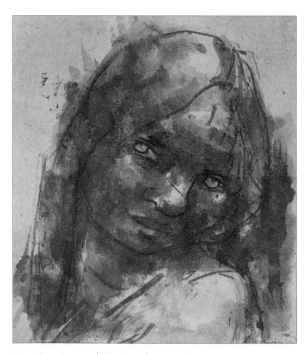

Hans Theo Richter (1902–1969): Young girl, 1969.

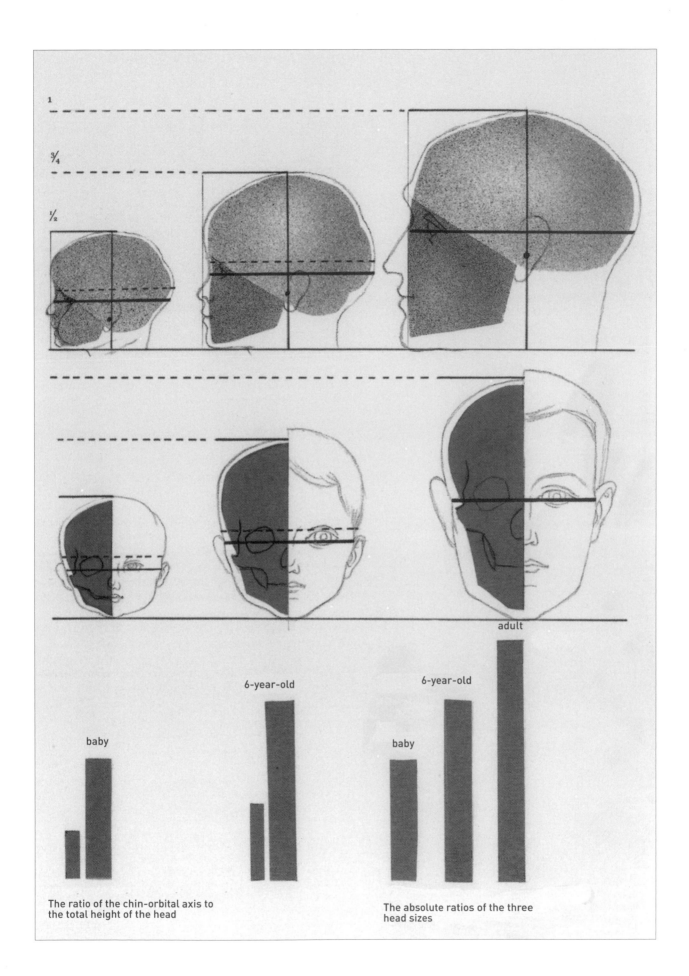

1

¾

½

The ratio of the chin-orbital axis to the total height of the head

baby

6-year-old

adult

The absolute ratios of the three head sizes

baby

6-year-old

Giovanni Battista Tiepolo (1696–1770): Head study, undated.

EXERCISES FOR PROPORTION STUDIES IN PROFILE

Pages 215–219:
The head profile, with its forward-backward, outward-inward moving line is as dynamic as the entire body profile. In contrast to a frontal portrait that engages visually with the viewer, there is no eye contact in profile. However, a person can be identified from a two-dimensional silhouette, though not from a pure frontal outline.

The following factors need to be borne in mind alongside the previously discussed studies of proportion:

• In the first place, it is necessary to explore the continuous shape of the profile – prominent and receding parts (page 215, subsidiary drawings).

• The curves of the individual profile sections (forehead, mid-face and lower face) can be checked by using a plumbline and comparing curves (e.g. the location of the chin compared to the forehead).

• The hairstyle should be treated as a shape added to the outline of the head (page 215).

• The major exploration of proportion must be performed during the first stage of drawing: the ratio between the head height and the head depth (page 216, top left).

• You can check the profile likeness in a critical way by filling in the outline with a broad-tipped drawing implement (page 216, top right).

• You should give the head profile a more three-dimensional relief only when the outline is right (page 216, bottom) and if there is an explicit need to do so.

• You should not turn the generalised data on proportion given in the illustrations on page 211 into a dogma, but rather keep an eye on the differences in ratios and relationships between parts of the head (e.g. the ear insertion and its position and level in relation to the nose, page 217).

Because discussion of the parts of the head is still to come, it is preferable to use broad-pointed implements to create a silhouette in chalk or graphite dust (page 218), using a brush, or with a combination of these (page 219). Noses and ears drawn badly because of lack of understanding are painful to behold. With self-learning tools, you always gain far more by checking the angles and using actual reference lines than by attempting a direct formal likeness that is hard to erase.

Hans Theo Richter (1902–1969): Portrait head of H., 1963.

Josef Hegenbarth (1884–1962): Head of a woman, 1930s.

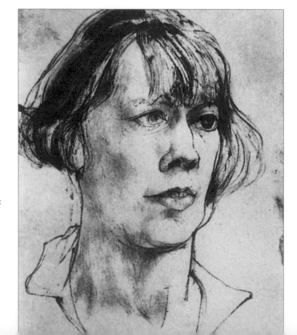

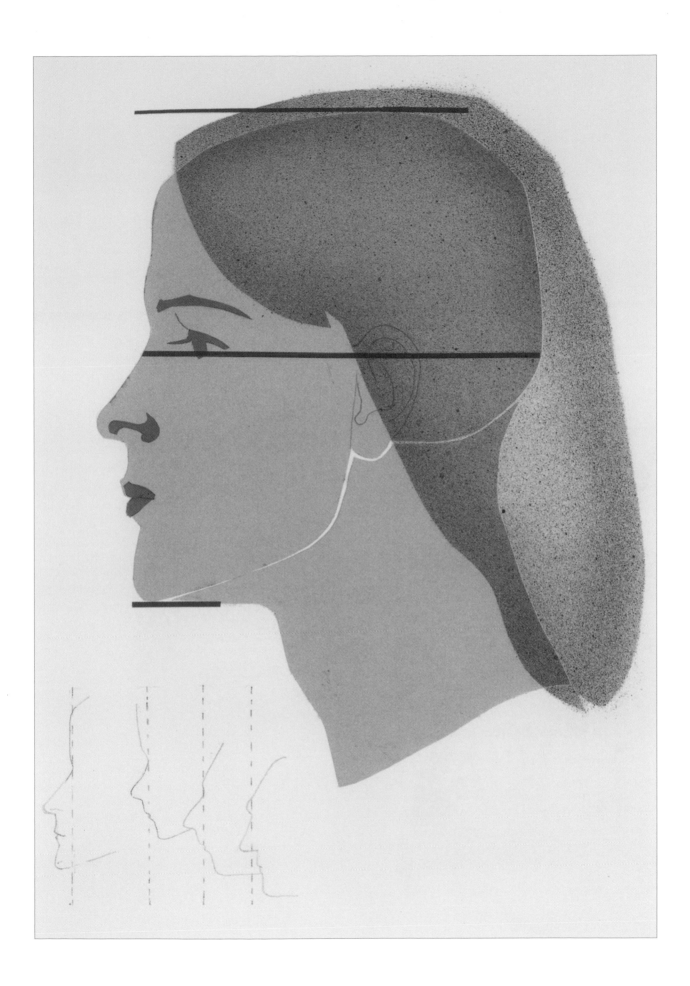

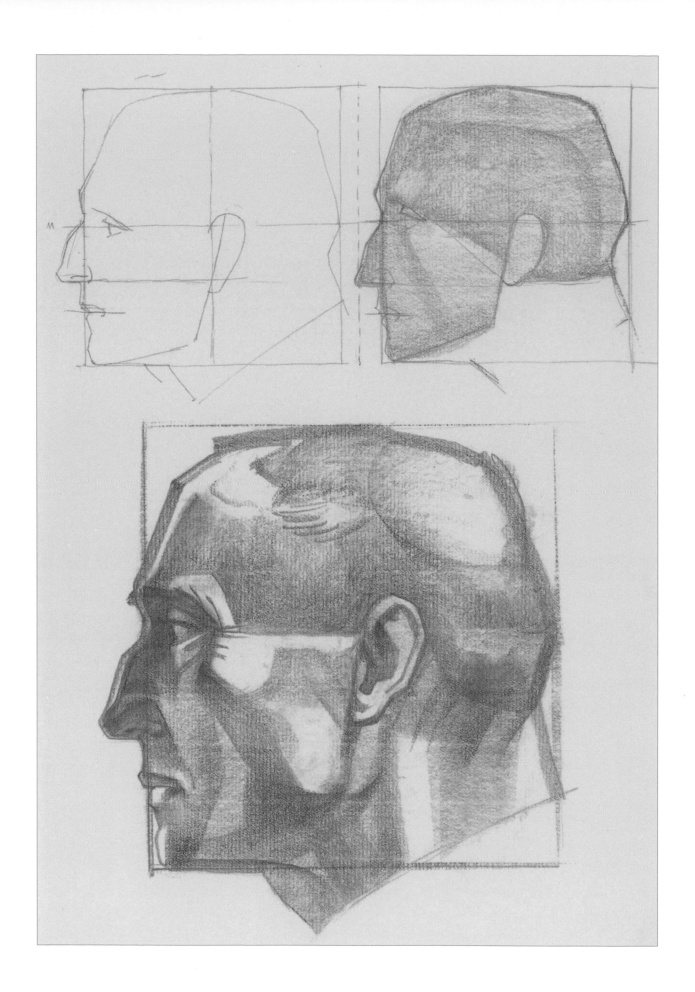

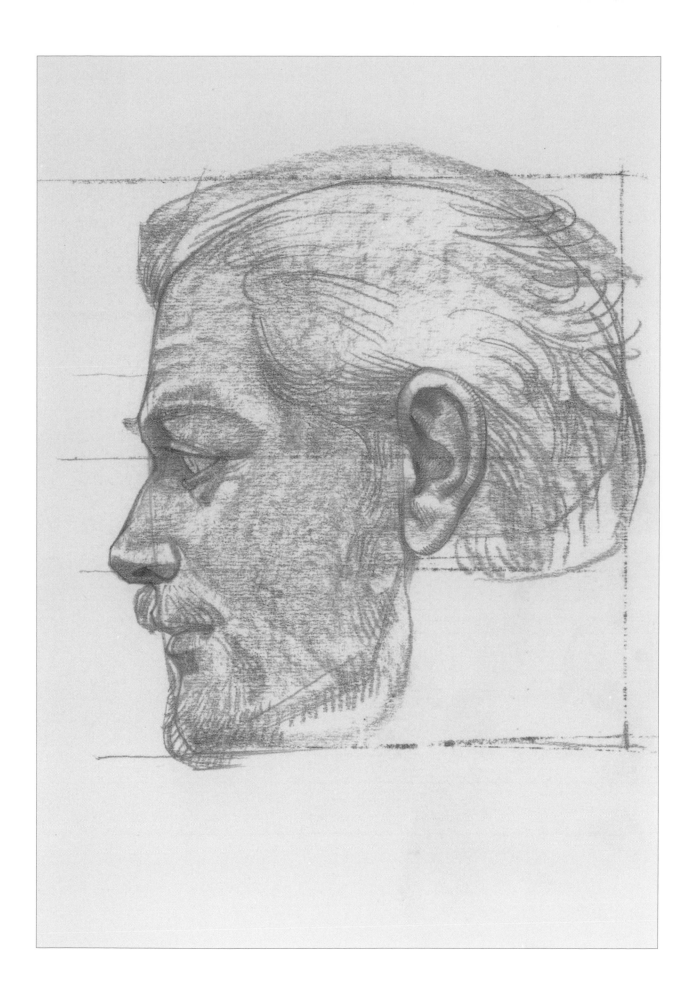

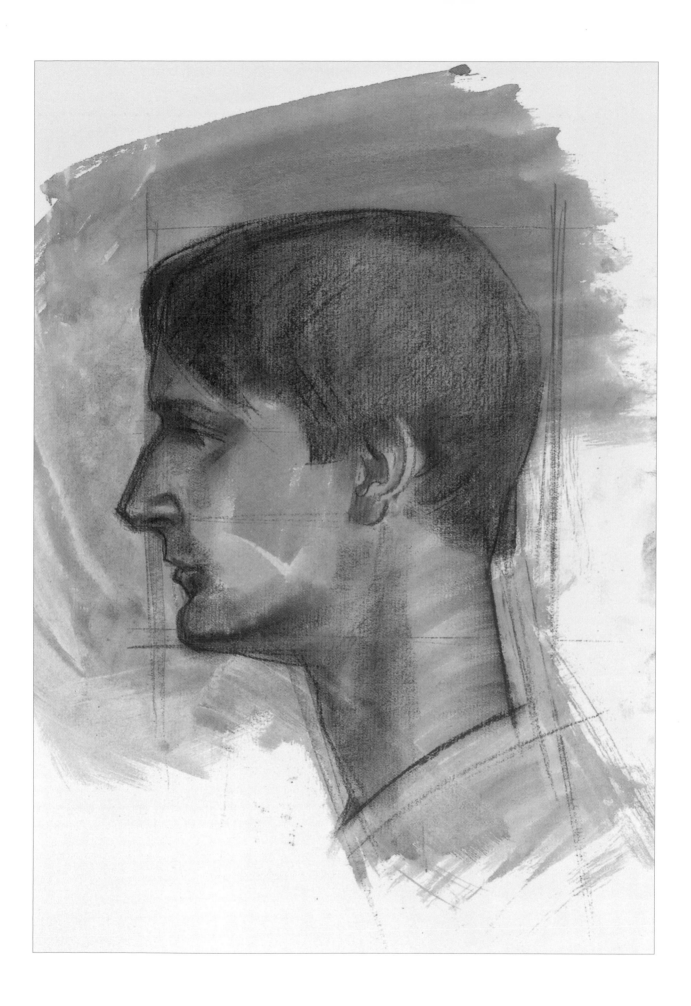

Edward Burne-Jones (1833–1898): Head of a girl, 1879.

THE MAIN FEATURES OF THE NECK STRUCTURE

When it is simplified, the neck looks like a cylinder resting on a base. The more rounded female neck is more comparable to a column than is the more animated neck surface of a male.

What makes up the base of the neck?
• At the front is the curved horizontal of the clavicle in connection with the crest of the shoulder (opposite, top left).

• At the side, we have the descending section of the trapezius, itself an important neck muscle (top right).

• At the back of the neck is the trapezius muscle as far as its attachment to the shoulder blade (not shown).

The base of the neck is thus the accumulated shape of its bony and muscular parts. The base rises from the clavicle to the triangular nape of the neck. The function of the neck, which is to move the head in order to modulate the sensory organs, depends on the muscles acting on it:

• The head-turning paired sternocleidomastoid muscles run from the sternum and the inner clavicle to the deeper layers of the neck and attach to the mastoid process of the temporal bone of the skull behind the ear. Both these muscle bundles stick out sharply when you turn your head, incline it to the side or pull it forwards (peering position).

• The bow shape of the laryngeal prominence (Adam's apple) and the slender superior and inferior stylohyoid muscles at the joint are overlapped by the cradle of the paired sternocleidomastoid muscles.

• The most important counterbalance, and at the same time co-worker, is the neck area of the trapezius muscle, attached to the occipital bone at the back of the head (see the illustration bottom right and on page 155), which allows the head to bend backwards, holds it when it bends forward, and also supports twisting and lateral movements.

The head-turning sternocleidomastoid muscle and the neck area of the trapezius muscle both tend to form a spiral shape, which enables such versatile positioning of the head. The two create a nearly parallel space which is filled by the deeper neck muscles.

Essentials in drawing the neck are:
• Gentle tapering of the neck column towards the base of the neck.

• The division of the triangular nape of the neck by the sternocleidomastoid muscles (front view).

• Intersection of the sternocleidomastoid muscles by the trapezius muscle (rear view).

• The trapezius muscle intersecting itself in the transition from the nape of the neck to the shoulder.

André Derain (1880–1954): Bust of a woman, undated.

N. A. Tirsa: Study of a seated woman leaning sideways, with separate study of head, undated.

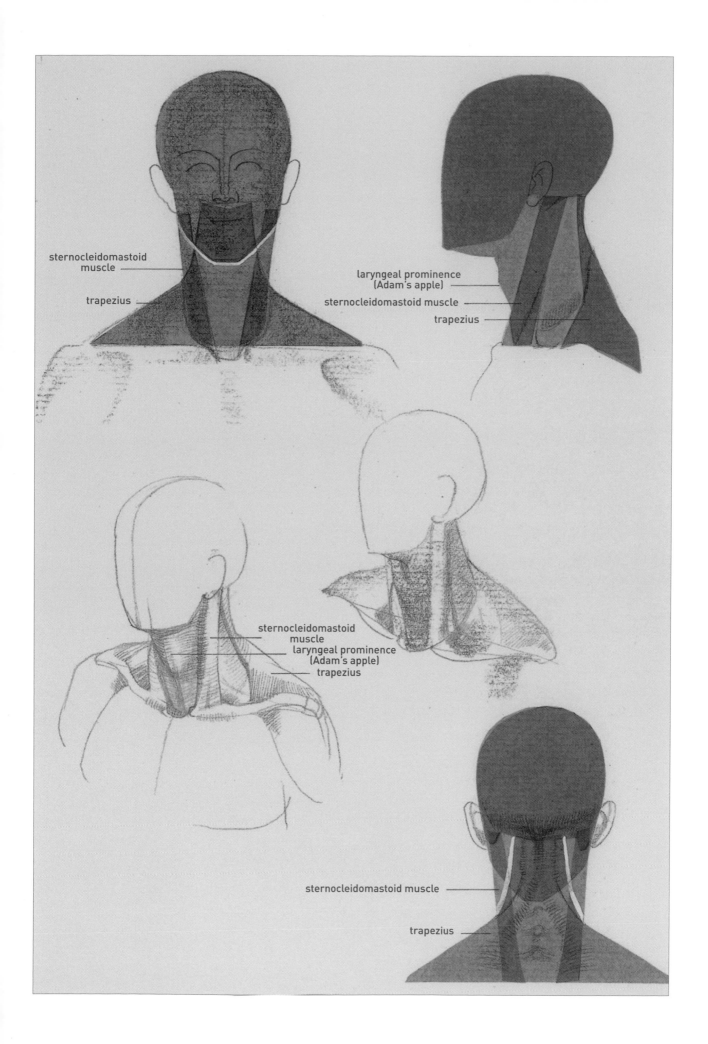

sternocleidomastoid
muscle

trapezius

laryngeal prominence
(Adam's apple)

sternocleidomastoid muscle

trapezius

sternocleidomastoid
muscle

laryngeal prominence
(Adam's apple)

trapezius

sternocleidomastoid muscle

trapezius

Karl Hofer (1878–1955): Self-portrait, c. 1940.

Josef Hegenbarth (1884–1962): Head of a forest worker, late 1920s.

SIMPLIFYING THE MAIN HEAD SHAPES

In order to support the physical appearance of the head and to learn to portray it from different views and in various positions, the two main shapes formed by the skull around the brain and the face are first reduced to the mass of their volumes. There are a number of factors to consider here.

Page 223:
• The ovoid shape of the cranium must be rendered concisely, that is, it must be given planes of view that relate to one another at various angles. Think about the frontal, temporal, parietal (back of the head), occipital (across the eyes) and base planes.

• The planes of view must be rendered according to the sphere shape of the head.

• The bow shape of the facial bones needs to be added from below to the front, sloping base of the cranium.

The representation would gain even more from the modelling of these simplified shapes, on the basis of which many angles and foreshortenings would need to be graphically amalgamated (page 225, bottom right). Once you have mastered the representation of the major shapes of the head, the actual constructive drawing of the skull can begin.

Page 224:
• You need to understand the skull as a composition of facets, much like those of a prism.

• Bring the middle and the side pillars of the facial bones (horizontal maxillary branches) into functional and spatial connection with the cranium (for example, the inner wall of the orbital pyramid is part of the face's central pillar).

• Build secondary shapes on top of the basic shapes, e.g. the cheekbone arch (like a handle), a bony nose and so on.

• Use hatching to give all planes clear and highly contrasting three-dimensional inclines.

Page 255, top:
As a prerequisite for these steps, the initial design must be preceded by a spatial reference system (using vertical and horizontal axes) that must deal with the problems of foreshortening right from the start.

Page 225, bottom:
• All hidden corners and edges must also be plotted, in order to realise the shape wherever it becomes hidden from view (bottom right).

• This means that reference points (also hidden) must always be fixed on both sides: what is on the near side and what is on the far side of the symmetrical axis?

• The partial shapes of the head must be placed on the skull drawings.

If skull drawing is not practised as if it were architecture, with a perpetual ordering of primary and secondary aspects – if it is not done with awareness – it will degenerate into nothing more than clever copying and will not provide any gain in knowledge or vision.

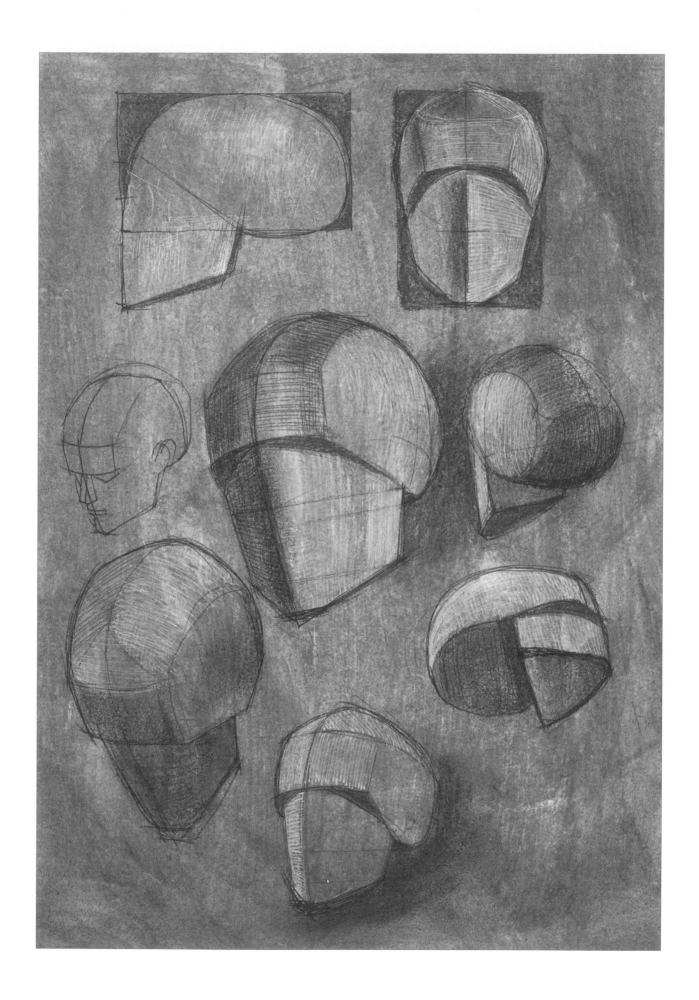

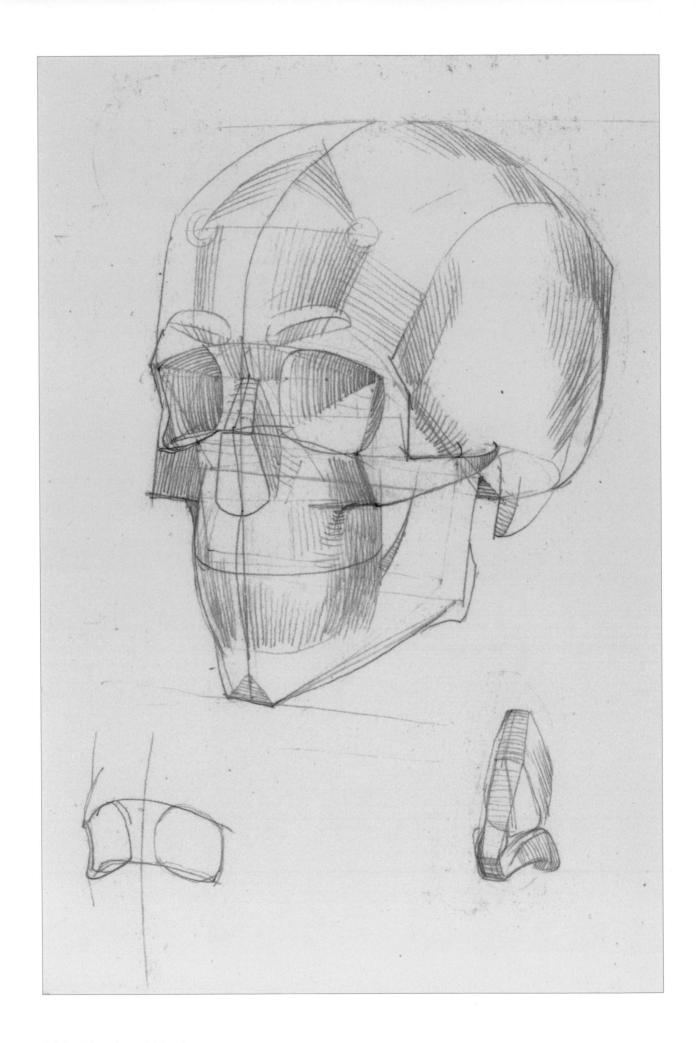

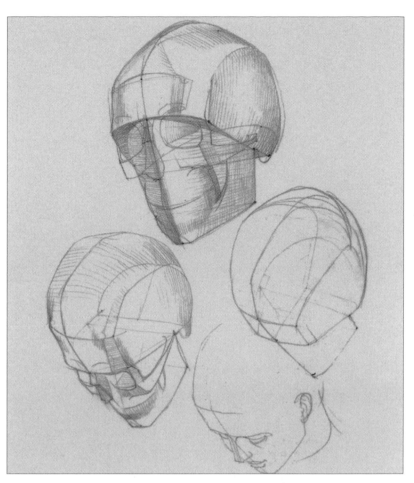

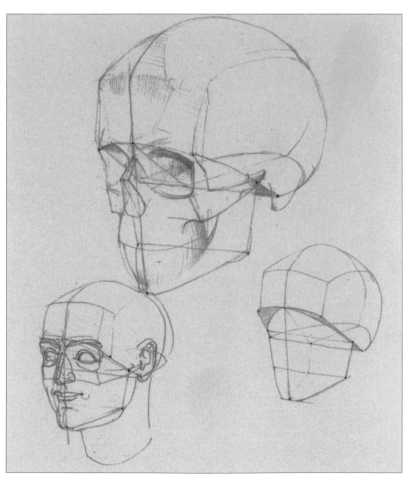

Andrea del Sarto (1486–1530): Head of a
man, undated.

Giovanni Bellini (c. 1430–1516): Portrait of a man
in a turban, undated.

THE MUSCLES AND THE EYES

Page 227:
The undeveloped volume of the face's mimic muscles, whose course is significant only for the correct rendering of wrinkles, is not dealt with here, but the more voluminous mastication muscles are covered.

• The fan-shaped muscle of the temple originates in the temporal fossa and is joined to the muscular process of the lower jaw.

• The bulbous jaw muscle originates at the cheekbone and cheekbone arch and is joined to the corner of the jaw.

Both muscles use the jaw joints as a pivot point for compression of the lower jaw against the upper jaw.

The basic shape of the eye, page 228:
• Drawing the eye must always be guided by the idea of a sphere (eyeball) with an adjustable optical aperture (top), surrounded by the skin of the eyelids.

• The shape of the skin, which releases a small portion of the eyeball, is called the lid crop (centre), with an inner and outer corner of the eye (canthus).

• The imaginary axis between the two angles bisects the arched lid into a larger upper part and smaller lower part.

• The brown arrows show the position at the apex of the curvature of the lid crop. The curvature of the apex is asymmetrical and does not resemble an almond shape.

• The coverage of the inner canthus with skin (epicanthus) gives the eye the familiar 'mongoloid' shape (secondary drawing, below left).

• The iris is partly covered by the upper lid (open resting position, bottom centre). When fully visible, the iris makes the eye look rigid with fear.

• In profile, the eye is foreshortened into the shape of a spherical triangle. Note: The lids are bulky and can be adapted to the spherical shape of the eyeball.

Page 229:
• The lid crop is smaller than the width of the eyeball and the orbit and in Europeans also rises a little towards the outside.

• When drawing the shortened eye (when it is turned away), it must be made clear that the lids stretch over the eyeball and any intersections must also be shown. It is absolutely essential not to omit these spatial considerations.

• The eyeball and the eyelids are situated in the same cavity. The nearest surrounding space, with its bulging form, matches the bulge of the eye.

• The possible views of the eye are: frontal (a), averted slightly to the side (b and c), turning away more definitely to one side (d and f – watch those intersections), from above, with foreshortening of the lower lid (e), from below, with foreshortening of the upper lid (g).

• Even if you develop the volume and spatial intricacies of the eye (h), do not forget the basic idea: a sphere similar in form to its immediate environment.

Josef Hegenbarth (1884–1962): Glass worker, 1929/30.

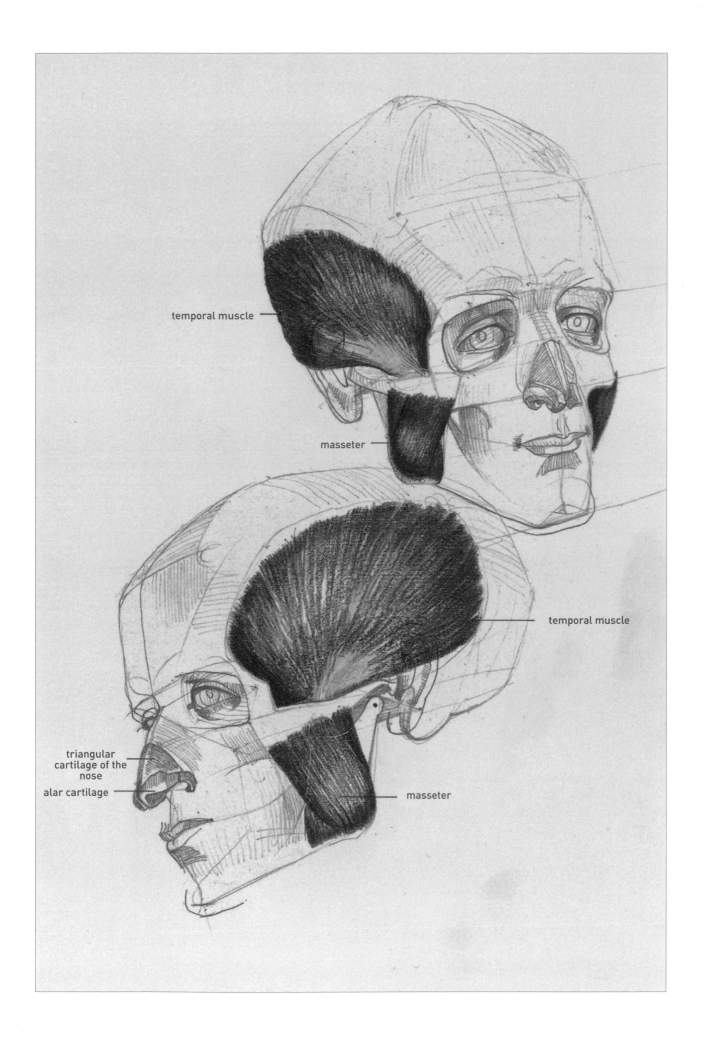

temporal muscle

masseter

temporal muscle

triangular
cartilage of the
nose

alar cartilage

masseter

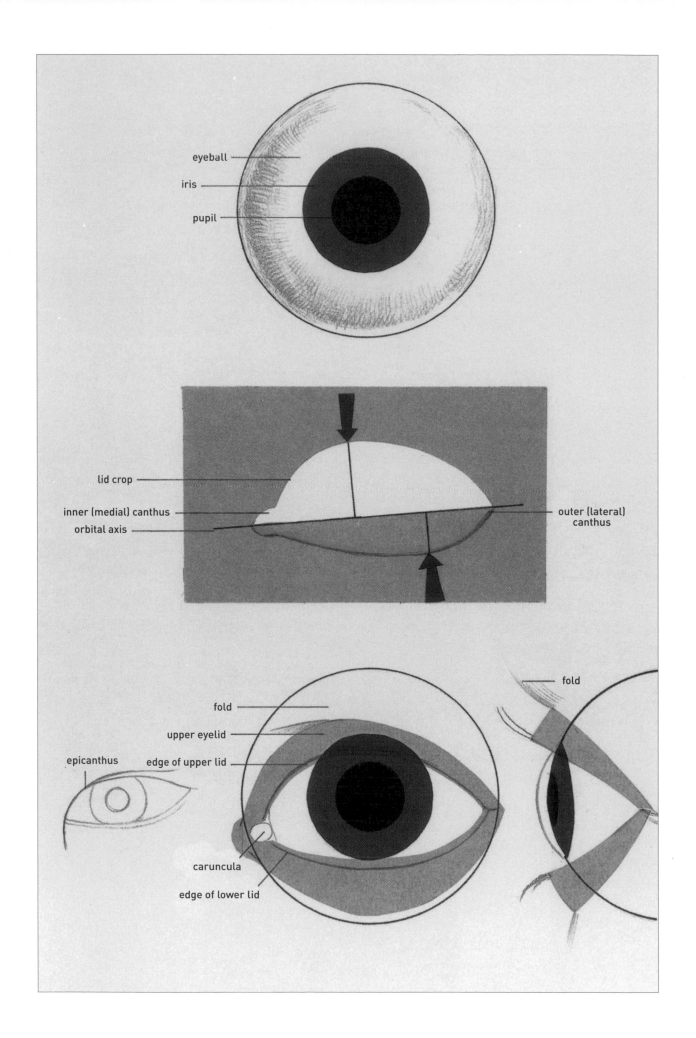

eyeball

iris

pupil

lid crop

inner (medial) canthus

orbital axis

outer (lateral) canthus

fold

fold

upper eyelid

epicanthus

edge of upper lid

caruncula

edge of lower lid

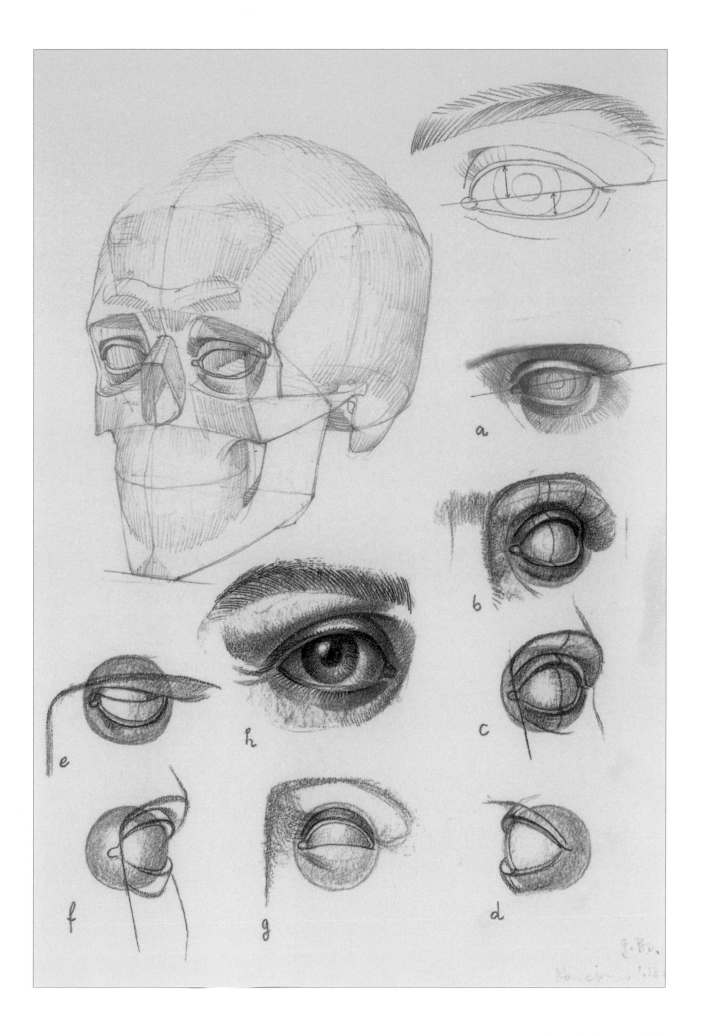

a

b

c

d

e

f

g

h

THE EAR

The ear is one of the sub-shapes of the head that is most neglected by illustrators. Although the outer ear varies considerably in shape, its structure is governed by general laws:

• The auditory opening is surrounded by protective, enveloping shell-like cartilage.

• Its attachment to the skull is usually on an inclined plane, which corresponds to the direction of the rising maxillary branch (illustration top left).

• The entire outline can be compared to an opened-out spiral whose stability is ensured by the cartilaginous helix and fades above the earlobe (skin and connective tissue). This is shown in dark grey shading.

• Connected to the helix by a fold (but not parallel to it), the anti-helix divides into a Y-shape in the splayed-out upper part of the ear, creating a dip called the fossa triangularis.

• The anti-helix surrounds the actual outer ear (concha) and ends in its lower section at the anti-tragus.

• The tragus wraps itself protectively in front of and above the auditory opening.

• The tragus and anti-tragus are separated by a gulf.

• The cartilage-free earlobe hangs below the tragus and anti-tragus, and is often closely fused with the membranous part close to the posterior cheek and partly divided from it by a deep incisura (notch).

• The sweeping arched helix connects on one side to the skull in the junction of the cheekbone (zygomatic arch) with the skull, and passes on the other side into the depths of the concha.

The illustrations opposite show the structure of the ear (top left), the same view in more detail (top right), the front view (bottom left), a view slightly from the side (bottom centre) and a rear view (bottom right).

Drawing the ear reveals a number of overlaps and areas requiring careful deliberation.

Albrecht Dürer (1471–1528): Upturned head of a man, study for the Heller altarpiece, 1508.

Aristide Maillol (1861–1944): Head study of a young girl, 1894.

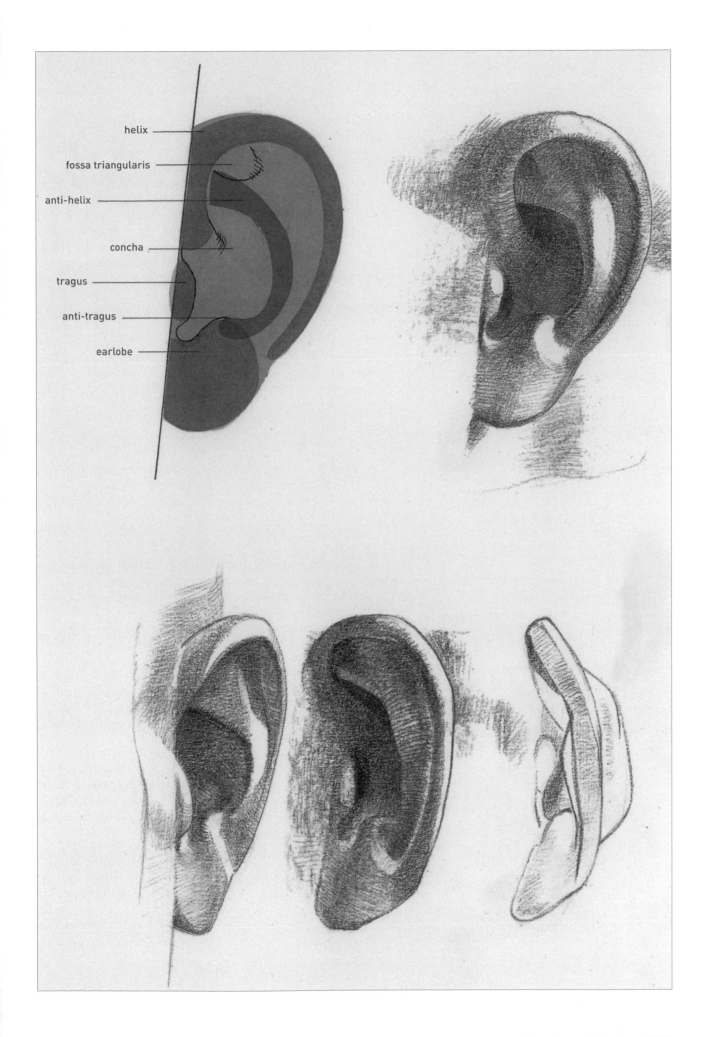

helix

fossa triangularis

anti-helix

concha

tragus

anti-tragus

earlobe

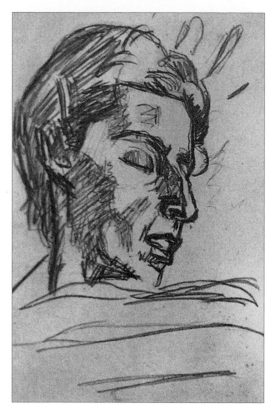

Ferdinand Hodler (1853–1918): Valentine Godé-Darel while ill, 1914.

THE MOUTH, WITH EXERCISES IN DRAWING THE PARTS TOGETHER

The mouth:
• The mouth aperture is identifiable by the surrounding vermilion of the lips. The corners of the mouth are accompanied by gentle dips or dimples.

• Technically the upper lip extends all the way up to the nostrils. The red part of the lip is known as the lip vermilion. In the middle of the upper lip vermilion, especially in children and girls, there is a small elevation, the lip protuberance.

• The border of the upper lip is formed by the nasal spine, while that of the lower lip is formed by the groove called the mentolabial sulcus.

• The chamfered mouth shape is widened by its ring of muscle and the rows of teeth.

In three-dimensional views, key intersections arise in the mouth and its vicinity (page 233, bottom left), which can be used as a way of expressing graphically the three-dimensional shape.

Exercises for drawing the parts together
1 Build up the complex of the mouth, nose and eye and make clear the relationships between these shapes (page 234).

2 Imbed the eye as a ball shape in more-or-less flat surroundings (pages 234, 235 and 236).

3 Give the nose a front ridge and sloping sides (pages 234–239).

4 Express the three-dimensional rhythm, especially from the tip of the nose down, as forward and backward movement, which is particularly important for three-quarter views (page 235).

5 In three-dimensional views of the whole head, first reinsert the spatial reference system of head midline and its intersecting axes (page 237, secondary drawings) and decisively construct the planes and shapes with broad-headed implements.

6 When inserting partial shapes into the whole head (page 236), always first portray the major closed head ovoid shape and its position in space before moving on to the partial shapes and inserting or attaching them.

7 Increasingly let go of the support provided by the structure (proportion requirements, spatial reference system) and gradually abandon generalisations in favour of personal features (pages 238 and 239).

It is possible to test the preparatory work of drawing the skull for the purpose of insightful drawing of the head. You should cover a skull study with tracing paper and draw the life-like image on to it (compare the skull study on page 229 with the corresponding head study on page 238). Also, when drawing the whole figure, never lose sight of the overall shape. The free, multiform playing out of what has been understood takes place only after one has become familiar with the shapes.

Giacomo Manzú (1908–1991): Study for a large female portrait, undated.

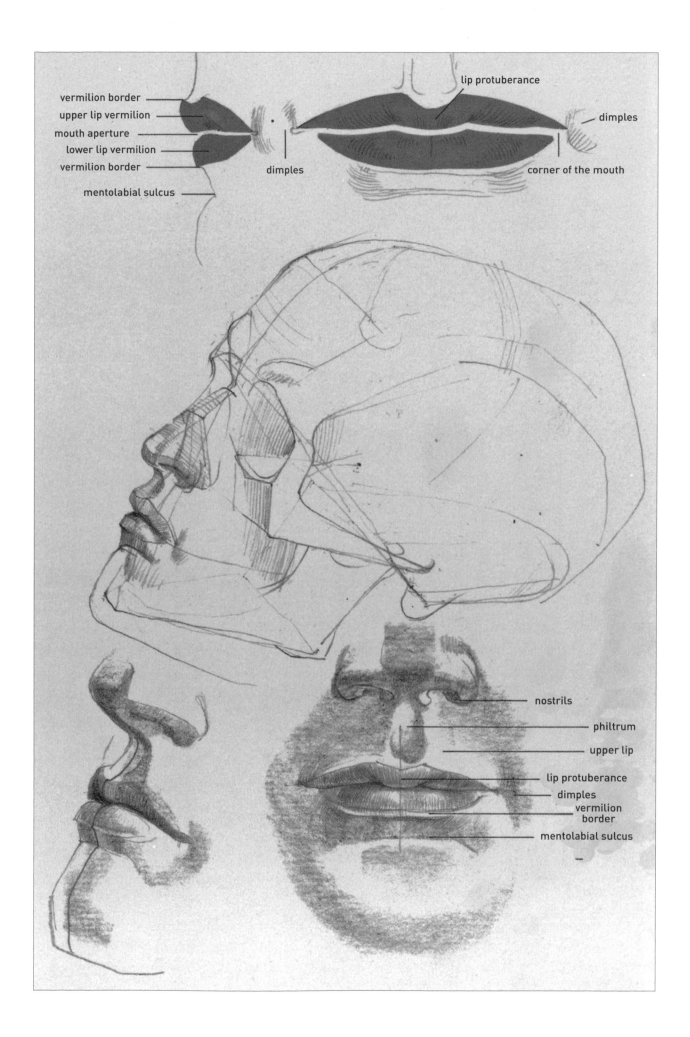

vermilion border
upper lip vermilion
mouth aperture
lower lip vermilion
vermilion border
mentolabial sulcus

dimples

lip protuberance

dimples

corner of the mouth

nostrils
philtrum
upper lip
lip protuberance
dimples
vermilion border
mentolabial sulcus

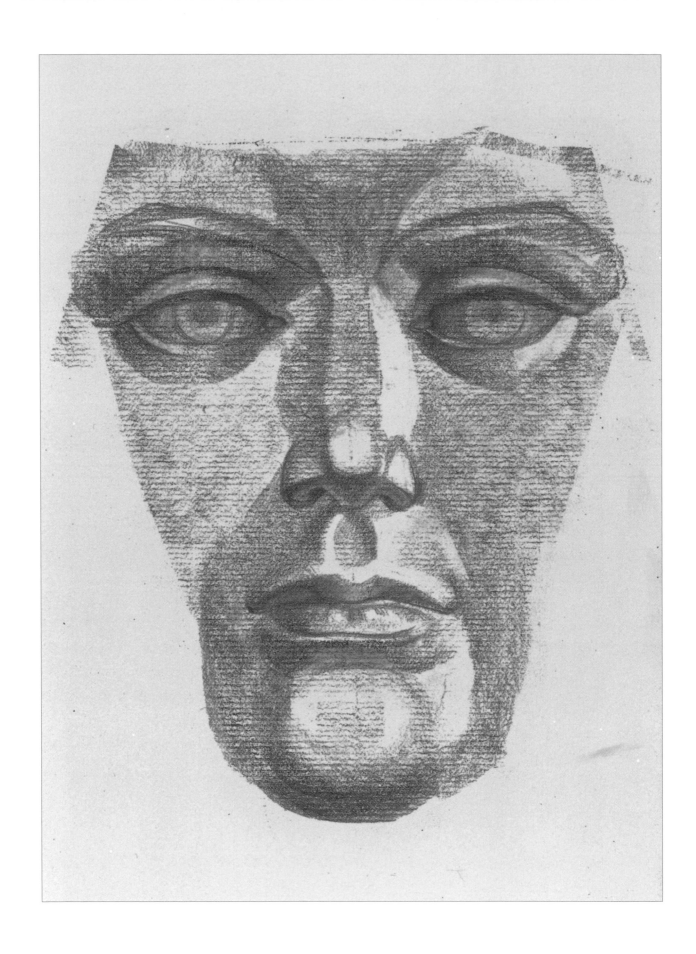

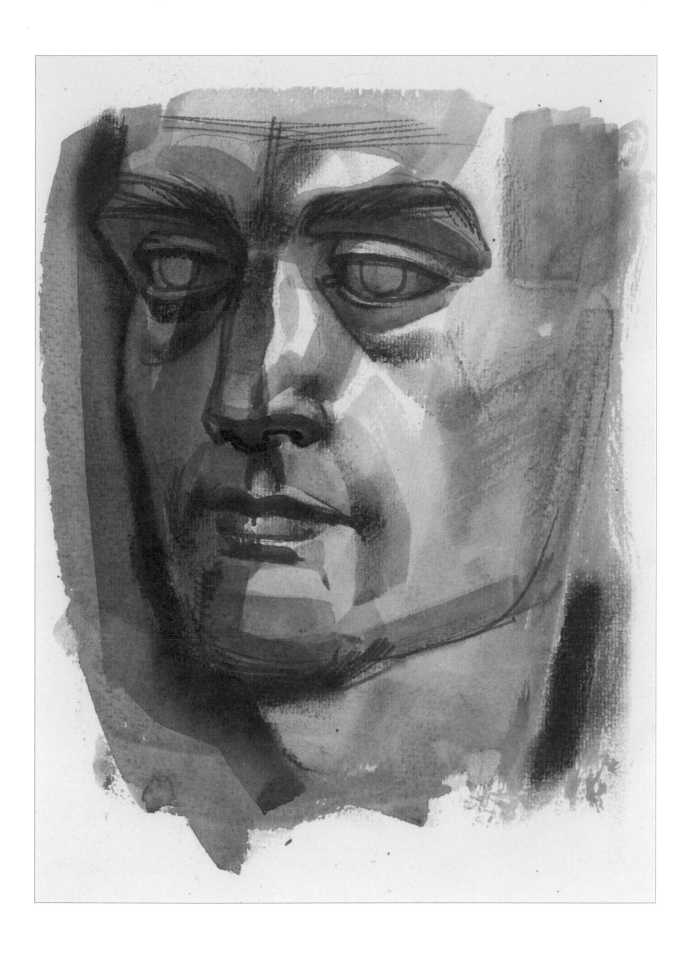

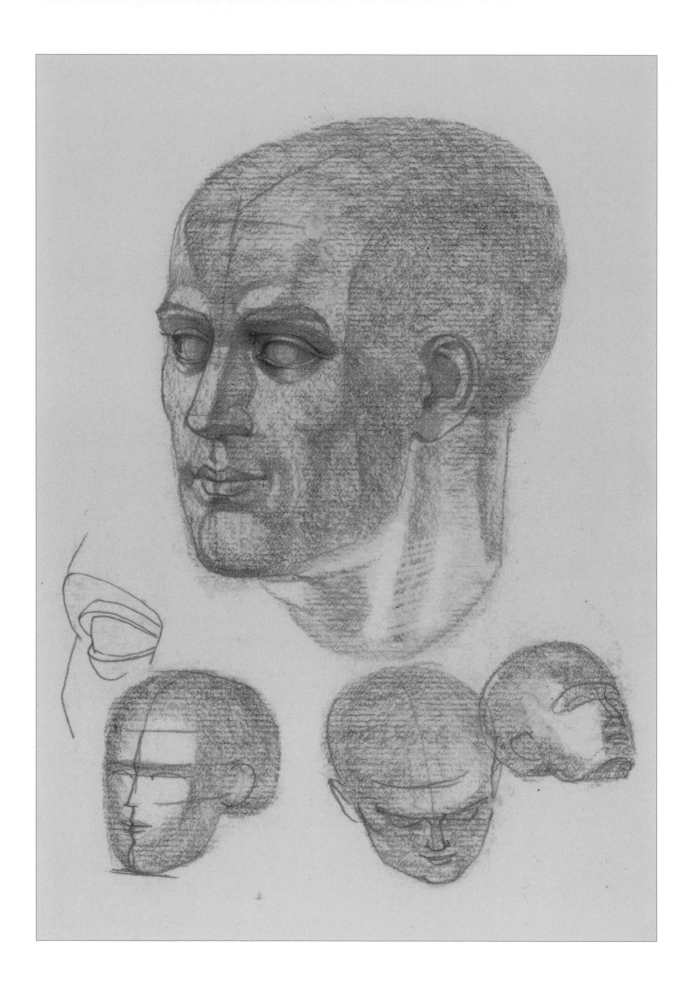

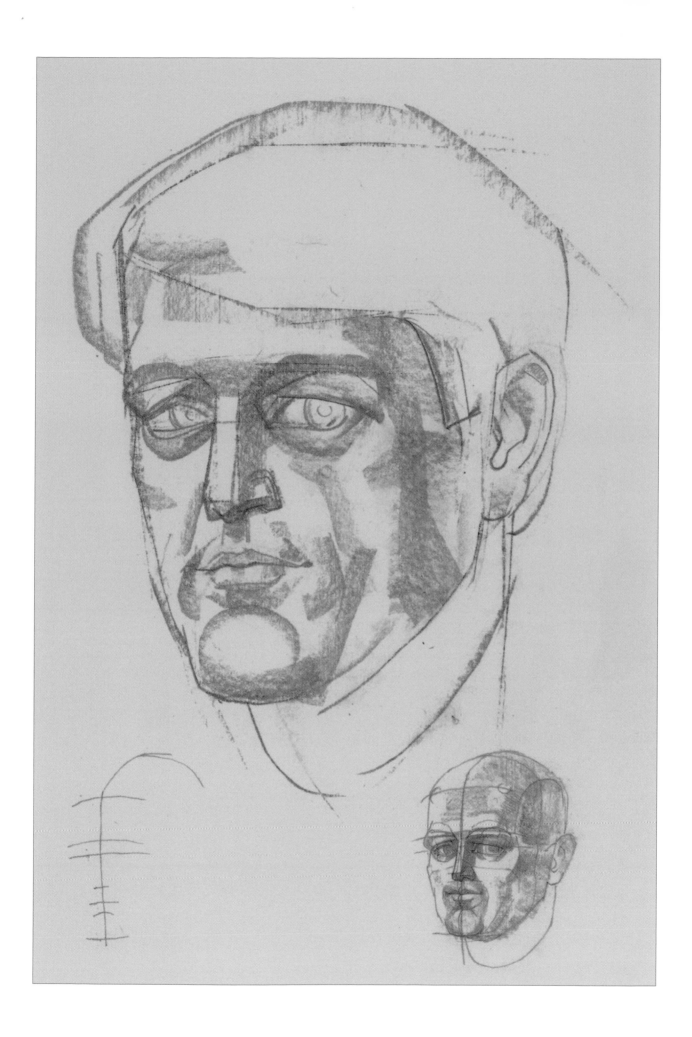

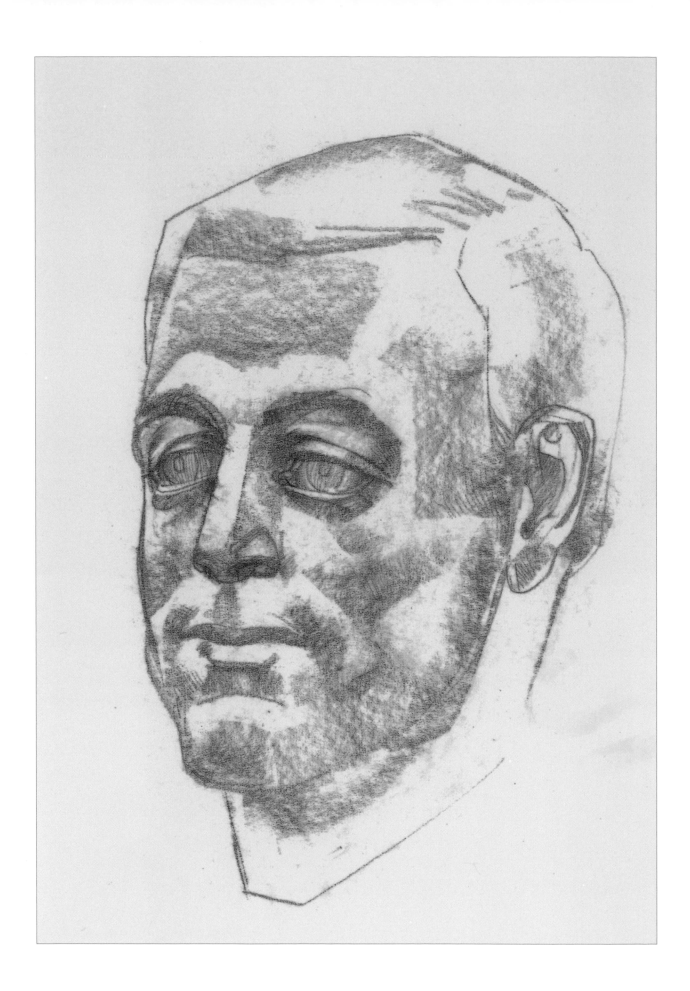

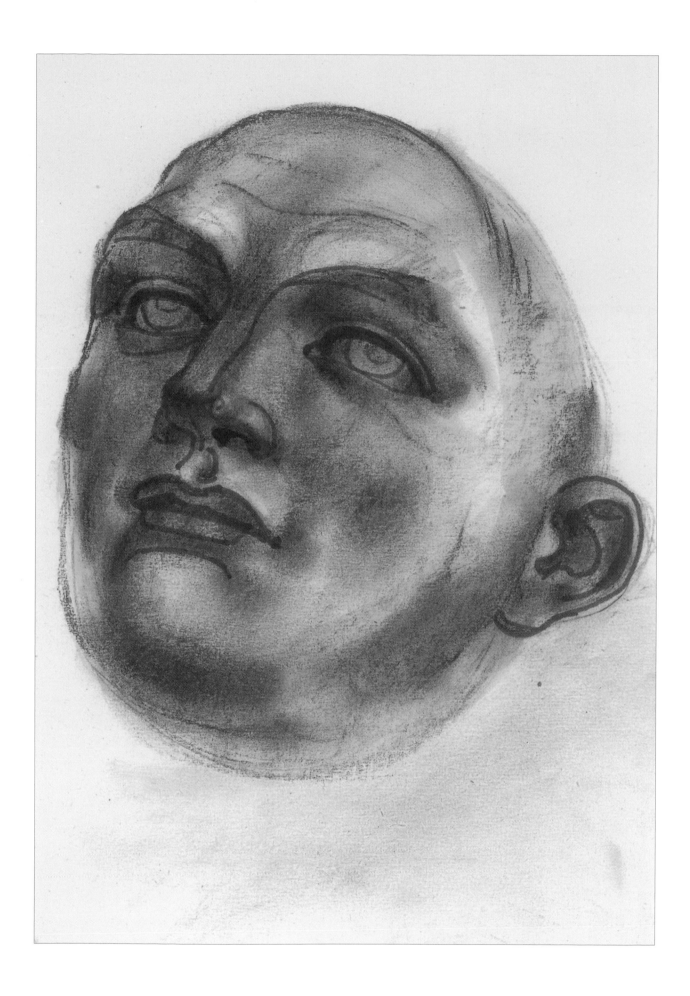

SKETCHBOOK WORK AND OBSERVATIONAL DRAWINGS

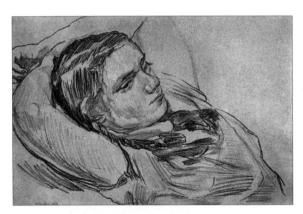

Hubertus Giebe (b.1953): Man's head and hand, undated.

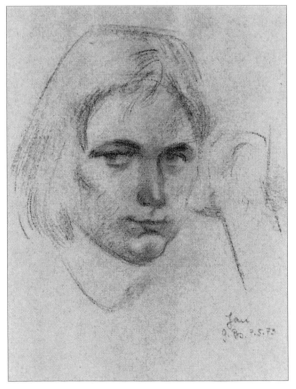

Oskar Kokoschka (1886–1980): Trudl, 1931.

Gottfried Bammes: Portrait of Jan, 1973.

Pages 241–243:
The range of sketchbook work is virtually unlimited, encompassing anything you like: objective notation, impressions (which can be both remarkable and memorable), notes on experiences and ideas, first sketches of a subject or simply the delightful, unplanned play and pleasure of using a pencil.

The statement that a sketch merely provides the major outlines of an idea or impression and is therefore too fleeting in its treatment of details needs to be amended or even revised: the need for haste in relation to fleeting visual or conceptual ideas requires the highest level of concentration. But this has nothing to do with erratic, 'skilful' negligence or any alibi for covering up what has not been resolved. Far from it. The perception-related attributes of this activity go together with the ability to filter out and select anything not immediately essential to the fundamental realisation of subjects and ideas. In relation to the head: the shorthand here does not work simply through omission. There is increased activity of the inner or outer vision observing key features of face and disposition, from the characterful head to caricature, from friendly observation to caustic revelation.

In particular, very specific observation reveals the nuances and trends of the almost invisible, and endeavours to exalt the curiosities of individual forms. It is a very certain way to find the truth: an elongated, slightly aquiline nose becomes a long hooked nose and its tip, with corners, edges and lines, becomes the place where its prominence is adequately expressed; a low forehead and a short nose are reasons to compress and then stretch out the entire face, with a pinched eye and a mouth half-closed determining the expression. Or else attributes of the face, such as a distinctive pair of spectacles, reduce the size of the eye to a single point or even nothing at all; while a ruffled head of curls may largely replace the rest of the physiognomy.

'Making things solid' is one aspect, while mimicry and inner mood are another. There is smug satisfaction, an iconic open eye, the furtive glance round the corner betraying a lack of full attention, the sleepily drooping eye, the tired look upwards, the shielding covered eye, the glassy eye kept open in a battle against sleep, the dozing eye, the eyebrows raised in attention or weighed down with thoughtful concern. It is precisely the juxtaposition of many people with different reactions that offers a broad field of action for the drawing pen, a pen which has the ability to capture even the quiet humour of many situations.

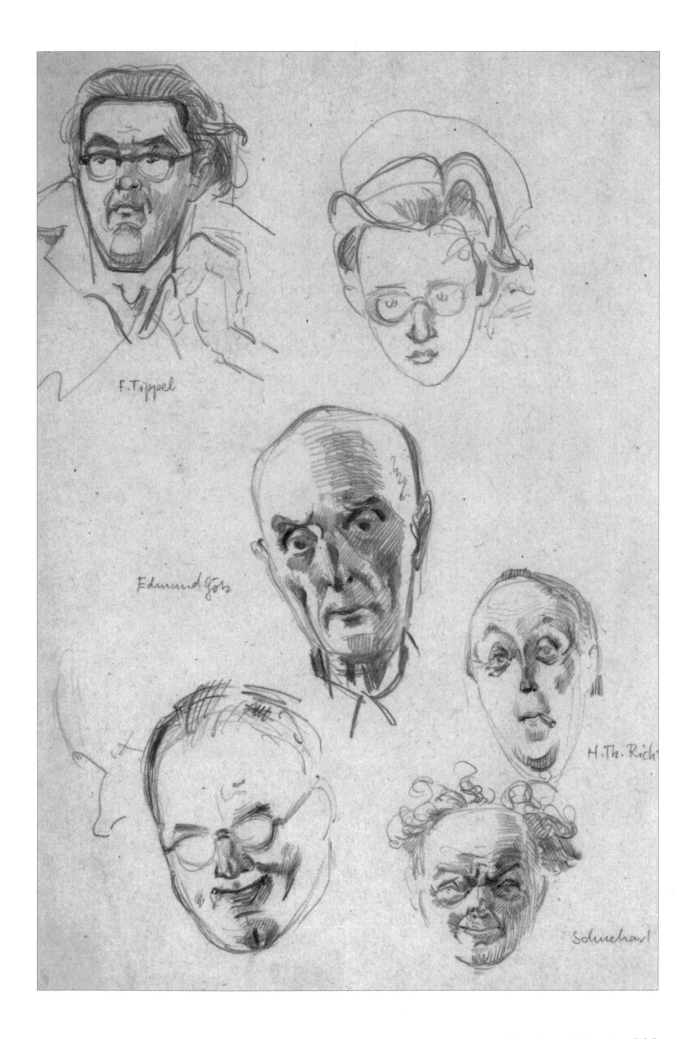

F. Trippel

Edmund Götz

H. Th. Rich

Schuchart

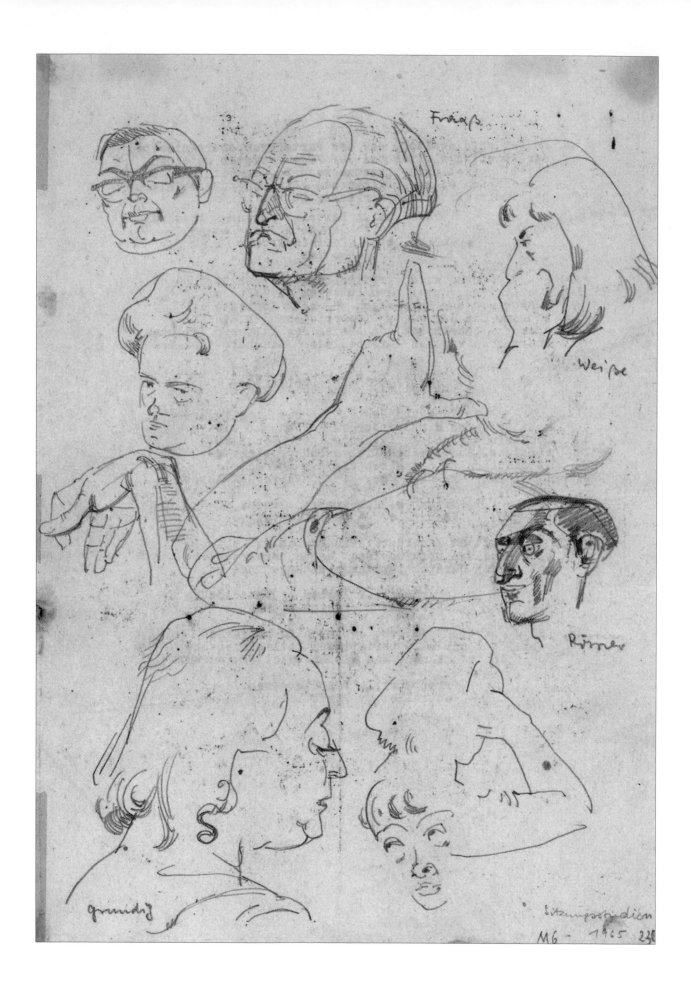

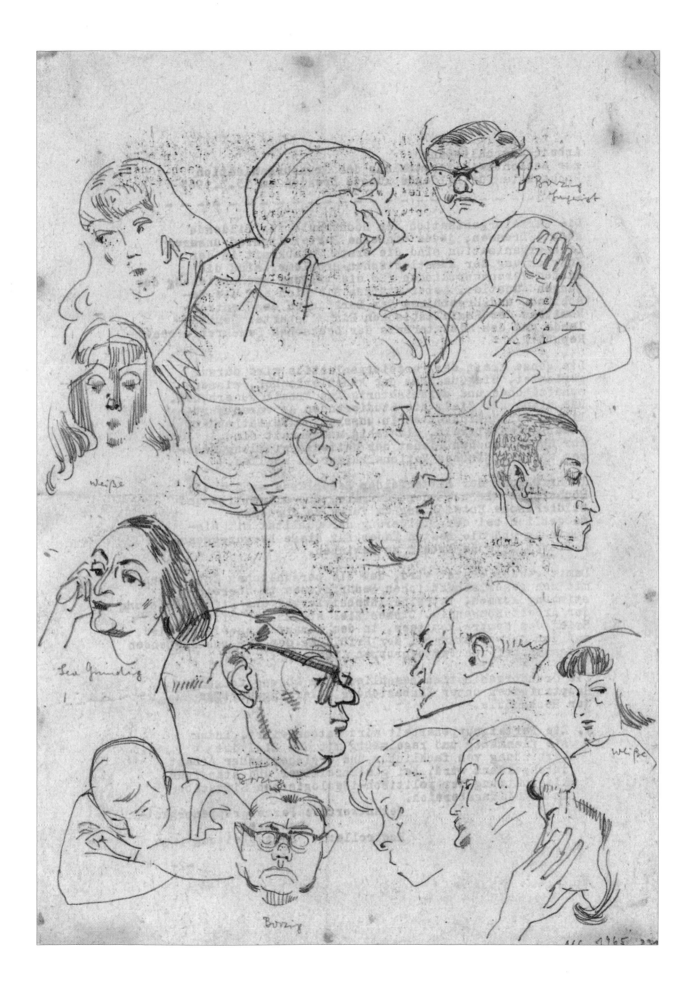

PORTRAITS AND SELF-PORTRAITS

Auguste Rodin (1840–1917): Portrait of Séverine, 1893.

Pages 245–251:

Portraits, including self-portraits, revolve around a presentation of the person's appearance, but there are increasing demands for more than that – for liveliness and for a presentation which also describes some of the sitter's inner world.

For the student and master alike, the self-portrait, besides its many other important objectives, has the function of dealing with what is closest at hand (literally), as a test of both craft quality and expressiveness. In this regard, the way the various techniques and practical methods are handled plays a significant role:

• The drawing on page 245 shows how the sharp, hard pencil has the capacity to harmonise subtleties and sensitive structures.

• In the drawing on page 246 we see how hard pastel can be used to create edgy, broad shapes and hard lines, forcing simple, concise formulations which create harsh, expressive tension.

• The oil and pastels study, reduced to two colours and painted fluidly with pure turpentine, turns the light itself into a source of both enlightenment and obscurity, as a counterpart of the inner world (page 247, top).

• The whimsical use of the brush gives the sense of spontaneous flinging, an outpouring of feeling towards oneself (page 247, bottom).

Thus, the use of different media and techniques is not just a matter of variation and experimentation, and the gathering of experiences (important as they are), but rather about testing what is and what is not appropriate for the expression of one's own internal dialogue.

Such a deliberate listening-in to the expressive language of practical methods also applies, of course, to portraiture, albeit with the not unimportant difference that the non-accomplished artist no longer has the same candour and lack of inhibition towards his model as towards his own image in the mirror.

In the quest to express something of the inner person, the following can be said of various different media:

• The silver pencil, with its thin metallic stroke, is a servant of the tender devotion to the individual subtleties of the person (page 248). It is the instrument of wafer-thin weaving, of filigree work on the portrait.

• The suggestive, welcoming red chalk, with its warm and cosy tones, already bears within it the life needed for atmosphere, intimacy and emotion, i.e. lyricism (page 249).

• Watercolours strengthen the emotional expression of the person, making it free and vibrant instead of fixing it forever (pages 250 and 251). With the central position of the watercolour portrait between drawing and painting, portraiture and head studies both reach their limit.

Adolph Menzel (1815–1905): The artist's sister Emilie, 1851.

Peter Paul Rubens (1577–1644): Study of the head and right hand of a young woman.

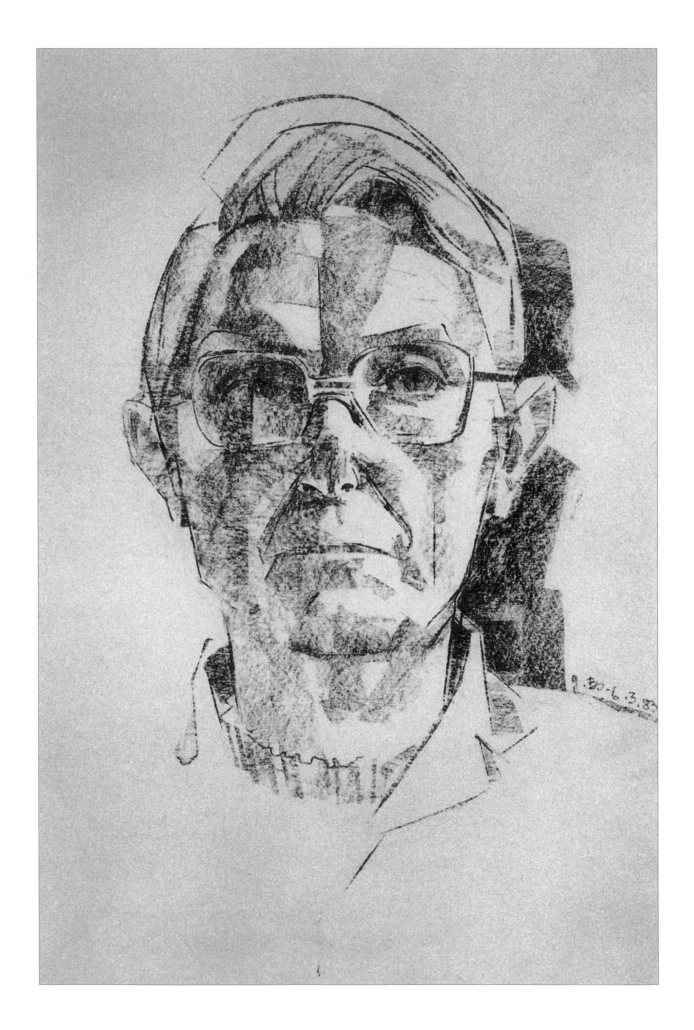

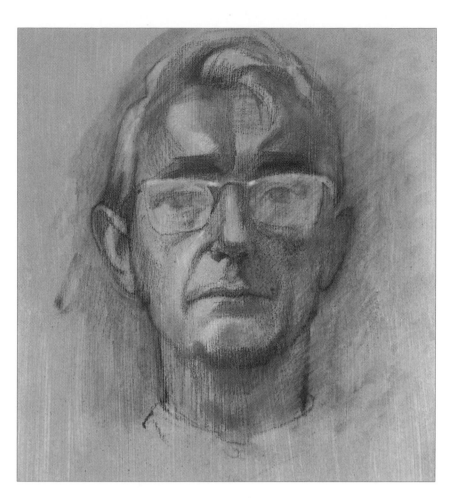

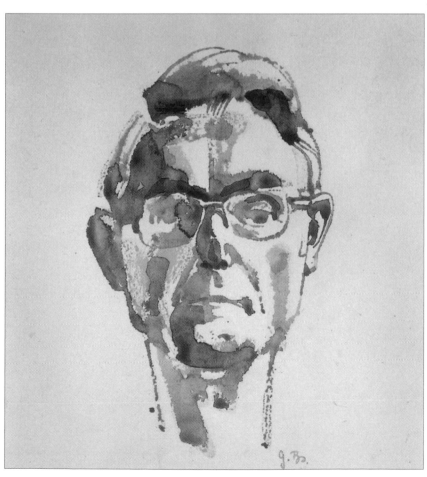

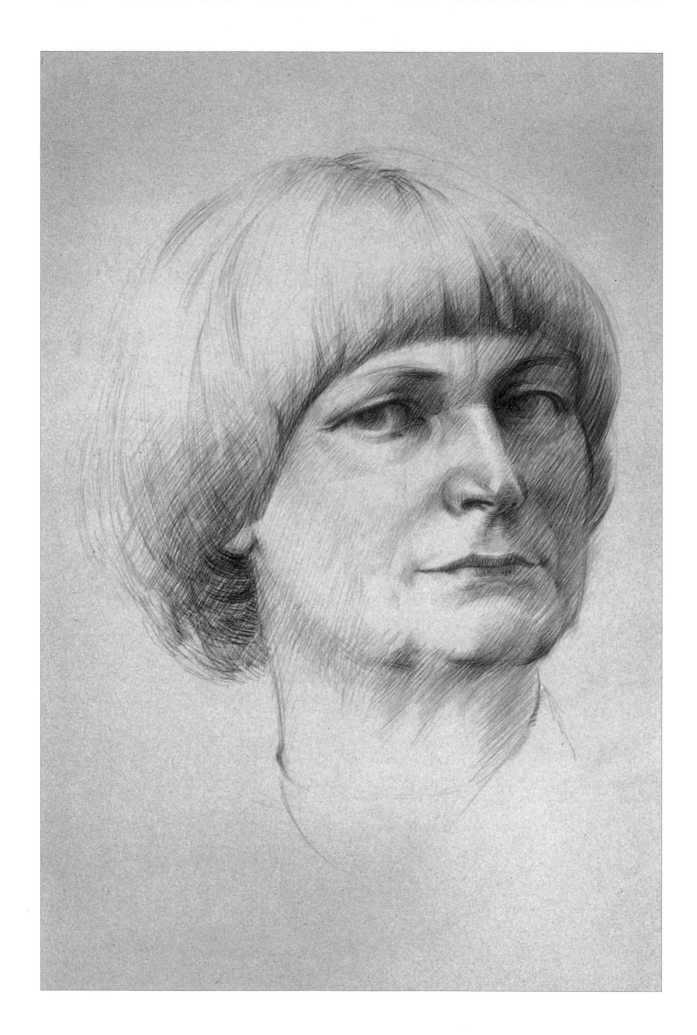

Building up the
Whole Figure

Josef Hegenbarth (1884–1962): Standing female nude,
before 1930.

THE SIMPLE STANDING POSE

Pages 253–257:
The body, which is constantly balancing its energy and
posture, presents the artist with ever-new and sometimes
surprising challenges. Everything that has been discussed
so far in relation to proportion and function, to activities
and changes in the limbs, requires no further analysis
here. Instead, you as the artist, supported chiefly by
the illustrations provided, should investigate through
straightforward experience the interplay of the many with
the one. The selection provided here gathers together
those examples in which resting and active forms
associated with the mechanics of body movement are of
primary importance. In this final chapter, body expression
will be presented primarily as a visual expression of
inner being.

Let us start with the simplest of standing poses and note
the following:

• Even in a two-footed stance (when the body is balanced
laterally) the front masses equal the masses protruding
from the rear.

• Most of the models are viewed not directly from the front,
back or side but from an angle, so that the transverse body
axes are subject to the laws of perspective.

• The body stretching upwards in the drawing on page
255, left, expresses suffering; the soft-tissue masses are
stretched vertically, while their expansion exposes the
fixed points of the skeleton.

• The tiring pose of the model pictured on page 255,
right, makes the upper body flexible, and once the tension
relaxes, the figure collapses.

• In the position taken up by the model for the drawing on
page 256 the slightly wide-legged stability brings out not
just the general body tone, but especially that of the legs
and their natural bowing (outer leg angle).

• Arms held akimbo must express whether they rest on a
soft or a solid body surface (pages 257, right and
page 256).

• The varying thickness of the skin influences the shape of
the joints (see pages 256 and 257).

The simple standing pose offers the first coherent
opportunity to build the structural interplay of the
whole body.

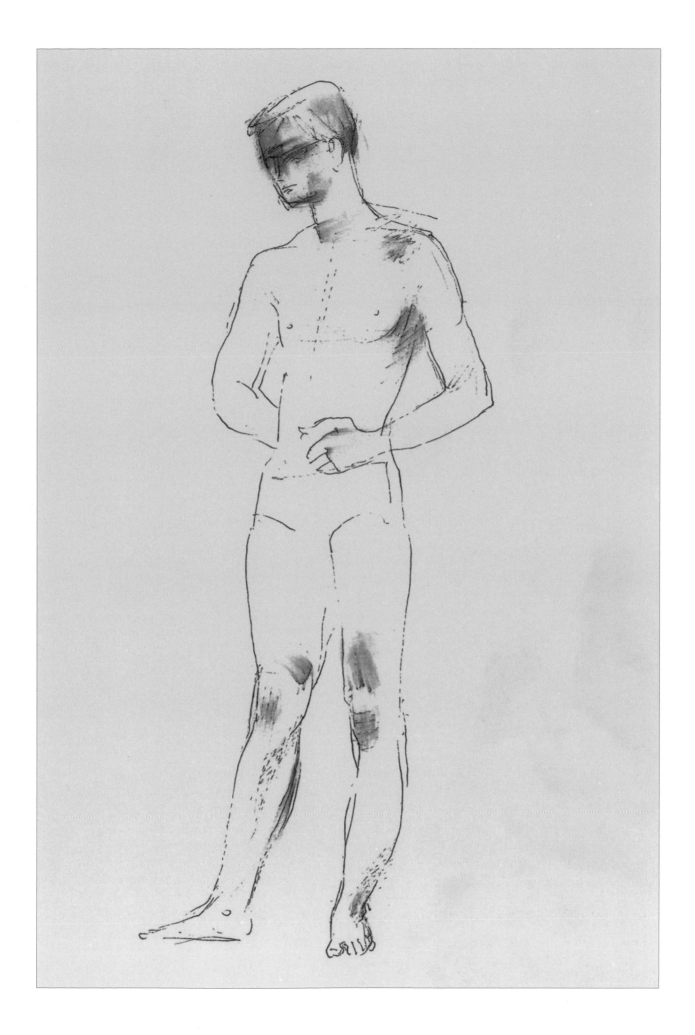

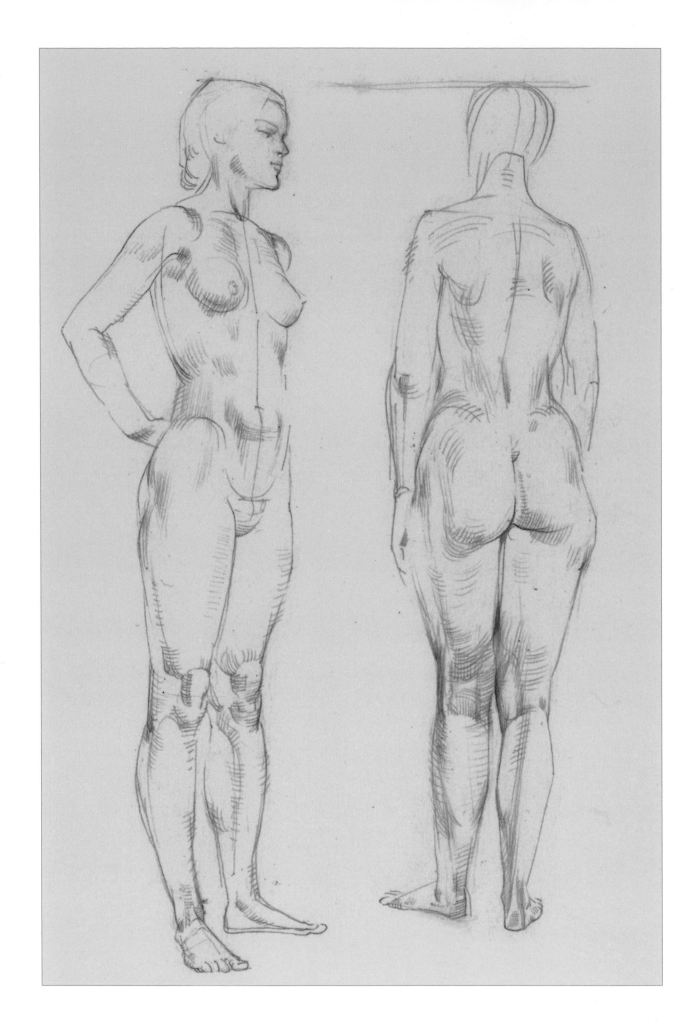

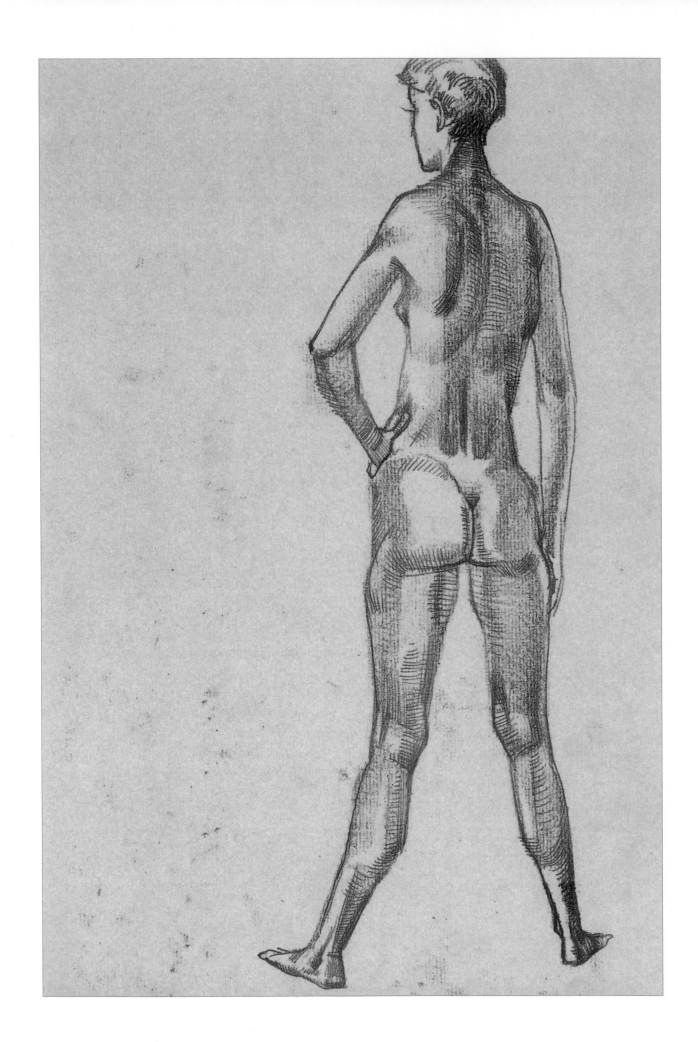

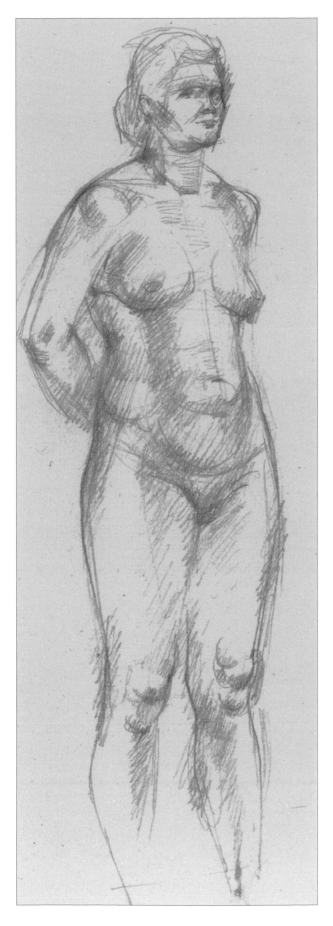

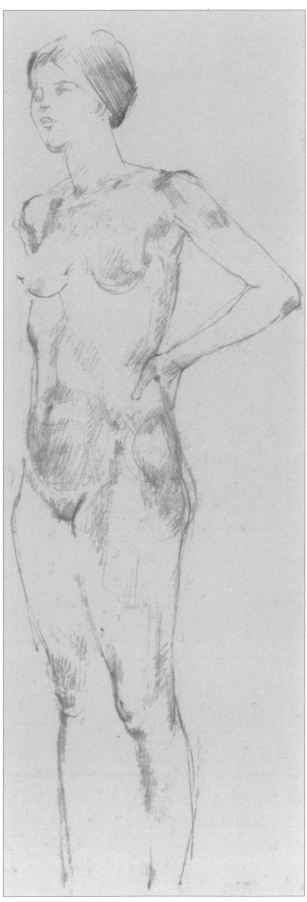

Aristide Maillol (1861–1944): The American Woman, 1935.

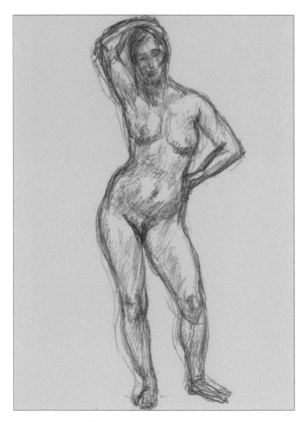

Wilhelm Rudolph (1889–1982): Female nude standing in motion, front view, right hand on head, left hand on hip, undated.

THE DYNAMIC STANDING POSE

Pages 259–267:
A dynamic standing position here means primarily the general moving shape of the entire body, in whose oscillating flow the free inner posture also participates.

The illustrations, which go back once again to the corrective studies, initially enable recognition of the different stages and states of the composition (pages 259–262). All these stages share the following:

• The difference between supporting and supported, flowing and compressed forms.

• The relation of the form's flow to the standard relationship between gravity and support.

• The major oscillations and interconnections of the moving form.

• The elaboration and emphasis of the culminating points of the movement.

The detection of the differences in treatment of the same standing subject – its advances or retreats, rounding off or accentuation – depends on individual students' levels of understanding.

There are many ways of depicting physicality and the main functions that control the body. Here are some of them:

• An arrangement of strokes following the curvature of the body, organised by sympathetic thinking in terms of cross-sections (pages 260 and 266).

• Hatched areas that create the spaces and depths of the body reliefs (pages 261, 262 and 263).

• Line-work, which chiefly adapts itself to and emphasises the direction in which the body is moving (page 264).

• Elementary clarification of the spatial surfaces, producing the interrelationships between the large volumes and clearly incorporating them into the overall dynamic stance (page 265).

Subjecting the model to a gentle diffuse light brings out depressions and elevations. Consequently, even the softness of the skin, its tension and relaxation, demands special treatment: the hardness of the arrangement of strokes must alternate with careful wiping movements (page 267). On the whole, however, the graphic presentation should remain committed to its essential medium – the stroke – and nip in the bud any temptation to conceal lack of mastery with the easy effectiveness of wiping and blending.

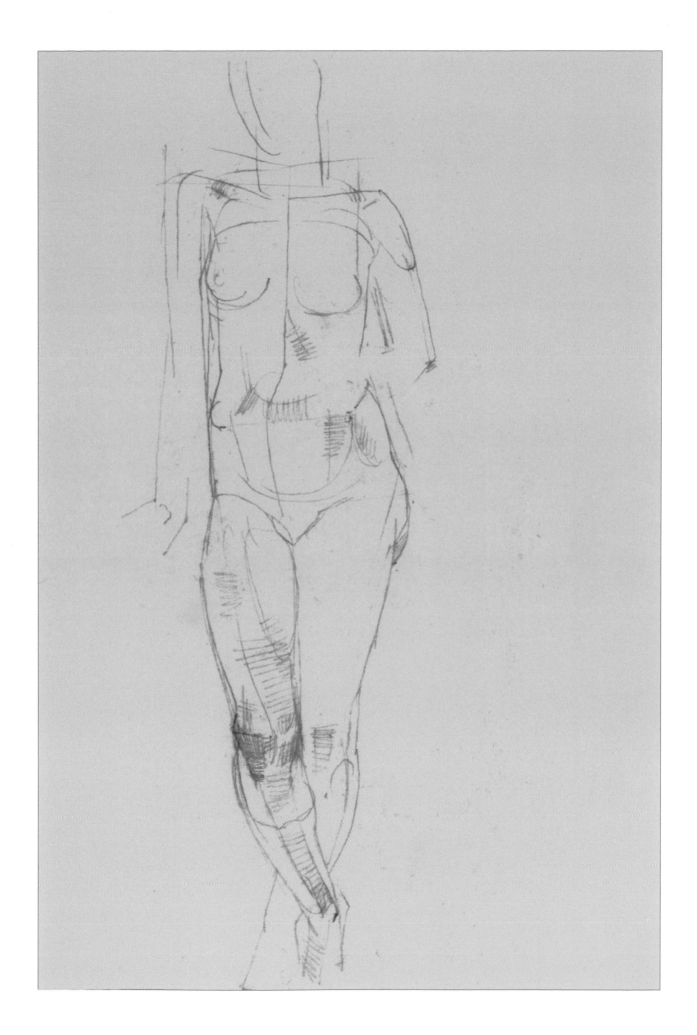

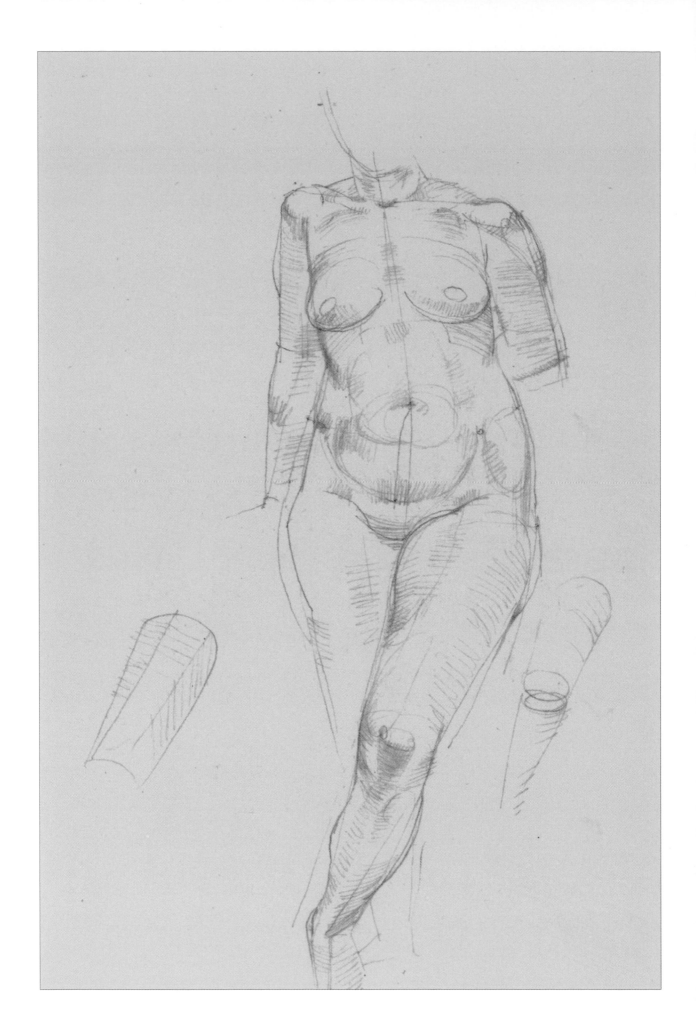

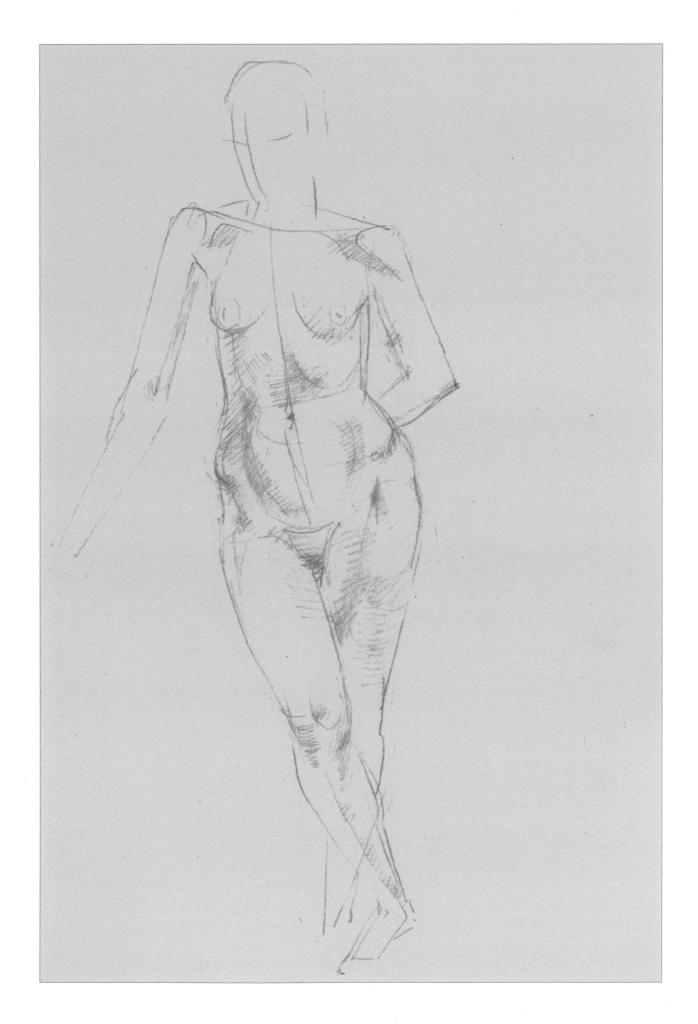

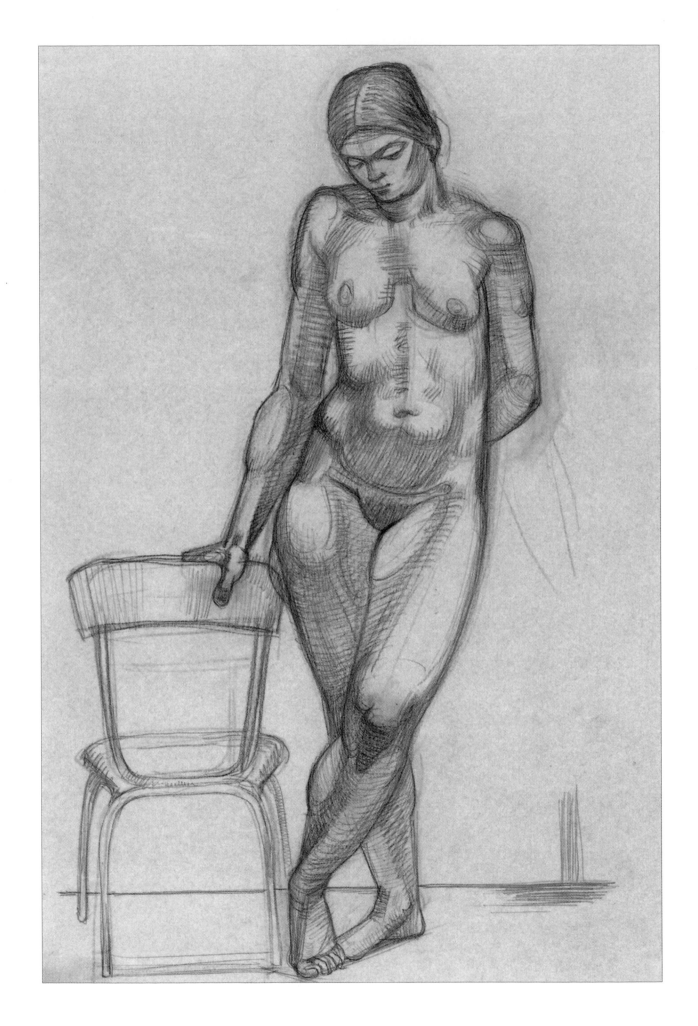

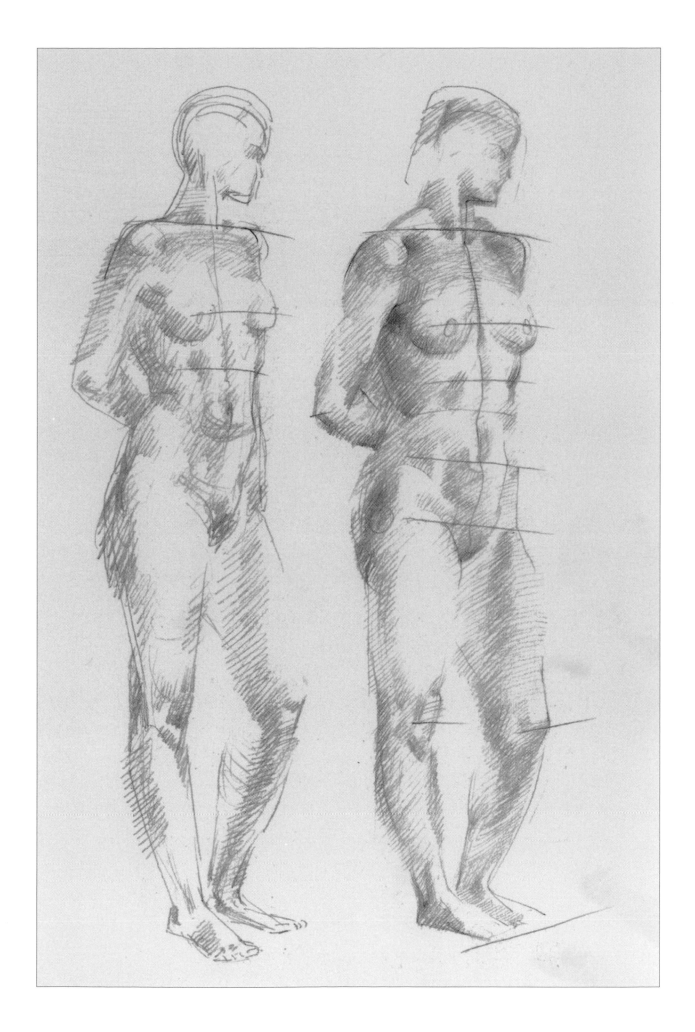

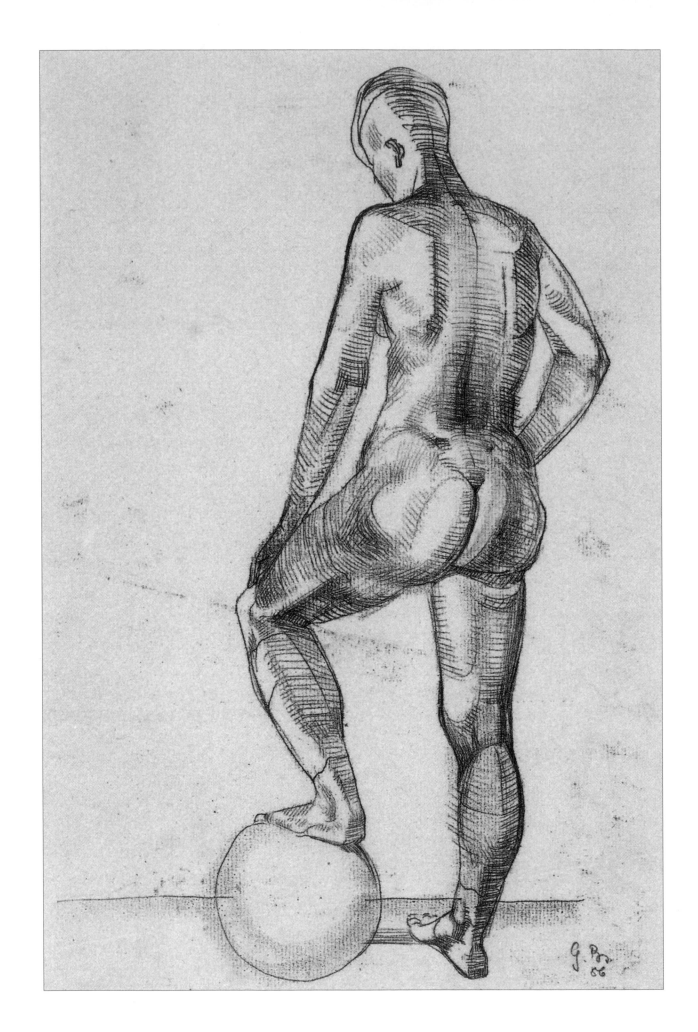

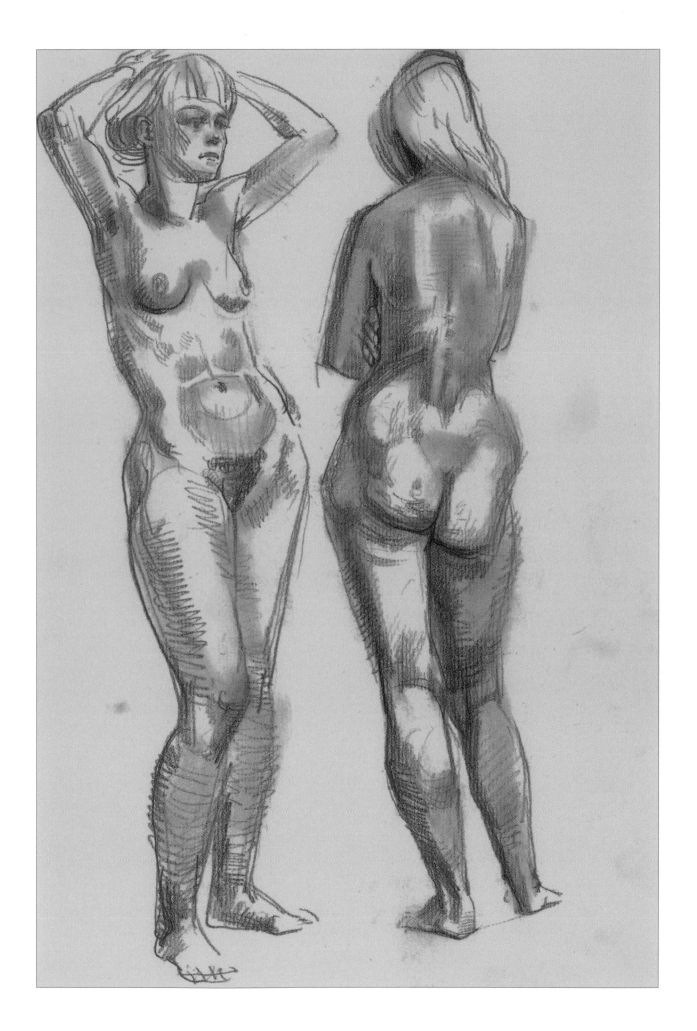

LEANING POSES

Pages 269–275:
The body is constantly looking for additional support to make standing easier, which produces the dual function of standing while being supported on something. Whether the artist merely notes this in passing or makes a more thorough investigation of it determines the nature of his presentation:

• He focuses only on the flow of the movement and comes to feel its rhythmic current. His pencil exclusively follows the outline of the shapes, and so line alone seems the right method to use (pages 269, 270 and 273).

• He looks for the contrasts but also the similarities in function between weight-bearing and non-weight-bearing limbs. In the drawings on page 270 and pages 272 to 275 the shapes of the supporting arm are also expressed in the supporting leg. The artist looks for the transfer and equalisation of this function.

• He also notes the balance between the weight-bearing and non-weight-bearing leg. See page 271, where the weight-bearing standing leg is able to maintain the vertical position because there is no longer any pressure to shift the body's centre of gravity. The holding arm ensures that the hanging side can relax, with all the consequences for changes in the shape of the expanded side. An inquiry is needed into the matter of how body weight is transferred to the holding arm.

Three studies (pages 272–274) of the same supporting position of both arms draw attention not only to different stages of the composition process but also to the following new problems:

• The behaviour of the abdomen, distorted by bending forward and twisting (page 272) and the weight-bearing hip.

• The sculptural qualities of the form (page 273).

• The pure flow of form movement (page 274).

Finally (page 275), the quest for synthesis prevails in the corrective study of lateral support provided by a single arm (compare the linear study on page 270). Notice the following:

• The body-based sculptural structure of the mature female figure and its graphic tension.

• Weighting as an expression of the harmonious balance of forces.

It should be clear that the examples given here of poses and their associated studies are not templates, but merely suggestions.

Hans von Marées (1837–1887): Group of figures, undated.

Karl Stauffer-Bern (1857–1891): Female nude, undated.

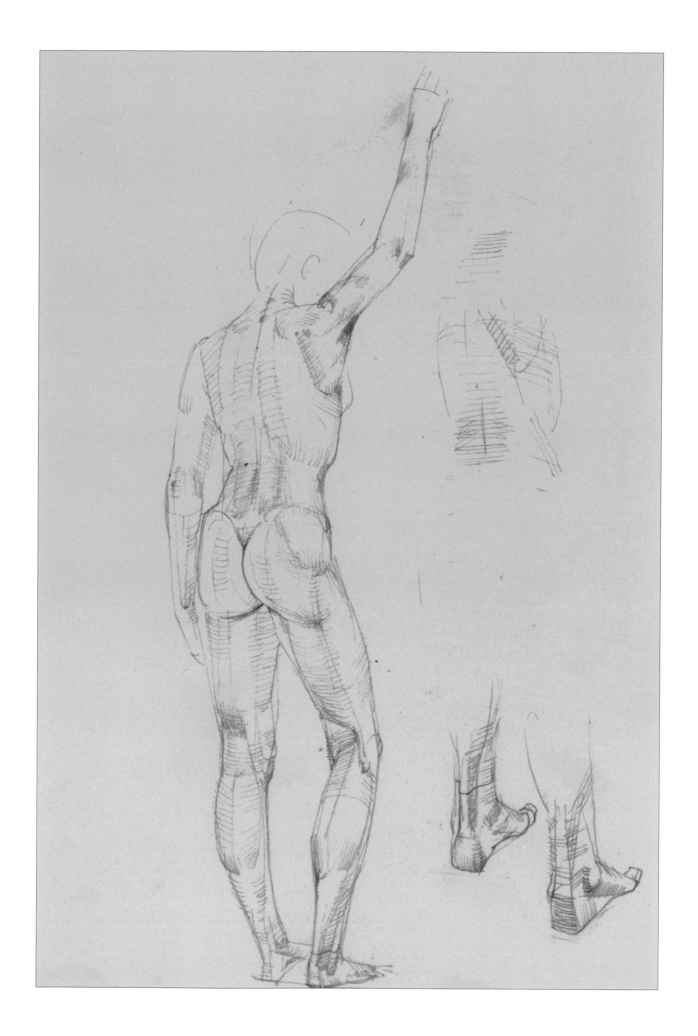

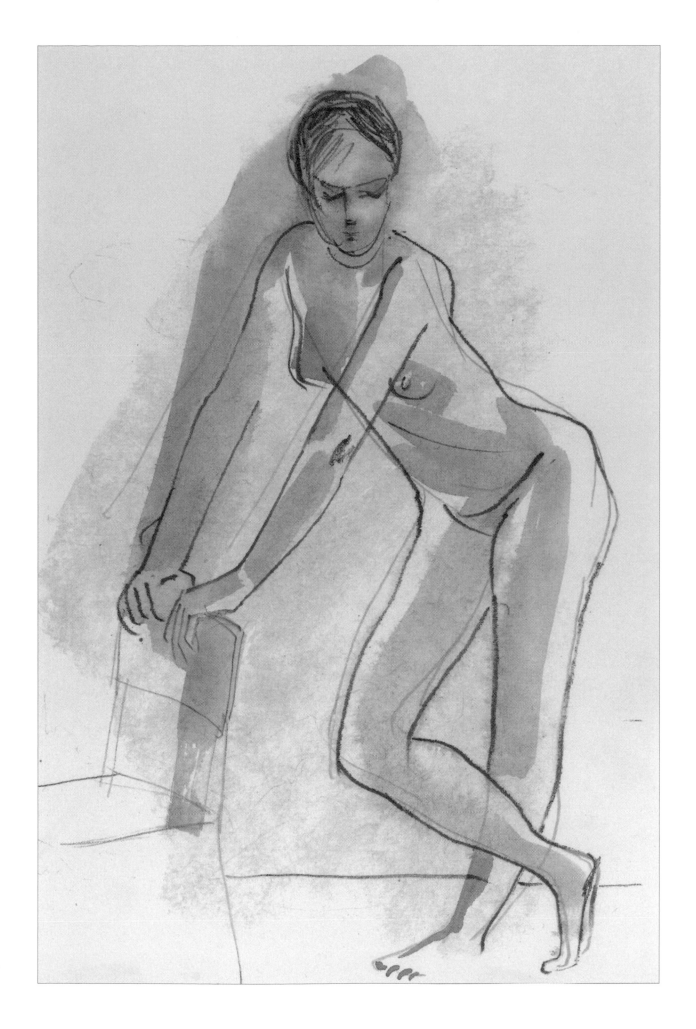

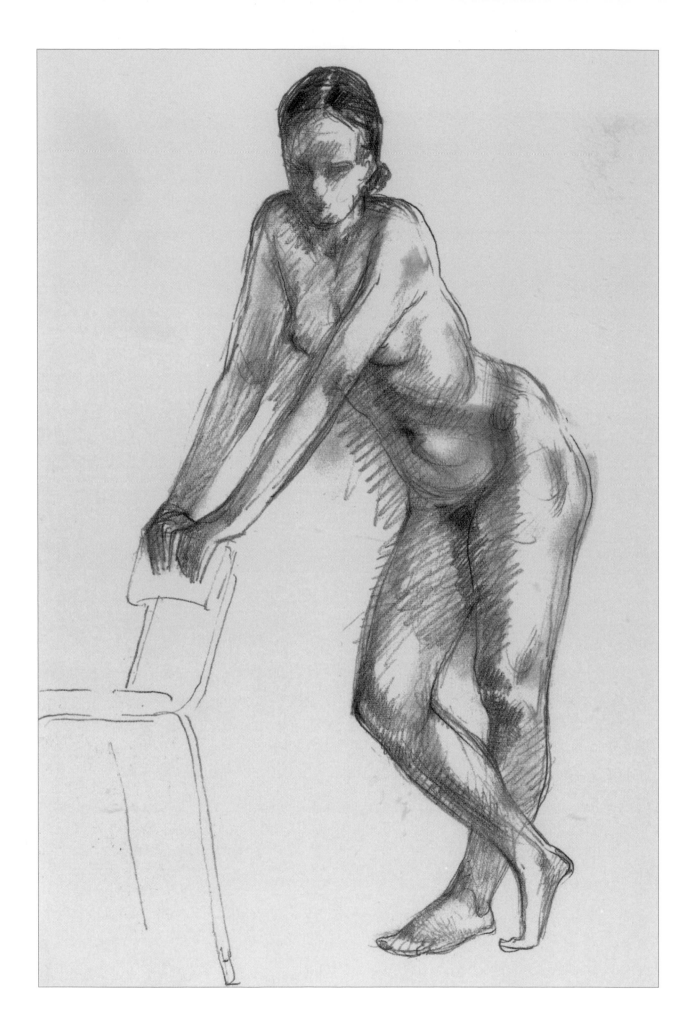

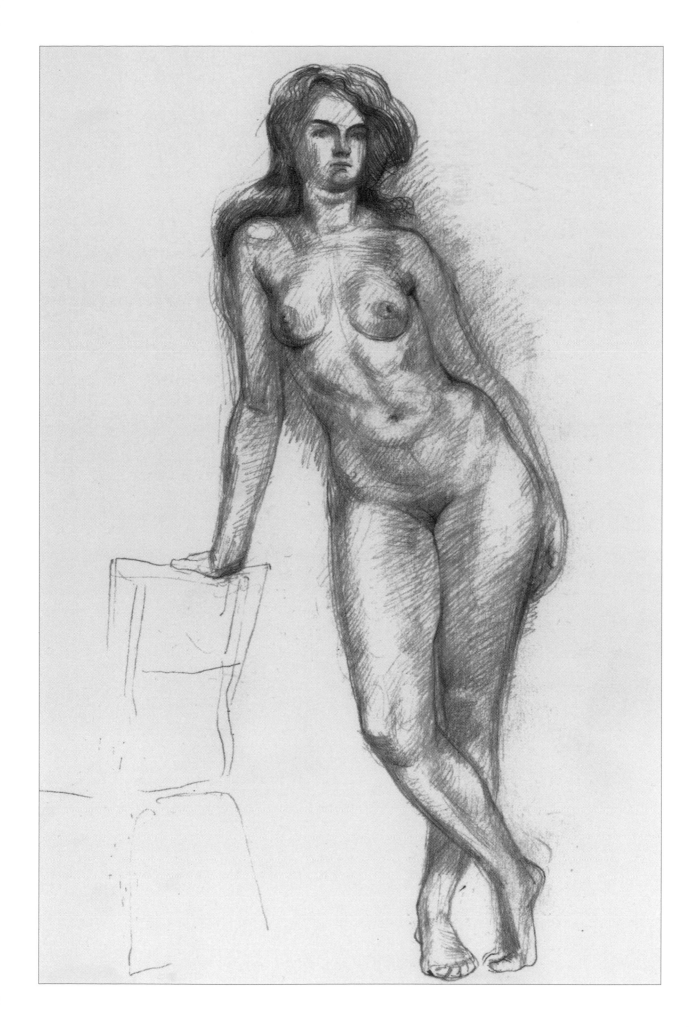

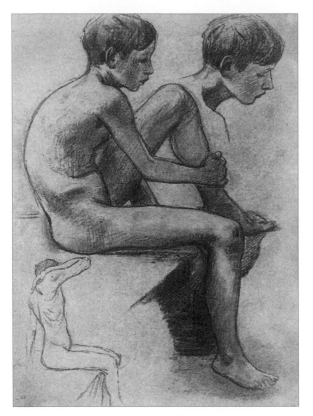

Ludwig von Hofmann (1861–1945): Seated boy in right profile, left shin moved upwards, undated.

SIMPLE SEATED POSES

Pages 277–281:

Under this heading we bring together a group of studies in which the seated model assumes a backward-leaning or free upright position without any major involvement of the arms. Note the following:

• The position of the body in relation to the seat (height of seat, seat back, etc.) will determine whether and how the body fits into the angle between the seat and the seat back. This also determines the angle (space) created between the trunk and the pelvis and the behaviour of the abdominal wall.

The varied skin consistency of the models 'reacts' in a correspondingly variable fashion: thin skin reduces the depth of the compression (pages 277–280) while thick skin increases it (page 281). In any case, telescoping of the abdominal mass is inevitable. This also means that:

• The entire imprint of the sitting posture on the abdomen is not a simple, smoothly rounded groove, but is produced by a series of articulated bent joints: the upper body/ rib cage against the abdomen as an intermediate mass (pages 277, 278 and 281), from here against the pelvis, which is tilted backward but rises in front; and from there against the thigh.

More directly frontal views (pages 279 and 281) increase the three-dimensional puzzle of the front area (feet, knees) in contrast to the rear. Here, besides the obvious overlaps, the effect arises from 'drawing forward' the front parts of the body by means of an optical increase in size (pages 279, 280 and 281) and by strengthening the stroke (pages 279, 280 and 281). Once the main content has been given expression, the detailed work can begin:

• Setting up the secondary forms (protruding breasts, thighs and buttocks as an expression of weight).

• Distinguishing between softly mobile and hard shapes.

• The fine tuning of axes, according not only to perspective but also to their functional shifts.

• Relating the posture of the head and neck to the rest of the body, which confirms the overall mood of the sitting (fatigue, alertness, sheer relaxation).

• Drawing the feet and hands (they too help to round out the overall impression) and the facial shapes, once the expression that determines the sitting has been dealt with.

In fact, one can also make further modifications to the sitting.

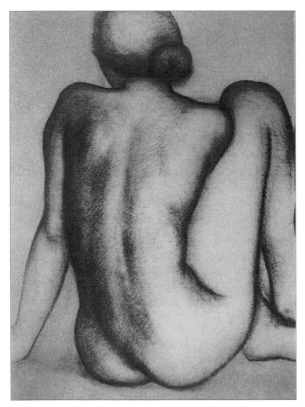

Aristide Maillol (1861–1944): Rear view of Thérèse, 1929.

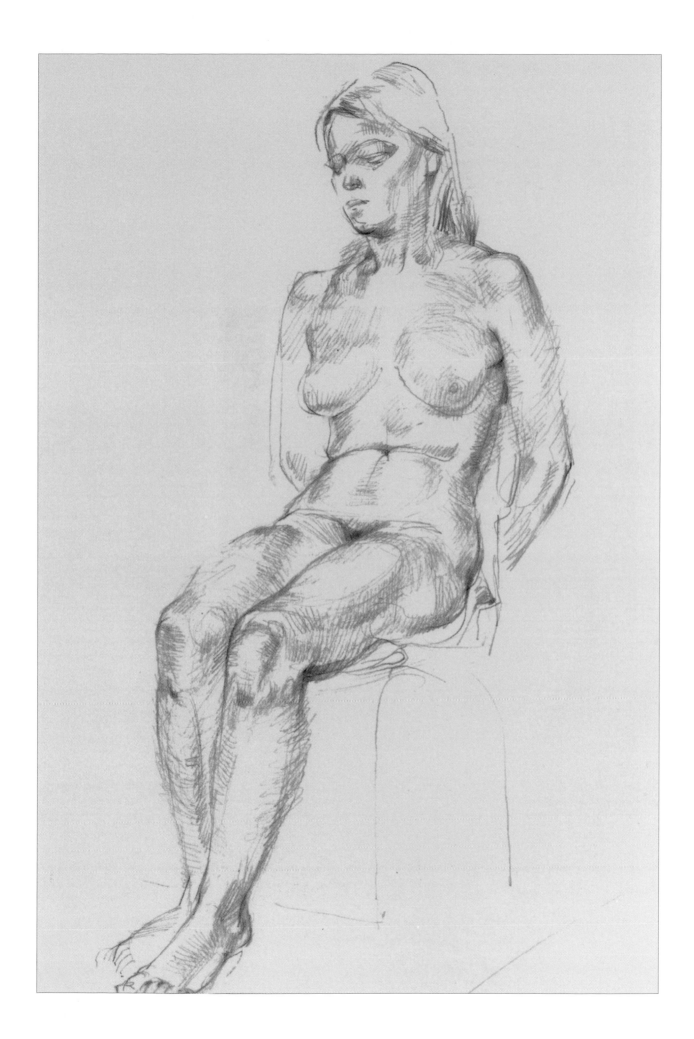

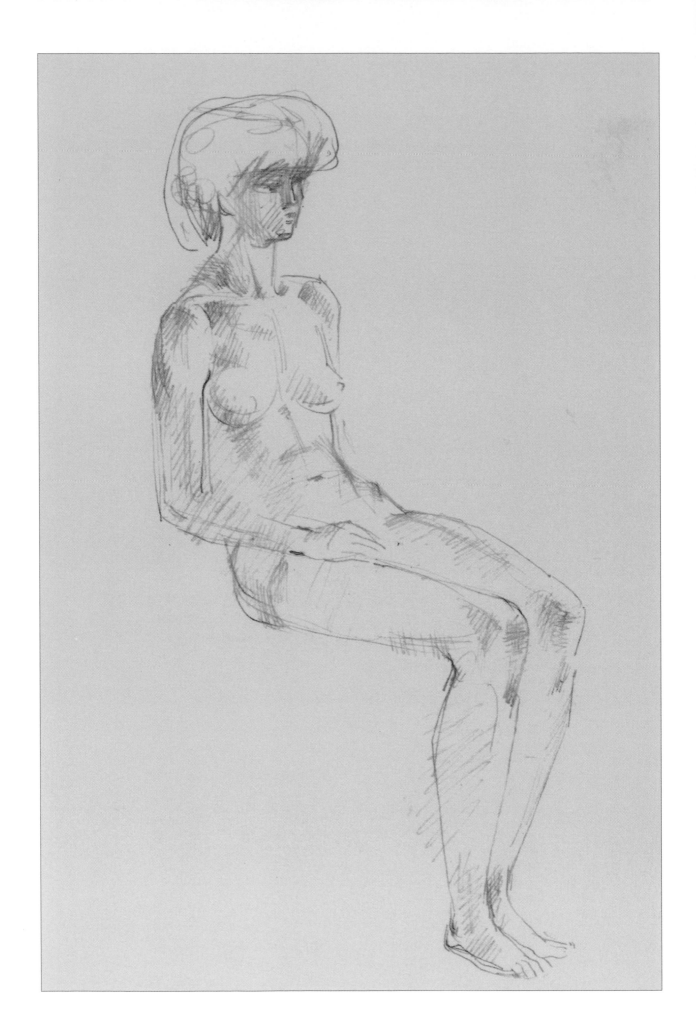

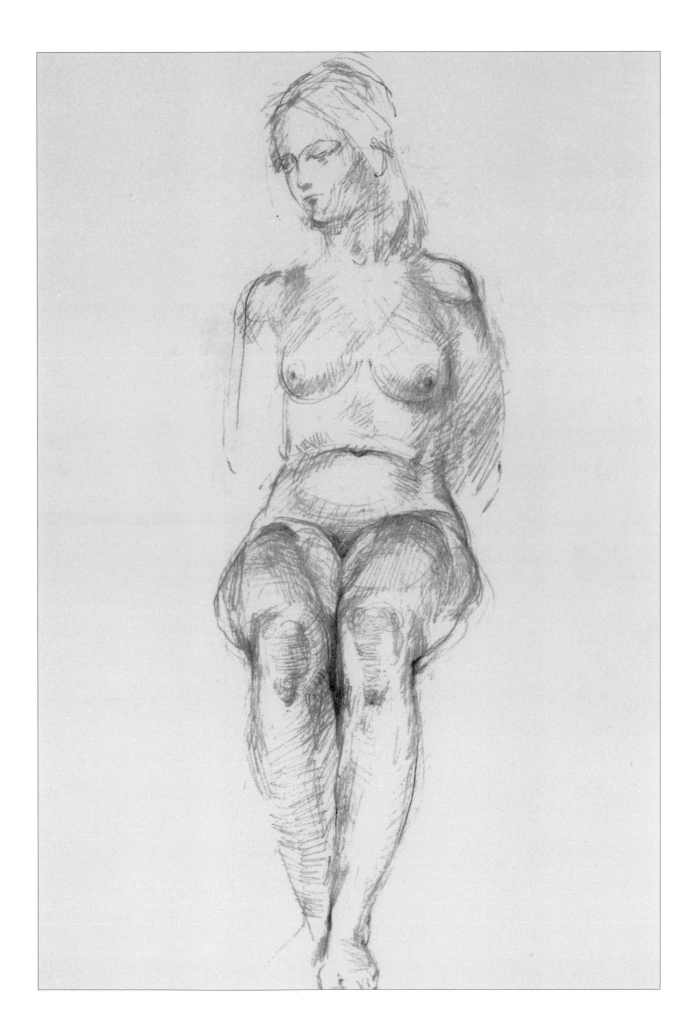

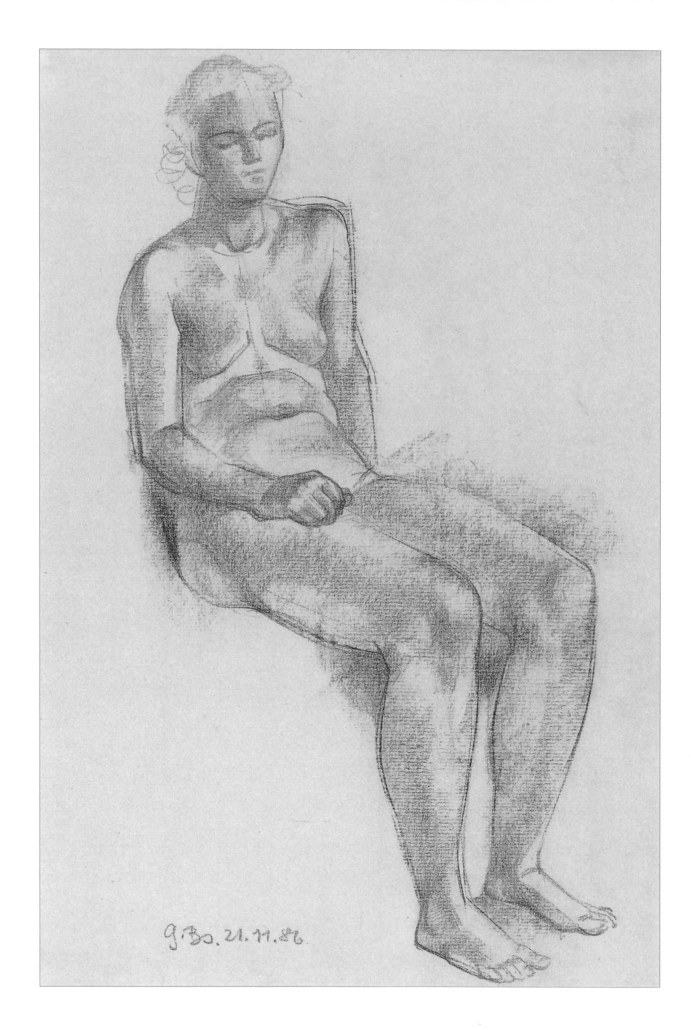

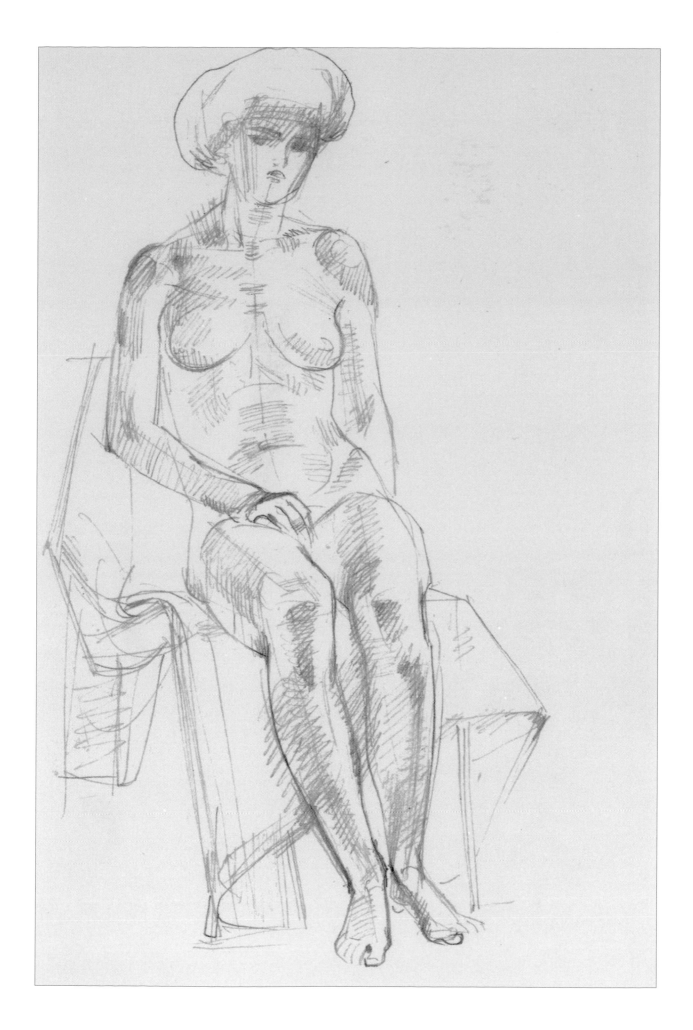

Georg Kolbe (1877–1947): Seated female nude with right knee drawn up and holding the foot with her right hand, undated.

DYNAMIC SEATED POSES

Pages 283–289:
This subject has inexhaustible scope. The amount of movement that a sitting pose can contain depends on the degree of activity that goes with it – seated with the weight on one side, supported or twisted in different directions. In other words, forms that result from increased basic movements of the spine, not least those involving the head, arms and legs, contain more movement.

You will be tempted to over-emphasise form-related aspects in the expression of the gesture itself, as well as in the graduations of functions and forms. When one understands what is happening, one should risk over-emphasis, at least experimentally:

• The dropping of the body on the side not supported by the arm and the protrusion of the weight-bearing arm (pages 283 and 285).

• The upper body rotation of the pelvis and the intensified transfer of activity in the direction of the arms (page 284), an overall increase such that the shoulder axis is at right angles to the pelvis and even in line with the thigh (pages 286 and 287).

• The stress on the flexibility of the abdominal wall, which, unlike a garment, spirals around the body, held only by its fixed origin and insertion points.

• The crowding together of the volumes of the breasts over their sculptural core (chest) as a result of the forward presentation of the shoulder blade and upper arm (page 287). These are distortions that need to be repeated in the abdominal wall, clamping the abdomen between the fixed points of the two anterior superior iliac spines (hip bones).

Compare this with the calm, measured flow of the relaxed reclining form in profile (pages 288 and 289):

• In the sketch on page 288 the unelaborated line travels round the simple outline in long strokes, almost without stopping, although the rising and falling of the body require total accuracy.

• If one introduces some concrete form into this line, it would be good to arrange it like music in order to facilitate the flow even further.

The linear presentation represents a desire for certainty and, not coincidentally, it usually only emerges after many attempts. But it occurs equally at the start of the drawing enterprise, as a first statement of form against the white of the paper.

Max Pechstein (1881–1955): Seated female nude with her head turned towards her outstretched arm, undated.

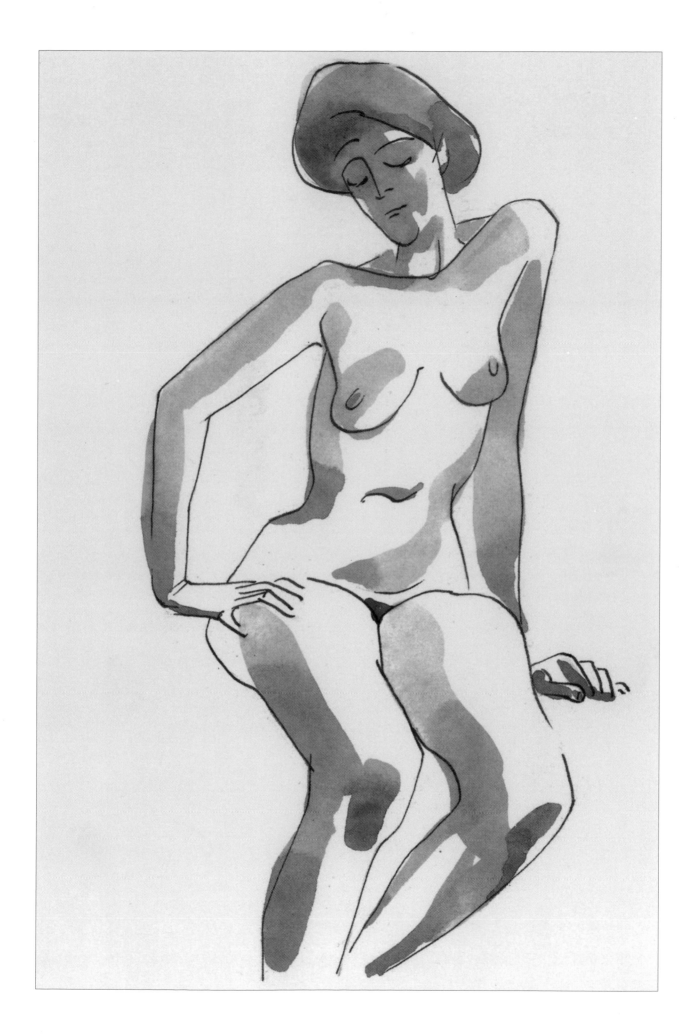

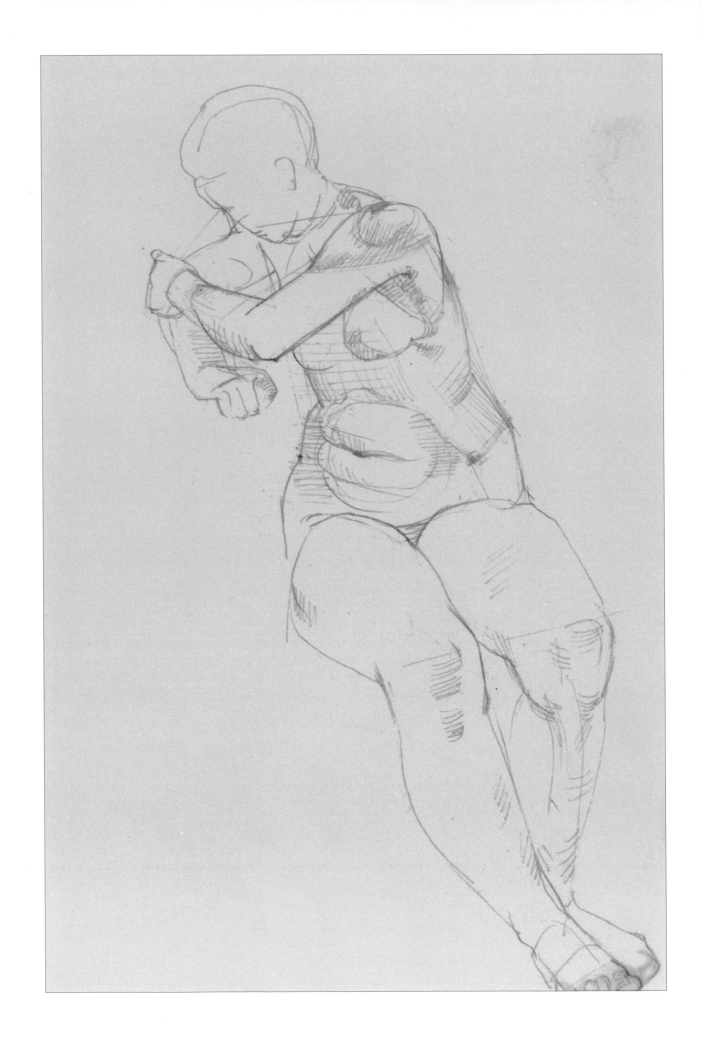

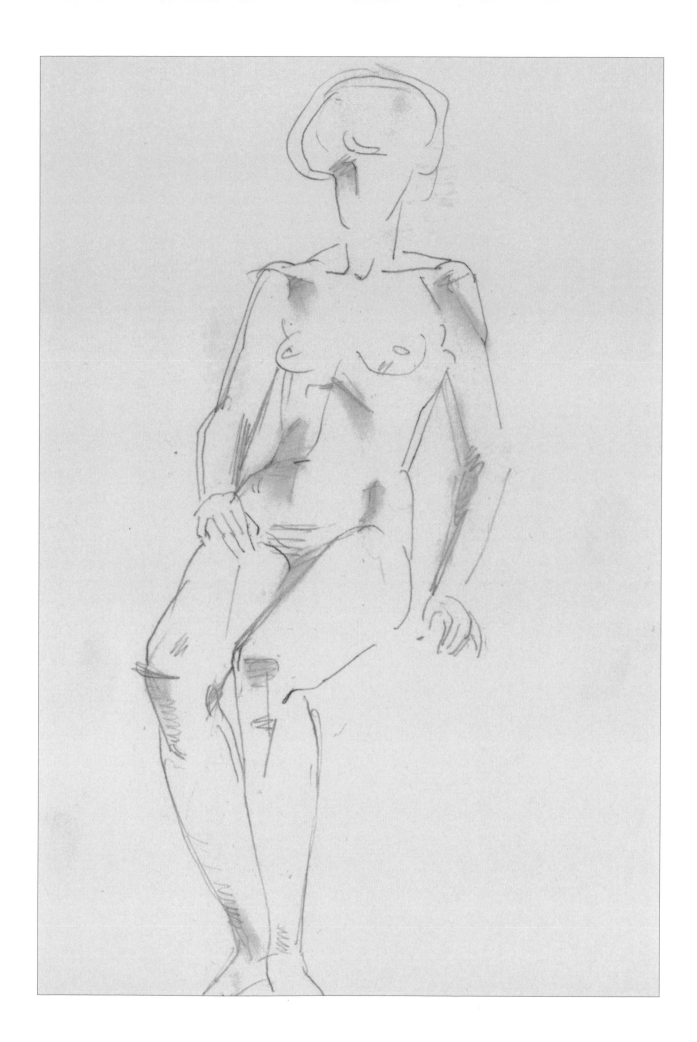

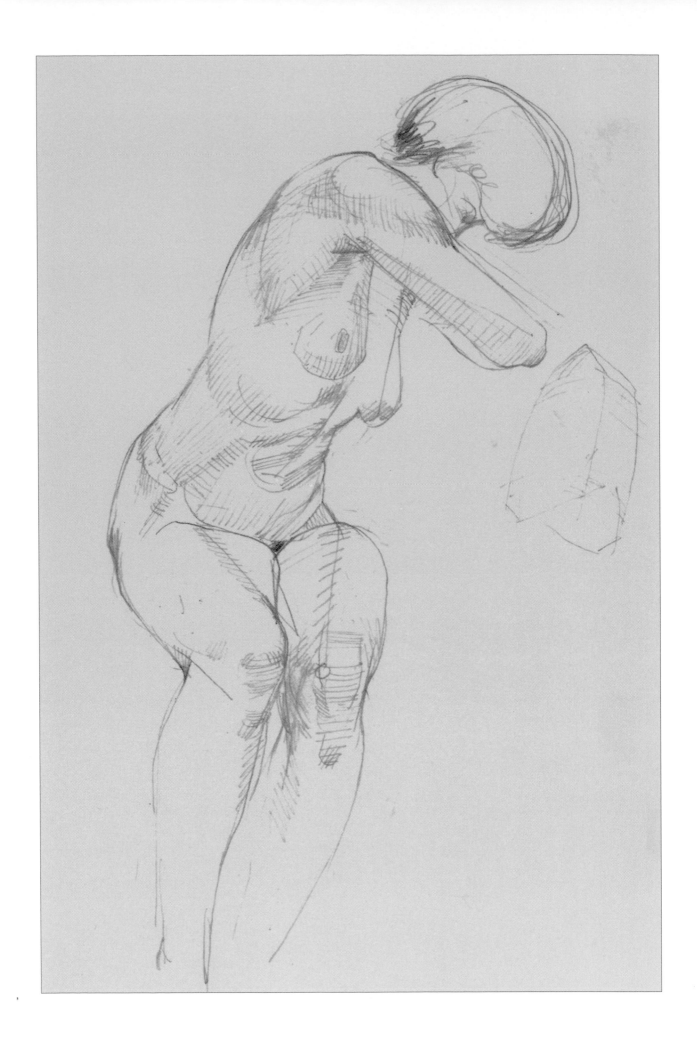

RECLINING POSES

Pages 291–297:

The ways of lying down are extremely varied: lying on the back and the side, lying with the chest and the pelvis turned out of line, intermediate positions between reclining and lying down and so on. The increased difficulties for the artist are probably related to the unfamiliar and also to a feeling of having abandoned the vertical orientation of the body (which is not yet completely relinquished while sitting).

We would therefore be well advised at this point to remind ourselves once again of the basic steps of the method:

• In addition to the spatial aspect ratio, in which the artist sees the body at a specific horizontal height, we must add a marking of the body's centre (see page 291, top).

• Consider also the profiles of the transverse axes of the shoulders, the chest, the transverse folds of the abdomen, the pubic bone, the kneecap, and possibly the foot (page 291, top and bottom).

• Given these parameters, the visually changed spatial distances must be inserted as an expression of the development of the body in depth: the denser sequence in the background and the opened-out sequence in the foreground (page 291, top and bottom).

• Only then should the basic forms of the sculptural cores, the pelvis, chest and head, be built in, and after this the limbs added in a simplified roll-like form.

• Attention must be paid to the behaviour of the intermediate form of the abdomen. How far has it collapsed between the three-dimensional cores and how much has it succumbed to its own weight in lateral rotation?

• When the body is in a lying position, the breasts too flatten out and take the shape of the curvature of the chest much more than in the standing or sitting position (page 291, top and bottom).

By using this framework, the difficulties of the free recording of the subject and of accuracy of line are significantly reduced (page 291, bottom). In addition, if there is a need for further amalgamation of forms (page 292), the recommendations already given for the postures apply (see pages 276 and 282).

Supported lying has functional consequences for the acromioclavicular joints (shoulder girdle), owing to the protrusion of the humeral head, from which hangs a portion of the upper body weight (page 292).

Foreshortening from a precise front viewpoint, as shown on page 293, gains in security from the representation of the body shapes in their elementary forms, including the sequence of their intersections, as well as the visual increase in size nearer the front and reduction in size towards the back.

William Cadenhead: Reclining girl with slightly twisted body, undated.

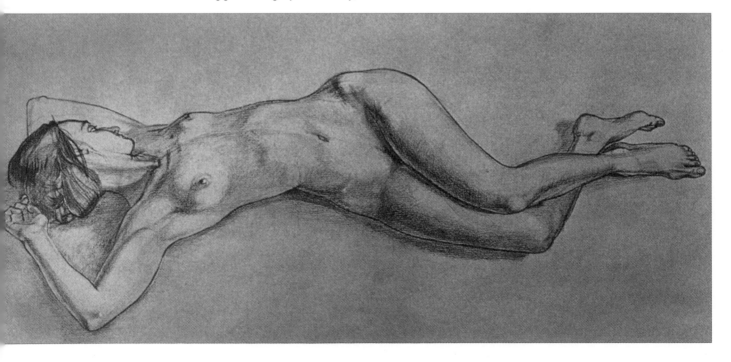

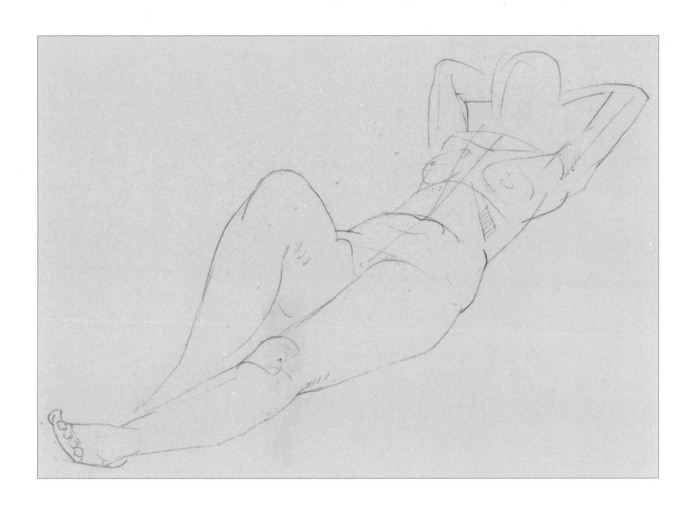

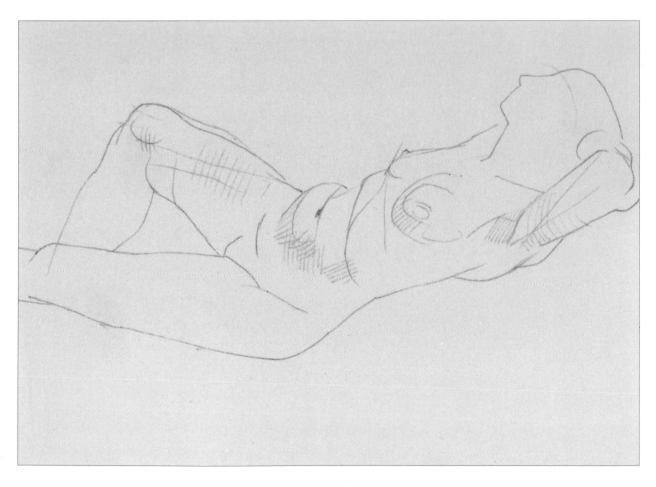

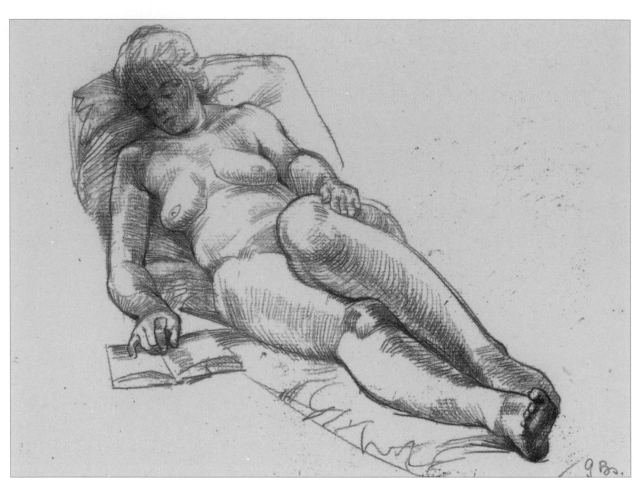

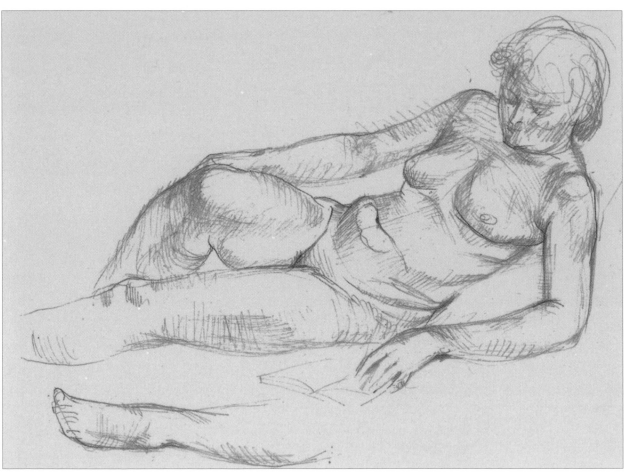

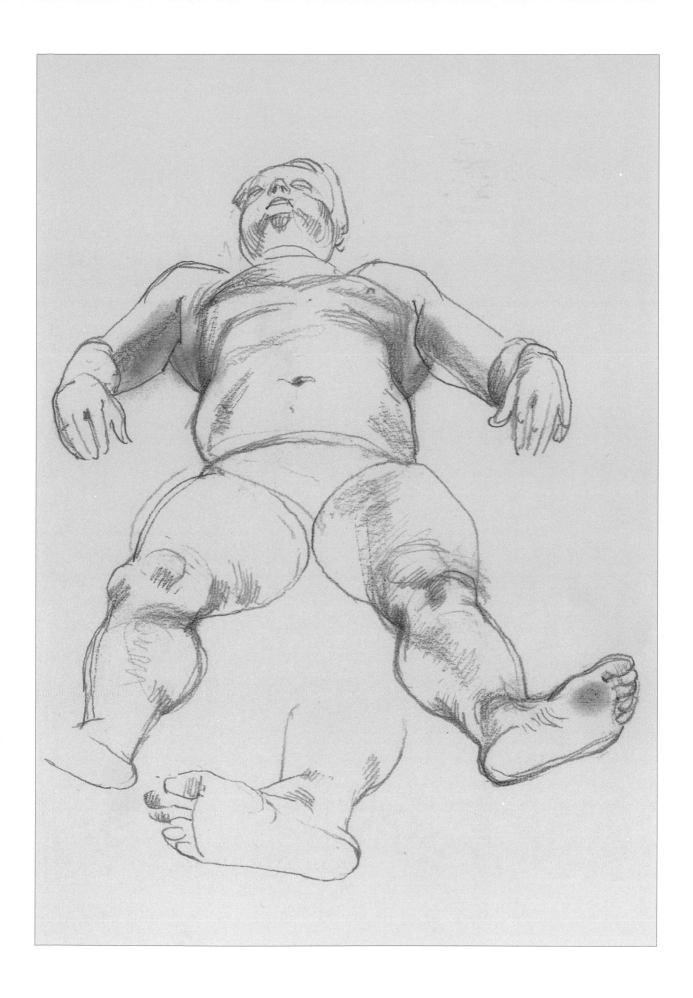

ADVICE ON WORKING WITH A SKETCHBOOK

Pages 295–297:

The considerations when sketching a reclining figure are not so very different from those when making a more considered drawing (see page 290), but, more than ever, it is necessary to recall the basic structure of the body in the mind's eye without having to practise it, for the speed at which you have to work does not allow for much anyway:

• Consider elementary forms, such as the four edges of the rib cage (page 295, top).

• Foreshortening effects must be taken into account, where 'missing' intermediary forms overtax the eye's ability to make the body into a whole. Very strong foreshortening (page 295, bottom right, and page 297) show the smallest intermediate distances between the sole and chin.

• Lightly drawn clothing, in effect representing body cross-sections, can be of great benefit here for the purpose of defining volumes in space.

• The body should be treated as a landscape with rises and falls (page 296, bottom).

• In profile view, a person lying on her stomach has a back outline similar to a gentle wave (page 296, top).

• Time and again, attention must be paid to the behaviour of key sculptural forms and their relationships to each other, which only then makes the diverse expression of different poses possible (page 297, top).

• With activities such as careful reading (page 296 and 297, top), the intertwining of the arms and legs should not be overlooked as a moment of tension in relation to the rest of the body. Compare these tensions with the total relaxation of the figure on page 297, bottom.

• Last but not least, attention needs to be paid to the reclining expression; in particular, the precise way in which the body weight affects the area that supports the body (pages 293 and 297, bottom), and whether the support yields to weight or is deformed or flattened out in any way.

Carefully catching such visual experiences in graphic terms becomes all the more important the closer the view of the recumbent figure moves towards the precise front or rear view.

So far, we have considered the construction of the figure as a whole, especially with regard to the dynamic behaviour of body mechanics. It is therefore necessary to pay special attention to the expression of mood.

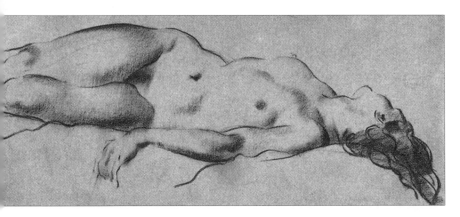

Alois Gruber: Recumbent female nude with twisted body and head averted, 1916.

Karl Hofer (1878–1955): Reclining nude, viewed from rear, resting on left elbow, undated.

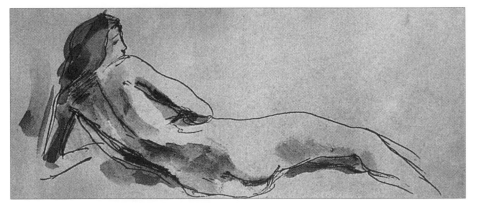

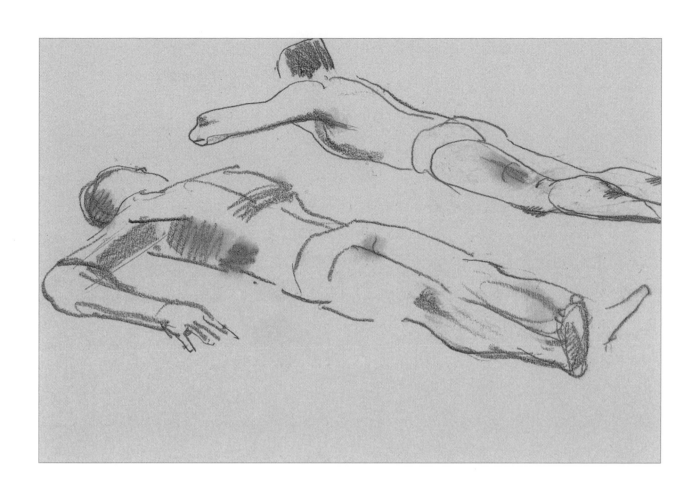

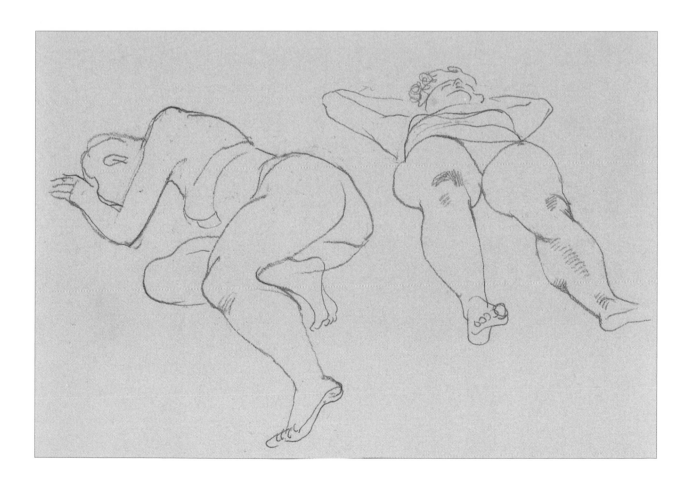

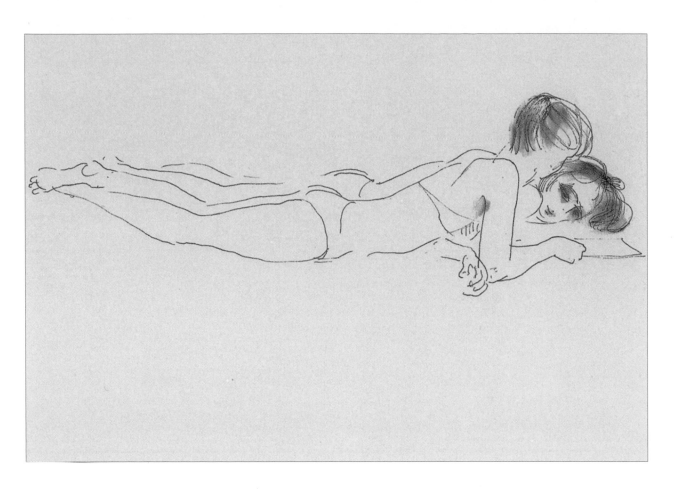

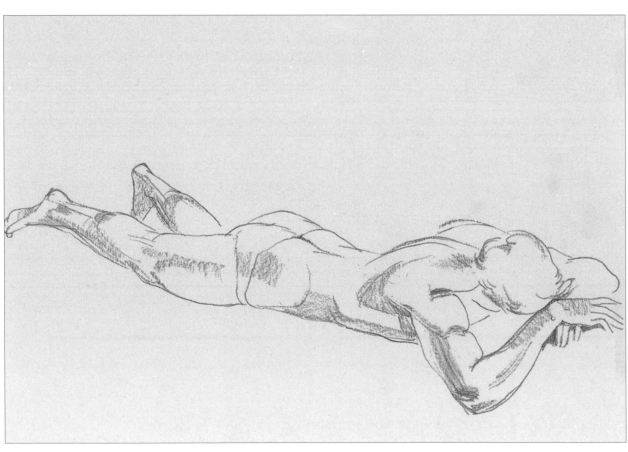

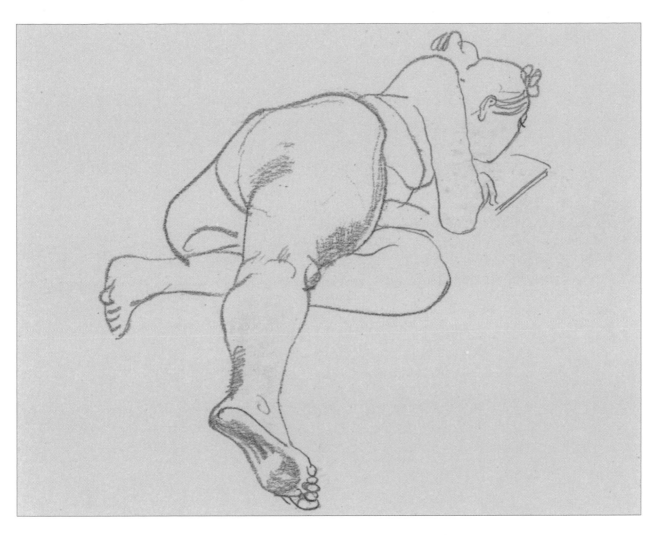

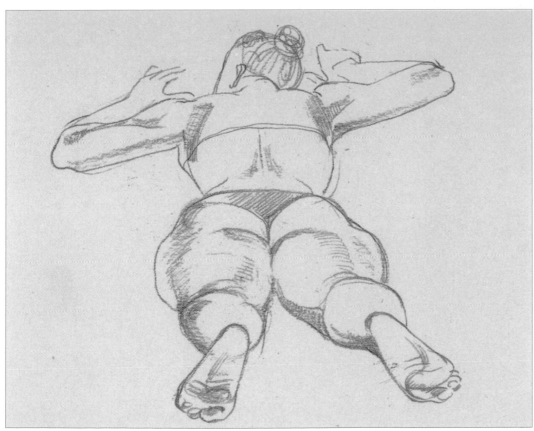

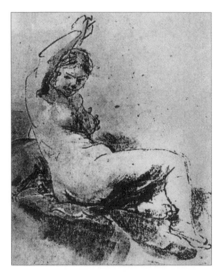

Rembrandt van Rijn (1606–1669): Seated female nude, c. 1661.

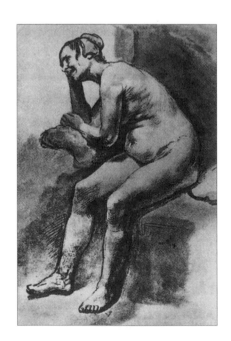

Rembrandt van Rijn: Naked young woman, half sitting up in bed, c. 1658/60.

Seated woman with head propped up, c. 1640.

SITTING POSES AS EXPRESSIONS OF EMOTION

Pages 299–311:
Whenever specific poses are not required from the model in order to demonstrate some particular function, we should seize the opportunity for unforced candour, whether this is a rest break (pages 299, 302, 306, 308, etc.) or simply a resting position taken by the model. At the right moment, these should then be captured as a separate subject. Good models generally follow their own devices and do not react to their environment.

In such cases, natural behaviour will prevail, automatically giving space to feeling, which is then expressed in the positions of the head and the body. Here, the view of the model brings about important decisions about possible willingness to communicate or otherwise or any 'defensiveness':

• Profile views of the body and the head prevent an inner dialogue (pages 299-302, 306, 310-311). The model has her own life regardless of the artist.

• Frontal views permit the creation of eye contact, although the final decision in this regard is determined by the position of the head, and most of all by the eye movement (pages 303 and 309).

• Rear views are defensive poses, suggesting loneliness and drawing the viewer into a kind of double reflection, namely into conveying a mood snapshot (pages 307 and 308).

Gestures, with their expressions of mood, can be interpreted and understood by the viewer:

• The raised head and its gaze are related to participation in internal or external reality; while the supported chin and crossed legs or the relaxed position of the hands clasped over the head are all evidence of relaxed alertness (pages 300 and 306), in contrast to strained attention (page 304).

• The forward-leaning body, with the face resting between supporting arms, is an expression of brooding (page 311), while the face resting on the hand indicates pensiveness (page 307).

• The propped-up, not fully extended arms form a pose that cannot be lingered in and produce an upbeat mood (page 305).

• The fully supporting arm in relation to the idly hanging head sunk to one side, gives the pose a mixture of lyrical and plaintive feeling (page 303).

• The slightly lowered head, the backward-leaning pose and the anchoring of the hands on the knees maintain, in spite of the evident relaxation, an expression of consciously maintained rest (page 306).

• The sinking of the upper body and head, the elbows' weak search for support, the hair succumbing to its weight, are all signs of lethargy.

The devout absorption in the body's pose teaches an essential lesson: every outer has an inner.

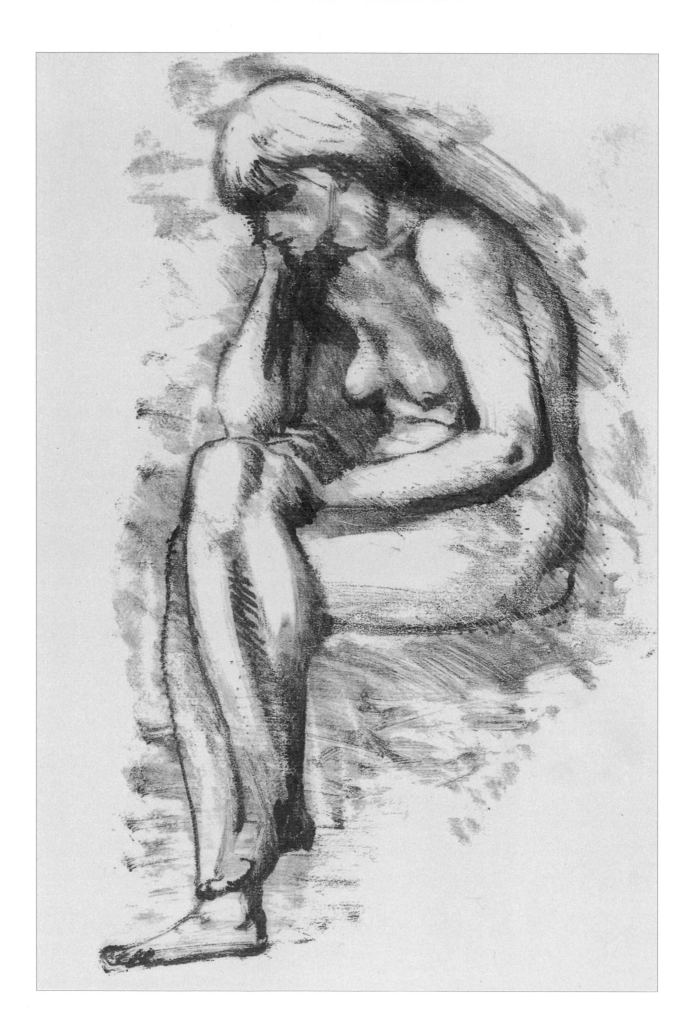

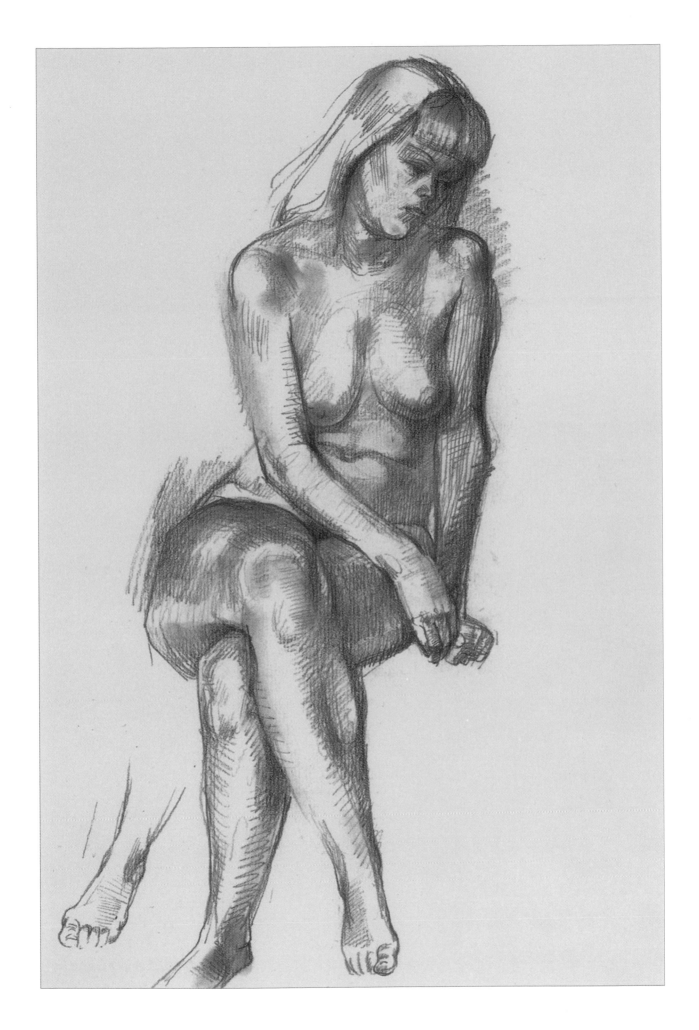

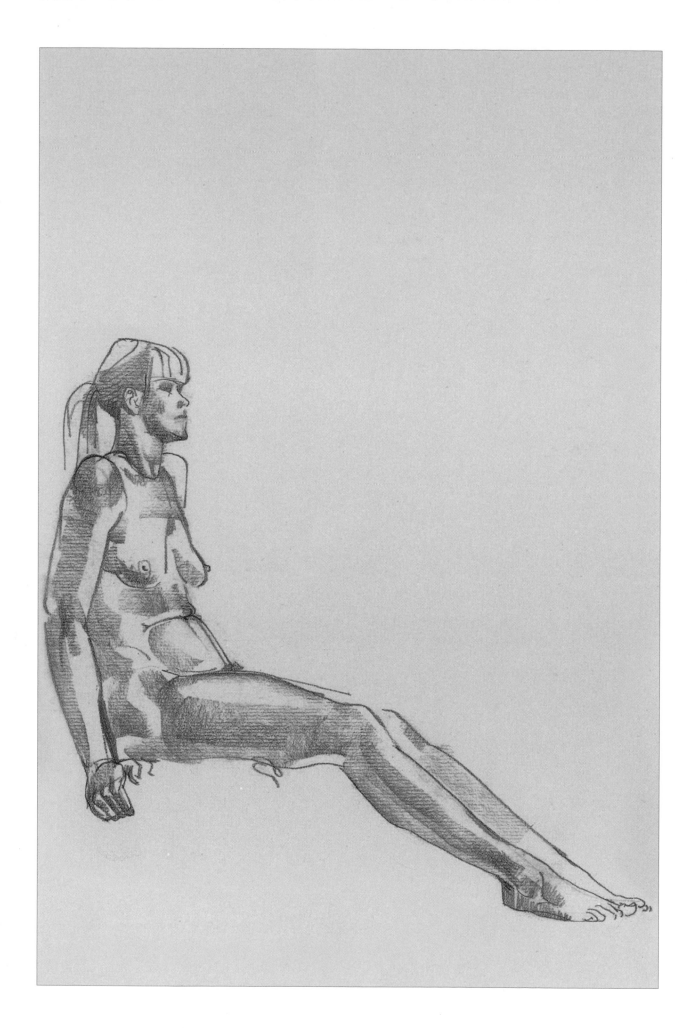

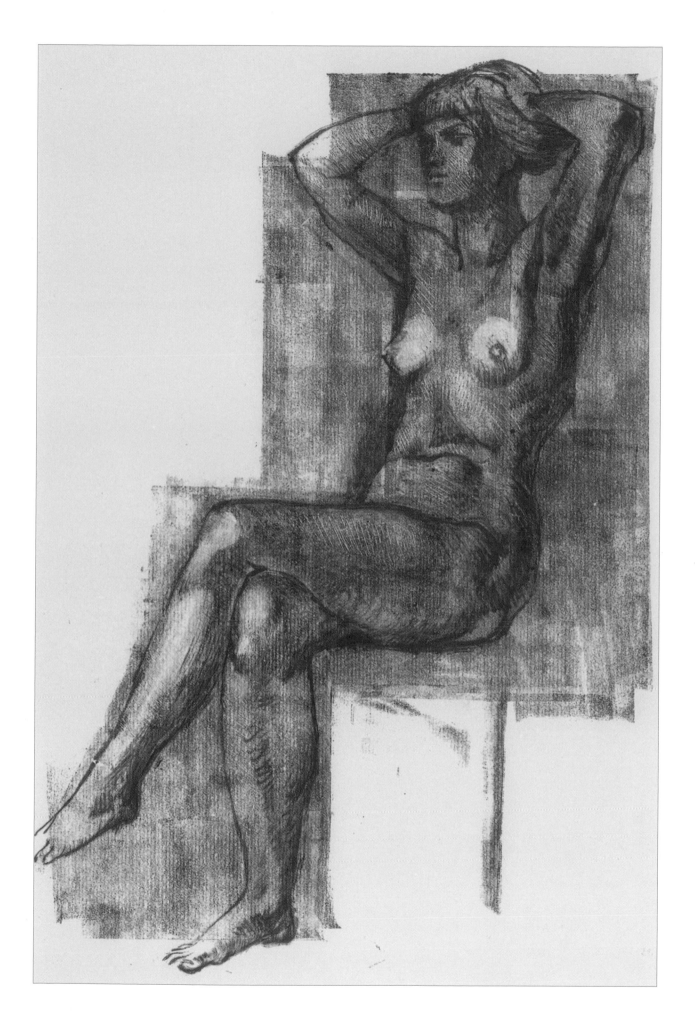

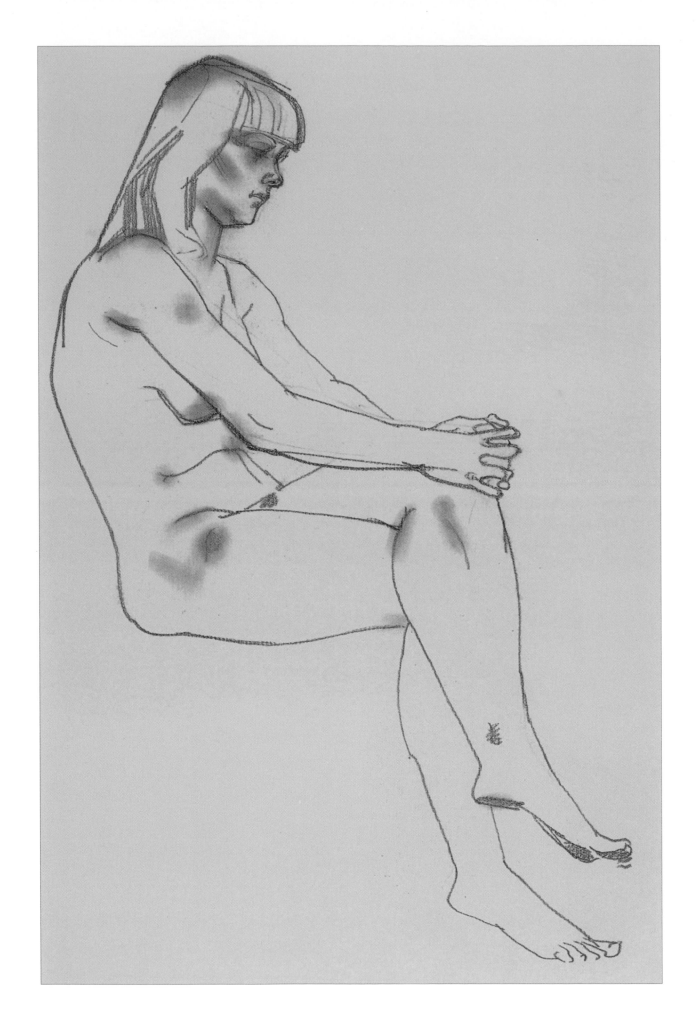

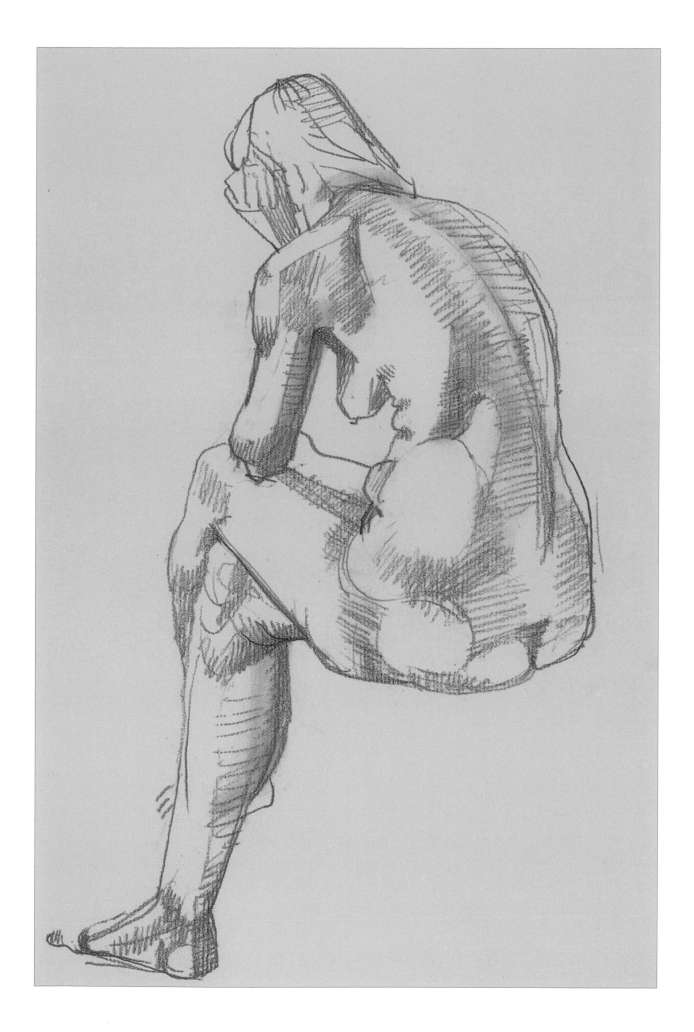

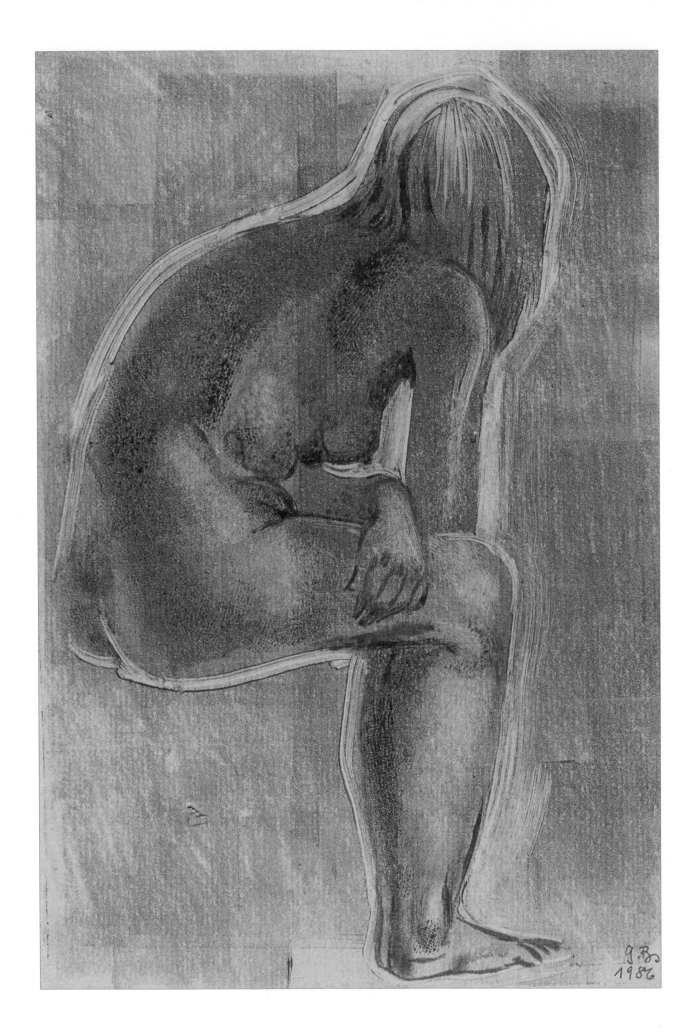

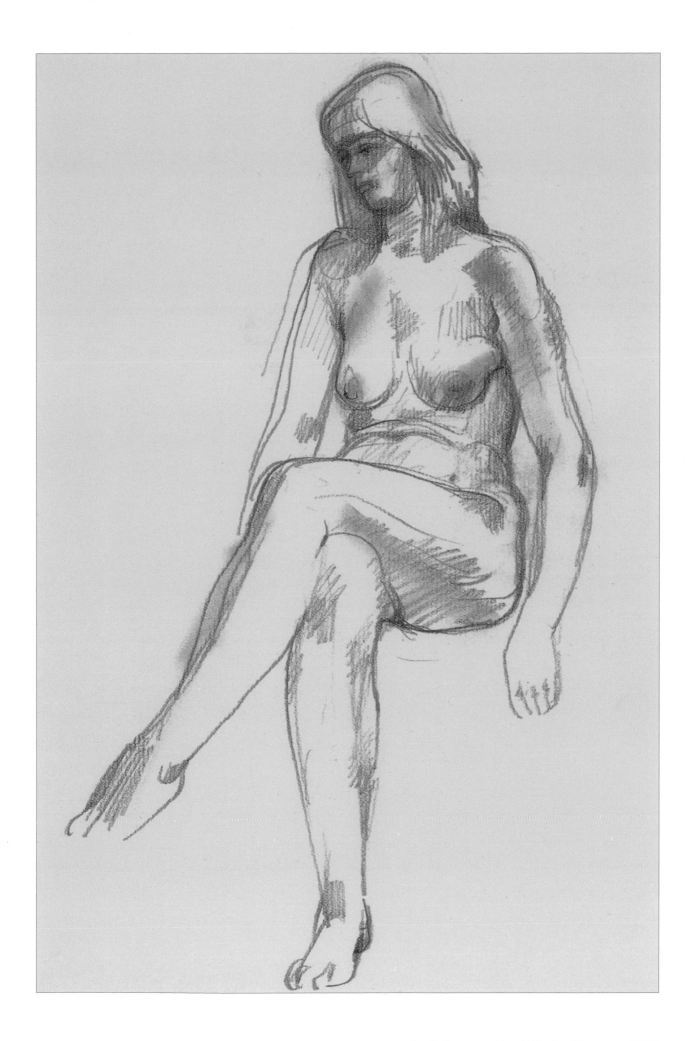

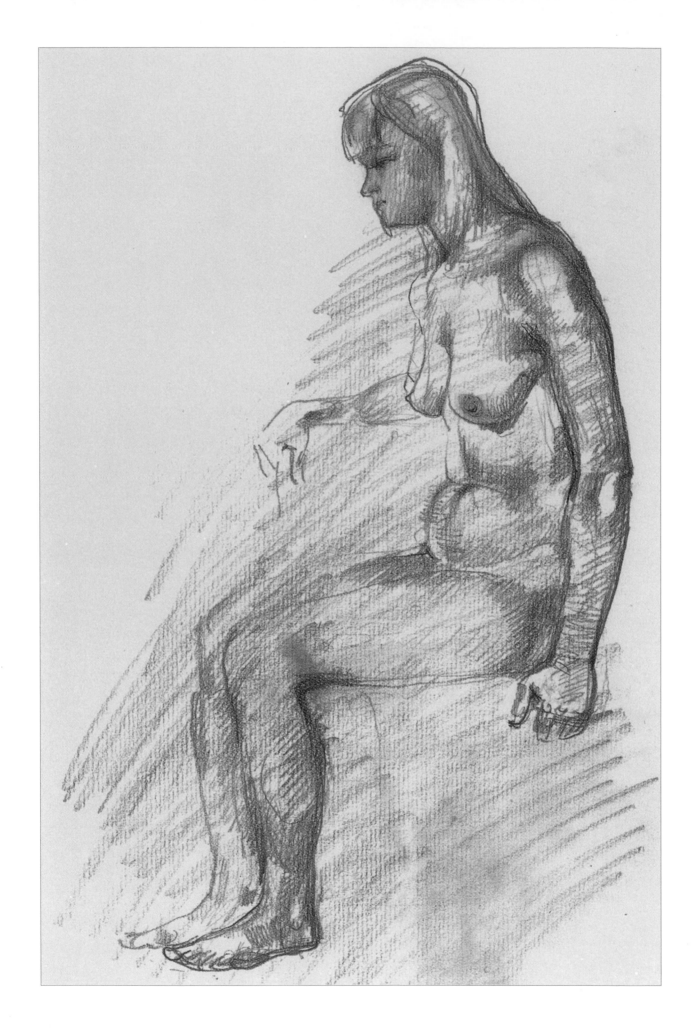

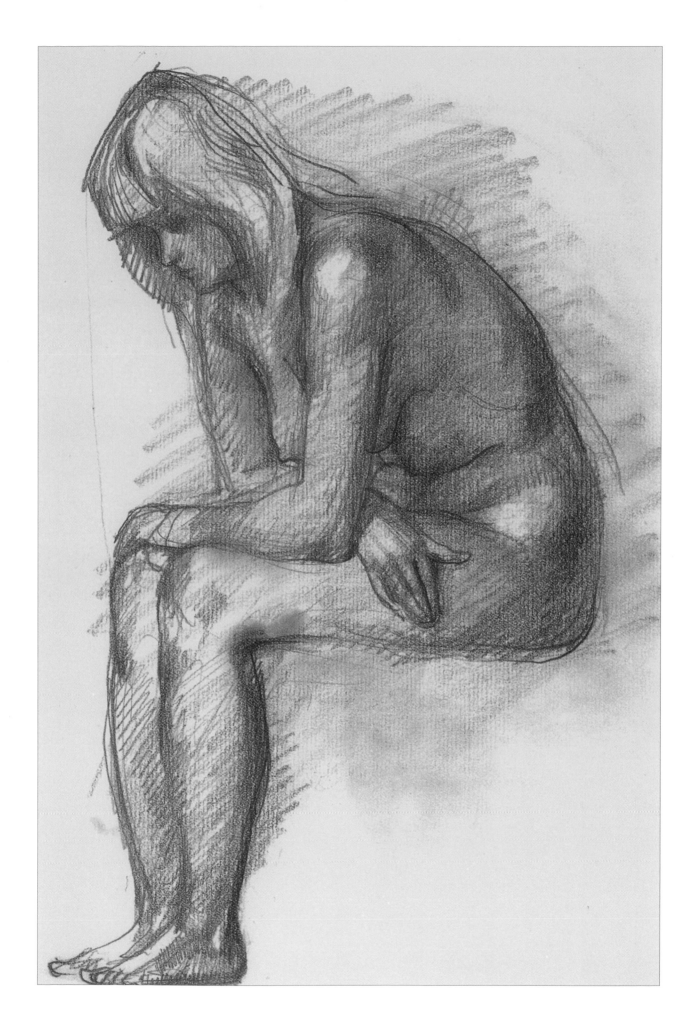

PICTURE CREDITS

Academy of Arts of the GDR: 200 b, 214 c; Academy of Arts of the USSR: 681, 104 t, 112 br, bl, 156 c, 168 t, 172 t, 204 t, 220 b, 232 b; Alazard: *Le Portrait florentin de Botticelli à Bronzino.* Paris, 1914: 226 c; Bammes: *Gestalt des Menschen.* Dresden: Verlag der Kunst, 1964: 18 b; Berenson: *Italian Pictures of the Renaissance.* London: The Phaidon Press, 1957: 94 t; *Berti.* Milan: Rizzoli Editore, 1973: 170 b; Beyer, Weimar: 226 b; Borden: *More Figures in Arts.* Alhambra, Calif.: Borden Publishing Company, 1968: 144 bl; Borden, *The Hand in Art.* Alhambra, Calif.: Borden Publishing Company 1963: 174 b, 178 t; Buchhold, Dresden: 246-251; *Catalogue illustré des oeuvres de Bouguereau.* Paris, 1885: 120 t; Choulant: *Geschichte der Anatomischen Abbildung.* Leipzig, 1852: 14 c; Geneva: Cosmopress: 210 t, 240b; Degas. London: Thames and Hudson, 1974: 40 b; Deusch: *Die Aktzeichnung in der europäischen Kunst 1400-1900.* Berlin, 1943: 298 t, c; *Drawings of Sir Edward Burne-Jones.* London, New York, n.d.: 220 t; *Albrecht Dürer 1471 bis 1528. Das gesamte graphische Werk. Handzeichnungen.* Berlin: Henschelverlag, 1971: 172 b, 230 l; Fischel: Raphael. Berlin (West): Gebrüder Mann Verlag, 1962: 112 t, 120 bl, 166 t; Hilaire: Derain. Geneva: Pierre Cailler, 1959: 146 b, 220 c; *Hofer – Katalog.* Staatliche Kunsthalle Berlin (West), 1978: 50 b, 222 t, Lankheit: *Franz Marc. Katalog der Werke.* Cologne: Verlag M. Du Mont-Schauberg, 1970: 116 b, *Leonardo da Vinci,* Berlin 1939: 13; *Leonardo da Vinci. Zeichnungen.* Ed. Anny E. Popp. Munich 1928: 20 t; Leporini: *Handzeichnungen großer Meister: Michelangelo.* Berlin, 1941: 132 t; Leporini: *Handzeichnungen großer Meister: Del Sarto.* Vienna/Leipzig, n.d.: 190 t, 226 t; Levy: *The Artist and the Nude.* London: Barrie and Rockliff, 1965: 156 r; *Großes Lexikon der Grafik.* Braunschweig: Westermann Verlag GmbH, 1984: 244 c, b; Löffler: *Josef Hegenbarth.* Dresden: VEB Verlag der Kunst, 1980: 182 b, 210, 222 b, 252; *Maillol bis 1944. 17. Juni bis 3. September 1978.* Staatliche Kunsthalle Baden-Baden: 230 r, 276 b; *Ein Maler vor Liebe und Tod. Ferdinand Hofer und Valentine Godé-Darel.* Geneva: Kunsthaus Zurich and Jura Brüschweiler, 1976: 232 t; Menzel. *Katalog der Hamburger Kunsthalle,* 1982: 244 c; *Michelangelo. Zeichnungen.* Ed. A. E. Brinkmann. Munich, 1925: 176 b; Mitsch: *Egon Schiele.* Salzburg: Residenz Verlag, 1974: 128 l; Museum of Fine Arts, Leipzig: 30 t, 128 t, 154 t, 170 t, 282 t; Museums of the City of Erfurt, Anger Museum: 116 c, 168 b; Müller, Basel: 94 b, 156 l; Nationalgalerie Berlin (West): 182 t; National Museum of Wales, Cardiff: 68 c, 72 c; Pirchau: *Gustav Klimt. Ein Künstler aus Wien.* Vienna/Leipzig 1942: 540; Sächsische Landesbibliothek, Abteilung Zentralbibliothek: 13 t, 14 t, b, 16 t, 18 t, 32 t, b, 62 t, 108 t, 174 t; Sächsische Landesbibliothek, Abteilung Deutsche Fotothek: 212 b; *Schadow: Atlas zu Polyklet oder von den Maassen des Menschen.* Berlin, n.d.: 46; Scheidig: *Rembrandt als Zeichner.* Leipzig: VEB E. A. Seemann-Verlag, 1962: 100 b, 298 b; Schweizerisches Institut für Kunstwissenschaft: 34 t, 86 t; Singer: Meister der Zeichnungen. Vol. 6, Leipzig, 1912: 96; Singer: *Zeichnungen von Franz Stuck.* Leipzig, 1912: 136 b; Staatliche Kunstsammlungen Dresden / Kupferstichkabinett: 26 t, 276 t, 294; Staatliche Kunstsammlungen Dresden / Kupferstichkabinett / Pfauder: 116 t, 178 b; Staatliche Kunstsammlungen Dresden / Kupferstichkabinett / Schurz: 26 c, 54 bl, b, 64 t, 100 t, 136 t, c, 144 t, 166 t, 176 t, 180 t, b, 268 r; Staatliche Kunstsammlungen Weimar / Renno: 104 b, 132 b, 140 t, 144 b, 190 b, 212 b, 214 t; Staatliche Museen zu Berlin / Borgwaldt: 40 t; Staatliche Museen zu Berlin / Nationalgalerie: 50 t, 58 b, 62 b, 68 r, 72 r, 84 r, b, 100 tc, 268 l, 282 b; Steinlen. Katalog der Kunsthalle Bremen, 1978: 74 t; Trier: *Zeichnungen und Radierungen.* Munich: Piper Verlag, 1955: 200 t; Waldmann: *Auguste Rodin.* Vienna: Schroll Verlag, 1945: 30 b, 244 t; Webb, Zürich: 46 t, 240 c; Zorn, Dresden: 214.

All other illustrations are photographs taken by the author.